Wonder *of the* Age

MASTER PAINTERS OF INDIA
1100–1900

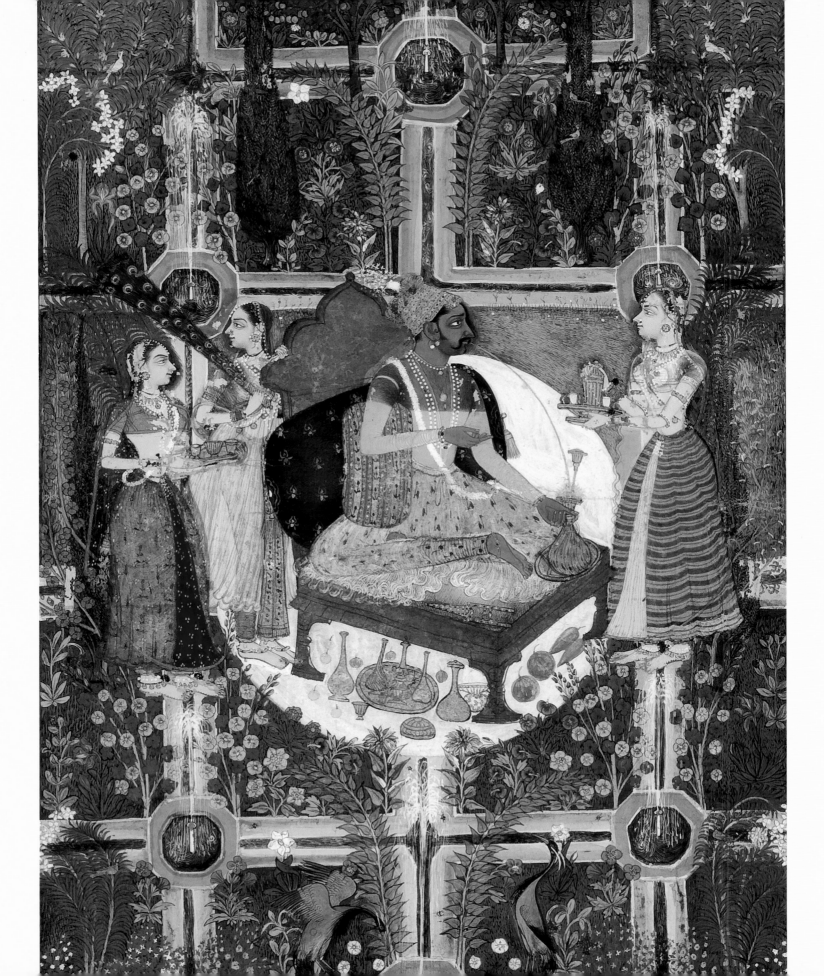

Wonder *of the* Age

MASTER PAINTERS OF INDIA
1100–1900

John Guy and Jorrit Britschgi

The Metropolitan Museum of Art, New York

Distributed by Yale University Press, New Haven and London

This catalogue is published in conjunction with "Wonder of the Age: Master Painters of India, 1100–1900," on view at The Metropolitan Museum of Art, New York, from September 28, 2011, through January 8, 2012.

The exhibition is made possible by **MetLife Foundation**

Additional support provided by Novartis Corporation.

The exhibition was organized by the Museum Rietberg Zurich in collaboration with The Metropolitan Museum of Art, New York.

Published by The Metropolitan Museum of Art, New York
Mark Polizzotti, Publisher and Editor in Chief
Gwen Roginsky, Associate Publisher and General Manager of Publications
Peter Antony, Chief Production Manager
Michael Sittenfeld, Managing Editor
Robert Weisberg, Assistant Managing Editor

Edited by Barbara Cavaliere
Designed by Rita Jules, Miko McGinty Inc.

Bonnie Laessig, Assistant Production Manager
Jane S. Tai, Image Acquisition Manager
Anandaroop Roy, Mapmaker

Typeset in Fleischman and FF Bau
Printed on 150 gsm Leykam Matt Classic
Separations by Professional Graphics, Inc., Rockford, Illinois
Printed and bound by CS Graphics PTE LTD, Singapore

Jacket illustrations: (front) Shah Jahan riding a stallion: page from the Kevorkian Album, Mughal court at Agra, ca. 1628. Detail of No. 40; (back) Krishna flirting with the *gopis* to Radha's sorrow: folio from a *Gita Govinda* series, Kangra, Himachal Pradesh, ca. 1760. Detail of No. 95
Frontispiece: Rao Jagat Singh of Kota at ease in a garden, Kota, Rajasthan, ca. 1660. No. 48
Page 14: Nanda touches Krishna's head after the slaying of Putana: folio from a *Bhagavata Purana* manuscript, Delhi-Agra region, North India, ca. 1540. Detail of No. 7

The Metropolitan Museum of Art
1000 Fifth Avenue
New York, New York 10028
metmuseum.org

Distributed by
Yale University Press, New Haven and London
yalebooks.com/art
yalebooks.co.uk

Cataloging-in-Publication Data is available from the Library of Congress.
ISBN 978-1-58839-430-9 (hc: The Metropolitan Museum of Art)
ISBN 978-0-300-17582-0 (hc: Yale University Press)

CONTENTS

Maps appear on pages 16, 111, and 147.

DIRECTOR'S FOREWORD

It is with great delight that The Metropolitan Museum of Art presents *Wonder of the Age: Master Painters of India, 1100–1900*. This publication and the exhibition it accompanies represent the collaboration between two museums and many scholars. The exhibition was conceived by three of the most eminent scholars in the field of Indian painting, Drs. Milo Beach, Eberhard Fischer, and B. N. Goswamy. Jorrit Britschgi, Curator of Indian Painting at the Museum Rietberg in Zurich, realized the exhibition in collaboration with John Guy, Florence and Herbert Irving Curator of the Arts of South and Southeast Asia at The Metropolitan Museum of Art, and they jointly prepared this publication.

This catalogue sets out to dispel the conventional view of Indian painting as an anonymous activity, akin to the practice of other crafts in traditional India, and asserts the critical role of named painters through the study of individual hands, filial relationships, and artists' lineages. The forty identified artists in this publication were each seminal in shaping the development of Indian painting in their age. Some were celebrated in their time; others were assigned identities later on the basis of an assembled corpus of works. Inscriptional evidence has been combined with the analytical tools of connoisseurship to define the authorship of many works. The sweep is broad, spanning the course of eight centuries, from the earliest surviving examples of the Indian art of the book in the twelfth century to the rise of photography in the nineteenth.

This publication provides a rare opportunity to study and savor works never brought together before, and acknowledgment is due to the many lenders who made this possible. Foremost, we are grateful to Her Majesty Queen Elizabeth II for her generous loans from The Royal Collection at Windsor Castle, and to the Government of India for sanctioning major loans from the nation's collections.

We also extend our gratitude to MetLife Foundation for understanding the importance of such international collaborations and supporting the show so generously. In addition, the Metropolitan wishes to thank Novartis for its remarkable commitment to the project.

Thomas P. Campbell
Director
The Metropolitan Museum of Art, New York

PREFACE

The forty eminent painters chosen for this exhibition are among the greatest in the history of Indian painting. Each could lay claim to the honorific titles bestowed by Mughal emperors on their most prized painters: *Nadir al-Asr*, "Wonder of the Age," and *Nadir al-Zaman*, "Wonder of the Times." These titles were awarded by the emperor Jahangir to his two favorite artists, Ustad (master) Mansur and Abu'l Hasan, respectively. Such special recognition was in keeping with an Iranian tradition of awarding honorific titles to the most gifted artists of the day. Variants of these titles were awarded in the intense, somewhat hothouse atmosphere of the imperial Mughal workshops. Other eminent painters, such as Mir Sayyid 'Ali, 'Abd al-Samad, and Daswanth, were similarly esteemed, as was the famed Shiraz painter Khajah Abduccamad with the honorific *Shirinqalam* (Sweet Pen.)[1] Abu'l Fazl, biographer of the emperor Akbar, wrote in the *A'in-i Akbari*:

> More than a hundred painters have become famous
> masters of the art, whilst the number of those who approach
> perfection, or those who are middling, is very large. . . .
> It would take too long to describe the excellence of each.
> My intention is "to pluck a flower from every meadow,
> an ear from every sheaf."[2]

Like Akbar, his son Jahangir boasted of his role as a guiding patron, nurturing his artists' development. In the case of the master painter Abu'l Hasan, Jahangir recorded in his personal memoirs: "I have always considered it my duty to give him much patronage, and from his youth until now I have patronized him so that his work has reached the level it has."[3] The signatures of the artists of course speak a very different language, reflecting the assumed humility required when addressing the emperor. They assume such epithets as "servant," "least of the unworthy," or "slave." It is telling that in Abu'l Hasan's Accession of Jahangir (No. 29),

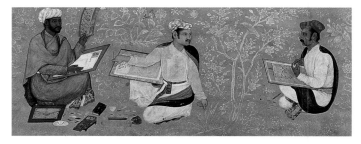

FIGURE 1. Border illuminations with a self-portrait and portraits of the painters Govardhan and Bishandas (detail), by Daulat, ca. 1610. Golestan Palace Library, Tehran

he signed his work on the shovel used in cleaning up elephant dung as an expression of his humility. With few exceptions, the painters left no self-portraits. This makes the rare appearance of a self-portrait in imperial *dardar* (audience) scenes all the more remarkable, and it alludes to those artists, such as Payag and Balchand, as having a special relationship at court that allowed them to be admitted into the inner circle (No. 38).

The Rajput patrons were less effusive but nonetheless prized their finest painters. In the case of the Guler ruler Raja Balwant Singh and his court painter Nainsukh, the patron and artist clearly had a special relationship, as is witnessed by Raja Balwant Singh viewing a painting presented by the artist (No. 83). The appearance of artist's portraits and especially self-portraits as early as the 1570s in Akbari studio circles marks a moment of change when painters were permitted to indulge in depicting themselves. Keshav Das's remarkable self-portrait as the poor petitioner is a defining moment (No. 25).

This publication and the exhibition it accompanies challenge the conventional wisdom that extols the anonymity of Indian art, instead emphasizing how the combined tools of connoisseurship and inscriptional evidence can reveal the identities of both individual artists and their oeuvres through an analysis of style. The

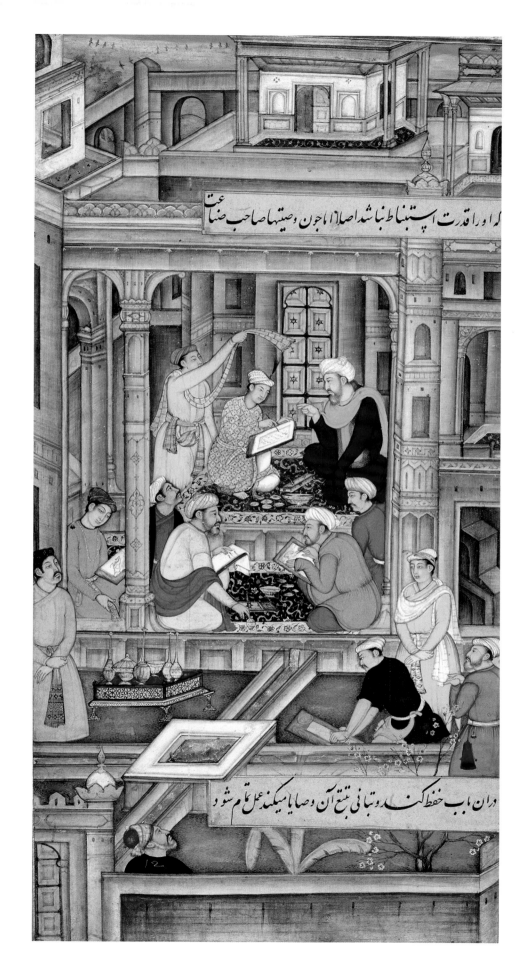

FIGURE 2. The Painters' atelier (*kitabkhana*), from
an *Aklaq-i Nasri* manuscript, attributed to Sajnu
(or Sahu), ca. 1590–95. Aga Khan Trust for Culture,
Aga Khan Museum Collection, Geneva

FIGURE 3. Sansar Chand of Kangra admiring pictures with his courtiers, attributed to Purkhu, ca. 1788–1800. Museum Rietberg, Zurich, Bequest of Balthasar Reinhard

and Payag, the Pahari Hill painters Manaku and Nainsukh, and Shivalal and Mohanlal of Mewar were pairs of brothers, and Aqa Riza, Basawan, Bagta, and Tara were fathers whose sons followed in their profession. When Abu'l Hasan signed an early work, he displayed due humility to his father, Aqa Riza, by adding after his name the phrase "dust of the threshold of Riza."[4] Such lineages were a source of pride, as Nainsukh's entry in a pilgrim's register reveals: "Written by Naina [Nainsukh], carpenter-painter, native of Guler. Son of Seu. Grandson of Hasnu. Great-grandson of Bharathu. Great-great-grandson of Data."[5]

For the vast majority of artists, no biographical information has come down to us, but at least we have patrons' observations in the case of the most distinguished Mughal artists, scribal notations from attentive librarians who assigned artists' names to works, or a note by some archivist who inventoried his prince's picture holdings, linking the works to a named patron. Only rarely is one fortunate enough to discover an artist's portrait or self-portrait (Fig. 1). Nor did painters routinely sign their work. The absence of signatures on the majority of Indian paintings forces one to question the artists' social position and self-image. As B. N. Goswamy among others has suggested, the painters' relative anonymity also had to do with the fact that they saw themselves as part of a crafts tradition that drew from a common pool of pictorial ideas and established iconographies, and therefore considered it inappropriate to identify themselves as a picture's creator. It was in the context of secular painting, such as much of the work undertaken for Mughal patrons, that the desire for recognition was first permitted to surface (Fig. 2).

The connoisseurship of Indian painting has been shaped by the preferred medium of expression—small-scale manuscript illustrations or larger format independent folios. The former lend themselves to private contemplation and enjoyment, to be shared with an intimate circle within a prince's audience room (No. 83) or private apartment, or in the *zenana* with the ladies of the court. Larger scale paintings, such as those produced in Rajasthan and the Pahari Hill states of Himachal Pradesh in the eighteenth and early nineteenth centuries, were displayed, but again in private interiors of the palace. Others served as templates for mural paintings intended for these interiors. This was an art reserved for the enjoyment of the elite (Fig. 3).

Where biographical sources are scant or nonexistent, it is stylistic analysis that can support the construction of credible

formation of workshops under the charismatic influence of identified master painters comprises a transforming moment in the evolution of Indian painting. Scholarly research in recent decades has fundamentally changed our understanding of the paintings of India. The names of dozens of artists have been recovered; pictorial styles have been analyzed; contemporary references to the works have been evaluated; and literary sources, including palace archives and accounts, pilgrimage and land registers, have been combed for mention of artists. Today, we no longer think of Indian painters as anonymous craftsmen but as identifiable individuals working within an atelier or in a contractual relationship with a patron. One striking aspect of these studies has been the recognition of filial relationships between known artists. A surprising number of those presented here are related—father and son or brothers who followed their father's profession. When this relationship is recognized, it is usually readily detectable in the work. For example, the imperial Mughal painters 'Abid and Abu'l Hasan, Balchand

scenarios pending confirming evidence. Many of the attributions of works we present here are built on such informed judgments and are offered as a starting point for critical review and analysis. In many cases, they point out the direction that further research should take. The scope is ambitious, extending from a monastic artist of the early twelfth century to the court painters of Mewar who recorded the last flourishes of courtly life at Udaipur before the imposition of the Raj in 1857. This moment of political transition coincides with the appearance of the glass-plate camera, which effectively marked the end of the art of court painting in India. A vogue for the hand-painted photograph provided an interregnum phase, but by the 1870s, the camera had replaced the palette.

The mobility of artists, many of whom ventured across the subcontinent in search of new patronage, played a key role in the dissemination and diffusion of style. Many instances are recorded in the artists' biographies included herein; the more notable are Nainsukh, who left his father's workshop in Guler in order to work in Jasrota, and Bagta and his son Chokha, who after their training in Udaipur moved farther north to Devgarh. Bhavanidas, who began his career in the Mughal workshops, found later employment in the principality of Bikaner in Rajasthan. The most spectacular instance is that of Farrukh Beg, who from his native Iran, where he was an established painter, accepted an invitation to the Mughal court at Kabul, then Lahore, spent several years at the court of Bijapur in the Deccan, and ended his career back in Mughal employ at Agra. Since Mughal rulers and their retinues were on the move for much of the year, bringing new territories under their control or inspecting parts of their empire, painters were required to accompany them. Rajput princes also occasionally took their painters with them; Ruknuddin accompanied his patron on a military campaign into the Deccan. This mobility, combined with the practice of gift exchange between rulers that often included fine books, resulted in constant traffic in artistic styles and ideas.

Although single artists are featured in this volume, it is the groupings of painters that make it easier for viewers to appreciate visual links and the artistic legacy of a given school. The focus is thus not on patrons but on the individual painters and their lineages as well as their geographical and historical settings. The first section is devoted to artists who worked during the period between 1100 and 1500, before the Mughal conquest but already a period subjected to Muslim influence from the Sultanate courts of India. The second grouping includes artists who were active at the various Mughal courts, beginning with the Persian emigrants who laid the foundation for the development of the Mughal style in India. Painting in Bundi and Kota was directly influenced by these artists. Pahari painting of the hill states of the modern Himachal Pradesh and Jammu-Kashmir comprises a major corpus of documented painters, many touched by subimperial Mughal influences. Painting from the courts of Rajasthan, provided by the group of Mewar painters who are documented from the early seventeenth century until the late nineteenth century, comprises the final grouping.

This project was conceived by three *acharyas* in the field of Indian painting studies, Milo Beach, Eberhard Fischer, and B. N. Goswamy, and reflects their substantial contributions to this field over the past thirty years. Much of what appears here is informed by the scholarship of these and other scholars who have helped define this field of study. The pioneering studies of Ananda Coomaraswamy, Moti Chandra, Karl Khandalavala, William Archer, Robert Skelton, Jagdish Mittal, and Saryu Doshi laid much of the groundwork upon which later scholars have built. Pramod Chandra, Stuart Cary Welch, and his protégé Mark Zebrowski advanced the study of Mughal and Deccani painting, as Daniel Ehnbom, Jeremiah Losty, Linda Leach, Andrew Topsfield, and John Seyller have done more recently in their respective fields. The *Artibus Asiae* publication *Masters of Indian Painting* that has been released to coincide with this exhibition reflects the research of many scholars: Molly Aitken, Milo Beach, Catherine Benkaim, Michael Brand, Sheila Canby, Asok Kumar Das, Saryu Doshi, Daniel Ehnbom, Eberhard Fischer, B. N. Goswamy, John Guy, Navina Haidar Haykel, Steven Kossak, Jeremiah Losty, Tryna Lyons, Terence McInerney, Jagdish Mittal, Amina Okada, Keelan Overton, John Seyller, and Andrew Topsfield. Suffice it to say that their contributions to the field have made this project possible.[6]

John Guy
Florence and Herbert Irving Curator of the Arts of
South and Southeast Asia, Department of Asian Art
The Metropolitan Museum of Art, New York

Jorrit Britschgi
Curator of Indian Painting
Museum Rietberg, Zurich

ACKNOWLEDGMENTS

The partnership between the Museum Rietberg and The Metropolitan Museum of Art that generated this exhibition has necessitated the cooperation of many colleagues in museums in India, Europe, and the United States, as well as those within our respective institutions. We are indebted to the Museum Rietberg's director Albert Lutz and to Thomas P. Campbell and Philippe De Montebello, present and former Directors of The Metropolitan Museum of Art, for their unstinting support of this complex project, which has drawn works of art from lenders in three continents.

The former director of the Museum Rietberg, Eberhard Fischer, together with his longstanding colleagues Milo Beach and B. N. Goswamy, conceived the exhibition and passed the baton to curator Jorrit Britschgi and registrar Andrea Kuprecht. Upon entering into a partnership with the Metropolitan, the Museum's Associate Director for Exhibitions Jennifer Russell and Registrar Aileen Chuk gave their full support, and John Guy undertook the co-curatorship.

This exhibition could not have been realized without the generous cooperation of major lenders from three continents. Her Majesty Queen Elizabeth II graciously agreed to lend works from The Royal Collection. Major loans were generously provided by The Aga Khan Trust in Geneva, the Bodleian Library and the Ashmolean Museum at Oxford, The Institute of Oriental Studies at the Russian Academy of Sciences in St. Petersburg, the Museum of Islamic Art in Doha, the State Library in Berlin, the Ethnographic Museum of Munich, and the Musée Guimet in Paris.

As a result of the generous support of India's Minister of Culture and the cooperation of the directors of the four lending institutions, Indian collections have a major presence in the exhibition. We thank India's Secretary of Culture, Jawhar Sircar; the National Museum New Delhi, especially Dr. Jayshree Sharma; director Dr. D. P. Sharma and staff of the Bharat Kala Bhavan at Banares Hindu University, Varanasi; trustees and staff of the Chhatrapati Shivaji Maharaj Vastu Sangrahalaya, Mumbai, especially the director Mr. S. Mukherjee; the Udaipur City Palace Museum, Udaipur and His Excellency Arvind Singh of Mewar. The Indian Ambassador to the United States, Ambassador Meera Shankar and her staff were especially helpful. In India, the Swiss Ambassador Philippe Welti lent great support.

Colleagues in museums across Europe and the United States have responded with generous loans. The directors and staff of the museums named in the List of Lenders herein must be acknowledged. In addition, we wish to thank those individuals who responded to our innumerable requests: Anita Chung, Debra Diamond, Sir Howard Hodgkin, Benoît Junod, Stephen Markel, Darielle Mason, Sonya Quintanilla, Julian Raby, Andrew Topsfield, and Laura Weinstein. A number of private collectors made highly significant loans to the exhibition, and they also appear in the List of Lenders.

A large number of people assisted in various ways to the exhibition's realization, and we thank them here: Taryn Adinolfi, Jude Ahern, Catherine Benkaim, C. V. Ananda Bose, Michael Brand, Prahlad Bubbar, Allison Busch, Dr. Daljeet, Asok Kumar Das, B. G. Deshmukh, Nancy Fessenden, Kjeld von Folsach, Jürgen Frembgen Sven Gahlin, Chandrika Grover, Ludwig Habighorst, Sara Hardin, Diane Hart, Franak Hilloowala, Steven Kossak, Naval Krishna, Pramod Kumar, Vijay S. Madan, Terence McInerney, Mary McWilliams, Aldo Mignucci, Theresa-Mary Morton, Sarah Murray, Nahla Nasser, Kit Nicholson, Antony Peattie, Cynthia Polsky, Irina Popova, Vandana Prapanna, Neeta and Sushil Premchand, Bruno Rauch, Honorable Lady Roberts, Michael Ryan, Konrad and Eva Seitz, D. P. Sharma, Gursharan and Elvira Sidhu, Rajeswari Shah Amaresh Singh, Bhupendra Singh Auwa, R. P. Singh, Anita Spertus, Cynthia Talbot, Elena Tananova, Wheeler Thackston, Audrey Trusche, Oliver Watson, Edith Welch, Mary White, the late Doris Wiener, and Mrinalini Venkateswaran.

At The Metropolitan Museum of Art, thanks are due to colleagues in the Asian Art Department. James Watt, Curator Emeritus, and Maxwell Hearn, Curator-in-Charge, have given this project their fullest support. Administrator Judith Smith supported by Jill Wickenheisser and colleagues in the Collection Management team, led by Hwai-ling Yeh-Lewis, have been vital to the exhibition's realization, and special thanks go to Alison Clark and Crystal Kui for their dedication to the management of the loans. For further assistance in supporting loans and research, we wish to thank Kurt Behrendt, Thelma Carter, Kristan Liu, and Karen Weissenborn. Use of the resources of the Museum's great library was provided by Robyn Fleming, Jennie Pu, and Min Xu. Unfailing technical support was received from Imtikar Ally, Lori Carrier, Luis Nuñez, and Beatrice Pinto. Further assistance was provided by Taylor Miller and his construction team.

Colleagues Sheila Canby, Maryam Ekhtiar, and Navina Haidar Haykel, in the Metropolitan's Department of Islamic Art,

generously agreed to loans from their department's collection and responded to numerous questions. Sharon Cott and Kirstie Howard in the Counsel's Office provided valuable guidance on legal matters and skillfully negotiated the loan agreements and contracts. In Paper Conservation, Yana Van Dyck brought her usual professionalism to bear on the works entrusted to her care; we are particularly grateful to her for curating the Materials and Techniques section of the exhibition, which was supported by Christopher Noey's cinematic skills. The Exhibitions team, led by Linda Sylling, ensured that all the complexities of planning and implementing the installation went smoothly. The installation design was skillfully conceived by Dan Kershaw, as were the graphics by Sue Koch. Press was ably supported by Elyse Topalian and Naomi Takafuchi. Harold Holzer kindly assisted in External Affairs. The educational program was managed by Joseph Loh, Nicole Leist, and colleagues. The publication was beautifully designed by Rita Jules of Miko McGinty Inc. Finally, the Editorial Department team responsible for this catalogue saw it to press with efficiency and skill; particular thanks to Gwen Roginsky, Peter Antony, Michael Sittenfeld, Barbara Cavaliere, Bonnie Laessig, Jane Tai, and Robert Weisberg.

John Guy and Jorrit Britschgi

LENDERS TO THE EXHIBITION

INSTITUTIONAL LENDERS

Aga Khan Trust for Culture, Aga Khan Museum Collection, Geneva

The Art and History Collection; Courtesy of the Arthur M. Sackler Gallery, Smithsonian Institution, Washington, D.C.

Arthur M. Sackler Gallery, Smithsonian Institution, Washington D.C.

Ashmolean Museum, University of Oxford

Bharat Kala Bhavan, Banaras Hindu University, Varanasi

Bodleian Library, University of Oxford

Chhatrapati Shivaji Maharaj Vastu Sangrahalaya, Mumbai

The Cleveland Museum of Art, Cleveland

David Collection, Copenhagen

Harvard Art Museums, Cambridge

Los Angeles County Museum of Art, Los Angeles

City Palace Museum, Udaipur. Maharana of Mewar Charitable Foundation

Musée des asiatiques Guimet, Paris

Museum of Fine Arts, Boston

Museum of Islamic Arts, Doha

Museum Rietberg, Zurich

National Museum, New Delhi

Philadelphia Museum of Art, Philadelphia

The Royal Collection, Windsor Castle

Russian Academy of Sciences, Institute of Oriental Manuscripts, Saint Petersburg

The San Diego Museum of Art, San Diego

Staatliches Museum für Völkerkunde, Munich

Staatsbibliothek zu Berlin, Preussischer Kulturbesitz

Williams College Museum of Art, Williamstown

PRIVATE LENDERS

Barbara and Eberhard Fischer

Catherine and Ralph Benkaim

Cynthia Hazen Polsky

Danielle Porret

Eva and Konrad Seitz Collection

Gursharan S. and Elvira Sidhu

The Kronos Collections

Ludwig Habighorst Collection

Private Collection, U.K. Courtesy Prahlad Bubbar

Sir Howard Hodgkin

Anonymous private lenders

Wonder *of the* Age

MASTER PAINTERS OF INDIA
1100–1900

Indian subcontinent, showing major centers of painting production

THE ART OF THE BOOK IN SOUTH ASIA

John Guy

ORIGINS OF INDIAN PAINTING

Painting in India is ancient, and of two kinds. It was used to decorate the interiors of both palaces and places of worship, and it was employed to illustrate texts in manuscripts, both secular and sacred. Early in their development, all Indian religions experienced the precariousness of relying exclusively on oral transmission and became aware of the necessity of a written tradition. Perhaps the most extreme case was that of the Jains, whose elders resolved perhaps as early as the third century BCE to commit the teaching of their historical founder Mahavira to writing to ensure that the lineage of knowledge transmission was not broken.[1] Sometime around this period, the Buddhist Councils similarly resolved to commit the Buddha's teachings to written form. Books, written on birchbark and palm-leaf, are assumed to have come into existence around this time. In addition, a vast body of Brahmanical literature had to be recorded.

The traditional medium throughout most of India's past has been the palm-leaf manuscript. This humble form of the book, at once both fragile and resilient, provided the vehicle for transmitting the vast body of Indian thought for more than two thousand years and, for at least half of that period, was a medium for the visual arts in the form of illustrated manuscripts. It is not known when the practice of illuminating texts became a regular part of manuscript production, but it appears to have been an established convention by the twelfth century, the period from which dated illustrated manuscripts became a more regular feature of religious texts.

The other major stream of early Indian painting — again, of which almost nothing survives — was that of mural painting, both temple and palace decor. Connoisseurship of the visual arts was elucidated by both Vatsayana in his famous fourth-century guide to sensual pleasures the *Kamasutra*, and by Kalidasa, the great fifth-century Sanskrit poet and commentator on Indian aesthetics,

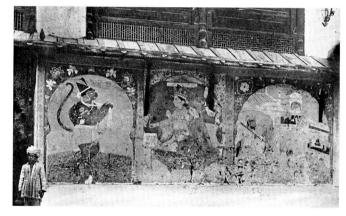

FIGURE 4. Mural paintings dedicated to Vishnu and Hanuman, in the northern courtyard of the temple adjacent to the Old Palace, Chamba. Photograph by J. C. French, ca. 1920s

who celebrated the beauty of the Gupta age in drama and verse. In his lyric poem *Meghaduta*, he described the stuccoed palaces of the city of Ujjayini in Malwa as richly painted with scenes to delight the senses.[2] No first millennium secular murals survive in India, but the rock-face murals at the fortified palace complex of Sigiriya, dated to around the seventh century, give us a glimpse of their sensuous nature as alluded to by the literary commentators of the era. Large-scale mural paintings that in the early twentieth century were still preserved beneath verandas in the northern courtyard of the temple adjacent to the Old Palace, Chamba, provide an insight into this largely lost tradition (Fig. 4), as do those in various states of preservation in a number of palace interiors in Rajasthan.[3]

Works of literature, notably dramas and romances, must have been a regular feature of court culture, and manuscript editions may well have incorporated illustrated covers from an early period. A rare survivor of this secular tradition of painting is a

FIGURE 5. Scene from Kalidasa's romance-drama *Sakuntala*. Painted wooden manuscript cover, 2 x 8 in. (5.1 x 20.2 cm). Nepal, 12th century. The Metropolitan Museum of Art, New York, lent by The Kronos Collections

twelfth-century Nepalese manuscript cover illustrating scenes from Kalidasa's play *Sakuntala* (Fig. 5). Regarded as the greatest of the Indian heroic romances, this play explores the gamut of human emotions and the power of memory through the love of King Dushyanta for Sakuntala, the adopted daughter of a forest sage.[4] The work is renowned for the beauty of its imagery and for its blending of eroticism and tenderness, qualities that charge this miniature panel painting in equal measure. The drama is set against a red ground, and landscape elements are used to demarcate narrative sequences. The figures are rendered with finely controlled line and subtle use of form-defining tonality.

All these traditions of painting—for temple, palace, and dramatic arts alike—share a common ancestry. This can be termed the Pan-Indian style, providing a painting style and expressive language that span from the painted plaster cave interiors of the Buddhist rock-cut sanctuaries of fifth- and sixth-century Ajanta to the fragmentary murals still to be seen at the greatest of the Pallava temples, the eighth-century Kalaishanatha in Kanchipuram.[5] These share an aesthetic in which a striving for fidelity to nature is balanced with a desire to generate powerful emotional states (*rasa*) through pictorial imagery and literary allusion. Kalidasa, in writing of the goddess Parvati in his *Kumarasambhava*, used the language of painting to describe her beauty: "Her body modeled by youth appeared as it were a red lotus in full bloom and as a modeled figure with contour line."[6] Again, the poet employed pictorial imagery as a metaphor to evoke memories of love lost:

My heart's affection made me feel.
The joy of seeing her—
But you remind me again
that my love is only a picture.[7]

In describing a likeness so compelling that for a moment the separated lover allows his distressed mind to imagine that the painting is reality, the writer confirms the flavor of Gupta painting—naturalism infused with a powerful humanist sentiment. This dimension also finds expression in portraiture, one of the earliest confirmed appearances of which is the celebrated dual portrait of the Chola king Rajaraja Chola (r. 985–1012) and his spiritual mentor Karuvur Devar, preserved in the ambulatory passage of the Brihadisvara temple at Thanjavur, dedicated in 1010 (Fig. 6).

The act of painting was described in early prescriptive texts; the most famous is the *Chitrasutra*, a short commentary outlining the requirements of good painting, preserved as a chapter in the *Vishnudharmottara*, dated variously from the fourth to the sixth century.[8] This text is thus contemporaneous both with the murals at Ajanta and with the secular writings of Kalidasa and so provides a textual foundation for what is otherwise a largely lost Indian pictorial tradition. It is clear from at least one twelfth-century source that professional mural painters were expected to extend their skills to the art of manuscript painting. The *Manasollasa* (1129), a Sanskrit encyclopedic compilation attributed to the

Western Chalukyan king Somesvara III (r. 1126–38), expressly states that an accomplished painter was "not only a fresco painter but was [also] well versed in the technique of miniature painting on palm-leaf (*patra-lekhana*)."[9]

While an important corpus of secular writing from the Gupta period confirms the importance of the art of painting, principally murals, it was religious expression that provided the most lasting inspiration in the premodern era. Indian religious texts are of three principal types. First, there is the Vedic literature, which claims a high level of divine authority and is the prime literature of Hinduism. Its authority is greater than the individual gods, transmitted by the thought of Brahma and heard by holy men (*rishis*), who are its custodians. Second, there are the Puranas, which are legendary accounts of ancient times, largely concerned with the legends of the gods and dynastic genealogies, and in effect, illuminate many aspects of ancient Indian history. They have been characterized as Vedas for the populace, as they present complex metaphysical notions through myth, legend, and storytelling. They serve as commentaries on the Vedas and embody generations of Indian philosophy, and they take the form of traditional history and complement the Epics. Third, there is the Epic literature, which provides the mythological framework for the Indian world cosmology and is expressed principally in the Hindu *Mahabharata* and the *Ramayana*. Finally, the *Jatakas* provide the closest equivalent to the Epics in the Buddhist context, as do aspects of the Jain *Kalpasutra*.

No illustrated Hindu texts from before the twelfth century are known, and it is most probable that when they do appear, as in Shaivite manuscript covers depicting the assembled high gods of Hinduism, or in Nepalese editions of the *Devi Mahatmya* (Glorification of the Goddess) manuscripts for example, they take their inspiration both from Buddhist practice and, as is witnessed by the *Sakuntala* book cover, from secular painting.[10] Buddhist *Jataka* stories and scenes from the life of the Buddha, together with the hagiography of the twenty-four *tirthankaras* as recounted chiefly in the *Kalpasutra*, provided a reservoir of narrative and imagery for artists throughout the period leading up to the year 1100 and beyond. The commissioning of a copy of a religious text was, in all Indian faiths, a meritorious act for which the sponsor was understood to earn religious merit. The names of Buddhist and Jain donors frequently occur in the colophons of such manuscripts, which often were well preserved in temple libraries. Within

FIGURE 6. Presumed portraits of the Chola king Rajaraja Chola (r. 985–1012) and his spiritual mentor Karuvur Devar, preserved in the ambulatory passage of the Brihadisvara temple at Thanjavur, dedicated in 1010. Photograph by V. K. Rajamani

the Hindu temple, texts were routinely used for learning, and brahmins undertook the task of copying those that needed replacing. As a result, very few Hindu manuscripts of any great age survive today, despite the antiquity of the texts they bear. In Buddhist monasteries, transcribing and illustrating texts was seen as a worthy profession to be undertaken by monks. There is no evidence that the Jain clergy undertook this task; indeed, the *Kalpasutra* warns monks and nuns against the art of painting, as an activity prone to arouse sensuous thoughts.[11] The *jnana bhandars* (knowledge storehouses)—the temple library-cum-strong rooms—so integral to the medieval Jain temples of western Indian and the Deccan were already assuming an important custodial role as storehouses of Jain religious art.

Earlier painted manuscript covers do survive, datable to the ninth century from Gilgit, a small kingdom west of Kashmir.[12]

Uniquely, these scenes are painted vertically on the panel, and one pair that accompanied a birchbark manuscript depicts a standing Padmapani gracefully blessing a kneeling devotee, very probably identifiable by comparison to donors depicted on Gilgit metal sculptures as a ruler of the Patoli (Palola) Shahi clan.[13] The prototypes for these manuscript cover paintings are murals and undoubtedly banner cloth paintings.

That Buddhist painted images routinely existed earlier is verified by textual and visual evidence. A fourth-century Gandharan sculpture from Mohammad Nari, Pakistan, depicts the Buddha honored by multiple appearances of Past Buddhas, Bodhisattvas, and donors, together with two standards displaying hanging banners with raised-up Buddha images representing banner paintings.[14] Late first-millennium examples survive in Central Asian monastic contexts such as Dunhuang, Murtuk, Khara Khoto, and Kyzil.[15] A mural at the Buddhist cave complex of Kyzil, in Xinjiang Autonomous Region of China, provides confirming evidence datable to the first half of the seventh century (Fig. 7). In the scene, a Buddha is celebrated with a painted banner cloth depicting the legend of Ajatashatru, the king of Magadha who is famed for being present when the Buddha preached the *Lotus Sutra*.[16] The Chinese Buddhist pilgrim Fa Xian described seeing five hundred "brightly colored" bodily forms of the Buddha, past and present, lining both sides of the street at Anuradhapura, along which the tooth relic was carried in procession to Abhayagiri vihara, during his sojourn in Sri Lanka in the early fifth century.[17]

Painting in medieval India was increasingly linked to the art of the book. The watershed is the beginning of the second millennium, when palm-leaf manuscripts began to appear with pictorial elements. These may not be the oldest examples of the illustrated book in India; they are simply the oldest that have come down to us. Again, Central Asia provides an earlier precedent, as is witnessed by a unique hoard of Manichean manuscripts dating from the eighth to the tenth century in which pictorial components are integrated into passages of text. They embody Indic imagery, providing interesting parallels with the murals at Kyzil and elsewhere that have representations of Shiva as well as Buddha imagery. Such Indian imagery, we may assume, would have found its way to Central Asia via the Buddhist network and most probably would have been transmitted via illustrated manuscripts. No such manuscripts survive to prove this hypothesis.

CONVENTION AND INNOVATION

This introduction presents in a summary manner much of what we know about Indian painting of the first millennium as it relates to the art of the book. The chapters that follow provide a synoptic account of the continuing development of Indian painting from 1100 to 1900, beginning with the earliest extant evidence, miniature cartouche illuminations on palm-leaf folios, and examining the major examples of the paintings on paper that began to appear

FIGURE 7. Banner painting depicting the legend of Ajatashatru, the king of Magadha, detail from a scene of the Buddha being adored by devotees. Mural painting from the Buddhist cave complex at Kyzil, Central Asia. Xinjiang Autonomous Region of China, ca. 600–650 CE. Formerly Museum für Völkerkunde, Berlin (destroyed)

in the fourteenth century. The Italian traveler Nicolo Conti, who visited Gujarat around 1440, observed that only the artisans of Cambay, the region's renowned port and a known center of Jain religious art production, used paper, while others were still using "the leaves of trees, from which they make beautiful papers."[18] At the time, Cambay served as India's principal port for the Arabian Sea trade. It is known that Arabs settled in Ahmedabad soon after it was founded in 1411 by Sultan Ahmad Shah, and they introduced paper making to that city. The oldest dated paintings on paper in India appear in a Svetambara Jain manuscript edition of the *Kalakacharyakatha*, from Yoginipur (Delhi), dated 1366.[19] At around that time, Sultanate manuscripts, the most popular of which were editions of the Persian Book of Kings, the *Shahnama* by Firdawsi, began arriving in India, suggesting new solutions to pictorial problems. By the second quarter of the fourteenth century, the *Shahnama* was copied routinely in India.[20] Their influence was not confined to Muslim circles but quickly spread to Hindu and Jain artists active at this time for patrons in their own communities.

The prevailing style of mid-fifteenth century western India is well documented by two remarkable dated cloth paintings produced in 1447 and 1451 at Ahmedabad, the commercial heartland of Gujarati Jainism. These works epitomize the mature style of the period. The victory banner (*Jayatra Yantra*) was dedicated on the festival of Diwali in the year equivalent to 1447 CE.[21] The center field consists solely of sacred syllables (*mantras*) and numerals, configured to form a sacred diagram (*yantra*), intended to serve as a visual aid to meditation. The borders carry beautiful and evocative passages of painting, depicting deities, landscape, and the natural world. This victory banner and a closely related cloth painting, the *Vasanta Vilasa* (Spring Sports) dated 1451, both display the same celebration of nature and joie de vivre, capturing evocatively and explicitly the spirit of the text's theme, the arrival of spring.[22]

Innovations in Jain style form a critical bridge between the conventional western Indian style of the thirteenth and fourteenth centuries and the radical integration of Indian and Iranian elements in the early sixteenth century. New stylistic and iconographic features have appeared, reflecting a growing awareness in Jain painting studio circles of the manuscript art of Timurid Iran, with which the Sultanate courts of north and western India had routine contact.

By 1500, painting styles in India were on the cusp of a revolution, triggered by the Sultanate kingdoms of northern India that maintained active links with the court ateliers of Iran and Afghanistan. The workshops of the Sultanate courts of Delhi and Bengal provided imported models for their artists, but these ateliers were obliged to largely recruit Indian artists, trained in the Hindu and Jain traditions, as were their Mughal successors. The fusion of these Indian and imported painting styles was the catalyst for the radical developments that mark the first half of the sixteenth century and beyond. Indian painting was entering a new age.

Highly influential schools of Hindu devotional manuscript painting were being produced in northern India in the early to mid-sixteenth century, most probably concentrated around the prosperous commercial centers of the Sultanate Delhi-Agra region. A radical innovation had occurred, in which the pictorial component now predominated over the textual; we are witnessing the appearance of the independent painting, unshackled from the text to which it was traditionally bound. In the *Bhagavata Purana* series (Nos. 7, 8) the image has taken over the page entirely, and the text has been relegated to a synoptic line or two on the upper margin. The function of these paintings was to evoke the mood of the texts that inspired them, no longer merely to illustrate an accompanying text. Even the *Hamzanama*, the most ambitious painting project of the early Mughal period, was conceived for highly charged show-and-tell presentations at court. The text appears on the reverse, allowing the narrator to consult it while presenting these spectacularly large and dramatic paintings to the assembled audience (No. 10).[23]

Two streams of development prevail henceforth, the traditional Indian landscape format that embodies memories of the palm-leaf folio and the codex form introduced from the Islamic lands into Sultanante India (Nos. 3, 4). In the ongoing and evolving Muslim (Mughal) and Hindu (Rajput) schools, these two traditions continued to coexist. The coalescing of these styles in variant forms shaped the regional schools that evolved over the next three centuries. Both were largely swept away with the advent of new technology, the glass-plate camera, in the 1860s. This proved to be a transforming moment; the established genres of Indian court painting were swiftly taken up by professional photographers, and the art of the brush was finally abandoned.

FROM PALM-LEAF TO PAPER
MANUSCRIPT PAINTING 1100–1500

John Guy

Indian painting around the year 1100 CE, as far as we can judge from the few dated works that can be assigned securely to the period, was devoted almost exclusively to the illustration of Buddhist and Jain manuscripts. We know from pilgrim descriptions that the great Buddhist monasteries of eastern India were richly painted with murals devoted to sacred images, although none have survived. The murals in the Sumtsek chapel at Alchi monastery, Ladakh, dated to around 1200, are among the most extensive mural paintings of this period extant, providing insight into the richness of the medieval mural painting tradition (Fig. 8).[1] The great monasteries (*mahaviharas*) of northern India, from Kashmir to Bengal, undoubtedly had equally magnificent painted interiors, radiant with Mahayana Buddhist imagery. The multistoried libraries of these centers were renowned as treasure houses of learning and Buddhist knowledge, housing vast stores of both manuscripts and the finest paintings of the age (Fig. 9). The Jain temple also had its knowledge repository, the *jnana bhandars*, which over time assumed a critical role as the custodial preserver of Jain knowledge and religious art.

The overwhelming majority of Buddhist illustrated texts are devoted to the *Ashasahasrika Prajnaparamita* (Perfection of Wisdom in 8,000 Verses) and the *Pancaraksa* (Five Protective Goddesses). The mystic spells and charms (*vidya*) that comprise both collections came to be personified as female deities, their iconographic forms already codified by the twelfth century in the *Sadhanamala* (rosary/garland of invocations) and *Nispannayogavali*.[2] These profoundly influential texts gave voice to the Mahayanist preoccupation with compassion embodied in the cult of bodhisattvas and taras.

Buddhist artists — mostly monks, we can assume — produced a great corpus of illustrated palm-leaf texts in eastern India during the eleventh and twelfth centuries. They draw imagery from two prototypes — temple sculptures that embody the elaborate

FIGURE 8. Prajnaparamita, Sumtsek chapel, Alchi monastery, Ladakh. Mural painting on plaster, ca. 1200. Photograph by J. Poncar

iconographic schema developed in the parent texts (Fig. 10) and mural paintings of which almost nothing survives from this period. In both instances, the manuscript artists had to miniaturize radically, which they achieved with consummate skill. The sophisticated linear and chromatic complexity of the Pala painting style is evident by the date of the oldest survivors, two editions of the *Ashasahasrika Prajnaparamita* manuscript produced in the

FIGURE 9. Monks in a monastery with multistoried hall, stupa, and lion-stambha. Painting on palm-leaf manuscript, ca. 12th century. Nepal. National Archives, Kathmandu

eleventh century during the fifth and sixth year of the reign of Mahipala I (the later one at Nalanda monastery).[3] A century or so later, an artist produced manuscript paintings of the unsurpassed quality seen in the Vredenberg manuscript commissioned by the donor Udaya-simha in the thirty-sixth year of Ramapala's reign (first quarter of the twelfth century, a near contemporary of the Mahavihara Master manuscript (Nos. 1, 2).[4] The place of production is not recorded for either work, but for the Vredenberg manuscript, in which the compositions are dominated by large-scale figures in compact settings, the monastic scriptoria at Nalanda or Vikramasila are real possibilities. Three of the only six provenanced Pala manuscripts are assigned to Nalanda, suggesting that this was a major center for the production of illustrated Buddhist manuscripts, along with Vikramasila and Uddandapura.[5] The Mahavihara Master manuscript paintings, with their highly elaborated architectural and lush treescape settings, more likely are products of one of the great monastery scriptoria of Bengal.

No Buddhist paintings of this period carry an artist's signature or a scribal attribution. Texts were written first, with space reserved for the artist to insert the painting, the latter routinely overlapping the script at the margins. Sometimes, the scribe wrote instructions for the painter, confirming their separate roles. Literate monks working in monastic scriptoria must have been responsible for both activities. In many instances, the iconography does not strictly conform to the iconographic prescriptions, suggesting that some painters were less than fully conversant with the authority texts. That scribes are often named in colophons, and painters never, indicates a hierarchy of activities that placed the learned skill of writing above that of picture making.

The Buddhist artists display an astute sensitivity of line and form, and they work in a confident if sometimes summary manner that suggests long familiarity with the conventions of this style. Figures are rendered in flat washes of intense color, with limited tonal modeling and assured silhouetting. A hierarchic ordering of deity and devotee is observed. Over a period of two centuries, the artists of this era redefined the possibilities of miniature painting, creating miniaturizations of large-scale mural painting into a format averaging 2 by 3 inches (5.1 x 7.6 cm). By the close of the twelfth century, Buddhist monastic painting had come to an abrupt end as the monasteries of eastern India fell victim to a series of devastating campaigns by the Sultanates of Bengal.

Painted narratives on Jain wooden manuscript covers (*pothi*) count among the earliest surviving examples of Indian manuscript art. The oldest datable painted manuscript cover can be assigned securely to the first half of the twelfth century, on the basis of its association with a revered Jain Svetambara guru, Sri Jinadatta Suri, who is depicted discoursing in the Discussion Hall (*Vyakyana Sabha*).[6] This renowned teacher was elevated to the rank of Acharya in 1112 and died in 1154, and thus, this manuscript reasonably can be assigned to the period between those dates. Another Jain painted cover depicts an important contemporary event, a theological debate held in 1124 at the court of the Solanki dynasty ruler Siddharaja Jayasimha in Patan, Gujarat. The two leading Jain theologians of the day, the Digambara Kumuda Chandra and the Svetambara Vadi Devasuri, engaged in an extended debate in which the celebrated Svetambara monk prevailed.[7] The last scene shows the defeated Digambara challenger banished from the palace, whereupon he is attacked by a cobra, no doubt to be understood as divine retribution for his misguided beliefs.[8] This painting, which may be datable to within a few years of the event depicted, demonstrates the advanced state of the Jain pictorial style, with its strong use of linear silhouette and flat washes of intense color and inclusion of scene dividers.

Manuscript painting in the succeeding two centuries was largely the domain of the artists of western India, serving the needs of the Jain community and the occasional Hindu patron, as seen in illustrated editions of popular Hindu stories such as the *Balagopalastuti* (Praise of the Youthful Krishna), a devotional work of prose recounting the exploits of the young Krishna (Fig. 11).[9]

The style, best described as Western Indian, is archaic and conservative, echoing ancient compositions (Fig. 12). It is characterized by areas of flat color of saturated intensity, heightened by

the use of black linear outline. The painting style of the human figure is particularly distinctive. The silhouette is angular and sharp; the figure has a slender waist and swelling chest; the nose and chin are pointed; and the face in three-quarter profile has a projecting almond-shaped eye that appears alert and worldly. This eye convention became a hallmark of such paintings, and of figurative designs in other mediums, such as painted cotton textiles of the late fourteenth and fifteenth centuries.[10] Manuscripts of this and later periods retain several anachronistic features, the most obvious of which is the long and narrow horizontal format of the palm-leaf, which persisted long after the widespread availability of paper. It is perhaps significant that the oldest dated paintings on paper in India appear in a Svetambara Jain manuscript edition of the *Kalakacaryakatha*, dated 1366 and produced in Yoginipur (Delhi).[11] Yoginipur had become an important center in the thirteenth century for Jains, who were drawn there no doubt by the commercial opportunities offered by the Sultanate rulers of Tughlaq and Lodi Delhi.[12]

Western Indian painting underwent a number of changes during the first half of the fifteenth century. Artists responded enthusiastically to the availability of new colors and presumably so too did the clients who had to pay for these expensive ingredients. Lapis lazuli, which produced the most luminous ultramarine, became more widely available, and also a new crimson, probably produced from a native lac (a resin secreted by insects). This brilliant red quickly displaced blue as the preferred background color, as is demonstrated in a superb *Kalpasutra* painted at Mandu in 1439.[13] Gold and silver were also introduced into the artist's palette and became fashionable materials for the enrichment of commissioned manuscripts, often to the detriment of pictorial clarity; even the most finely executed painting was often rendered flat and lifeless by the indiscriminate application of gold or silver overpainting.

These changes were largely of emphasis and embellishment rather than fundamental shifts in style. They were partly a result of the growing commercial contacts between northern India and the Islamic cultures of Mamluk Egypt and Timurid Iran. The circulation of illustrated Islamic manuscripts and their richly tooled and gilded bindings — principally Korans but also editions of the *Shahnama* and other literary works — together with luxury goods such as Timurid carpets, textiles, and metalware, contributed to the enriching of the visual landscape of the Indian subcontinent.

By around 1400, paper folios had gained more height to accommodate greater pictorial decoration, no doubt inspired by Islamic codex books in circulation through the Sultanate courts. The enhanced scale also allowed artists to develop the border designs, some of which display direct Iranian influence, echoing decorative elements such as the flowering vine and tree that had become so prevalent in fifteenth-century Sultanate architecture and textile design. Other centers also witnessed the Jain patronage of finely painted manuscripts, a superb *Kalpasutra* painted at Mandu in 1439, for example.[14] Two dated editions of the *Kalpasutra*, produced in Jainpur in 1465, and the so-called Devasano Pado *Kalpasutra* and *Kalakacharyakatha* produced in Ahmedabad about 1475 (Nos. 5, 6), represent important stages in the progression beyond conventional western Indian style with the gradual integration of Indian and Iranian elements in the early sixteenth century. Both display a growing awareness in Jain painting studio circles of the manuscript art of Timurid Iran. It is thus apparent that artists working for Jain clients had access to Islamic court culture, as can be seen most vividly in the frequent borrowings

FIGURE 10. Bodhisattva Simhanada Lokesvara. Reportedly from the site of Sultanganj monastery, Bhagalpur District, Bihar, late 11th–12th century. Black basalt. Birmingham Museums and Art Gallery, Gift of Samuel Thornton, 1864 (1885A1472.1)

of decorative schema—interlaced vine border cartouches, for example—and in a newfound confidence to add elaborate marginal decor that occupies a significant area of the page. Placement of the picture components also became more varied, and text size was reduced and often given a decorative treatment in gold on red or blue ground. The use of conspicuously expensive materials, notably gold, silver, and lapiz lazuli, is a prevailing feature of this final phase of the Western Indian style.

These innovations in Western Indian painting were not confined to Jain and Hindu manuscripts. A recently discovered edition of the *Shahnama*, the Persian Book of Kings by Firdawsi, datable to around 1450, establishes a Sultanate-period Islamic manuscript firmly in the Western Indian style (Nos. 5, 6).[15] Its paintings observe the conventions of Central Asian dress of the Sahi nobility, no doubt following imported Iranian editions of the *Shahnama* as their model, while using the rich palette, including a brilliant red ground, of the Indian school.[16] Although this manuscript is in a codex form and draws heavily on its Iranian model, the pictures are landscape format, sharing the page with text in various configurations. Conventions for rocks and clouds are of Iranian derivation, which seems to be filtered through a Jainesque prism, fused with other motifs, such as figure types and trees, of Western Indian style.

Over the course of the thirteenth to fifteenth century, the Muslim Sultanates had established power across northern India, from Gujarat to Bengal. Their center in Delhi was to have the most lasting importance for the history of Indian painting; there, a viable alternative to the western Indian style was created. Together with the highly influential school of Hindu devotional manuscript painting that emerged subsequently in the Delhi-Agra region in the early to mid-sixteenth century—represented by the *Caurapancasika* and the Palam and Isarda *Bhagavata Purana* manuscripts—this location became the new epicenter of artistic innovation.

By 1500, painting styles in India were on the cusp of a revolution, triggered by the Sultanate kingdoms of northern India, which maintained active links with the courts of Iran, Egypt, and Afghanistan. The workshops of the Sultanate courts of Delhi and Bengal provided imported Iranian models for their artists but were obliged to largely recruit Indian artists trained in the Hindu and Jain traditions, as were their Mughal successors.[17] The fusion of these Indian and imported painting styles was the catalyst for the radical developments that mark the first half of the sixteenth century and beyond.

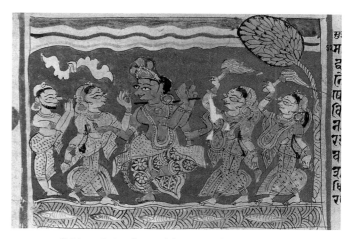

FIGURE 11. Krishna playing flute and dancing to the delight of the *gopis*; folio from a *Balagopalastuti* manuscript. Gujarat, ca. 1450. Opaque watercolor on paper. Museum of Fine Arts, Boston, Denman Waldo Ross Collection (30.106)

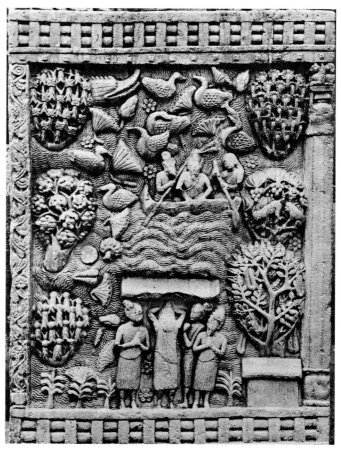

FIGURE 12. Miracle of Sravasti. Relief sculpture from the gateway of Stupa No. 1, Sanchi, India. Early 1st century CE

Mahavihara Master

Active in the early 12th century, in Bengal

This master painter of the Pala-era Buddhist monastic tradition is known from one extant palm-leaf manuscript, now shared between New York and Lhasa. The illustrated manuscript is a deluxe edition of the *Ashtasahasrika Prajnaparamita* (Perfection of Wisdom in 8,000 Verses), a Mahayanist text of profound importance to the development of esoteric Buddhist practice. The paintings that accompany this text display not only highly sophisticated painting skills but also such a sensitivity and empathy for the subject matter that one cannot avoid assuming the artist was a monk, deeply versed in the text he was engaged to illustrate. This pious artistic venture, to fulfill a royal commission, was probably undertaken in the scriptorium of one of the great monasteries (*mahaviharas*) of eastern India at the height of Buddhist activity there. The colophon leaf is preserved in Lhasa and although providing no clue about place or date of production, does identity the edition as "the pious gift of the queen Vihunadevi."[18] As this queen is otherwise unknown, we have no means of constructing a provenance or reign date for her. Nevertheless, naming her as the donor fits a well-established pattern of female royal patrons of Buddhist religious art.

The Mahavihara Master displays a practiced ease combined with astute skill and sensitivity, resulting in miniature paintings of dazzling dexterity. His fluid lines and schematized color palette capture the sensuous flexing of the body profiles. The body colors are iconographically prescribed, as is the theatrical use of symbolic gestures (*mudras*). The subjects are standard, Buddhist saviors performing acts of charity and compassion: bodhisattvas and taras granting boons (No. 2) and expounding the *dharma* (No. 1), and Kurukulla protecting the faithful. The choices underscore the essentially talismanic function of these paintings, to extend protection to both the text they accompany and those who read it.

There is evidence, both in the text and beyond, that the *Ashtasahasrika Prajnaparamita* book became the focus of a cult of veneration and hence, worthy of extravagant embellishment. Certainly, these painted folios, among the oldest surviving masterworks of the Indian tradition, are appropriate to the task. The Mahavihara Master successfully miniaturized compositions originated for large-scale mural painting programs into a book format averaging 2½ by 3 inches (6.4 x 7.6 cm). That they convey the essence of the Buddhist *dharma* with grace, gravitas, and a sense of monumentality is all the more remarkable.

1

Bodhisattva Avalokitesvara expounding the *dharma* to a devotee: folio from an *Ashtasahasrika Prajnaparamita* manuscript

Bengal, eastern India or Bangladesh,
Pala period, early 12th century
Opaque watercolor on palm-leaf,
2¾ x 16½ in. (7 x 41.9 cm)
The Metropolitan Museum of Art, New York,
Purchase, Lila Acheson Wallace Gift, 2001
(2001.445.f)

The enthroned Avalokitesvara, bodhisattva of compassion, who is crowned, bejeweled, and framed by two white lotus blooms, sits in a temple shrine setting with *bhadra*-style superstructure of the Pala style. His hands held in double *vitarkamudra* preach the Perfection of Wisdom sutra to the female devotee who looks up in rapture at her savior. In this scene of powerful humanist sentiment, the psychological drama follows textual prescriptions describing how devotees should gaze on the deity. The Buddha essence (*dhatu*) is evoked by the depiction of a stupa, embodying the presence of both the Buddha relics and Buddha teachings.

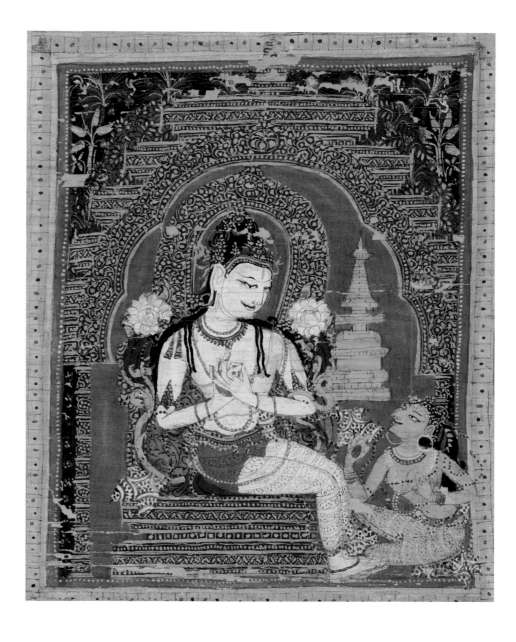

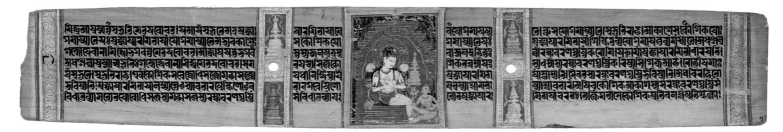

2

Green Tara dispensing boons to ecstatic devotees: folio from an *Ashtasahasrika Prajnaparamita* manuscript

Bengal, eastern India or Bangladesh,
Pala period, early 12th century
Opaque watercolor on palm-leaf,
2¾ x 16½ in. (7 x 41.9 cm)
The Metropolitan Museum of Art, New York,
Purchase, Lila Acheson Wallace Gift, 2001
(2001.445.i)
Published: Kossak, "Recent Acquisitions . . . Tara,
the Buddhist Savioress" (2002), p. 60

This painting evokes the ecstatic character of worship in Indian religions. Here Mahayana Buddhism employs the visual language of *bhakti*, fervent and passionate devotion to god as devotees appeal to share in the Green Tara's benevolence. Strings of pearls and gold-set jewels adorn her hair; diaphanous muslin drapes her fulsome breasts and reveals a short dhoti; and a golden throne-back arches with her body. She is accompanied by two divine attendees who share her golden pedestal and gaze up at her rapturously. The dense foliage that fills the background bursts out of the upper margin of the composition like some lush creeping vine, a foretaste of spatial devices used in later Hindu painting styles.

Master of the Jainesque *Shahnama*
Active 1425–40, in western India, probably Malwa

At every turn, this artist reveals his origins as one trained in the western Indian style so closely identified with Jain and Hindu manuscript painting. That he turned these skills to the illustration of the most famous of all Islamic epic narratives, the *Shahnama* (Book of Kings) of Firdawsi, was a daring and challenging move. The catalyst must have been a commission from a Muslim patron who, wishing to have an edition of this illustrated epic, sought out an accomplished local artist. The patron with such a keen interest was probably a local Sultanate ruler well versed in Persian literature, who already maintained a library containing imported Iranian illustrated manuscripts. Access to such works would have been essential to provide visual models for the Indian artist unfamiliar with either the imagery or the conventions of Iranian painting. The specific treatment of armored soldiers with their caparisoned horses draws directly on Iranian models, as does the depiction of rocky landscapes, sky-cloud boundaries, and specific icons such as the mythical bird *Simurgh*. For the more routine pictorial building blocks, the artist reverted to the tradition in which he was trained, as examples show in the stylization of trees and water and use of the Hindu-Jain convention of a red ground, which makes no provision for spatial needs. Most compelling of all are the figures, seen routinely in three-quarter profile, in a manner closely related to the *Caurapancasika* style.[19]

This manuscript, in its original condition, was bound as a single codex format volume comprising 350 pages of Persian text, 66 of which are illustrated.[20] The artist confined all his paintings to a landscape format, never daring to fill the entire page, betraying his origins as one trained in the illustration of palm-leaf and paper manuscripts in the *potli* tradition.[21] Jain *Kalpasutra* and Hindu *Balagopalastuti* manuscripts provide contemporary models (No. 5 and Fig. 4).

This remarkable manuscript reflects a broader movement toward integration and cultural accommodation between occupier and occupied across Sultanate India, as foreign Muslim rulers imposed their authority over the Hindu majority. The culturally liberal approach for which the Mughal emperor Akbar (r. 1556–1605) is praised has its roots in the Sultanate era, as is vividly witnessed by these paintings. Unknowingly, this artist set in motion a series of dynamic exchanges between native Indian schools of painting and imported Iranian styles that would have profound consequences on the development of Indian painting in the century that followed.

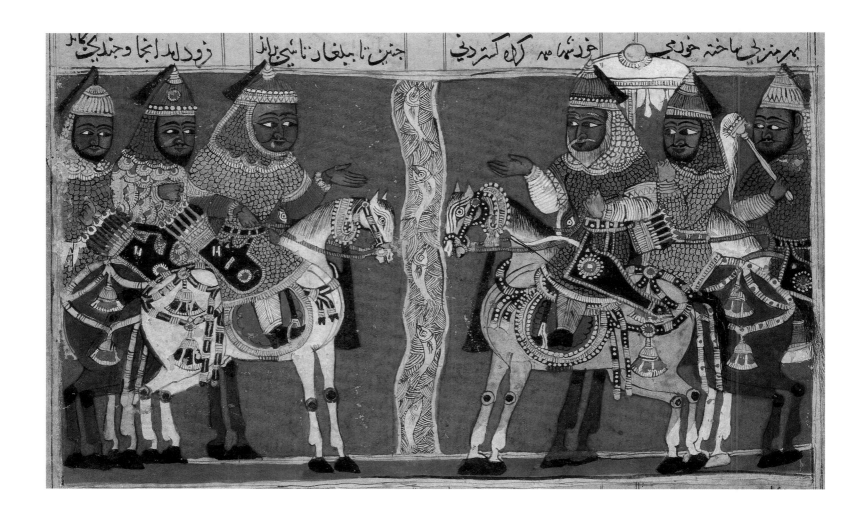

3

Siyavash faces Afrasiyab across the Jihun River: page from a *Shahnama* manuscript

Unknown workshop, possibly Malwa, ca. 1425–50

Inscribed: text of Firdawsi's *Shahnama*

Opaque watercolor and ink on paper, painting: 7⁷⁄₈ x 4¹³⁄₁₆ in. (20 x 12 cm); page: 12¹¹⁄₁₆ x 9¹⁄₄ in. (32 x 23.5 cm)

Museum Rietberg, Zurich, Gift of Balthasar and Nanni Reinhart (RVI 964, f. 108v.)

Published: Goswamy, *A Jainesque Sultanate Shahnama* (1988), fig. 10

The youthful prince Siyavash negotiates a peaceful accommodation of his clan's rival king Afrasiyab. Both armies are represented in a style modeled after Iranian conventions of the period. The river divides the composition vertically and is treated in a basket-pattern design that can be traced back to Indian sculptures of the Shunga era. A narrow green band suggests a foreground space for the assembled armies, and the flat red middle ground fills the remaining space; no horizon or sky-line is indicated. The aged king Afrasiyab is attended by guards bearing a parasol and fly whisk (*chauri*), insignia of office not seen in Iranian depictions of this subject, a confirmation of the Indian origins of this painter.

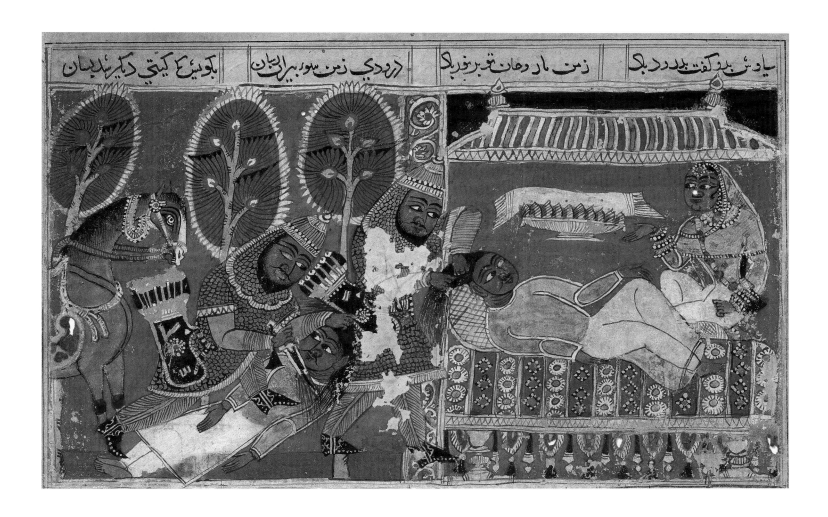

4

Siyavash is pulled from his bed and killed: page from a _Shahnama_ manuscript

Unknown workshop, possibly Malwa, 1425–50
Opaque watercolor and ink on paper,
painting: 4⁷/₁₆ x 7¹³/₁₆ in. (11 x 19.8 cm);
page: 12³/₈ x 9⁵/₈ in. (31.5 x 24.5 cm)
Museum Rietberg, Zurich, Gift of Lucy Rudolph and Ursula Dohrn (RVI 1881, f.120v)
Published: Goswamy, _A Jainesque Sultanate Shahnama_ (1988), fig. 18

In this dramatic murder scene, prince Siyavash is dragged by the hair from his bed chamber while his hapless wife Farangish gestures in horror. In a rare instance of continuous narrative, the murder and (presumed) decapitation are seen in the outdoor scene marked by trees. The juxtaposition of the Iranian-dressed soldier and the Indian-styled pavilion and stylized trees bears witness to the hybridism of this manuscript's painting style. Farangish wears a diaphanous shawl (_orhani_), rather than a tight-fitting _choli_ bodice, a mode of dress unknown in Iranian painting. The intense red ground and other strident colors are the clearest indication that the artist's origins are Indian.

Master of the Devasano Pado *Kalpasutra*

Active in the late 15th century, in Gujarat, probably at Patan

This manuscript, executed on paper in the palm-leaf (*potli*) format, is a masterpiece of the late Jain tradition of western India. It embodies a number of pictorial innovations that foretell imminent changes in Indian painting. The bulk of the original 201 folios are preserved in the temple library (*bhandar*) of the Devasano Pado temple in Ahmedabad.[22] Its now incomplete colophon names members of the family of one Minister Deva, presumably a respected Jain serving in the Muslim Sultanate administration, and refers to the port city of Gandhar, on the Gulf of Cambay.

The *Kalpasutra*'s Prakrit text is written in gold paint on a red ground in an elegant Jain *nagari* script reminiscent of the royal editions produced under the pious Solanki king of Patan, Kumarapala (r. 1148–74) and deposited in the twenty-one royal endowed temple *jaina-bhandaras* he founded. Colophon evidence from the fourteenth and fifteenth centuries indicates that Patan remained the principal center for Jain manuscript production.[23] Professional scribes often added their names to a text before passing the manuscript to the studio of painters. Artists' names are rarely recorded, an established pattern seen in earlier Buddhist palm-leaf manuscript colophons. The first appearance of an artist's name in a Jain context is in a *Kalakacaryakatha* manuscript produced at Patan in 1416, which names both the scribe, Somasinha, and the painter, Daiyaka.[24] More common are donor names, which are invariably written in a different hand from that of the scribe, indicating that they were added later, when the finished manuscript was purchased. Clearly then, these are the activities of commercial workshops supplying lay Jain clientele rather than temple or court ateliers.

The paintings are in the conventional Jain tradition, with faces in three-quarter profile and a projecting eye. In the later fifteenth century, the highly confident linear style of earlier palm-leaf and paper editions, typically black ink silhouette and color wash against a red ground, gave way to two technical innovations learned from Iran that had a transforming effect on the aesthetic impact of these paintings. One is the introduction of lapis lazuli to produce a deep ultramarine blue ground; the other the use of painted gold, typically applied over the black silhouette figures to negative effect, obscuring the subtlety and expressiveness of line. A further innovation in this manuscript, also borrowed from the Iranian painting tradition, is the introduction of symmetrical and interlocking floral designs, which appear in the borders of Jain manuscripts for the first time. Gujarat came under Sultanate rule in the fourteenth century and became an independent Muslim state after 1407, the center shifting from Patan to the new capital of Ahmedabad in 1411. The artists working for Jain clients undoubtedly increasingly served Muslim patrons as well and so were exposed to Iranian and Sultanate models. As a result, Jain manuscript painting assumed unprecedented levels of lavishness.

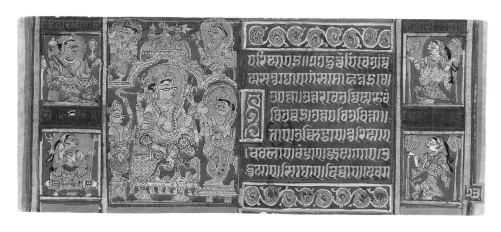

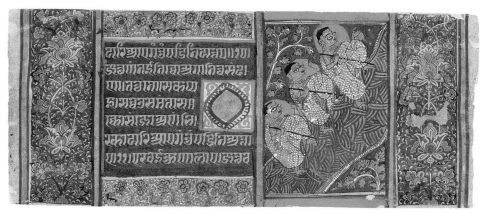

5

The embryo is brought by Harinaigameshi before Indra: folio from a *Kalpasutra* manuscript

Gujarat, possibly Patan, ca. 1475

Inscribed: Seven lines of Prakrit text and numeral 23 in gold *devanagari* script, the *ragini's* names in silver

Opaque watercolor, ink, and gold on paper, 4⁷⁄₁₆ x 10⁹⁄₁₆ in. (11.3 x 26.8 cm)

The San Diego Museum of Art, Edwin Binney 3rd Collection (1990:189, f. 23v)

Published: Goswamy and Smith, *Domains of Wonder* (2005), no. 4

The presentation of the embryo of the future Jina Mahavira to Indra (the king of the gods in Jain heavens) by Harinaigameshi, his horse-headed general, is the main narrative of this folio, complemented by the textual description provided by the *Kalpasutra*. A new innovation for Jain paintings is the presence of the four

raginis, female personifications of *ragamalas* (musical modes).[25] *Ragamalas* were emerging in this period as a subject for depiction in manuscript paintings, a theme that became important in Hindu painting a century later. Their appearance here seems to relate more to the celestial musicians who frequent Indra's Heaven than to the later concept of vehicles for expressing independent emotional states.

6

Three monks fording a river: folio from a *Kalpasutra-Kalakacharyakatha* manuscript

Gujarart, possibly Patan, ca. 1475

Opaque watercolor, ink, and gold on paper, 4⁵⁄₁₆ x 10¼ in. (11 x 26 cm)

Los Angeles County Museum of Art, Gift of Dr. and Mrs. Pratapaditya Pal (M.87.275.3, f. 163)

Published: Pal, *Indian Painting,* vol. 1, *1000–1700* (1993), no. 20

This folio is illuminated on both sides, a rare occurrence in Jain manuscripts. It appears to illustrate a scene from the *Kalakacaryakatha* (Life of Kalacha), which often accompanies editions of the *Kalpasutra* as an appendix. This uniquely lavish manuscript is known as the Devasano Pado manuscript after the Jain temple library (*bhandar*) in Ahmedabad, Gujarat, where the other sections reside. The interlaced floral decor on the border panels clearly reflects the artist's awareness of and responsiveness to fifteenth-century Islamic book illumination. The artists working for the wealthy Jain clients of this manuscript, identified in the colophon as bankers from the region of Broach, undoubtedly also enjoyed support from Muslim patrons.

EARLY HINDU-SULTANATE PAINTING
1500–1575

John Guy

Painting styles in northern India at the beginnings of the sixteenth century were subjected to unprecedented forces for change. These emerged overwhelmingly from the growing power of the Muslim invaders—Afghans and Turks—who conquered much of northern India in the early thirteenth century and over the next two centuries, consolidated and expanded their control. The most powerful were the Delhi Sultanates, whose legacy can be seen at the Tughlaq dynasty's fortified city of Tughlahabad (1320–1413), and in those of their successors, the Sayyid (1414–51) and Lodi (1451–1526) Sultanates. The Delhi Sultanates brought prosperity to northern India, stimulated by political stability and promotion of a monetorized economy disseminated through networks of regional markets. Hindu and Jain merchants were attracted to such epicenters of prosperity, and hence, we witness some of the most innovative and luxurious illustrated Rajput and Jain style manuscripts being produced in and around Sultanate Delhi (Nos. 5, 6).

In Gujarat, the Khiljis began establishing Muslim authority, and a Sultanate was created in the early fourteenth century and in 1411 relocated their capital from Patan to Ahmedabad. Tughlaq Sultanate authority had been secured in the western Deccan by the fourteenth century, and in 1347, a rebellious governor began the Bahamani dynasty in defiance of Delhi. It prospered until 1518, when it fragmented into the five Deccan Sultanates— Ahmadnagar, Berar, Bidar, Bijapur, and most powerful of all, Golconda. Each of these kingdoms maintained highly cultured courts, as did their Bahamani predecessor.[1] All were in need of poets and painters.

In eastern India, Afghan Sultanates had been active since the close of the twelfth century, and their clash with the established authority of Buddhism, closely aligned to the Pala-Sena dynasties, resulted in the destruction of the great monastic universities of Bihar and Bengal. Over the next two centuries, Sultanate power was consolidated and a sometimes uncomfortable integration into the Hindu cultural milieu achieved. Linguistically, an accommodation was arrived at with the creation at Sultanate Delhi of Urdu, a hybrid Indo-Muslim language blending Sanskrit, Hindi, Persian, Arabic, and Turkic. Literature and the arts further bridged the cultural and religious gap between these two communities.

In each of these cases, this transition to Muslim power is marked by the appearance of painted manuscripts, not only Korans but also a large corpus of secular literary works, some of Arab origin but most from Iran (see Glossary of Literary Sources). A Sultanate manuscript of the *Iskandarnama* from Bengal dated 1531–32 and commissioned by Nusrat Shah (r. 1519–38), a cultured ruler of Arab descent who patronized the arts at his capital of Gaur, is a landmark document in the development of early sixteenth-century Sultanate painting (Fig. 13).[2] Here, Iranian painting conventions had already undergone a partial metamorphosis, as can be seen in the Shiraz-style clouded sky, which is shot through with bright Indian colors. Indic architectural elements, such as the cusped arches and bracketed eaves, have been integrated, and throughout, there is a heightened chromatic palette inconceivable in the Iranian parent styles of Shiraz and Tabriz. The Bengal *Iskandarnama* can be compared to another major Hindu work of the period, a painted version of the *Laur Chand*, a moralizing romantic tale composed in 1370 and widely enjoyed in Muslim circles. A Delhi Sultanate edition of around 1525–50 reveals a more integrated blending of Hindu conventions of figure types and dress with a Muslim love of complex ornamentation combined with specific architectural forms, such as the triple cupolas. Such manuscripts as the *Iskandarnama* were not an isolated phenomenon, as a folio from the *Tarif i-Hasain Shahi*, a unique manuscript produced in the Sultanate court of Ahmadnagar a generation later, testifies.[3] Although dress reflects regional costume, the style is pan-Sultanate. Clearly manuscripts circulated, perhaps

as diplomatic exchanges between rulers, and artists certainly are known to have traveled widely in search of new or more generous patrons (see Farrukh Beg and Masters of the Chunar *Ragamala*, pp. 62 and 95).

Hindu painting in the Sultanate period suffered from a substantial loss of courtly patronage and was largely kept alive by support from the Hindu merchant community. This period coincided with an upsurge of popular devotional cults centered on Vishnu and his avatars, especially Krishna. The "blue lord's" exploits were celebrated in devotional verses written in both Sanskrit and Hindi and also in other vernaculars, and were seen in illustrated editions of these works. The Delhi-Agra region appears to have been a center for this vogue in fifteenth-century painting, no doubt with the Mathura area, the homeland of Krishna, as its epicenter. The text most widely selected for illustration is Book 10 of the *Bhagavata Purana*, which provides the most detailed account of the young Krishna's exploits, his infantile misdemeanors and his adolescent amorous philandering. The so-called Palam (Dispersed) *Bhagavata Purana* of around 1520–40 is a masterpiece of this genre (No. 7). It was a highly ambitious production, consisting of an estimated three hundred illuminated folios,[4] a commission unprecedented in size, only surpassed a generation later by the studio productions of the Mughals under Akbar, as is witnessed by the *Hamzanama* (No. 10). More radical than the scale of production is that, for the first time, these are independent paintings, occupying the whole page free of text apart from a short synoptic line on the upper margin. No longer is painting serving merely as a visual amplification of a textual narrative; rather, this is painting featured in its own right. At the center of these paintings is Krishna himself, as the infant already capable of miraculous acts (No. 7), as the outrageous lover whose "water-sports" with the cow-maidens (*gopis*) of Braj represent an intense expression of the fervent devotional sentiment *bhakti* (No. 8), and as the divine warrior-king suppressing evil. The style is distinctive: full profile heads with large almond-shaped eyes and frontally rendered torso, arranged in a shallow picture space suggested only by the overlapping of forms. The artists responsible for this manuscript drew heavily on the early Rajput school of painting identified as the *Caurapancasika* style, after a famous manuscript edition of that story in the N. C. Mehta Collection, Ahmedabad (Fig. 14).[5]

The early Rajput style, most closely identified at this period with Malwa, is difficult to document beyond this one series of

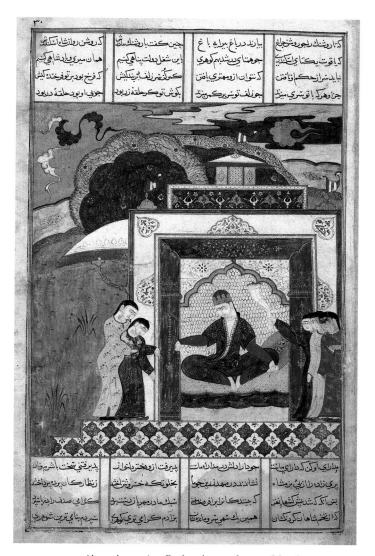

FIGURE 13. Alexander receives Roshanak, page from an *Iskandarnama* manuscript. Gaur, Bengal, Sultanate period, dated 1531–32. The British Library, London (Or. 13836, fol. 31b)

FIGURE 14. Champavati aflame with longing, folio from a *Caurapancasika* manuscript. Early Rajput style, ca. 1520–40. N. C. Mehta Collection, LD Institute Museum, Ahmedabad

paintings, but a stray surviving folio from another work, perhaps the oldest surviving *Ragamala* series, demonstrates the pervasiveness of this early style. *Bhairavi Ragini* is a superb study in devotional imagery tinged with eroticism, a mingling typical of the later Hindu painting tradition. A female devotee is worshipping at a Shiva shrine located within a palace compound; a pond with lotus and ducks is in the foreground.[6] She is playing hand cymbals (*manjira*) and, we know from the *ragamala* verse written above, is singing hymns in praise of her Lord Shiva. She has already made offerings of fresh pink lotus buds and leaves placed on the *linga* and an oil lamp at the foot of the altar. The eave-bracket spout supporting a banner is in the form of a mythical *makara*, a creature closely associated with Kama, the god of love. Intense glowing colors underscore the true theme of this subject, the passion of *bhakti*. The same Sultanate palace architecture also pervades the *Caurapancasika* series (Fig. 14), as do many of the iconographic metaphors, such as the *makara* eave-spout allusion to the god of love, the virulent tree bursting into flower and, an added feature here, the honey bees hovering around her body, sweetness itself. The verse of the poet Bhilana inscribed above sets the flavor:

> Even now I remember her, of a slender build, with her limbs afflicted by the fire of separation, and as one having the eyes like those of a deer, and as the sole resort of love-sports, with her ornaments of many kinds, her beautiful face, and with the movement of a swan.[7]

By mid-century, the transition to a Mughal style was underway. The Central Asian Mongol Babur (r. 1526–30) had invaded northern India in 1526 and conquered the Delhi Lodi Sultanate, so beginning Mughal rule in India. His son Humayun (r. 1530–56) ruled with an interruption of fifteen years, when he took refuge in Iran and Kabul. This proved critical for the future development of Indian painting, as at the court of the Shah Tahmasp (r. 1525–76), he recruited two eminent Iranian masters

trained in the Safavid style, who joined his court-in-exile in Kabul and then accompanied him back to India in 1555. They began expanding the imperial atelier, a process accelerated by the young Akbar soon after his ascension in 1556. Mir Sayyid 'Ali and 'Abd al-Samad were in turn responsible for directing the largest painting commission recorded in Indian history: 1,400 folios painted on cloth illustrating the Adventures of Amir Hamza, the *Hamzanama*. To realize this uniquely ambitious project, they recruited artists across the length of India, many trained in the Hindu tradition. The scene was now set for the rapid integration of these streams into a hybrid style that evolved into that we call Mughal.

A major step in this synthesis is represented by the Cleveland *Tutinama* manuscript (No. 9), remarkable not least because it appears to be mid-century Rajput work, possibly from the court of Mandu, that was substantially repainted in the Mughal studio around 1570, by Manohar among others.[8] This remodeling brought it in line with the style that was being developed in the course of creating the *Hamzanama*. The story likewise blends Iranian and Indian folk tales that won popularity in both Muslim and Hindu literary circles in Sultanate and Mughal India. It is profusely illustrated, with 218 painted pages extant and with twelve named painters associated with it. Most of the artists are unknown apart from this appearance, but two, Basawan and Dasavanta, rose to high rank in Akbar's atelier. Pramod Chandra has suggested that at least another thirty or so additional hands are identifiable in this manuscript, a clear indication of the corporate studio approach to manuscript production in the 1560s and 1570s.[9] The *Tutinama* was produced alongside the monumental royal commission, the *Hamzanama*, and undoubtedly involved most of the same artists; Basawan, Sravana, and Tara are credited with pages in the *Tutinama*, and they are attributed as the joint authors of a folio in the *Hamzanama* (No. 10).

The *Hamzanama* was an epic undertaking that represents the culmination of the developmental phase of the early Mughal style. Over its fifteen some years of production, probably from 1557–58 to 1572–73,[10] the style developed in response to both an increasing Hindu artist participation and a growing distancing from the Safavid-source style of its original progenitors. The intense "Hindu" palette of the series is combined with complex landscape and architectural configurations that create spatial vistas unprecedented in Indian painting. Safavid-style fantastic rock projections compete with indented fortress walls that allow wondrous aerial views of interior spaces in which much of the dramatic action is set. These are grand storytelling pictures, each painted on cloth and lined with paper on which the story is written in *nasta'liq* script Persian. The literary style is vernacular, storytelling to be narrated to illiterate audiences to thrill and enchant. The youthful Akbar was clearly captivated by these fantastic adventure tales and made their illustration the principal mission of his fledgling atelier for the next fifteen years (see 'Abd al-Samad, p. 54). Never again was a project on this scale attempted in the history of Indian painting, nor was one undertaken again that so profoundly changed its course.

Masters of the Dispersed
Bhagavata Purana

Active 1520–30, in north India, probably Delhi-Agra region

The painters responsible for the series of paintings in this manuscript belonged to a workshop-studio most likely active around Delhi or Agra, where wealth generated by the political stability of the Sultanate rulers of the region attracted Hindu and Jain merchant communities. This manuscript is widely known as the Palam *Bhagavata Purana*, after a suburb of Delhi, the hometown of one of the individuals named in an owner's colophon, although the style also can be associated with Agra.[11] It is the earliest known illustrated manuscript of this text, and it was and remains one of the most ambitious. Daniel Ehnbom has estimated that the original series consisted of around 300 folios, of which some 200 are extant.[12] This undertaking was artistically challenging and expensive and necessitated a well-organized studio in which highly literate scribes (the text is written in a precise and correct Sanskrit) and experienced painters worked together. The only illustrated manuscript to rival this one is the *Hamzanama* (No. 10), produced under very different circumstance, namely imperial Mughal patronage and direction. We know nothing of the circumstance of its production beyond the evidence of the surviving pages, which suggest that it is a workshop production for a devout Vaishnava patron, very probably one with close links to the Vallabha *bhakti* cult at Vrindavan, near Mathura, the place of Krishna's childhood.[13] In all probability, such a patron was a wealthy merchant emulating courtly patronage through the commissioning of a work of intense devotion that rivaled Sultanate Muslim productions of the time. The manuscript may have been the joint property of two individuals named in several colophons, *Sa. Mitharam* and *Sa. Nana*, perhaps brothers; one appearance of *Sa. Mitharam* is accompanied by the phrase *Palan nagar Madhye* (in the city of Palam), suggesting that they were residents of this town, near Delhi. Independent manuscript evidence, notably the dated 1540 Palam *Mahapurana*, established this town as a known center for scribes and painters.[14]

The Palam *Bhagavata Purana* embodies much that characterizes the *Caurapancasika*-group style and expresses a single aesthetic, achieved using a shared visual vocabulary. These conventions dictate that flat washes of intense color, most typically red, fill the ground, allowing no possibility for special perspective rendering. Figure types and their expressive gestures follow well-understood conventions, displaying silhouette profiles with large almond-shaped eyes, and a strict dress code, the women wearing *choli* bodices drawn tightly over full breasts and waistcloths, the men in crossover jackets and *jama* combined with distinctive *kulahdar*-style turbans. Palatial architectural settings in a Sultanate manner recur throughout the series, even though these events as described in the text are set in a rural village, a strong indicator of the manuscript's probable origins in the Delhi area, the home of the Lodi Sultanate until its overthrow by the Mongol Babur in 1526.

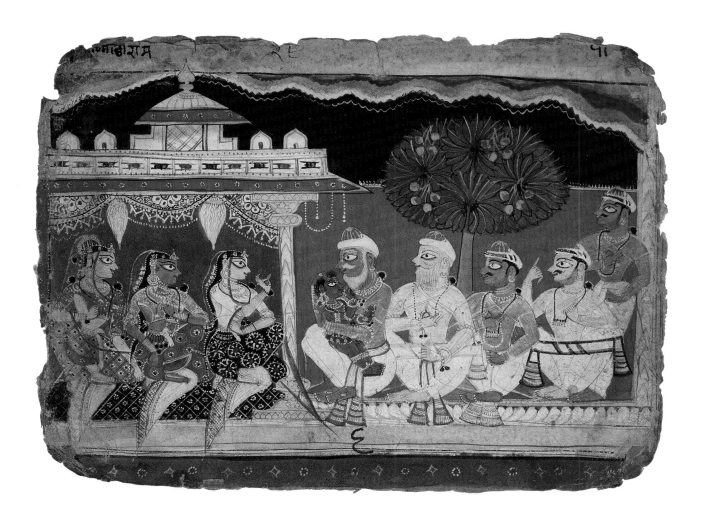

7

Nanda touches Krishna's head after the slaying of Putana: folio from a *Bhagavata Purana* manuscript

Delhi-Agra region, North India, ca. 1520–40
Inscribed: obverse, later annotations; reverse, exerts of Sanskrit text in *devanagari* script
Opaque watercolor and ink on paper,
7 x 9⅜ in. (17.7 x 23.8 cm)
Museum Rietberg, Zurich, Gift of Fritz and Monica von Schulthess (RVI 907)
Published: Fischer, Lutz, and Bernegger, *Asiatische Malerei* (1994), p. 16

This painting is one of a series illustrating the Tenth Book of the *Bhagavata Purana*, which is devoted to celebrating the exploits of the young Krishna. Here, the infant Krishna is praised by his adoptive father Nanda for having just slain the demoness (*dakini*) Putana by draining life from her breasts. The assembled family rejoices at this, one of the first of many miraculous feats of the child-god. This work embodies much that characterizes the *Caura-pancasika*-group style: flat intense color, profile heads with wondrous pronounced eyes, cloud-edged skyline, and elaborate Sultanate architecture, turreted and crenellated, and festooned with colorful textile awnings.

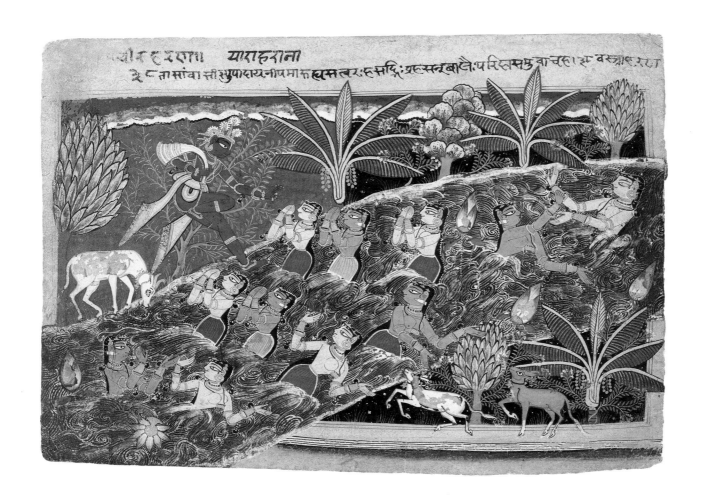

8

The *gopis* plead with Krishna to return their clothing: folio from the "Isarda" *Bhagavata Purana*

Delhi-Agra area, North India, ca. 1560–65

Inscribed: on obverse, later annotations; on reverse, exerpts of Sanskrit text in Devanagari script

Opaque watercolor and ink on paper,

7⁹/₁₆ x 10⅛ in. (19.2 x 25.7 cm)

The Metropolitan Museum of Art, New Yori, Gift of the H. Rubin Foundation, Inc., 1972 (1972.260)

Published: Kossak, *Indian Court Painting* (1997), no. 5

Perhaps the greatest of the pre-Mughal Hindu manuscripts known, this edition of the *Bhagavata Purana* is admired for its pictorial sophistication, its animated narration, and above all, its sheer joie de vivre. This painting captures the essence of the text, which recounts Krishna's amorous water-sports with the *gopis* (cowherds). Krishna sits in a tree, the robes of the women fluttering from his shoulder, as the dark lord reaches out to touch them, all and one together. They gaze with warm love-laden eyes and gesture devotion, praying for union with their lord. Hindu devotional worship (*bhakti*) had rarely been so passionately expressed in manuscript painting. Stylistically, this series evolved from the *Caurapancasika* group of paintings and forms a bridge with the emerging hybridity represented by the *Tutinama* (No. 9). It displays a complex spatial rendering of a river in landscape, which can be traced to sculptural reliefs of the first century CE (see Fig. 12, p. 25) but here flows unchecked off the edge of the page, defying the composition's own frame.

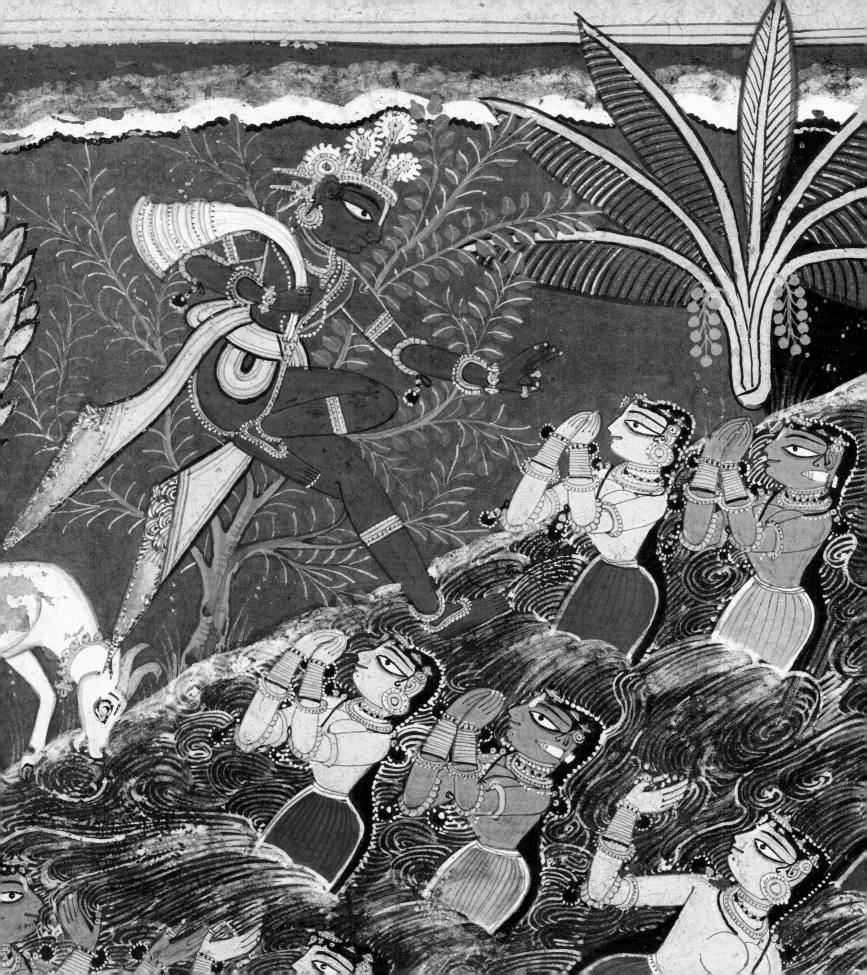

Basawan

Active ca. 1556–1600, at the Mughal court; father of Manohar

Basawan joined Akbar's atelier at Delhi as a young Hindu recruit and was involved in every major manuscript production throughout his emperor's reign. Abu'l Fazl recorded that Basawan surpassed all in composition, drawing of features, distribution of colors, and portrait painting, and was even preferred by some to the "first master of the age, Daswanth."[15] The mature Akbar prized Basawan above all others for his gift of faithful representation and also for advancing the Mughal style. He was a pioneer in responding to and absorbing new pictorial devices from European art; naturalistic portraiture, atmospheric perspective, and a painterly approach to landscape are his hallmarks.

Basawan was already an accomplished painter in the early 1560s, when he participated in the Mughal reworking of the *Tutinama* manuscript. *The Origin of Music* (No. 9) demonstrates his talent for portraiture and his ability to render rocks and trees with a naturalism not seen before in subcontinental painting. In addition, Basawan was a key contributor to the monumental *Hamzanama* series, as a painter of portraits, rocks, and trees, and also as a master of composition. In the folio that portrays a night attack on the camp of Malik Iraj (No. 10), Basawan's hand is visible in the rock formations and the densely foliated trees, as a comparison with those motifs in his *Khamsa of Amir Khusrow Dihlavi* page clearly demonstrates (No. 12). The composition of this *Hamzanama* folio has an underlying similarity to an ascribed work by Basawan in the Victoria and Albert's *Akbarnama* that shows Akbar witnessing the armed combat of Hindu ascetics, made some twenty years later.[16]

Basawan's most lasting legacy is the response to European art that he brought to Mughal painting. His ability to grasp the pictorial possibilities of both atmospheric and linear perspective was unmatched. His paintings of the later 1590s are a revolutionary fusion of these European pictorial devices into a newly emerging post-Safavid Mughal style. The vain dervish from an imperial copy of the *Baharistan* dated 1595 displays Basawan's gift for theatricality combined with an astonishing ability to capture naturalistic detail, as witnessed in every aspect of this masterpiece, from the figures in conversation to the goats and peacocks that inhabit the setting (No. 11). Basawan routinely used his signature rocks and trees to create receding intercepting spaces in the European mode. Like all imperial painters of his time, he had access at the court to northern European engravings of Christian subjects and cameo-type portraits, and he drew freely on that imagery. Basawan typically placed his European-inspired figures in a visionary Mughal setting with fantastic rock formations of Iranian derivation.

9

The Origin of Music: page from a
***Tutinama* manuscript**

Mughal court at Delhi, ca. 1565–70

Opaque watercolor and ink on paper;

painting: 3¹⁵⁄₁₆ x 4¹⁄₁₆ in. (10 x 10.3 cm);

page: 8¹⁄₁₆ x 5¹¹⁄₁₆ in. (20.5 x 14.5 cm)

Cleveland Museum of Art, Gift of Mrs. Dean A.
Perry (1962.279.110.b)

Published: Simsar, ed., *The Cleveland Museum of
Art's Tutinama* (1978), pl. 20

The Iranian legend of the mythical bird the
Mausiqar, which provides the seven notes
that are said to comprise the origin of music,
is the inspiration for this composition. The bird
that serves as the musician's muse almost
goes unnoticed, while attention focuses on the
vina player seated on a beautiful rug. This work
aspires to invoke aesthetic pleasure (*rasa*),
and music is deemed a means to stimulate
love: "What enchantment was hidden in last
night's potion! I lost my head but [it was] not a
drunken sensation."[17] The reworking of this
painting recently has been attributed by John
Seyller to the young Basawan, the Iranian
painter recruited to Akbar's atelier who
became Akbar's personal favorite.[18] Basawan's
participation in this project was first identi-
fied by Pramod Chandra in 1976.[19] That
the *Tutinama* was Mughalized during the
period the *Hamzanama* was in production is
witnessed by the treatment of such signature
motifs as the shield, sword, and bow, as
well as the quiver hung on a tree, a device
directly repeated in a number of *Hamza-
nama* paintings.

10

Asad ibn Kariba launches a night attack on the camp of Malik Iraj: folio from a *Hamzanama* series

Delhi-Fatehpur Sikri, ca. 1570

Inscribed: captioned in Persian, written in *nasta'liq* script "Asad attacks Iraj at night and assails [his army] with arrows"

Opaque watercolor, ink, and gold on cotton cloth, mounted on paper, 27 x 21¼ in. (68.6 x 54 cm)

The Metropolitan Museum of Art, New York, Rogers Fund, 1918 (18.44.1)

Published: Glück and Diez, *Die Kunst des Islam* (1925), fig. 38; Dimand, "Several Illustrations from the Dastan-I Amir Hamza in American Collections" (1948), p. 7; Lukens, *Islamic Art* (1965), pp. 44–45, fig. 59; Grube, *The Classical Style in Islamic Painting* (1968), fig. 94; Kossak, *Indian Court Painting* (1997), no. 8; Seyller et al., *Adventures of Hamza* (2002), no. 82

Asad ibn Kariba, having just presided over a slaughter of the troops of the Zoroastrian Malik Iraj, is seen in the foreground on a white horse as he leads his troops away to safety in the cover of darkness. The composition is complex; the intercepting triangular and conical forms of the encampment evoke the chaos of battle, and figures battling in close quarters occupy all intermediate spaces. Beyond, the crenulated wall of the fort emerges from the rocky landscape below. The hand of Basawan is evident in the surging rock formations at upper left and the densely foliated trees, as a comparison with those motifs in his *Khamsa of Amir Khusrow Dihlavi* manuscript page clearly demonstrates (No. 12).

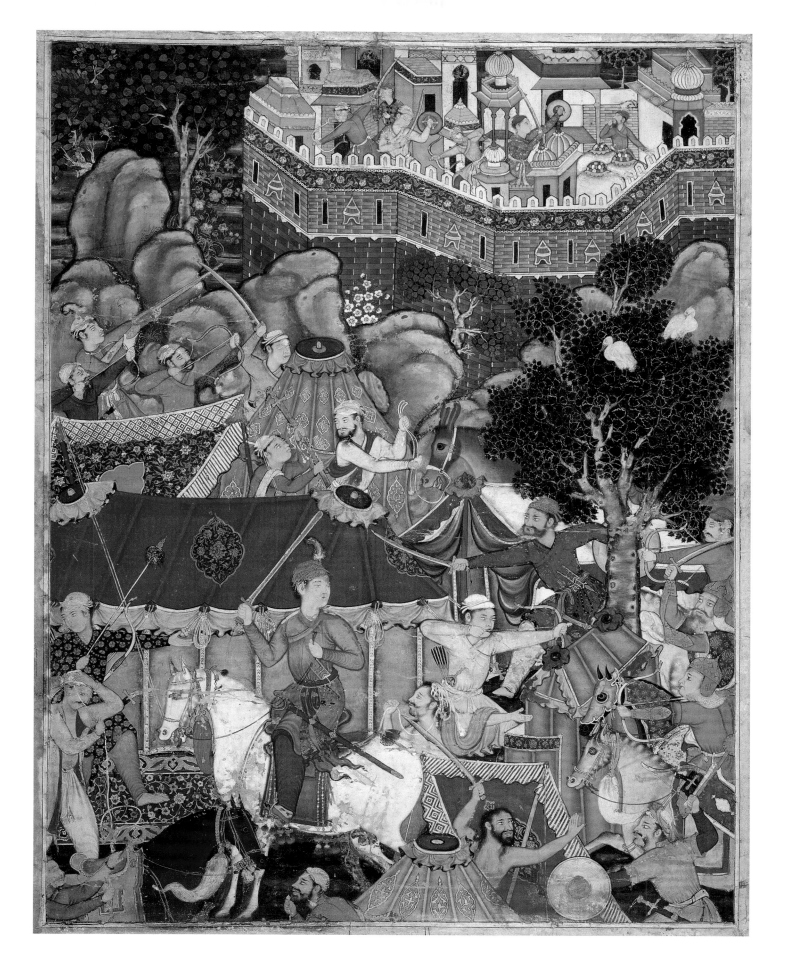

درویشی را دید که جامه خود را میدوخت

11

The Sufi Abu'l Abbas rebukes the vain dervish: page from a *Baharistan of Jami* manuscript

Mughal court at Lahore, dated 1595
Inscribed: painting ascribed to Basawan; calligraphy to Muhammad Husain al-Kashmiri Zarin Qalam (Golden Pen); colophon dated February 3, 1595
Opaque watercolor and ink on paper;
painting: 7¹¹⁄₁₆ x 4¹⁵⁄₁₆ in. (19.5 x 12.6 cm);
page: 11¹³⁄₁₆ x 7¹¹⁄₁₆ in. (30 x 19.5 cm)
Bodleian Library, University of Oxford
(Ms. Elliot 254, f. 9a)
Published: Welch, "The Paintings of Basawan" (1961), fig. 3; Okada, "Basawan" (1991), fig. 5; Okada, *Indian Miniatures of the Mughal Court* (1992), fig. 78; Topsfield, *Indian Paintings from Oxford Collections* (1994), no. 6; Topsfield, *Paintings from Mughal India* (2008), no. 12

This is one of six superb painted folios, each by a master of the imperial atelier, from an imperial copy of Jami's *Baharistan,* prepared for Akbar at Lahore in 1595 illustrating the chapters devoted to Wise Men, Generosity, and Love. Basawan's creation of courtyard and interior spaces displays a vigorous engagement with linear perspective learned from European painting, capturing the red sandstone architecture of Lahore fort as a staged setting for this moral tale of lost humility. The Sufi mullah gently admonishes the vain dervish for prizing his ascetic's coat, symbol of humility, more than he prizes serving God. The mullah declares: "Would you consider this robe as your god?"

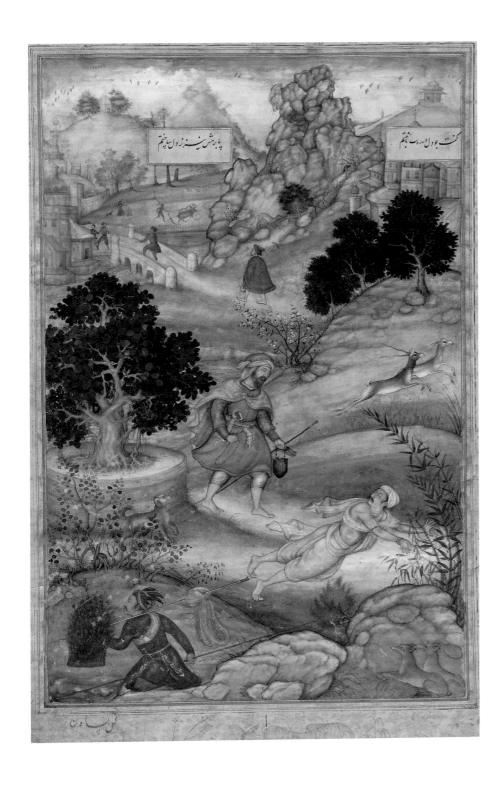

12

A Muslim pilgrim learns a lesson in piety from a Brahman: page from a *Khamsa of Amir Khusraw Dihlavi* manuscript

Mughal court at Lahore, dated 1597–98
Inscribed: ascribed in margin "amal-I Basavana"
Opaque watercolor, ink, and gold on paper;
painting: 8½ x 5⁵⁄₁₆ in. (21.6 x 13.5 cm);
page: 11³⁄₁₆ x 7½ in. (28.4 x 19.1 cm)
The Metropolitan Museum of Art, New York,
Gift of Alexander Smith Cochran, 1913 (13.228.29)
Published: Dimand, *A Handbook of Mohammedan Decorative Arts* (1930), p. 65; Welch, "The Paintings of Basawan" (1961), fig. 3; Welch, *Art of Mughal India* (1963), no. 8a; Okada, *Indian Miniatures of the Mughal Court* (1992), fig. 96; Seyller, *Pearls of the Parrot of India* (2001), pp. 46–47

This painting conveys the message of piety embodied in Amir Khusraw Dihlavi's *Khamsa*, in which a Hindu devotee is seen proceeding prostrate on the ground to the Shiva temple at Somnath in Gujarat. The Muslim traveler is also a pilgrim — witness his bare feet, prayer beads, and book (presumably a Koran) — but is nonetheless moved by this act of selfless devotion and unquestioning faith. The painter Basawan imbued this scene with a startling and new realism, situating the tangibly modeled figures in an atmospheric landscape of European derivation (below). His signature rocks and trees create a series of receding spaces in the European mode, chromatically linked.

Africa, from *The Four Continents*, by Adriaen Collaert, after Maarteen de Vos. Antwerp, engraving. The Metropolitan Museum of Art, New York, 1949 (49.95.1516)

13

Woman worshipping the sun: page from a *Jahangirnama* manuscript

Mughal court at Lahore or Delhi, ca. 1590–95
Opaque watercolor and gold on paper;
painting: 9¹/₁₆ x 4½ in. (23 x 11.4 cm);
page: 16¾ x 10½ in. (42.5 x 26.7 cm)
Museum of Islamic Art, Doha (Ms. 157)

This page once formed part of the *Muraqqa-e Gulshan*, Tehran, and formerly must have been part of a Mughal album belonging to Akbar and Jahangir. It represents a summation of Basawan's engagement with European art; he has creatively interpreted borrowed imagery to meet new pictorial objectives. Here, a robed woman raises her clasped hands in veneration of the sun in a gesture performed daily by Hindus. Akbar actively promoted sun-worship as part of his new fusion religion, designating Sunday as a holy day sacred to the sun and, according to his biographer Abu'l Fazl, he had a lexicon of Sanskrit names of the sun recited daily. A drawing attributed to Basawan in the Musée Guimet, Paris, after an untraced allegorical engraving provides the likely intermediary, as is evidenced in the windswept robes, the pitcher, the placement of attendant, and the transformation of a god in clouds into a classic Basawan rock formation with a radiating sun bursting through clouds.

BASAWAN (ATTRIBUTED)

THE GOLDEN AGE OF MUGHAL PAINTING
1575–1650

John Guy

The period 1575 to 1650 encompasses the reigns of the Mughal emperors Akbar (r. 1556–1605), Jahangir (r. 1605–27), and Shah Jahan (r. 1628–58). The imperial court culture that developed under the direction of these three great emperors, resourced from the riches of an entire subcontinent, came to bedazzle the world. Ambassadors and merchants alike were sent from Iran, Spain, England, and many lesser powers to engage with this empire. Traders, missionaries, and diplomats first passed through the Portuguese enclave of Goa, and later the ports of Cambay and Surat, to do business with the Mughal court at Delhi, Fatehpur Sikri, or Agra.

When the young Akbar inherited this then fledgling empire, he also inherited a modest manuscript workshop, which his father, Humayun, had assembled during his exile in Kabul, and which came to Delhi with his invading army. Akbar clearly had empathy for the art of the book, and although reputedly semiliterate, he nurtured the creation of a great imperial library (*kitabkhana*) rich in illustrated manuscripts (Preface, Fig. 2).[1] Akbar's biographer Abu'l Fazl recorded that the emperor enjoyed daily readings of these works, adding that "among the books of renown there are few that are not read in His Majesty's Assembly Hall."[2] In a painting from the second edition of the *Akbarnama*, Akbar is seen in evening discourse with two Jesuits, the carpeted floor scattered with books (Fig. 15). This duo included Antonio Monserrate, whose memoirs of his visit to Akbar's court at Fatehpur Sikri in 1580 provide an insight into the emperor's inquiring mind.[3]

The *kitabkhana* was also home to the imperial atelier, whose scribes, painters, and librarians ensured that a steady flow of new manuscripts was added to the library. What manuscripts were produced was very much determined by the emperor himself. All three emperors of this period were instrumental in commissioning specific works and in many cases in directing which painter should receive the royal instruction. Abu'l Fazl tells us that Akbar visited

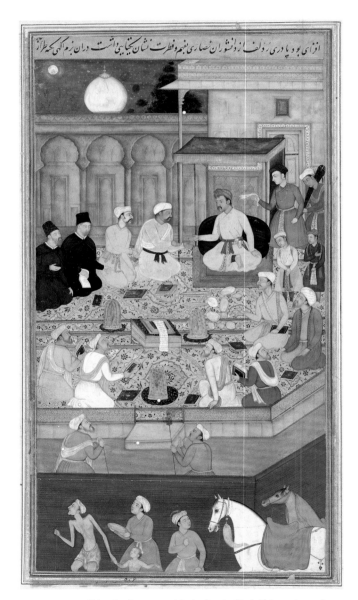

FIGURE 15. Akbar in discourse with the Jesuits Rudolf Aquaviva and Antonio Monserrate, at Fatehpur Sikri, 1580: page from the *Akbarnama*, painted by Nar Singh, 1597. Chester Beatty Library, Dublin (MS 3, f.263b)

the *kitabkhana* regularly, rewarding with salary increases those calligraphers and painters who pleased him with the excellence of their work.[4] Over time, such intense royal attention inevitably shaped the development of style in the studio, as artists strived to win the attention and favor of their imperial patron. Each of the three emperors in turn directly and personally shaped style, although each in a different way, according to their own aesthetic and personal aspirations.

The imperial studio was not confined to the principal capital alone. Branch workshops appear to have functioned at secondary capitals, and painters—who often held military rank and could be expected to serve in times of need—routinely accompanied the emperor on tours and campaigns, recording events as instructed, rather in the manner of a war artist or photographer today. Manuscript paintings of the period provide accurate depictions of all the stages of book production, from paper making, burnishing, calligraphy and painting, marginal illumination, and gilding to finally binding (Fig. 16).[5] For the first time in the history of Indian art, the artists were permitted to incorporate their own portraits in marginalia and, even more remarkably, on occasion in the primary pictures depicting the emperor himself.

Under Akbar, the imperial painting workshops expanded exponentially, employing some hundreds of artists and artisans recruited from across the subcontinent. Hindu painters made up a significant percentage and were singled out for praise in the *A'in-i Akbari* section of the *Akbarnama* for their remarkable skills.[6] The catalyst for this expanded studio appears to have been the extraordinary demands that were placed on the atelier producing the *Hamzanama*. Iranian trained painters worked alongside Indian Muslim and Hindu artists, generating the fusion of styles that characterizes early Mughal art. To add to the mix, Akbar avidly collected all things exotic, and according to the contemporary observer Monserrate, he routinely had them copied in his imperial workshops.[7] He was particularly fond of European paintings and engravings, which entered the imperial library collection largely as diplomatic gifts and as a form of evangelizing propaganda supplied by the Jesuits.[8] A copy of the *Royal Polyglot Bible* (1568–72) was delivered to Akbar only two years after its publication in Antwerp (Fig. 17). These sources had an immediate impact on the direction of Mughal painting, providing new solutions to perspective and atmospheric rendering, tonal modeling and chiaroscuro, grisaille, and other modeling tools. Portraiture, especially

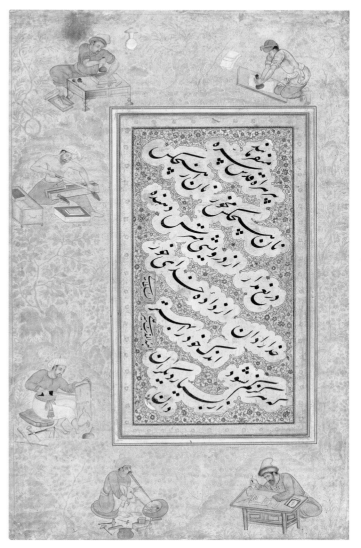

FIGURE 16. Calligraphic folio by Mir Ali, Iran, ca. 1550. Remounted with marginal paintings of the stages of manuscript production: page from a Jahangir album, ca. 1600. Freer Gallery of Art, Smithsonian Institution, Washington D.C., Purchase (F1954.116r)

the studied profile, took on a new importance as a signature motif of the imperial image.[9] Again, the *A'in-i Akbari* provides the confirmation of this: "His Majesty himself sat for his likeness, and also ordered to have the likeness taken of all the grandees of the realm," and "an immense album was thus formed," the earliest reference to the assembly of an imperial *muraqqa*, a practice much favored by Jahangir and especially Shah Jahan.

Akbar deployed his master painters to record the history and achievements of his reign, and those of his ancestors — five known illustrated editions of the memoirs of Babur, the *Baburnama*, were produced at Akbar's command.[10] While dynastic history and biography painting remained at the core of manuscript production in Akbar's reign, the range of other subjects deemed worthy of the attention of the royal scribes and painters is staggering; all manner of Persian and Arabic works of literature were produced in illustrated editions. Akbar's passion for the universality of religions extended to directing that Persian translations of Sanskrit classics be prepared, of which the imperial *Harivamsa* (Genealogy of Vishnu, 1586) and *Ramayana* (Adventures of Rama, 1587–88) are masterpieces of Mughal painting. A Life of Christ was commissioned from the Jesuits expressly so that it could be translated into Persian (see Glossary of Literary Sources). All displayed the early Mughal taste for dramatic action combined with historical description. Two models were in competition, a lingering taste for Safavid soft colors and languid forms prevailed among the Iranian-born and trained artists such as 'Abd al-Samad, while a painter like Basawan, a young Hindu recruit to 'Abd al-Samad's team, introduced a strong palette of primary colors and a new pictorial approach, especially for the rendering of form and the realization of pictorial space. This latter approach, which incorporated a response to European art, prevailed. Rare talents like Farrukh Beg, an émigré from Iran, made the transition with consummate skill, as can be witnessed by his enigmatic Sufi sage in his study (No. 23), directly modeled on European depictions of Saint Jerome but rendered in the mannerist palette unique to the artist's late work.

At two moments in Akbar's reign, circumstances conspired to ensure that the imperial style was disseminated widely beyond the court. On the completion of the *Hamzanama* around 1577, many painters and others were released from employment and dispersed across India in search of new patrons. The second recurrence of this was in 1605, when Jahangir succeeded his father and further reduced the imperial atelier to a core of master painters. Many of those released entered the service of provincial Muslim courts; other those of Hindu rulers. To both, they brought their intensive training in the Mughal style, thus triggering a revolution in Indian painting that crossed geographical, cultural, and religious divides. The three Masters of the Chunar *Ragamala* (1591) demonstrate this pattern; reputedly having been trained at

Fatehpur Sikri under the great 'Abd al-Samad, they then served a Rajput prince stationed in Chunar, near Varanasi, and with his return to Rajasthan, they acted as a catalyst for the diffusion of the Mughal style to the Bundi and in turn Kota courts (Nos. 48, 49). Likewise, the Mewar painter Nasiruddin, known to have served in the Mewar court-in-exile at Chawand in 1605, had already been exposed to subimperial Mughal influences, probably during an apprenticeship served at Udaipur (Nos. 45, 46). A generation later, artists like Sahibdin were displaying a new naturalistic and descriptive approach to portraiture and dress, breaking with these Rajput conventions while preserving vestiges of the old style in the use of flat washes of intense color and a vertical treatment of space. Perhaps the pinnacle of this hybrid style is seen in the work of the Hada Master, based at Kota; his portrait of Rao Jagat Singh is a masterful blending of the stylistic forces at play, producing a new vision, the beginnings of the Mughalesque Rajput style (No. 48).

With Prince Salim's ascension as Emperor Jahangir in 1605, significant changes occurred, both in the patron's expectations and in workshop practices. Jahangir prided himself on his skills of connoisseurship; he maintained his own studio, directed by the Iranian-trained Aqa Riza, while still a prince under his father's roof at Agra, and took it with him into rebellious self-exile to Allahabad in 1600. These loyal painters, who included Mansur and Manohar in their ranks, returned with him as emperor to Agra and formed his inner atelier. A unique work that brings these rare talents together is Prince Salim's presumptuously imperial enthroned portrait, to which Manohar contributed the stern portrait and Mansur the dazzling throne (No. 33). Many of those still in his father's employ were dismissed, and a shift occurred away from the large-scale studio team productions of illustrated books to the commissioning of individual paintings for incorporation into albums (*muraqqas*). This shift was accompanied by a movement away from studio practices in which a team of lesser artists pooled their efforts, the master adding notable portraits or other highlights. Instead, we witness the routine appearance of the single-artist work, produced in an atelier increasingly restricted to master painters and gifted apprentices.

These shifts reflect Jahangir's self-image as a discerning connoisseur, the cultivator of those master painters he titled *Nadir al-Asr*, Wonder of the Age. He first conferred this title on Ustad Mansur, a master painter famed for his fidelity to nature, who produced animal and plant studies of unprecedented naturalism.

FIGURE 17. Frontispiece from the *Royal Polyglot Bible*, published by Christopher Plantin (Antwerp, 1578). Houghton Library, Harvard University, Cambridge, Massachusetts

ing a uniform house style as his father had done. He also permitted, for the first time, the appearance of artists' self-portraits.[13]

The succession of Shah Jahan on his father's death in 1628 marked a move further away from Akbari aesthetics. As a patron, Shah Jahan, whose title translates as King of the World, displayed an almost obsessive concern with the formality of court protocol and the projection of the imperial image.[14] This translated into court architecture of unprecedented splendor and opulence and an accompanying painting style that resembles in its decorative precision the *pietra dura* of the imperial darbar halls. In *Jahangir receives Prince Khurram* (No. 38), the audience balcony has a *pietra dura* dado, exotic glass and other treasures displayed, rich textiles hangings and canopy, and mural paintings. *Shah Jahan riding a stallion* embodies similar aspirations with its idealized, jewel-like precision of descriptive detail, all directed to one goal, the glorification of the person of the emperor; here, artistic endeavor and state ideology are as one (No. 40). A central preoccupation of court painting under Shah Jahan was formal portraiture, with a penetrating depiction of psychological character. The brothers Balchand and Payag dominated this genre at the peak of Shah Jahan's reign; their achievement is epitomized by the paintings preserved in the Saint Petersburg Album and the Windsor Castle *Padshahnama* (Nos. 38, 41). One of Payag's last known works, consciously done in a revisionist Safavid style, depicts an imagined likeness of the emperor Humayun seated in a flowery landscape admiring a pearl and jewel-encrusted *sarpesh* (turban ornament), an image of pure connoisseurship. Shah Jahan prided himself in his connoisseurship of jewels, akin to his father's self-regard as a most discerning patron of painting. The passing of Shah Jahan in 1648 and the usurpation of the throne by his younger son Aurangzeb marked a shift toward fundamental Islamic values and an increasingly puritanical world view in which court opulence of this kind was disavowed. Mughal painting was never to reach such heights of refinement again.

Jahangir routinely summoned him to record both the natural beauties of nature, such as the spring flowers of Kashmir, and all manner of exotic creatures presented at court, such as a zebra from Abyssinia or a turkey cock and dodo sent from Goa by the Portuguese.[11] As the emperor's personal memoirs, the *Jahangirnama*, make clear, Jahangir certainly did not see himself as the mere patron of history books but rather as a connoisseur of the highest sensibility and discrimination:

> I derive such enjoyment from painting and have such
> expertise in judging it that, even without the artist's name
> being mentioned, no work of past or present masters can be
> shown to me that I do not instantly recognize who did it.[12]

Jahangir savored the differences in style among his master painters and rewarded them with titles and recognition rather than demand-

'Abd al-Samad

*Iranian, born in Shiraz ca. 1505–15, trained at the court
atelier of Shah Tahmasp in Tabriz, served the Mughal emperors
Humayun and Akbar, active 1530s until his death ca. 1600*

'Abd al-Samad was a master trained in Safavid Iran. He served under Shah Tahmasp (r. 1524–76) at Tabriz and subsequently was recruited by the Mughal emperor-in-exile Humayun. Along with two other eminent Iranian court painters, Miravvir and his son Mir Sayyid 'Ali, 'Abd al-Samad, served Humayun at his court-in-exile in Kabul from 1549 and returned with his conquering army to Delhi in 1555. Within a year, he was working for a new patron, the young adolescent emperor Akbar, and codirecting with Mir Sayyid 'Ali a rapidly expanding imperial atelier. He was appointed by the young Akbar as his personal tutor in the art of painting, a singular honor. He became enormously influential in the court atelier, we may assume tutoring many protégés; the renowned painter Daswanth is recorded among his pupils. 'Abd al-Samad succeeded Mir Sayyid 'Ali as the director of the most ambitious painting project ever undertaken in Mughal India, the production of 1,400 large paintings on cloth narrating the Iranian epic, the *Hamzanama* (No. 10). Akbar's biographer Abu'l Fazl tells us that under 'Abd al-Samad's direction, ten volumes comprising a thousand paintings were created over seven years, so completing the project around 1571–72. To achieve this goal, 'Abd al-Samad recruited artists from across India, thereby precipitating the fusion of styles witnessed in the *Hamzanama*, which proved to be the genesis of the Mughal style.

'Abd al-Samad's demonstrative gifts as an administrator led him away from the world of court ateliers. In 1577, Akbar appointed him director of the royal mint at Fatehpur Sikri, and other senior government posts followed, culminating in the governorship of the city of Multan. No other Mughal court artist made the transition to the centers of political power achieved by 'Abd al-Samad. Nonetheless, it appears that he maintained a directorial role over the atelier for much of his career. In addition, his personal work retained a powerful allegiance to the Safavid aesthetic, most evident in the portrayal of two fighting camels (No. 15), which he painted in his eighty-fifth year as a gift to his son and which was his personal homage to the doyen of Iranian painters, Bihzad (ca. 1450–1535/36). The masterly control evident in this and other identifiable works earned 'Abd al-Samad the title *Shirinqalam* (Sweet Pen) from Akbar.[15]

14

Prince Akbar and noblemen hawking

Mughal court at Delhi, ca. 1555–58

Inscribed: (mis)ascribed as "the work of Mir
Sayyid 'Ali the artist"

Opaque watercolor and ink on paper; painting:
8½ x 5⅛ in. (21.6 x 13 cm); page: 14¼ x 9⁹⁄₁₆ in.
(36.2 x 24.3 cm)

Catherine and Ralph Benkaim Collection

Published: Brand and Lowry, *Akbar's India* (1985),
no. 69; Canby, "The Horses of 'Abd us-Samad"
(1998), fig. 1

This is among the earliest known examples of
Mughal painting in Delhi and is a rare work that
can be associated with the reign of Humayun.
It most probably was produced soon after
Humayun recaptured Delhi in 1555. Although
not inscribed, recent research suggests that it
most probably depicts, in the foreground, the
young prince Akbar hawking, accompanied by
his guardian Bairam Khan. A year later, the
prince's father was dead, and the prince was
emperor. This is a rare example of early Mughal
painting as an independent work, not part of an
integrated manuscript. It is one of the earliest
known pictures belonging to the Indian chap-
ter of 'Abd al-Samad's long and celebrated
career, along with the famous *Princes of the
House of Timur* (British Museum, London).

In this animated scene, the artist demon-
strates his remarkable ability to render fine
descriptive detail. A youthful fresh-faced
Akbar and a nobleman, both wearing turban
ornaments (*sarpech*) with heron-feather
plumes (*kalgi*), are enjoying hawking; the
prince appears to have made the first kill.
The landscape is treated almost monochro-
matically, in the *nim qalam* manner of a tinted
drawing, providing a perfect foil for the
strongly colored figures and horses. The fan-
tastic stylized rock formations represent a
continuation of the Safavid style, but the land-
scape has a new harshness, an edge of
Mughal realism.

15

Two fighting camels

Mughal court at Fatehpur Sikri or Lahore,
ca. 1590
Inscribed: signed by the artist at upper left, sub-
script, along with a dedication: "At the age of
eighty-five, when his strength has gone, his pen
has weakened and his eyesight has dimmed, he
has agreed to draw from memory/as a memento
for this album with every detail for his wise, witty,
and astute son Sharif Khan, who is happy, fortu-
nate, prosperous, and chosen by the memory
of the Merciful"
Opaque watercolor and ink on paper,
7³⁄₈ x 8¹⁄₁₆ in. (18.7 x 20.5 cm)

Private Collection
Published: Brand and Lowry, *Akbar's India* (1985),
no. 58; Goswamy and Fischer, *Wonders of a
Golden Age* (1987), no. 19

This painting serves as both an homage to
'Abd al-Samad's lineage and an appeal to his
son Muhammad Sharif not to lose sight of
his artistic roots. The artist's inscription tells
us that he has painted this version of a famous
original by the master Bihzad (ca. 1450–
1535/36) from memory as a gift for his son to
serve as a model of what is possible, even for
an artist in his eighty-fifth year. The work is a

testimony to the dazzling verisimilitude that
the finest painters could achieve; witness the
power of observation and the skill at render-
ing every minutia. 'Abd al-Samad was a mas-
ter trained in the Persian school, where
technical virtuosity was prized equally with
poetic sensibility.

16

Akbar and a dervish

Mughal court at Fatehpur Sikri or Lahore,
ca. 1580–90

Inscribed at center-right "Portrait of Shah Akbar.
Work of 'Abd al-Samad, *Shirinqalam* [Sweet Pen]"

Opaque watercolor and ink on paper;

painting: 9¹⁄₁₆ x 6⁵⁄₁₆ in. (23 x 16 cm);

page: 15³⁄₈ x 10 in. (39 x 25.4 cm)

Aga Khan Trust for Culture, Aga Khan Museum
Collection, Geneva (AKM 00141)

Published: Welch, *Indian Drawings and Painted
Sketches* (1976), no. 10; Welch and Welch, *Arts of
the Islamic Book* (1982), no. 56; Canby, *Princes,
Poets and Paladins* (1998), no. 80

This study, sensitively rendered in *nim qalam*
(half-pen) technique, a tinted drawing style
probably inspired by European grisaille tonal
drawing, is an early example of an independent
work for the patron's pleasure; it is not part of
an integrated manuscript. The theme of a
king meeting a holyman — wealth and power
versus wisdom and worldly detachment —
was popular in the Persian tradition and was
readily taken up in Mughal India. The sage-
like dervish wears an animal-skin cloak and
a large rython-like horn that serves as his
receptacle for alms. He gestures in suppli-
cation to the young emperor, who is seated
atop a rocky outcrop covered with a shawl
and rests against a *chunar* tree, supported
by a pillow. The two appear to be in dia-
logue. Produced late in 'Abd al-Samad's long
career — the artist must have been in his
80s — this work is uncharacteristically Akbari
in style, suggesting that he may have worked
in partnership with a younger artist or that
the work was finished by such a person.

Manohar

Active ca. 1582–1620s, at the Mughal courts in Lahore, Delhi, Allahabad, and Agra; son of Basawan

Remarkably, two portraits of Manohar are preserved, one in which he is depicted as a young teenage apprentice already entrusted with commissions befitting more senior artists and the other by his contemporary Daulat, painted some twenty-five years later.[16] As the son of Basawan, Manohar had the title of *khanazadan* (born at court) and was privileged to gain an early entrée into the court atelier. His long career spanned four decades, two emperors, and the ateliers in Lahore, Delhi, Allahabad, and Agra. Like his eminent father, Manohar cultivated great skill at working in a variety of styles. But he excelled most in composing history paintings that conveyed a story with fidelity and clinical clarity. His contribution to the first edition of the *Akbarnama* (1596–97, the Victoria and Albert *Akbarnama*) demonstrates his mastery of theatrical composition and his extraordinary gift for finely executed descriptive detail (No. 17). His assembled court scenes with multiple portraits of courtiers were without rival and were achieved with carefully constructed compositions in which the interplay of surface pattern provided the unifying visual element.

Unlike the works of some of his contemporaries, such as Abu'l Hasan, Manohar's portraiture rarely exhibits a psychological dimension; it appears equally concerned with fidelity in the rendering of jewels, fabrics, and faces. The remarkable depiction of the enthroned Prince Salim, with its radical placement of an obliquely viewed throne and uncompromisingly passive profile portrait of the future emperor, is a tour de force in emotional detachment. Henceforth, Manohar was Salim-Jahangir's painter of choice. He set new standards for the group portrait, typically for his *darbar* scenes in which all those of rank are assembled before the emperor. He retained this position until other luminaries such as Abu'l Hasan, Daulat, and Govardhan, for example, attracted the emperor's favor. When Jahangir's memoirs were written in 1618, Manohar was no longer listed among the favored artists of the day.[17]

Nonetheless, Manohar's lasting legacy is the celebration of imperial Mughal painting's central concerns—the glorification of the person of the emperor and the propagation of his achievements. He was both chronicler and propagandist par excellence of the Mughal court. His imperial patrons, Akbar and Jahangir, regarded themselves as discerning connoisseurs. Under the latter, Manohar increasingly had to devote his energies to creating images for the emperor's self-edification alone. His late group portraits reveal the degree of formulaic reproduction of figure and facial types that ultimately was his undoing as a court favorite.

Above: Portrait of Manohar, by Daulat, from the Gulshan Album, ca. 1610. Golestan Palace Library, Tehran

17

Akbar hunting in a *qamargha*, or the humiliation of Hamid Bhakari: page from an *Akbarnama* manuscript

Mughal court probably at Lahore, dated by association 1597
Opaque watercolor, ink, and gold on paper; painting: 8⁷/₁₆ x 5 in. (21.4 x 12.7 cm)
The Metropolitan Museum of Art, New York, Bequest of Theodore M. Davis, 1915 (30.95.174.8)
Published: Beach, *Early Mughal Painting* (1987), fig. 85; Kossak, *Indian Court Painting* (1997), no. 13

This folio is from one of the great manuscripts of the reign of Akbar, the second edition of the *Akbarnama*. The principal theme is not the one that dominates the composition — the deadly slaughter of wild animals who have been herded and corraled in a *qamargha* — but the one at lower left — the humiliated figure of shaved-headed courtier Hamid Bhakari, who is paraded while seated backward on a mule. The four-day hunt in 1567, and Bhakari's disgrace, were described in detail in the *Akbarnama*; they signal both the emperor's absolute power over his domain and his magnanimity.

18

Prince offering wine to his beloved: page from a *Diwan of Mir Ali Shir Nawa'i* manuscript

Mughal court at Agra, ca. 1606
Opaque watercolor and gold on paper;
painting: 5⁷/₁₆ x 5 in. (13.8 x 12.7 cm);
page: 11⁷/₈ x 7¹³/₁₆ in. (30.2 x 19.9 cm)
The Royal Collection, Royal Library,
Windsor Castle (1005033 f.269v)
Published: Seyller, "A Mughal Manuscript of the
Diwan of Nawa'i" (2011)

This folio from a manuscript edition of the *Diwan of Nawa'i* depicts a court scene in the subdued palette of the Safavid style. The kneeling youth receives the blessing of the nobleman seated in a palace interior with finely painted arabesque decor in the dome and spandrels; a beautiful flowering plant (or is it also a painting?) dominates the interior space. A vocalist and musicians provide entertainment. The vista with a pair of cyprus trees and a bird-filled sky beyond introduces a spatially ambiguous dimension to the composition, as does the crenulated turret with cupola occupied by an enigmatic couple who project above the picture frame.

19

**Mother and child with a white cat:
folio from the *Jahangir al' Album***

Mughal court at Delhi, ca. 1598

Inscribed: Persian in *nastaliq* script in cartouches:
"A beauteous moon has been born of the sun./And
feeds upon the milk of its breast/A dainty bud
floating upon the surface of the spring/Of beauty
with which the very face of heavens is washed"*

Opaque watercolor on paper;

painting: 8⁹⁄₁₆ x 5⅜ in. (21.7 x 13.7 cm);

page: 14⁹⁄₁₆ x 9⅝ in. (37 x 24.4 cm)

The San Diego Museum of Art, Edwin Binney 3rd
Collection (1990.293)

Published: Beach et al., *The Grand Mogul* (1978),
no. 4; Brand and Lowry, *Akbar's India* (1985),
no. 66; Okada, *Indian Miniatures of the Mughal
Court* (1992), fig. 84; Goswamy and Smith,
Domains of Wonder (2005), no. 49*

This anonymous work has been attributed by
Beach to Manohar and by Welch, Brand and
Lowry, and Okada to Basawan. The chromatic
subtlety, beautifully realized drapery, and
sophisticated handling of linear perspective
are worthy of both these artists. The subject
matter clearly is inspired by multiple Euro-
pean models; the woman's windswept drap-
ery echoes that of the *Pietas Regia* depicted
on the second frontispiece of the *Royal Poly-
glot Bible*, which was adapted to a reclining
nursing posture, hence prompting the Virgin
and Child identification (see Fig. 17). The four-
cartouche inscription has no overt Christian
associations, making this identification tenu-
ous, although such imagery is undoubtedly
embedded in this composition's multifarious
sources.

Farrukh Beg

Born in Iran ca. 1545, active 1580s–1615, at the Mughal courts in Kabul, Lahore, Agra, and the Sultanate of Bijapur, died in Agra ca. 1619

Few Mughal painters have such a catalogue of praise from their patrons. Farrukh Beg was first noted as Farrukh Husayn in the early 1580s in the service of the Safavid Shah Khodabanda, in Kabul, working for Akbar's brother. In 1585, while serving Akbar at Lahore, he was singled out for praise as Farrukh Beg (*beg* is an honorific title, perhaps conferred by Akbar) in Abu'l Fazl's official biography of Akbar, *Akbarnama*, alongside the unsurpassed Daswant.[18] By 1590, he was attached to Ibrahim 'Adil Shah II's atelier in Bijapur, where his astonishing skill was praised by the court poet. In 1609, he appeared in Jahangir's memoirs as "one of the peerless of his age."[19] It seems that the apparent freedom he enjoyed was commensurate with his talent.

Farrukh Beg contributed to Akbar's major commissions of the day, the *Baburnama* (1589) and the first illustrated edition of the *Akbarnama* (probably 1589–90).[20] His painting *Akbar's Entry into Surat* is one of the greatest works of that remarkable manuscript, subtly blending Timurid and Mughal conventions into a new vision of startling sophistication, but not in keeping with the earthy realism that appears to have been the official agenda, to mirror the aspirations that Akbar's biography would eulogize the emperor as a history maker.[21] A favored subject was youthful and graceful men in a flowering landscape, a well-established theme in Persian painting and one to which Farrukh Beg returned in his last years. While some of these works are clearly portraits, others seem to have a more poetic intent. His Bijapur sojourn produced a series of pictures unprecedented in Mughal India. In Ibrahim Adil Shah II hawking (No. 21), he self-consciously reintroduced the mannerisms of Persian landscape painting and fused them with the newly emerging European-inspired approach to pictorial space. It is above all a landscape of the mind, extraordinary, highly individualistic, and unprecedented.

Farrukh Beg's masterful vision of a melancholy Sufi (No. 23) brings together much that distinguished his life's achievement. The work marks his only known use of European models, here transformed by the radical chromatic experiments of his Bijapur works into a mannerist painting distinguished by surreal coloring and modeling of form. That it was created in his seventieth year, the same year as a self-portrait very close in mood, makes it all the more compelling (No. 24). Farrukh Beg ignored even nominal elements of perspective and instead treated surface decor as paramount in his highly individualistic, singular style.

Above: Self-portrait of Farrukh Beg, ca. 1615. Detail of No. 24.

20

Emperor Babur returning late to camp, drunk after a boating party in celebration of the end of Ramadan (*'id*) in 1519: page from a *Baburnama* manuscript

Mughal court at Lahore, dated 1589

Inscribed: in margin, "Farrukh Beg," and pagination 176

Opaque watercolor on paper;

painting: 9⁵⁄₁₆ x 5³⁄₈ in. (21 x 13 cm);

page: 16⅛ x 10⅝ in. (40.9 x 27 cm)

Arthur M. Sackler Gallery, Smithsonian Institution, Washington, D.C. (S1986.231)

Published: Lowry and Beach, *An Annotated and Illustrated Checklist of the Vever Collection* (1988), no. 62; Beach, *The New Cambridge History of India: Mughal and Rajput Painting* (1992), fig. 41

The memoirs of the first Mughal emperor Babur (r. 1526–30) were translated from Chaghatay Turkish into Persian at Akbar's instruction, and the first illustrated edition was presented to the emperor in 1589. This work and two additional folios from this manuscript are the earliest known works signed by Farrukh Beg, who already exhibits his prodigious talent for creating landscapes of the imagination. Here, the forbidding rocky foreshore leads to a tented encampment of bizarre complexity. These elements enhance the intoxicating mood that is the theme, which is suggested by the unsteady figure of Babur on horseback carrying a torch standard. Servants on foot follow behind him, one carrying a lantern, the other a wine bottle. Babur recalled the incident in his memoirs, the *Baburnama*: "Very drunk I must have been, for when they told me the next day that we galloped loose-rein into the camp, carrying torches, I could not recall it in the least."[22]

21

Sultan Ibrahim Adil Shah II Khan hawking: page from the St. Petersburg Album

Bijapur, Deccan, ca. 1590–95
Inscribed: signed "it is the work of Farrukh Beg"
Opaque watercolor and gold on paper;
painting: 11.3 x 6.1 in. (28.7 x 15.6 cm)
Russian Academy of Sciences, Institute of
Oriental Studies, St. Petersburg (E-14, f.2)
Published: Zebrowski, *Deccani Painting* (1983),
pl. 69; Seyller, "Farrukh Beg in the Deccan" (1995),
p. 320, fig. 1; Habsburg et al., *The St. Petersburg
Muraqqa* (1996); Soudavar, "Between the Safavids
and the Mughals" (1999), p. 59; Hutton, *Art of the
Court of Bijapur* (2006), pp. 99–101, pl. 20

This work was produced by Farrukh Beg in
the early 1590s for the Sultan of Bijapur, one
of the independent Sultanates of the Deccan.
Farrukh Beg was rated among the highest
artists of Akbar's atelier, then in Lahore. Why
this talented painter left the emperor's employ
and sought patronage in a distant and provin-
cial court in the Deccan remains a mystery.
Artistic freedom may well have been a factor;
certainly, Farrukh Beg's tendencies to the sur-
real were given full vent in this new environ-
ment. Here, the densely painted and fancifully
colored landscape serves as a foil for Ibrahim
Adil Shah II Khan, his white hawk, and his
red-legged piebald horse. This extraordinary
fantastical landscape could exist only in the
painter's mind.

22

Sultan Ibrahim Adil Shah II riding his prized elephant, Atash Khan

Bijapur, Deccan, ca. 1600
Opaque watercolor and gold on paper;
painting: 5⅝ x 4 1/16 in. (14.3 x 10.3 cm)
Private Collection
Published: Zebrowski, *Deccani Painting* (1983),
p. 96, figs. 71–72; Welch, *India: Art and Culture*
(1985), no. 194; Seyller, "Farrukh Beg in the
Deccan" (1995), fig. 4

This painting is an homage to the Sultan's
prized elephant, whose praises he sings in
his highly personal literary song-verse com-
position, the *Kitab-i nauras*. The imagery of
these songs appears to inform many of the
paintings commissioned by this acutely sen-
sitive ruler. Here, the emperor had himself por-
trayed as the mahout, directing his beloved
majestic elephant with a golden goad. Atash
Khan is richly caparisoned, and his tusks are
fitted with golden bands set with jewels. The
attendant below is curiously dressed in Euro-
pean attire of the sixteenth century, presum-
ably a whimsical detail borrowed from an
imported engraving or miniature. Landscape
forms defy the rules of nature, as do the
chromatics of this picture.

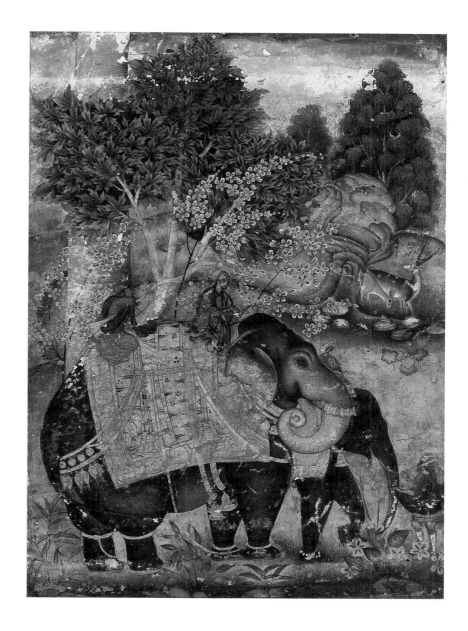

23

A Sufi sage, after the European personification of melancholia, Dolor

Mughal court at Agra, dated 1615
Inscribed: "the work of the Wonder of the Age
[Farrukh Beg] in his seventieth year, and dated
in the tenth regnal year [of Jahangir] Hijra 1024"
and signed lower margin "done by Farrukh Beg"
Opaque watercolor, ink, and gold on paper;
painting: 7⅝ x 5⁹⁄₁₆ in. (19.4 x 14.1 cm);
page: 15¹⁄₁₆ x 10¹⁄₁₆ in. (38.2 x 25.6 cm)
Museum of Islamic Art, Doha
Published: Welch, *India: Art and Culture* (1985),
no. 147, p. 222; Rogers, *Mughal Miniatures* (1993),
fig. 45; Seyller, "Farrukh Beg in the Deccan" (1995),
fig. 20; Das, "Farrukh Beg: Studies of Adorable
Youths and Venerable Saints" (1998), fig. 14

This extraordinary painting represents the last
chapter of Farrukh Beg's long career. He has
taken a European engravings of Dolor (Sor-
row/Melancholia) to create his own vision of
an aging Sufi, in what can be taken to be a
highly autobiographical image. The composi-
tional starting point is a Dutch engraving by
Raphael Sadeler after Maarten de Vos's *Dolor*
(below), which was inspired in part by Dürer's
Melancholia I and a long lineage of composi-
tions of Saint Jerome in his study. Psychologi-
cally, this work mirrors the mood of the
artist's last self-portrait, painted in or around
the same year (No. 24).

Dolor, by Raphael Sadeler I, after a
drawing by Maarten de Vos,
Netherlands, engraving, dated 1590.
The Metropolitan Museum of Art,
New York, Harris Brisbane Dick
Fund, 1944 (44.62.6)

24
Self-portrait of Farrukh Beg:
page from a *muraqqa* of Shah Jahan

Mughal court at Agra, ca. 1615
Inscribed: "Portrait and painting by Farrukh
Beg Musawar"
Opaque watercolor and ink on paper;
painting: $5^{13}/_{16}$ x $2^{7}/_{8}$ in. (14.7 x 7.3 cm);
page: $21^{15}/_{16}$ x $13^{11}/_{16}$ in. (55.7 x 34.8 cm)
Eva and Konrad Seitz Collection
Published: Das, "Calligraphers and Painters in
Early Mughal Painting" (1981), fig. 280; Verma,
Mughal Painters and Their Work (1994), pl. L;
Das, "Farrukh Beg: Studies of Adorable Youths
and Venerable Saints" (1998), fig. 1

This portrait of an elderly man, identified by
inscription as the work of Farrukh Beg, is a
presumed self-portrait, although the inscrip-
tion allows scope for ambiguity.[23] It is a mea-
sure of the status and esteem in which Farrukh
Beg was held at court; rarely would an artist
presume to undertake such a personal work.
The artist is depicted as an old man standing
amid a flowering landscape and leaning con-
templatively upon a long staff. The flowering
bush and skyline with horizontal clouds
embody elements from his Deccan years
(Nos. 21, 22). As in those works, the land-
scape is not of this world but rather an imag-
ined place. This page bears a colophon by
the emperor Shah Jahan indicating it once
formed part of a *muraqqa* (album) in the
imperial library. The album was presumably
inherited from his father, Jahangir, under
whose patronage Farrukh Beg worked in his
last years.

Keshav Das

Active ca. 1570–1604/5, at the Mughal courts in Delhi, Lahore, Agra, and Allahabad

The Hindu painter Keshav Das was an early local entrant into Akbar's atelier, probably at the instigation of the Iranian master painter Khwaja 'Abd al-Samad, who oversaw the studio at this time and had been instrumental in recruiting widely in order to complete the monumental *Hamzanama* project (1557–58 to 1572–73). He proved to be a prolific artist, producing major contributions to many imperial volumes, including an edition of the *Ramayana* (Jaipur Palace Museum) to which he contributed no less than thirty-five full-page compositions.[24] Akbar ranked Keshav Das fifth in the imperial studio, according to Abu'l Fazl's official history of the reign.[25] While Mughal painters had a habit of inserting their self-portraits discreetly into the margins of crowd scenes, Keshav Das created an early self-portrait in which he is the sole subject (above) and a later work in which he shares the stage with his emperor and patron, Akbar (No. 25). Skilled in the Mughal conventions of blending the strong Indian palette with the soft pastel tonality of Timurid courtly styles, he was equally at ease applying these skills to Islamic, Hindu, or indeed, Christian subjects.

Keshav Das is remembered most however as the preeminent and creative explorer of the European mode at the Mughal court. Akbar encouraged Jesuits and western diplomats to circulate Christian imagery at court; in 1580, he invited a Jesuit delegation from Goa that presented printed bibles and religious oil paintings to the emperor. Jahangir continued this interest, actively collecting Flemish and German engravings that were made accessible to his court atelier. English Ambassador to King James I, Sir Thomas Roe, presented miniature cameo portraits that engaged the attention of Jahangir, who immediately had them copied.[26] With their use of linear and atmospheric perspective and an intense interest in portraiture, these works stimulated numerous local copies and adaptions, and Keshav Das was regarded as the master interpreter of them. Most significantly, European art at the Mughal courts triggered an awareness of alternative pictorial solutions, particularly the use of chiaroscuro and spatial depth. Undoubtedly, the heightened Mughal interest in portraiture of this period was stimulated in part by that exposure. Keshav Das's receptivity to European art went beyond that of his contemporaries; he explored the tonal modeling of musculature in new ways and brought an innovative approach to landscape, especially the creation of middle and far distance through the subtle use of perspective and atmospheric effects.

Above: Self-portrait of Keshav Das, signed Kesu, ca. 1570. Mughal court at Delhi.
Williams College Museum of Art, Williamstown, Museum purchaser, Karl E. Weston Memorial Fund (81.44)

25

Akbar with falcon receiving Itimam Khan, while below a poor petitioner (self-portrait of the painter Keshav Das as an old man) is driven away by a royal guard: page from the *Jahangir Album*

Mughal court at Lahore, dated 1589
Inscribed: signed and dated by Kesu Das, and scribal annotation identifying Itimam Khan
Opaque watercolor and ink on paper;
painting 8½ x 5⅞ in. (26.7 x 15 cm);
page: 21⅛ x 15½ in. (53.7 x 39.5 cm)
Staatsbibliothek zu Berlin, Preussischer Kulturbesitz (Ms. 117, fol. 25 a)
Published: Kühnel and Goetz, *Indian Book Painting from Jahangir's Album in the State Library of Berlin* (1926), pl. 38; Beach, "Mughal Painter Kesu Das" (1976–77), fig. 17; Okada, *Indian Miniatures of the Mughal Court* (1992), fig. 99

An elderly man, stooped and emaciated, holds a scroll of paper upon which is written a salutation to Emperor Akbar — seen above — along with the artist's name and date. Surprisingly, it is written in Hindi in *devanagari* script, not Persian, the language of the Mughal court. This inscription makes clear that the humble petitioner is the artist himself. With great skill, Keshav Das created a rocky landscape in the Timurid manner to provide a two-tiered setting for his subject, ostensibly a scene depicting the emperor receiving a court petitioner but in reality, concerned with the artist's plight and a sense of injustice. He is being prevented from meeting the emperor by a hostile guard in a scene that must be read as allegorical.

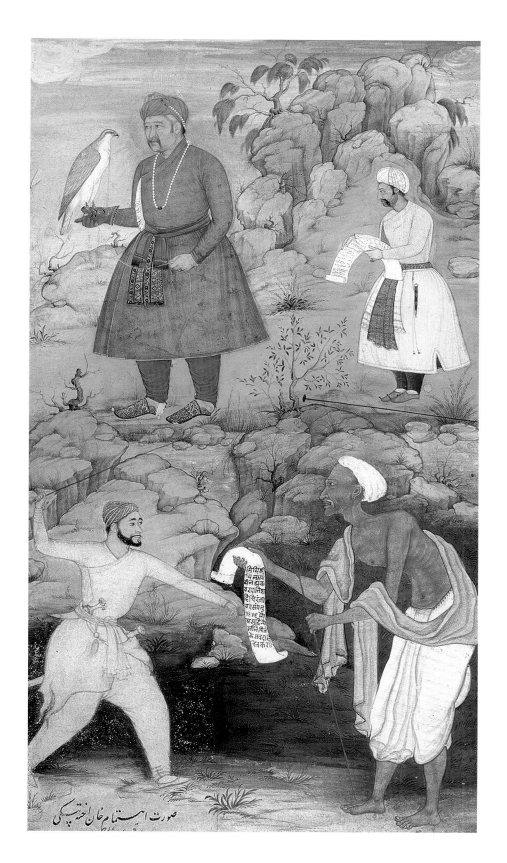

26

Saint Jerome

Mughal court at Delhi, ca. 1580–85
Inscribed: "Kesu Das"
Opaque watercolor on paper;
painting: 6¹¹⁄₁₆ x 3¹⁵⁄₁₆ in. (17 x 10 cm);
page: 12⅝ x 8¹⁄₁₆ in. (32.1 x 20.5 cm)
Musée National des Arts Asiatiques Guimet,
Paris (MA 2476)
Published: Beach, "Mughal Painter Kesu Das"
(1976–77), fig. 7; Bailey, *The Jesuits and the
Grand Mogul* (1998), fig. 9; Okada, "Kesu Das:
The Impact of Western Art on Mughal Painting"
(1998), fig. 9

This work, signed "Kesu Das," was adapted from a European source, in all probability an engraving by Mario Cartaro published in 1564 (below).[27] The wide circulation of European Christian prints in Mughal India in the late sixteenth century proved to be an important source of imagery and of new approaches to pictorial rendering for Mughal painters. Such engravings were assembled into albums at the imperial library. The ultimate source of Keshav Das's Saint Jerome is Antique Roman imagery of Neptune, their god of the sea. Michelangelo's drunken Noah in the Sistine Chapel (completed 1512) represents a famous moment in this figure composition's evolution and a source accessible to Cartaro in Rome some fifty years later. Following Cartaro's engraving, the Mughal artist merged two sets of European imagery, the drunken Noah in slumber and the studious Saint Jerome holding a book of learning. Das was exploring a painterly technique more akin to European oil painting than to Indian watercolor, and the atmospheric haze of the distant city vista, again a gesture to European conventions, serves to heighten the dreamlike quality of Saint Jerome's slumber.

Saint Jerome in a Landscape, by Mario Cartaro. Engraving, 1564. Albertina Museum, Vienna.

Aqa Riza

Born in Meshhed, Iran, ca. 1560, active at the Mughal courts in Kabul, Allahabad, and Agra until ca. 1621; father of Abu'l Hasan and A'bid

Aqa Riza was a recruit from Iran who served Prince Salim at the subcourt in Kabul before joining the atelier in Agra. It appears that he followed the crown prince to his rival court in Allahabad in 1599/1600, and then returned again to Agra with Salim's accession as Emperor Jahangir in 1604/5. He seems to have directed the court studio in Allahabad, and perhaps briefly Agra, and to have been responsible for supervising an "alternative" imperial atelier that included his gifted son Abu'l Hasan. Rigorously trained in the Safavid tradition, Aqa Riza favored the Iranian refined decorative approach over Akbar's earthy naturalism and so won favor with the young Prince Salim. A major work from the Allahabad years is the *Anvar-i Suhayli* (Lights of Canopus; British Library), to which the artist contributed five signed paintings, dated 1604–5.

Aqa Riza faded from sight in Agra, as Jahangir's taste matured and increasingly favored a more overtly laudatory style provided by others, including Abu'l Hasan. His later works remain uncompromisingly in the Iranian Safavid style, despite some attempt to absorb Mughal tonal modeling, as is witnessed by the youth fallen from a tree (No. 27), on which he collaborated with one of the greatest calligraphers of his generation, Mir 'Ali. This work epitomizes Aqa Riza's conservative style in the Iranian mode, which ultimately resulted in his loss of favor at court as Mughal taste moved in other directions. Jahangir, in his *Tuzuk-i-Jahangiri* (Memoirs), only referred to Aqa Riza in an entry in praise of his son Abu'l Hasan, noting that there is no comparison between their work.[28] Nevertheless, Aqa Riza's talents were considerable, even extending to his design in 1605 of the royal tomb of Prince Salim's wife Shah Begam, which is sited in the Khusrau Bagh garden outside the city of Allahabad. A favored wife of Jahangir at the time of this painting was Nur-Jahan, an Iranian whose considerable influence at court may have favored the tolerance of artists like Aqa Riza who were still devoted to the Safavid style.

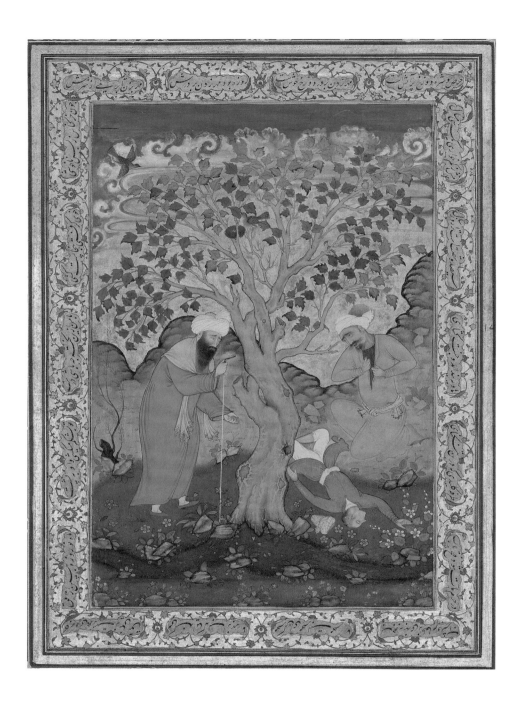

27

A youth fallen from a tree: page from the Kevorkian Shah Jahan Album

Mughal court at Agra, ca. 1610
Inscribed: in Persian, "Painted by Aqa Riza,"
"By its scribe, the sinful slave Mir 'Ali," and in the
lower gilt margin, "Work of Fath Muhammad"
Opaque watercolor, ink, and gold on paper;
painting: 8⁹⁄₁₆ x 5³⁄₈ in. (21.7 x 13.7 cm);
page: 14⁹⁄₁₆ x 9⁵⁄₈ in. (37 x 24.4 cm)
The Metropolitan Museum of Art, New York,
Rogers Fund and The Kevorkian Foundation Gift,
1955 (55.121.10.20v)
Published: Welch et al., *The Islamic World* (1987),
no. 53

This is a work of pure decorative abstraction, splendid in its descriptive detail and dazzlingly accomplished, yet devoid of any pathos and emotion that we might expect from the tragic event depicted, the death of a youth witnessed by his father. The pictorial elements—the grassy landscape, the plane tree and its foliage, the surreally colored rocky outcrops, and the cloud-trimmed sky—all serve as foils for decorative excess. Color is used in a purely theatrical manner, the robes of the three actors forming a counterpoint to the gold backdrop of the tree foliage. Such an approach could not be removed further from the earthy realism increasingly in vogue at Akbar's court. Aqa Riza was a master of the Safavid school, but in the context of Mughal painting of the early seventeenth century, his work appeared inherently conservative, indeed archaic.

Abu'l Hasan

*Born in India ca. 1588–89, active at the Mughal courts
in Allahabad and Agra 1600–1628; son of Aqa Riza*

As the son of the eminent Mughal court artist Aqa Raza, Abu'l Hasan was tutored early in the skills of manuscript painting, a vocation to which he displayed precocious aptitude. The sensitively drawn and psychologically insightful Saint John the Evangelist (No. 28) was adapted after Durer's original by Abu'l Hasan at the age of thirteen, and his first contribution to an imperial commission appears to be the 1604–10 edition of *Anvar-i Suhayli* (Lights of Canopus; British Library), while he was still in his teens. A portrait of the artist from this period by Daulat shows a youthful Abu'l Hasan working intently on his drawing board, his artist's tools arranged in front of him (above). Major works followed, such as squirrels in a plane tree of about 1610 (British Library), which closely follows his father's conservative Safavid style in its uncompromising flatness and gold ground, although some modulating of forms represents a concession to Mughal trends. Abu'l Hasan's technical brilliance resulted in nature studies of dazzling fidelity; his spotted forktail (The Metropolitan Museum of Art) is certainly on a par with great hornbill (No. 36) by Mansur, who was regarded as the great naturalist painter of the Mughal age.

Abu'l Hasan's heyday was in the last decade of Jahangir's reign (r. 1605–28). His pictures appear prominently in collected works recording the celebrations of Jahangir's accession, painted a decade after the event but incorporating portraits of contemporary personalities of the court, many identifiable through inscriptions in earlier portrait studies. Abu'l Hasan quickly emerged as the emperor's favored portraitist and was given the singular honor of painting the frontispiece for Jahangir's memoirs, the *Jahangirnama*. It was for this work that Jahangir awarded him the title *Nadir al-Zaman* (Wonder of the Times), in 1618.[29] He was engaged by Jahangir to portray the emperor in a series of allegorical portraits. With the regime change in 1627, Abu'l Hasan ceased to be active. He was closely identified with the personality and patronage of Jahangir and so did not find favor when Shah Jahan succeeded, although one imperial portrait indicates this decline was not immediate.[30] No work is known from beyond 1628.

Above: Portrait of Abu'l Hasan, by Daulat, from the Gulshan Album, ca. 1610. Golestan Palace Library, Tehran

28
Study of Saint John the Evangelist, adapted from Dürer's *Crucifixion* engraving of 1511

Mughal court, probably at Allahabad, dated 1600–1601
Inscribed: "Drawn by Abu'l Hasan son of Riza, disciple of Shah Salim. Done at the age of thirteen" and dated 1 April 1009
Brush drawn ink on paper, 3¹⁵⁄₁₆ x 1¹³⁄₁₆ in. (10 x 4.6 cm)
The Ashmolean Museum, Oxford, Gift of Gerald Reitlinger, 1978 (EA 1978.2597)
Published: Ashton, *The Art of India and Pakistan* (1950), no. 665; Beach, "The Mughal Painter Abu'l Hasan and Some English Sources for his Style" (1980), fig. 13; Rogers, *Mughal Miniatures* (1993), pl. 49; Topsfield, *Indian Paintings from Oxford Collections* (1994), pl. 8

This sensitive study was drawn by the thirteen-year-old son of Aqa Riza. The young artist certainly was working directly from the Dürer original rather than from some Mughal intermediary version. He produced a sensitive and accurate interpretation of the Dürer, with finely judged shaded modeling to give volume and form to the figure. The saint's anguish, seen in his intense facial expression and tightly clasped hands, reveals a psychological insight that soon would make Abu'l Hasan the foremost portrait painter of Jahangir's reign.

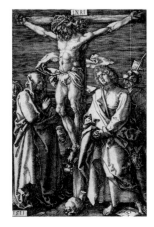

Crucifixion, from *The Small Engraved Passion*, by Albrecht Dürer, Nuremberg, engraving, dated 1511. The Metropolitan Museum of Art, New York, Fletcher Fund, 1919 (19.73.13)

29

Celebrations at the accession of Jahangir: page from a *Jahangirnama* manuscript; St. Petersburg Album

Mughal court at Ajmer or Agra, ca. 1615–18
Inscribed: "By the worthless of the humble, Abu'l Hasan, Jahangir Shahi"
Opaque watercolor and gold on paper; painting: 14⅞ x 8¹¹⁄₁₆ in. (37.8 x 22 cm)
Russian Academy of Sciences, Institute of Oriental Studies, St. Petersburg (Ms. E-14, fol. 10)
Published: Ivanova et al., *Al'bom indiuskikh i persidskikh miniatiur XVI–XVIII vv.* (1962), no. 7; Beach, "The Mughal Painter Abu'l Hasan and Some English Sources for his Style" (1980), fig. 23

The orientation of this composition is to the right, indicating that this was the left half of a double-page composition. The setting of the Red Fort at Agra is evoked by the splendid pink sandstone gateway through which an elephant emerges in a dramatic frontal view and mounted by a mahout dressed in a brilliant yellow *jama* and beating kettledrums. This melange of figures of the court, jostled together seemingly irrespective of rank, allows Abu'l Hasan to display his skills at portraiture to the fullest. Intermingled in this crowd are a number of foreigners, presumably diplomats, including at lower right, a European who is very probably Sir Thomas Roe, Ambassador to King James I of England, and above the red railing, a balding figure, likely Roe's cleric Edward Perry.[31] A number of the portrait studies of Mughal courtiers can be traced to earlier works, from which they have been borrowed.

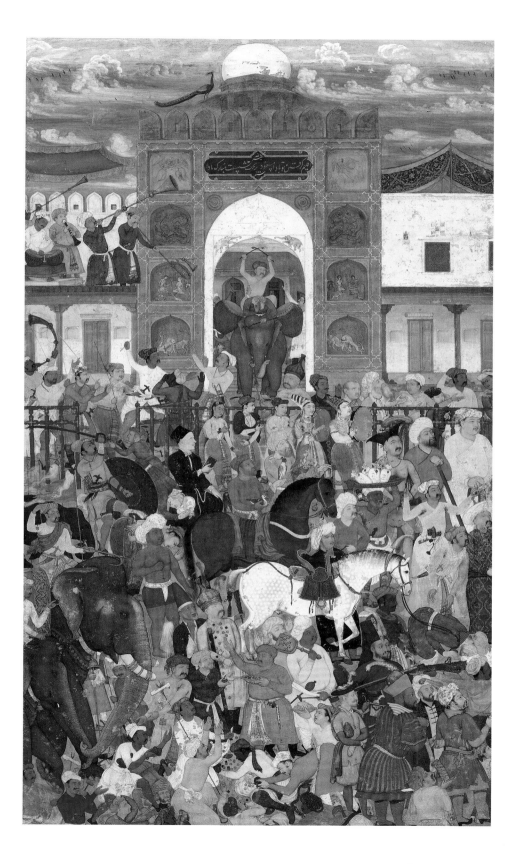

'Abid

Born in India in the 1590s, active at the
Mughal court 1604–45; son of Aqa Riza

'Abid was perhaps the greatest painter of Shah Jahan's atelier, yet one for whom no contemporary records survive, beyond one that names him as the son of Aqa Riza. The brother of Abu'l Hasan, 'Abid presumably entered the atelier of emperor Jahangir around 1615, but he is known only from signed works made during Shah Jahan's reign (r. 1628–58). He is largely invisible during the heyday of Jahangir's fulsome patronage of his imperial studio, perhaps overshadowed by his father and especially by his brother, who found special favor with the emperor. 'Abid only emerged from the shadows as a major artist with the accession of Shah Jahan.

'Abid is known principally for court, procession, and battle scenes, a number of which are preserved in the Windsor *Padshahnama*, the official history of Shah Jahan's reign. As the son of Aqa Riza, 'Abid was meticulously trained in the Safavid tradition, and he excelled in technical virtuosity and complex compositions. He favored symmetrical formations and enlivened them with intensely dramatized characterizations and complex interplay of motifs and surface textures to create dense decorative effects. His portraits of assembled noblemen, be they soldiers in the battlefield or couriers at a royal audience, are always highly individualized, radiating a strong sense of personality and of authenticity rarely seen in painting of the period. Although he is known only through a few signed works, including the masterful battle scene shown herein (No. 31), his compelling and daring approach to portraiture and figure characterization sets him apart from other painters of his generation. This master of virtuosity empathized with the aesthetics of Shah Jahan, who extolled the virtues of jewel-like perfection in all artistic matters, which were given fullest expression in his passion for jewelry and for the imperial architecture that climaxed in the Taj Mahal. Shah Jahan could not have found a master painter better suited to expressing the highly personal aesthetic of his age.

30

The Inscription of Jamshid: page from a *Bustan of Sa'di*

Mughal court at Agra. dated 1605–6
Opaque watercolor and gold on paper;
painting: 7 x 13¹¹⁄₁₆ in. (17.8 x 34.8 cm);
page: 10⁷⁄₁₆ x 6½ in. (26.5 x 16.5 cm)
Art and History Collection, Arthur M. Sackler
Gallery, Smithsonian Institution, Washington, D.C.
(LTS1995.2.190)
Published: Soudavar and Beach, *Art of the
Persian Court* (1992), no. 137a

The artist 'Abid was born into court atelier
circles; his father, Aqa Riza, was an Iranian
émigré. Undoubtedly, he learned to master
the refined Safavid style from his father; he
employed it in this work to illustrate a scene
of piety from the famed Iranian poet Sa'di's
Bustan (The Orchard). The muted palette
and unnaturalistic colors—mauve rock forma-
tions offset against a gold sky—create a rari-
fied landscape far removed from the earthy
realism fostered by Akbar and in keeping
with the new emperor Jahangir's cultivated
taste. The *Bustan of Sa'di*, a classic of Per-
sian literature, had long been a favored sub-
ject in Iranian painting and was regularly
copied and illustrated in Mughal editions by
the imperial workshops.

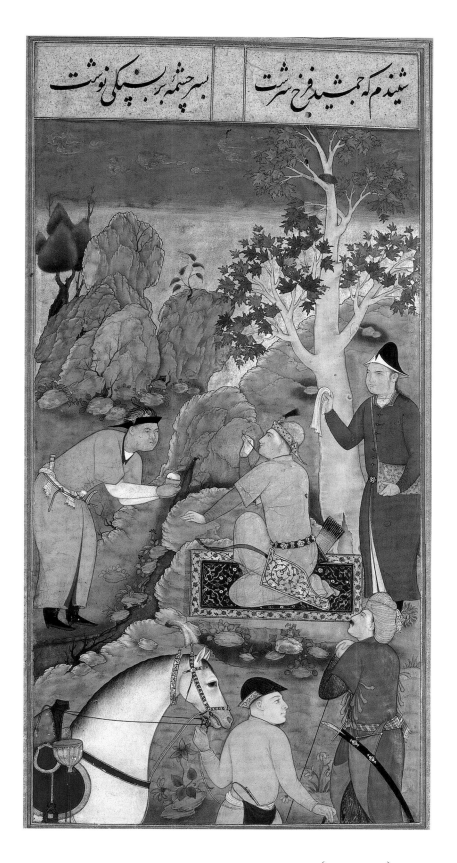

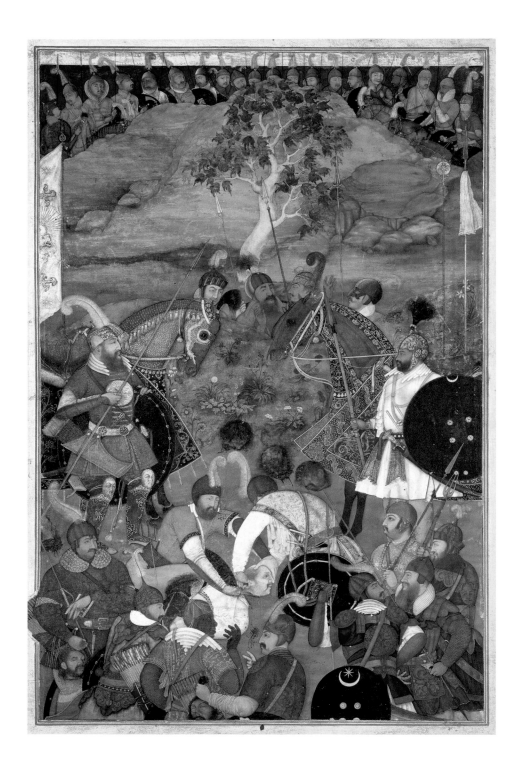

31

The death of Khan Jahan Lodi:
page from the Windsor *Padshahnama*

Mughal court at Agra, 1633

Inscribed: "work of the slave of the court Abid"

Opaque watercolor and gold on paper;

painting: 12½ x 7⅞ in. (31.8 x 20 cm)

The Royal Collection, Royal Library, Windsor

Castle (Ms. 1367, fol. 94b)

Published: Welch, *The Art of Mughal India* (1963),

fig. 4; Beach, *The New Cambridge History of*

India: Mughal and Rajput Painting (1992), pl. G;

Beach and Koch, *King of the World* (1997), no. 16

The Mughal obsession with chronicling history in the making is seen in this painting of 1633, which depicts the capture and decapitation of the rebellious nobleman (*amir*) Khan Jahan Lodi only two years earlier. In this work, we see 'Abid's sophisticated understanding of character types, which are clearly distinguished; a central figure in the composition stares directly at the viewer in an unsettlingly engaging manner. The setting is a Safavid-type landscape, vertically composed with improbable rock formations meeting a skyline lined with cavalry. The imperial presence is evoked by the centrally placed plane tree (*chunar*), a favored motif in Mughal landscape, which may be compared to the same motif in a painting by the artist's father, Aqa Riza (No. 27).

32

**Jahangir receives Prince Khurram,
Ajmer, April 1616: page from the
Windsor *Padshahnama***

Mughal court, possibly at Daulatabad, ca. 1635–36
Opaque watercolor and gold on paper;
painting: 14⅛ x 9½ in. (35.9 x 24.1 cm)
The Royal Collection, Royal Library, Windsor
Castle (Ms. 1367, fol. 192b)
Published: Beach and Koch, *King of the World*
(1997), no. 37

This *darbar* scene is a model of Shah Jahan-
period symmetry, and 'Abid its greatest expo-
nent. Within this formal ordering, he created
an intensity of human interest, which he
achieved through figures who break rank by
staring out of the picture or otherwise infuse
a human dimension to the regimented assem-
bly. The colorful ensemble of nobles outside
the railing are portraits of such compelling
individuality that they compete for our atten-
tion, dare one say, with the presence of the
emperor. This is a bold painting indeed. An
allusion to Jahangir's infatuation with alle-
gorical imagery appears in the grisaille paint-
ing of a Sufi mystic (*shaykh*) holding up to
the emperor and his son a globe, symbol of
world kingship.

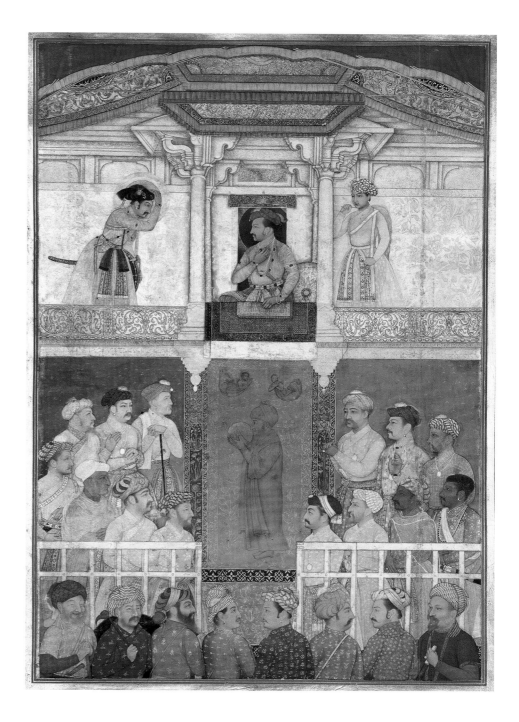

Mansur

Active at Mughal courts in Delhi and Lahore in late 1580s,
Allahabad 1600–1604, and Agra until ca. 1626

Ustad (master) Mansur received the highest accolade from emperor Jahangir, the title of *Nadir al-Asr* (the Wonder of the Age), for his ability to paint and preserve the likenesses of the animals and flowers that engaged the emperor's attention. Jahangir devoted the longest passage given to any artist in Mughal history to Mansur, stating that "in painting, he is unique in his time."[32] By studying the flora and fauna of India, Jahangir was continuing a tradition begun by his great-grandfather Babur, whose *Baburnama* has a section devoted to this subject.[33] Jahangir prided himself in being the first to direct artists to record these marvels of nature in natural history paintings. And in this, no one surpassed Mansur.

Mansur appeared as a named painter in the late Akbari period, first as one working for a senior master (notably Kanha, Miskin, and then Basawan), and later independently. He is accredited by the library scribes for his contributions to the first edition of the *Akbarnama* (1589–90), *Baburnama* (1589) and *Chinghiznama*. It is the *Baburnama* that reveals for the first time Mansur's unique gift for animal studies, for which he was quickly rewarded with the title of *Ustad* (master), presumably by Akbar himself. Mansur was also recognized for his gold illuminated and calligraphed frontispieces (*sarlawh*) and owner-title pages (*shamsa*), which were as esteemed as much as painting, if not more, in some connoisseur circles (No. 34). In one extraordinary joint work, Mansur employed his unsurpassed skills in gold work to depict the throne-dais on which Prince Salim sits imperially, in exile in Allahabad (No. 35).

Under Jahangir, whom he served first as a prince-in-exile at Allahabad, Mansur increasingly came to work on independent paintings intended to be gathered into imperial albums (*muraqqas*) rather than contribute to integrated illustrated manuscripts, Akbar's favored format. Mansur worked principally in fine line brushwork with thin washes of pigment, capturing the exotic nature of his subject, which he placed against a lightly sketched ground sparingly described with tufts of grass or wildflowers. What set Mansur apart from his contemporaries, and natural history painters in general, was his deep empathy for his subject matter, the creatures and plants of India. He routinely accompanied the emperor on his numerous travels, witnessing and recording his subjects firsthand. In spring 1620, Jahangir toured Kashmir to admire its natural beauty, and he recorded in his Memoirs, "The flowers seen in the summer pastures of Kashmir are beyond enumeration. Those drawn by the Master *Nadir al-Asr* Mansur number more than a hundred."[34] Mansur was always at hand to capture these wonders for Jahangir's curiosity and aesthetic pleasure.

33

Peafowls

Mughal court at Agra, ca. 1610

Opaque watercolor on paper, 14½ x 9⅞ in.
(36.8 x 25.1 cm)

Private Collection

Published: Beach et al., *The Grand Mogul* (1978),
no. 47; Welch, *Imperial Mughal Painting* (1978),
pl. 26; Beach, "The Mughal Painter Abu'l Hasan
and Some English Sources for his Style" (1980),
fig. 23; Welch, *India: Art and Culture* (1985),
no. 144

Mansur's ability to capture the essence of his
subject is exemplified here. A male peafowl
and hen display themselves in an unusually
descriptive landscape, which echoes and mim-
ics their deportment in a single vision of the
unity of nature. The artist deployed Timurid-
style rock formations to add to the imperial
tenor of his study of these majestic birds. The
mauve markings of the male are echoed in
the flowers in the foreground, his rich tail
plumage in the tree beyond. An attribution to
the Master (*Ustad*) Mansur seems secure.

34
Sarlawh: page from an *Akbarnama* manuscript

Mughal court at Lahore, ca. 1595–96
Inscribed: signed by Mansur
Ink, opaque watercolor, and gold on paper;
page: 13⅞ x 7¹/₁₆ in. (35.2 x 18 cm)
Staatliches Museum für Völkerkunde,
Munich (77-11-309)
Published: Bothmer, *Die islamischen Miniaturen
der Sammlung Preetorius* (1982), no. 54

Mansur, the artist responsible for the dazzlingly executed throne of Prince Salam (No. 35) also painted the jewel-like arabesques, interlaced floral designs, and Timurid-style strapwork that enrich this folio from the first edition of the *Akbarnama*. The *sarlawh* serve as decorative chapter openers, and they were given especially lavish attention in the imperial editions produced under Akbar's direction, as is witnessed by the participation of Mansur in this folio. The illumination of a closely comparable *sarlawh* belonging to a *Khamsa* of Amir Khusrow datable to the mid-1590s is also signed by Mansur (Walters Art Museum, Baltimore).

35 (opposite)
Prince Salim enthroned: page from the St. Petersburg Album (Folio 3)

Allahabad, dated by colophon 1600–1601
Inscribed: in part, "Manohar . . . drew a likeness of a king as glorious as Jamshid. Mansur's brush worked on it"
Opaque watercolor, ink, and gold on paper;
painting: 10¹¹/₁₆ x 7¹¹/₁₆ in. (27.2 x 19.5 cm);
page: 18¹¹/₁₆ x 13 in. (47.5 x 33 cm)
Russian Academy of Sciences, Institute of Oriental Studies, St. Petersburg (E-14, f.3a)
Published: Ivanova et al., *Al'bom indiuskikh i persidskikh miniatiur XVI–XVIII vv.* (1962), pl. 17; McInerney, "Manohar" (1991), fig. 11; Habsburg et al., *The Saint Petersburg Muraqqa* (1996), pl. 154 f. 3r

This remarkably imperial portrait of Akbar's rebellious son Prince Salim, painted in 1600–1601, soon after he established his alternative court at Allahabad, reveals a prince impatient for the trappings of power. It is the work of two of the greatest painters of the time, Manohar and Mansur. The young painter, Manohar, created the portrait figure of an intense and determined prince, while Mansur executed the dramatically pitched throne in complexly integrated gold and paint work. Both artists spent the next twenty years producing paintings that glorified the emperor Jahangir. Manohar celebrated the majesty and opulence of the reign, while Mansur became the emperor's personal recorder of his kingdom's natural wonders, its flora and fauna.

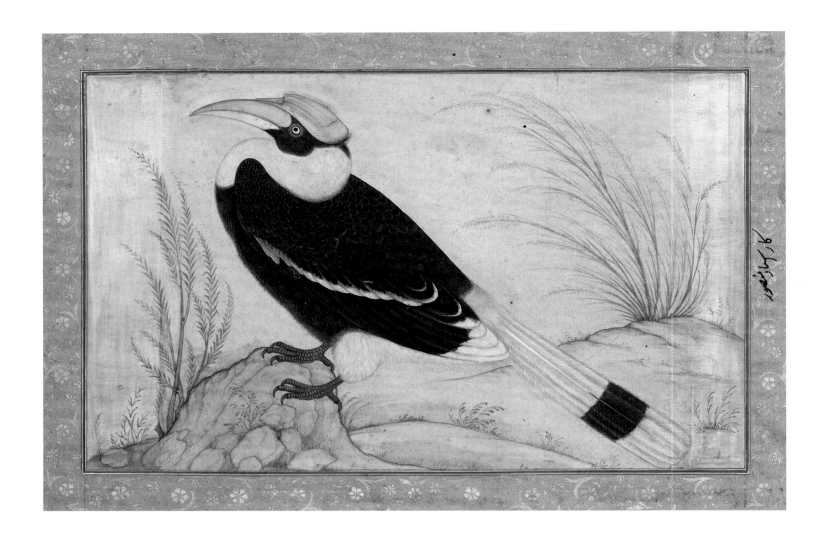

36

**Great hornbill: page from the Kevorkian
Shah Jahan Album**

Mughal court at Ajmer, ca. 1615

Inscribed: in Jahangir's hand, "Work of
Ustad Mansur"

Opaque watercolor, gold, and ink on paper;
page: 15⁵/₁₆ x 10 in. (38.9 x 25.4 cm)

The Metropolitan Museum of Art, New York,
Purchase, Rogers Fund and the Kevorkian
Foundation Gift, 1955 (55.121.10.14v)

Published: Okada, *Indian Miniatures of the Mughal
Court* (1992), fig. 254

This impeccably observed study typifies the refined dexterity that earned Mansur the imperial title *Nadir al-Asr*, Wonder of the Age. Such works, in the finest natural history tradition, were expressly commissioned by Jahangir to record his fascination with the natural world, well documented by contemporary observer's accounts and by the emperor's personal memoirs, the *Jahangirnama*. The attribution to Master Mansur in Jahangir's hand indicates that this painter's work was held in high regard. Although admired by Jahangir and Shah Jahan, who included many such works in his albums, Mansur's style has little lasting legacy. Its scientific detachment is far removed from the central Indian aesthetic concern, the expression of emotion.

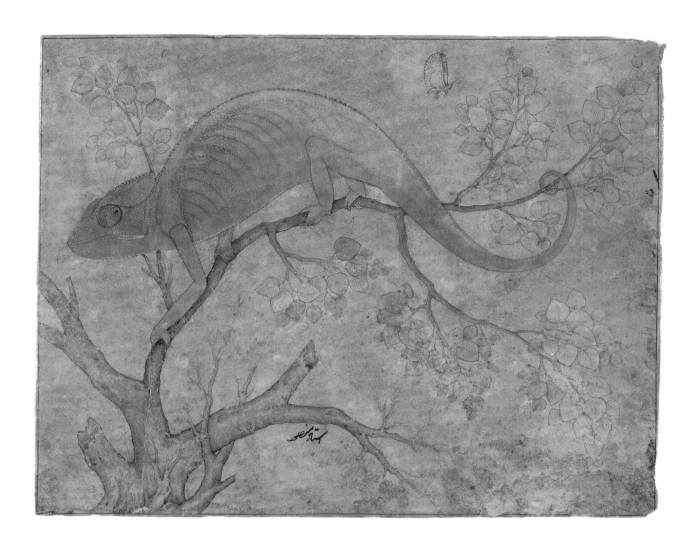

37

Chameleon

Mughal court at Lahore or Allahabad,
ca. 1595–1600
Inscribed: "Ustad Mansur"
Opaque watercolor and ink on paper;
painting: 4⁵/₁₆ x 5³/₈ in. (11 x 13.7 cm)
The Royal Collection, Royal Library,
Windsor Castle (RL 12081)
Published: Ashton, *The Art of India and Pakistan*
(1950), no. 724; Welch, *Indian Drawings and
Painted Sketches* (1976), no. 15; Welch, *India: Art
and Culture* (1985), no. 143

In this masterful and somewhat personal work in the natural world genre, Mansur deftly extended the chromatic range across creature and foliage alike, underscoring the chameleon's wonderful ability to blend with its surroundings. The monochromatic branches form a foil to the chameleon and the foliage with which it is has harmonized itself. Already in the employ of Prince Salam (the future Jahangir), Mansur no doubt intended this engaging image to capture his young patron's attention.

Balchand

Hindu artist active at the Mughal courts in Delhi, Lahore, Allahabad, and Agra, 1595–ca. 1650, brother of Payag

An Indian recruit who appears to have converted to Islam, Balchand entered the royal atelier in the last decade of Akbar's reign and had a long career spanning the reigns of three emperors. He followed Prince Salam to his court-in-exile in Allahabad in 1600 and returned with him in 1605 to Agra, where he continued to serve at court under Shah Jahan into the early 1650s. As a junior member of the inner circle of painters at court, Balchand was entrusted in 1589 with a double spread in the *Akbarnama* (Victoria and Albert Museum, London) and in 1595 with painting the figures in the border decorations of a deluxe imperial edition of the *Baharistan*, rare privileges for his age.[35] Although his work of this period does not warrant the confidence placed in him, he matured into a master painter excelling in portraiture and was entrusted with the most important commissions of his age. The grisaille-rendered figures — termed *nim qalam* (half-colored) in Persian — in the border decorations of a folio devoted to Faqir Ali's celebrated calligraphy of 1606, demonstrate Balchand's new mastery of figure studies. The marginalia of another folio in the series depict the stages of making a calligraphic album, notably paper making, burnishing, and the act of writing (compare Fig. 16).[36]

Balchand received his major imperial commissions under Shah Jahan, including a (retrospective) double-portrait of Jahangir and Akbar. As father and son are depicted in cordial and respectful attitudes, we can only assume that this was produced at Shah Jahan's instruction to "re-write history." Their relations were far from harmonious, the impatient Prince Salam having openly rebelled against his father. This and other works of the period demonstrate Balchand's gift at psychologically penetrating portraiture, a talent he displayed to its fullest in the complex *dardar* scenes that Shah Jahan increasingly demanded. This reached its highest expression in the illustrations to the *Padshahnama*, prepared for the emperor under the direction of the historian Abdu'l Hamid Lahori (No. 38). Balchand's paintings display a chromatic sophistication that enlivens and unifies his compositions.

That Balchand had some standing at court beyond that of a respected painter is indicated by the inclusion of a prominently positioned self-portrait in an imperial *dardar* scene (No. 38);[37] to do so otherwise would have been a dangerous presumption. He displayed a picture portfolio, emblematic of his trade, upon which is inscribed "the likeness of Balchand." This is an artist who was confident of his place in the court order.

Above: Self-portrait of Balchand, ca. 1635. Detail of No. 38

38

Jahangir receives Prince Khurram at Ajmer on his return from the Mewar campaign: page from the Windsor *Padshahnama*

Mughal court at Lahore or Daulatabad, ca. 1635
Inscribed: signed below throne, "slave of the court, drawn by Balchand" and inscribed on portfolio held by figure at lower left, "likeness of Balchand"
Opaque watercolor and gold on paper;
painting: 11^{15}/$_{16}$ x 7^{15}/$_{16}$ in. (30.4 x 20.1 cm);
page: 22^{15}/$_{16}$ x 14^{7}/$_{16}$ in. (58.2 x 36.7 cm)
The Royal Collection, Royal Library, Windsor
(RCIN 1005025, fol. 43b)
Published: Beach et al., *The Grand Mogul* (1978), fig. 5; Losty, *The Art of the Book in India* (1982), no. 82; Smart, "Balchand" (1991), figs. 1–2; Beach and Koch, *King of the World* (1997), no. 5

Balchand was a master of composition, giving subtle form and strength to potentially unruly and congested *darbar* scenes, creating instead compact and ordered psychological dramas. In inferior hands, these scenes would become mere regimented formality, mechanical and routine. In Balchand's, each participant has an individual presence, and the interactive dynamics among them creates an atmosphere of realism not encountered in *darbars* of lesser painters. His own portrait appears at lower left, with an artist's portfolio under his arm.

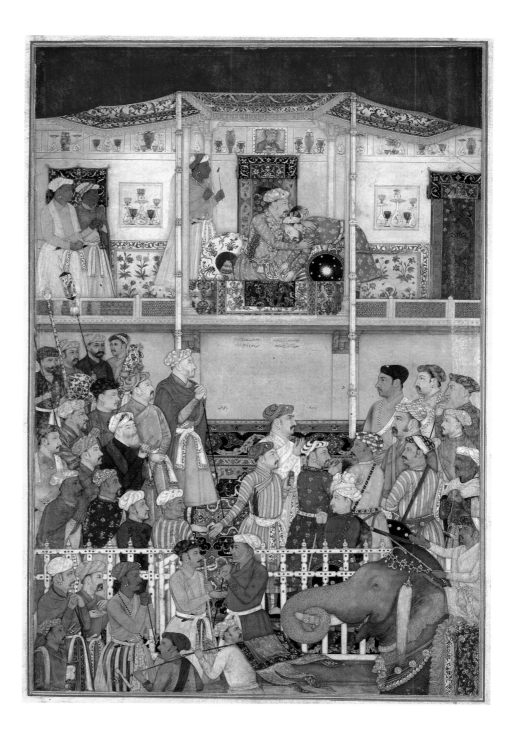

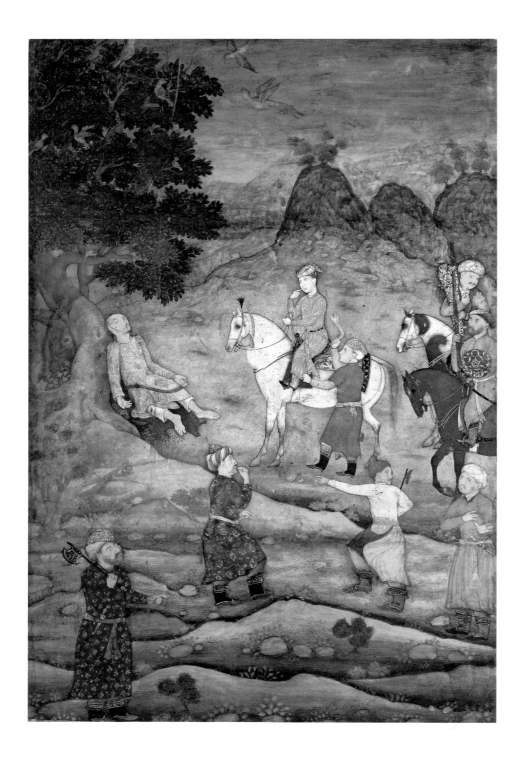

39

A youth expires when his beloved approaches and speaks to him: incomplete page from a *Gulistan of Sa'di* manuscript

Mughal court at Agra, ca. 1610–15
(additions ca. 1640)
Inscribed: beneath horse, *banda Balchand*
"the servant Balchand" and *'amal-i Balchand*
"work of Balchand"
Opaque watercolor on paper, mounted and lacquered; painting: 7⅜ x 5 in. (18.9 x 12.6 cm)
David Collection, Copenhagen (1/2009)
Published: Seyller, "Two Mughal Mirror Cases" (2010), figs. 1, 2

Balchand's skill in the portrayal of psychological drama is exemplified in this remarkable fragment, which is mounted onto a lacquered wood mirror box cover. It depicts the moment in Sa'di's *Gulistan* when a youth collapses and expires on seeing the handsome young prince, long the object of his desire, who approaches him on horseback. The prince expresses astonishment and perhaps puzzlement with his raised hand, a gesture repeated by several of his entourage. This is a beautifully observed scene of unrequited love. It is set in an atmospheric landscape in which a series of intercepting hillocks leads the viewer's eye to the center of the drama, the visual engagement of the prince and his admirer.

Payag

Hindu artist active at the Mughal courts in Delhi, Lahore,
Allahabad, and Agra, 1595–ca. 1650; brother of Balchand

Payag entered the atelier of Akbar alongside his brother Balchand, but he was slower to mature as a painter, and it appears that he did not gain recognition and senior rank as a court painter at that time. In the 1590s, he was assigned minor roles. Then he is no longer visible as an identifiable hand until the reign of Shah Jahan (r. 1628–58), when he emerged, this time as a major figure. All Payag's great works are associated with that reign. The commission from Shah Jahan of an equestrian portrait is a measure of his new standing at court; his astute powers of observation and facility in painting the minutiae of jewelry and weaponry enhance the grandeur of this imperial image (No. 40). It is one of the great imperial portraits of Shah Jahan's reign, commissioned soon after his accession. Payag introduced a shallow depth of field occupied by a stallion and its imperial rider, and he sprinkled it with beautifully observed wildflowers. Shah Jahan's white *jama*, gold sash (*patka*), and jewel-encrusted weapons are rendered impeccably. As a trusted royal portrait artist, Payag had privileged access to the inner court, where he could study closely the luxury goods he portrayed with such dazzling verisimilitude. The culture through which this highly idealized portraiture was filtered employed heightened aesthetic refinement as an expression of the imperial self.

But Payag also had other dimensions to his work, which allowed him to create poetic, almost dreamlike atmospheric landscapes. He was perhaps unique in the Mughal ateliers in exploring the pictorial possibilities of a single light source, a notion learned from European chiaroscuro techniques of scientifically determined light and shade. In *Prince Dara Shikoh hunting nilgais* (No. 42), set in the low light of an early evening hunt, a light source at upper right transforms the composition into a study in light and shadow. This technique was put to dramatic effect in one of the greatest theatrical pictures in the *Padshahnama*, Seige of the Fort of Qandahar (No. 41), in which the confusion of battle is heightened by the use of billowing clouds of smoke pierced through by the intense glow of a setting sun.[38] Little is known of Payag's work from the last decade of his career, though he is associated with the Late Shah Jahan Album.

Above: Self-portrait of Payag, ca. 1635–40. Detail from the Windsor *Padshahnama*, fol. 194v.
The Royal Collection, Royal Library, Windsor Castle

40

Shah Jahan riding a stallion: page from the Kevorkian Album

Mughal court at Agra, ca. 1628

Inscribed: in Persian, "work of Payag" in Shah Jahan's handwriting and signed by the artist, "Payag" on the tip of the bow. On reverse, calligraphy signed, "the poor sinner 'Ali the scribe"[39]

Opaque watercolor and gold on paper; painting: 11⅛ x 8³⁄₁₆ in. (28.2 x 20.8 cm); page: 15⁵⁄₁₆ x 10⅛ in. (38.9 x 25.7 cm)

The Metropolitan Museum of Art, New York, Rogers Fund and Kevorkian Foundation Gift, 1955 (55.121.10.21b)

Published: Welch et al., *The Islamic World* (1987), no. 59; Welch, "The Two Worlds of Payag" (1995), fig. 2

This is one of the great imperial portraits of Shah Jahan's reign, commissioned soon after his accession. Payag introduced a shallow depth of field occupied by a stallion and its imperial rider and sprinkled it with beautifully observed wildflowers. Shah Jahan wears a white *jama,* gold sash *(patka),* and jewel encrusted weapons, impeccably rendered. A radiant gold nimbus frames his portrait in profile, adding to the opulence of this representation of imperial power. This is idealized portraiture, filtered through a culture in which heightened aesthetic refinement was an expression of the imperial self.

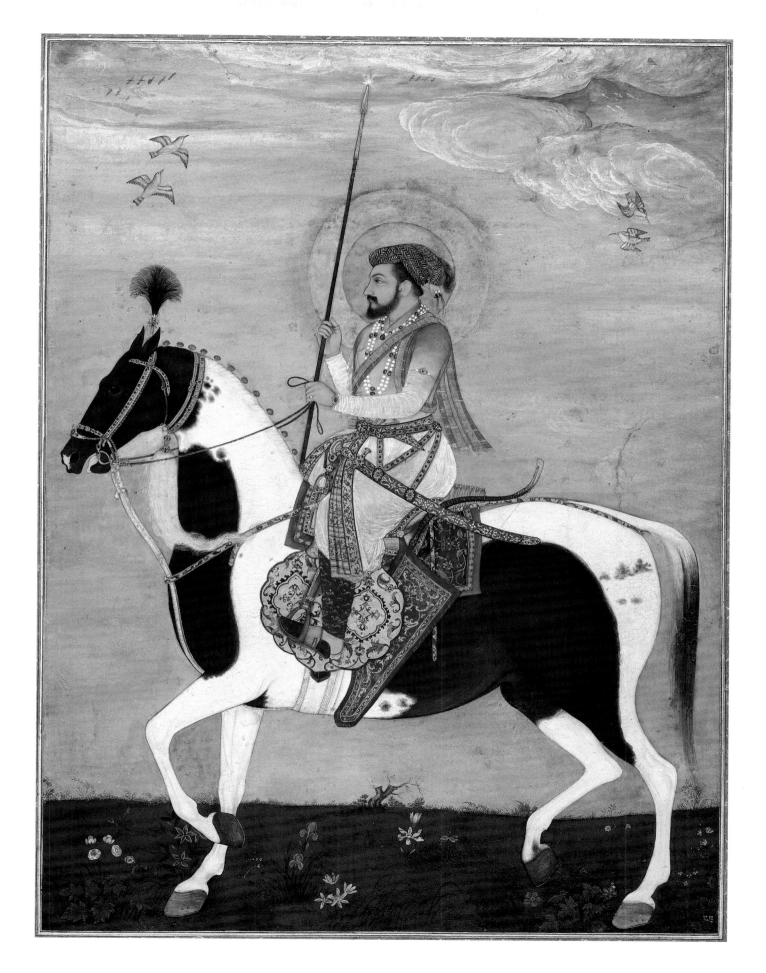

41

Nasiri Khan directing the siege of the fort of Qandahar, May 1631: page from the Windsor *Padshahnama*

Mughal court at Agra, ca. 1633
Inscribed: lower right on shield, "drawn by Payag"
Opaque watercolor, ink, and gold on paper;
painting: 12⅝ x 9 in. (32.1 x 22.9 cm);
page: 22¹⁵⁄₁₆ x 14⁷⁄₁₆ in. (58.2 x 36.7 cm)
The Royal Collection, Royal Library, Windsor
Castle (RCIN 1005025)
Published: Dye, "Payag" (1991), fig. 8; Welch,
"The Two Worlds of Payag" (1995), fig. 7; Beach
and Koch, *King of the World* (1997), no. 18

Payag's versatility is seen in this disturbing evocation of the horrors of war, in which mines are used to breach the fort defenses of Qandahar, near Hyderabad. Their explosive force sends billowing smoke littered with corpses into the sky. Like most artists in the employ of the Mughal ateliers, Payag probably held a commission in the imperial army. Certainly, his intimate knowledge of the machinery of Mughal warfare seen here was based on direct experience; Mughal painters were routinely sent to document campaigns, somewhat akin to modern-day war artists. The painting is startling for its European inspired theatrical use of the natural light source, which ricochets across the landscape like shrapnel. This is both a heroic and a humane image of warfare.

42

Prince Dara Shikoh hunting nilgais

Mughal court, probably at Lahore, ca. 1635
Opaque watercolor on paper, 6³/₁₆ x 8¹¹/₁₆ in.
(15.8 x 22.1 cm)
Arthur M. Sackler Gallery, Smithsonian Institution,
Washington, D.C. (S1993.42a)
Published: Koch, *Dara-Shikoh Shooting Nilgais*
(1998)

Prince Dara Shikoh (1615–1659), the eldest
and favorite son of the emperor Shah Jahan
(r. 1628–58), is seen stalking deer in a lightly
wooded landscape. Unusually informal in
its representation, this depiction nonetheless
belongs to a long Mughal tradition that cele-
brates the royal hunt in art. The hunt was seen
as a royal privilege, indeed the lion or tiger
hunt as a royal prerogative. Francois Bernier,
who in his *Travels in the Mogul Empire, 1656–
1668* gave firsthand accounts of Mughal court
life under Shah Jahan, recounted that a royal
hunt was seen as an auspicious omen for a
successful military campaign, and territorial
campaigns often were conducted under the
guise of a royal hunt.[40] Set in the glow of the
early evening, this composition becomes a
study in light and shadow. Figures of the
royal hunters emerge from the shadowy foli-
age, and decoy animals with crouching atten-
dants reveal the strategy of this drive hunt in
which the prey is lured toward the concealed
marksman, Prince Dara Shikoh, who waits
poised with his matchlock and tripod. A nearly
identical treatment of this subject, depicting
Jahangir, appears in the marginalia of the
Gulshan Album (fol. 41) in Tehran, painted by
Daulat, establishing the origin of this theme
that was eagerly taken up by later Rajput
painters.[41]

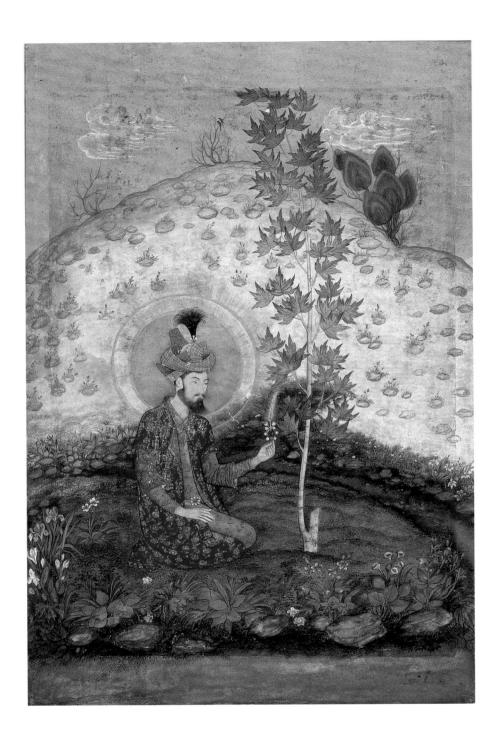

43

Humayun seated in a landscape, admiring a turban ornament: page from the Late Shah Jahan Album

Mughal court at Delhi, ca. 1650

Inscribed: on the base of the tree, "work of Payag"

Opaque watercolor and gold on paper;
painting: 7³⁄₈ x 4³⁄₄ in. (18.7 x 12.1 cm);
page: 17¹⁄₂ x 13 in. (44.5 x 33 cm)

Arthur M. Sackler Gallery, Smithsonian Institution, Washington, D.C. (S86.0400)

Published: Martin, *The Miniature Painting and Painters of Persia, India and Turkey* (1912), vol. 2, pl. 221; Leeuwen-Waller and Gallois, *Catalogus: Tentoonstelling van islamische Kunst* (1927), no. 33, Lowry with Nemazee, *A Jeweler's Eye* (1988), no. 52

In this idealized re-creation, Shah Jahan's great-great-grandfather Humayun is depicted in an imaginary landscape, admiring a turban ornament (*sarpesh*) set with pearls and jewels. He is seated on a flowering hillock by a *chunar* tree, a symbol of the imperial presence. Humayun is portrayed as the embodiment of connoisseurship, to which Shah Jahan saw himself as the natural heir. Although it is a romanticized image of Humayun, who in reality led a troubled and unsettled life, this painting is most immediately a reflection of Shah Jahan's passion for jewelry, and it served as a statement about power and wealth and as an affirmation of the imperial lineage.

Masters of the Chunar *Ragamala*

The artists Shaykh Husayn, Shaykh Ali, and Shaykh Hatim, trained in Akbar's imperial workshop under Mir Sayyid 'Ali and 'Abd al-Samad, active at the court in Chunar, near Varanasi, ca. 1591, and then in Bundi and Kota, Rajasthan

The joint work of these three named artists—their hands cannot be reliably distinguished—is preserved in one remarkable illustrated manuscript, the so-called Chunar *Ragamala*. Thanks to the pioneering research about this manuscript by Robert Skeleton and Milo Beach, we can now understand much more fully the process of stylistic dissemination and diffusion in Mughal India.[42] The production of this work bears witness to the complex, indeed convoluted manner in which the movement of styles, here at the instigation of a single patron, triggered totally unexpected innovations in Rajasthani paintings at the close of the sixteenth century. In summary, following the Mughal conquest of Bundi by Akbar in February 1569 and the surrender of the Rajput ruler Rao Surjan Singh (r. 1544–85), the royal household of Bundi was pardoned, and Surjan Singh distinguished himself henceforth as a loyal servant of Akbar. He was rewarded in 1575–76 with the governorship of Chunar and Kashi (near Varanasi, in Uttar Pradesh), which "he beautified and ornamented," building numerous facilities "for public benefit," including twenty public baths.[43] He died at Kashi, and his successor Bhoj Singh (r. 1585–1607) retained their territories until 1591, when emperor Akbar rescinded his governorship and ordered the family to return to their ancestral lands in Bundi.[44] Bhoj Singh rarely had been in residence, campaigning with the imperial army, and Chunar was left in the care of his son Ratan Singh. It was in all likelihood he who commissioned the Chunar *Ragamala*, recruiting artists trained in the Mughal court, then located at Fatehpur Sikri (capital 1569–84) or Agra. The eminent master-painter Mir Sayyid 'Ali and Abd al-Samad are named among the trio's teachers.

The Chunar manuscript is among the first attempts to show a Hindu theme, the musical modes expressing emotional states (*ragamalas*), through Mughal conventions and a vertical codex (Islamic) format. Its closest parallels are in the Chester Beatty *Tutinama* of around 1580 (Dublin).[45] A lengthy inscription on the last page of the set, the *Kedara Ragini*, declares, "The book Ragamala has been prepared [presented] on Wednesday at noon in the locality of Chunar. The work of the pupils of Mir Sayyid Ali Nadirulumulk Humayunshahi and Khwaja Abdul-Samad Shirin-Qalam the slaves Shaykh Husayn and Shaykh Ali and Shakyh Hatim son of Shaykh Phul Chisthi. Written on the 29th of Rabi' II of the year 999 [February 24, 1591]."[46] This is the only reference surviving that affirms the identity of these artists. That they accompanied Ratan Singh when he was ordered to return to Bundi in 1591 seems clear from the radical transformation that court painting at Bundi underwent in the following decades, including an ambitious mural painting program in the palace. The attributions thereafter are based on internal evidence, that is, stylistic traits and iconographic solutions in the paintings of Bundi themselves.

44

Malkausik Raga: page from the Chunar *Ragamala*

Chunar, Uttar Pradesh, dated 1591
Inscribed: "The book Ragamala has been pre-
pared [presented] on Wednesday at noon in the
locality of Chunar. The work of the pupils of Mir
Sayyid Ali Nadirulumulk Humayunshahi and
Khwaja Abdul-Samad Shirin-Qalam the slaves
Shaykh Husayn and Shaykh Ali and Shakyh Hatim
son of Shaykh Phul Chisthi. Written on the 29th
of Rabi' II of the year 999 [February 24, 1591]"
Opaque watercolor and gold on paper,
10⅜ x 6⁵⁄₁₆ in. (26.4 x 16 cm)
Private Collection, New York
Published: Cummins, *Indian Painting from Cave
Temples to the Colonial Period* (2006), p. 154

It is probable that the mustached male
depicted in this and other paintings in this set
is the patron, most likely Ratan Singh. This is
an altogether surprising painting, presenting
a primarily Sanskritic-Hindu *Ragamala* theme
in the guise of a subimperial Mughal style,
set in an Islamic codex format. The palace
settings are given dramatic perspectival treat-
ment seen at this time only in Mughal prod-
ucts. It is likely that the three Muslim painters
named as responsible for this set of paintings
were trained at the imperial Mughal atelier at
Fatehpur Sikri or Agra. Surface decoration is
intensely detailed, again a Safavid-Mughal
convention not to be found in Hindu painting
of the time.

Nasiruddin

Active at the exiled court of the Mewar rulers Rana Pratap Singh (r. 1572–97) and Rana Amar Singh (r. 1597–1620), in Chawand, Mewar, between 1585 and 1609, and presumed to have returned to Udaipur thereafter

This Muslim painter is known only from this *Ragamala* manuscript, dated April 10, 1605, and linked by its colophon to the southern Mewar outpost township of Chawand.[47] The artist is named. No documentation is provided regarding the patron, but likely it was the ruler Rana Amar Singh or one from among his small court in exile. Chawand Fort served as the last retreat for Rajputs still in defiance of Mughal suzerainty. It collapsed to Mughal forces in 1609, and Amir Singh finally submitted to Prince Khurram (the future Shah Jahan) in 1615 at Gogunda, an event recorded in the *Jahangirnama* and illustrated by the imperial artist Nanha in 1618.[48]

The painter Nasiruddin was not an innovator; rather, he was working in a style already familiar in the early Rajput tradition, as is witnessed by a series of works dated some fifty years earlier, the most pertinent of which are the *Caurapancasika* series, the Bhairavi *ragini*, and the *Vasanta Vilasa* (Festival of Spring) dated 1451. The central concern of all these works is love in its various guises. The *Vasanta Vilasa* is the most explicit in its description and depiction of lovers in springtime, but all these works are concerned with the emotions of lovers. The iconography of ornament as well as the sentiment evoked are expressly designed to enhance the erotic mood of *sringara rasa*. The Chawand *Ragamala* shares these romantic concerns, seen here in the image of a woman awaiting her lover in one folio and serving him *pan* in another.

Unlike the *Caurapancasika* and other early Rajput works, the Chawand *Ragamala* has broken from the horizontal layout, which derives from the *pothi* tradition, to assume a vertical format inspired by the Islamic codex book. This series also introduces new pictorial devices learned in the previous thirty years from artists who had served in the imperial Mughal atelier. Large numbers of Indian artists (*chitaras*), Hindu and Muslim alike, had been gathered to Akbar's workshop by 'Abd al-Samad to complete the monumental *Hamzanama*, and upon its completion around 1572, most were released. They scattered to the courts of Rajasthan and Malwa as well as the Muslim courts of the Deccan; some must have secured employment at Udaipur, where Nasiruddin would have learned his skills and developed his distinctive style. His Chawand *Ragamala* is a uniquely dated and provenanced series, representing a landmark in the development of Rajput painting. It is distinguished by its vibrant palette and intense emotional sensibility. Through the innovations of Nasiruddin's successor, Sahibdin, this work led directly to the mature Rajput court style that came to dominate Hindu court painting in both the plains and the hills.

45

Malashri Ragini: page from the Chawand _Ragamala_ series

Chawand, Mewar, Rajasthan, dated 1605
Inscribed: painted by Nasiruddin at Chawand
in 1605
Opaque watercolor on paper;
painting: 6¾ x 6¾ in. (17.1 x 17.1 cm);
page: 8⅜ x 7½ in. (21.3 x 19.1 cm)
Los Angeles County Museum of Art, From the
Nasli and Alice Heeramaneck Collection,
Museum Associates Purchase (M.77.19.16)

Published: Rosenfield, _The Arts of India and Nepal_
(1966), no. 147

This _ragamala_ scene depicts a noblewoman
waiting for her lover; the bedchamber is pre-
pared with two tasseled pillows and container
sets for _pan_ and other stimulants. She holds
a lotus in full bloom, savoring its fragrance.
The mood is one of distress at her lover's
absence, mingled with sweet memories and
longing anticipation. Nasiruddin has learned

well the lessons of Mughal-trained artists in
creating pictorial space through architectural
rendering. Trees before and beyond the com-
pound wall suggest a spatial dimension, as
does the vista into the bedchamber's interior.
The cloud-tipped skyline recalls the early
Rajput convention of suggesting space as a
series of vertically arranged registers, not
penetrating the picture plane.

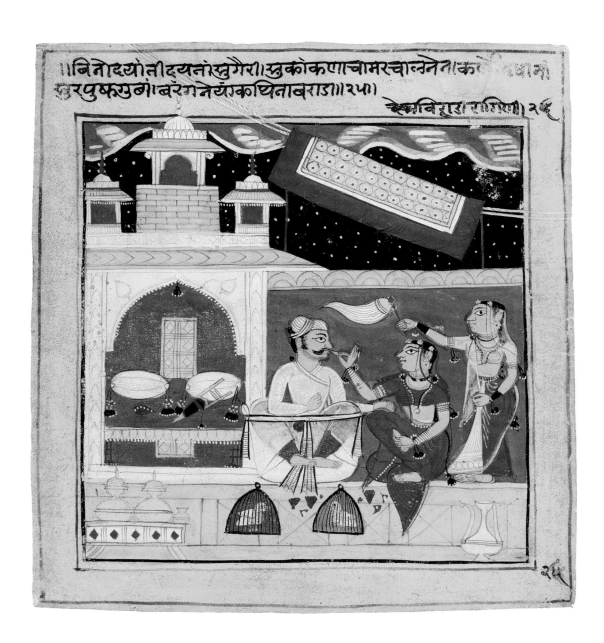

46

Varati Ragini: folio from the Chawand *Ragamala* series

Chawand, Mewar, Rajasthan, dated 1605
Inscribed: painted by Nasiruddin at Chawand in 1605
Opaque watercolor and ink on paper;
page: 8¹⁄₁₆ x 7½ in. (20.5 x 19 cm)
Museum Rietberg, Zurich, Gift of Martin and Sylvia Escher (RVI 1786)

In this folio, the lover has arrived and is being treated to *pan* by his mistress. Two caged birds evoke the mood of lovers kept apart. A female attendant fans the couple on what must be a warm starlit night. The mustached lover, who closely resembles the enthroned ruler in another work from the series, sits supported by a meditation strap (*yogapatta*); he has placed his punch-dagger in the bed-chamber, an indication of their intimacy. The figures preserve early Rajput conventions—the torso seen frontally with head in full profile and displaying a large deer-like eye that enhances the intensity of the gazes exchanged by the lovers. This physiognomy is a feature shared throughout the early Rajput group and is a significant part of its appeal.

Sahibdin

Active at Udaipur, Mewar, Rajasthan, ca. 1628–55

The artist Sahibdin (Shihab ud-Din) is known only through the inscriptions on his paintings. These are sporadic but nonetheless mark out his long career, from a *Ragamala* of 1628 (No. 48) to a *Sukaraksetra Mahatmya* of 1655, his last known work.[49] His catalogue of ascribed works corresponds closely to the reign of the Mewar ruler Maharana Jagat Singh I (r. 1628–52) at Udaipur. Sahibdin appears as the heir to the style of Nasiruddin, and he may have been related.[50] He certainly absorbed the rich palette and emotional intensity of his predecessor, along with the early Rajput approach to spatial rendering. Parallels can be drawn with the three artists responsible for the 1591 Chunar *Ragamala*, who achieved more complex solutions to similar pictorial problems. They are presumed to have settled in Rajasthan with the return of their patron from service in Chunar (near Varanasi) to his native Bundi, and they typify the subimperial Mughal-trained painters circulating in the courts of Rajasthan in the early seventeenth century. That Sahibdin was exposed early to the subimperial Mughal style, probably at Udaipur palace, is witnessed in a new naturalism he brought to his portraiture and a Mughalesque attention to descriptive detail, as seen in the accurate rendering of the prince's white *jama* in No. 47.

Sahibdin came to prominence with a *ragamala* series commissioned in 1628 by the newly enthroned Maharana Jagat Singh I. This series shows an early maturity in which the painter has assured command of his compositions, bold palette and intense emotive moods. In *Malavi Ragini* (No. 47), all the pictorial components — paired pots, erect cyprus trees, and exuberantly flowering foliage — enhance the message of this scene depicting the prince and his lover, arms entwined as they enter the bed chamber. The roof profile of white cupola flanked by twin pavilions echoes the newly extended palace architecture of Udaipur and of the lake pavilion, Jagmandir, built by Karan Singh (r. 1620–28).

Sahibdin appears to have dominated the Mewar atelier for the next thirty years, producing a series of secular works on themes of love such as the *ragamalas* and the *Rasikapriya* (ca. 1630) and religious works that explore similar themes, notably the *Gita Govinda* (1629, 1635). In the latter, he created lush forested settings for Krishna's amorous sports that are rich in leaf and flower detail, unprecedented in the Rajput school. For this, he looked to the literary descriptions in Jayadeva's text of the *Gita Govinda* itself, armed now with new rendering skills absorbed from subimperial Mughal models. In the 1640s, Sahibdin began producing Hindu devotional works, illustrations of the Hindu epics and Puranas, for his royal patrons. For these, he assumed a landscape format, as if in deference to their Indic ancestry.

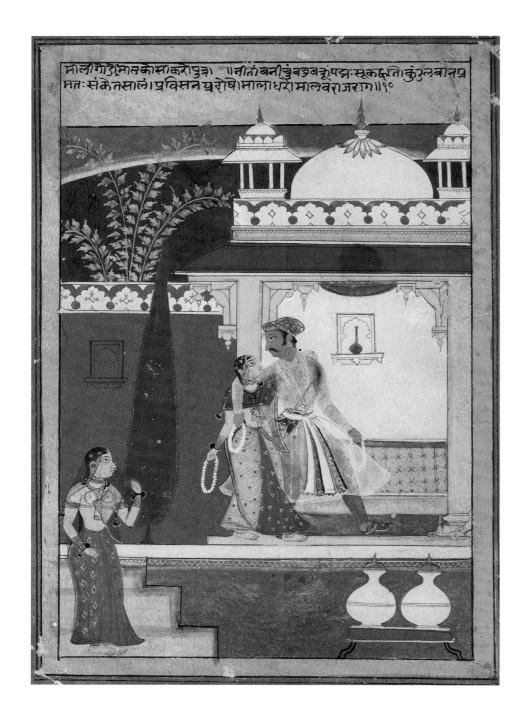

मालीगौडीमालकोसकरोपुत्र ॥नीलोबनीकुंबउबकृपद्यसूकद्धतिकुंठलबानम्
मतःसंकेतसालंप्रविसनधुरोषोमालाधरोमालवराजराग ॥१०

47

Malavi Ragini: folio from a *Ragamala* series

Udaipur, Mewar, Rajasthan, dated 1628
Inscribed: series "1628. Written [painted] at
Udaipur by the painter Sahibdin in the reign of
Rana Jagat Singh"
Opaque watercolor and ink on paper;
page: 9¹³/₁₆ x 7 in. (25 x 17.8 cm)
Private Collection, New York
Published: Goswamy, *Painted Visions* (1999),
fig. 104; Topsfield, *Court Painting at Udaipur*
(2002), fig. 31

The *Malavi Ragini* is evoked in a verse by the poet Narada: "The fair-hipped one has kissed his lotus-face. His brightness is as the parrot's. . . . At eventide, intoxicated, he enters the house of the tryst with a garland in his hand. (He is) the Malava Raga King."[51] The prince and his lover, arms entwined and carrying garlands of scented white flowers, approach the bedchamber. The setting, including a pair of pots and vigorous sprays of foliage, deftly echoes the mood of eroticism. Color is also employed to emotive effect; flat areas of intense red, blue, and white create the picture's energy, and human gesture generates the animation. In this series, the young Sahibdin redefined the Rajput style of the later sixteenth century that he inherited and set in place a new direction for seventeenth-century Rajasthani painting.

Hada Master and the Kota School

Presumably trained in Bundi, Rajasthan, and active in Kota soon after 1631 until the 1660s

In 1631, the Mughal government permitted the subregion of Kota to secede from Bundi and become an independent state. Some artists in the Bundi atelier appear to have taken the opportunity for advancement offered by a new ruler seeking to establish his cultural credentials and moved to Kota. Both Rao Madho Singh (r. 1631–48) and his successor Rao Jagat Singh (No. 48) were enthusiastic patrons and actively recruited painters from Bundi. As the Bundi atelier was strongly influenced by the Chunar *Ragamala* artists who appear to have had imperial or subimperial Mughal training, so elements of the courtly style were introduced to Bundi and thence disseminated to other court workshops in the Rajasthan region. Kota absorbed and developed the stylistic traits of the Bundi school most directly.

A leading hand at the new Kota school has been named, by Milo Beach, as the Hada Master, distinguished by figure types and characteristically robust elephants.[52] Through his highly original work, in which complex landscape compositions were populated by hunters and hunted, the Hada Master appears to have created a lasting vogue for dramatic hunting scenes (Nos. 67, 68) and exciting elephant fights (No. 49). All are distinguished by their theatricality, drama, and emphasis on action. Tiger hunts and raging elephants, locked in combat or running amok, were favorite subjects. Such themes became the hallmark of the Kota school thereafter, persisting into the nineteenth century.

Ragamalas also became an established topic in Rajasthani painting in Kota, as is witnessed by several sets of paintings, which, in their formulaic diagonal architectural recessions into space, perpetuate the Mughal style that migrated to Rajasthan courtesy of the Chunar *Ragamala* artists. A singular masterwork of the Hada Master is the portrait of his patron Rao Jagat Singh relaxing with female attendants in a lush water garden (No. 48). The combination of an aerial view of the garden's grid plan and the setting of figures and flowers in profile within it sets up a pictorial ambiguity that enlivens the composition. This painting belongs to the last decade of the Hada Master's known career.

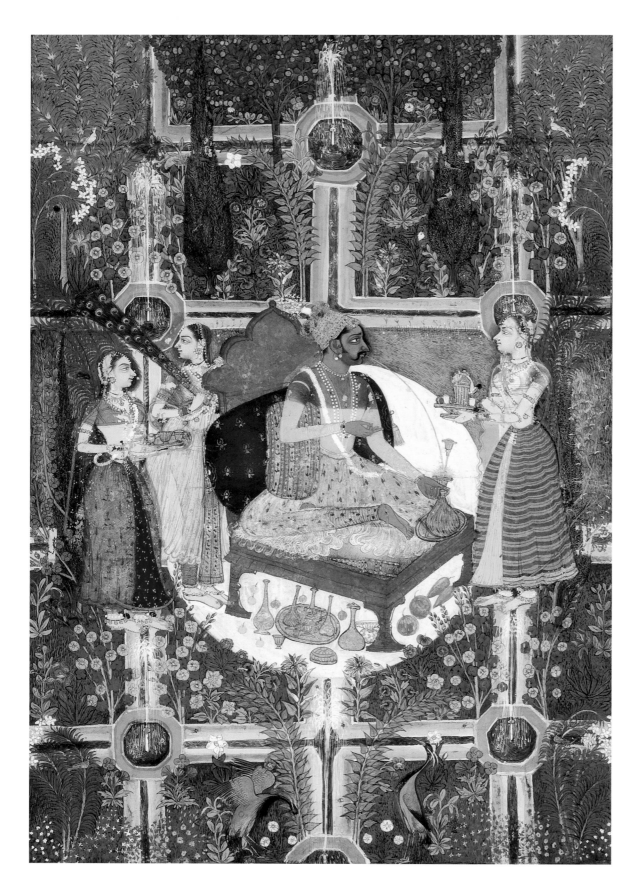

48

Rao Jagat Singh of Kota
at ease in a garden

Kota, Rajasthan, ca. 1660
Opaque watercolor and ink on paper;
painting: 10⅝ x 6¹⁵⁄₁₆ in. (27 x 17.7 cm)
Private Collection
Published: Welch, *Return to Kota* (1983), figs. 5, 6; Beach, *Mughal and Rajput Painting* (1992), fig. 124; Welch, *Rajasthani Miniatures: The Welch Collection* (1997), fig. 4; Kossak, *Indian Court Paiting* (1997), no. 29

The second ruler of the newly independent kingdom of Kota, Rao Jagat Singh, is enjoying sensory pleasures in a garden with watercourses and fountains. The artist used an ingenious pictorial device, a white circular "summer carpet," upon which the Rao's throne and condiments are arrayed. The exuberance of the garden's flowers and fountains is suggestively erotic, an undercurrent made more explicit by the placement of pairs of mango and other fruit beneath the throne and also by the pair of cranes enjoying a fountain. This is a picture full of sensual anticipation. As the early rulers of Kota spent much of their lives serving the emperor on campaign in the Deccan, such painting must have been a pleasant diversion from the harsher realties of military life. The dense palette and surface richness suggest links with the Golconda school, from which Rajput ateliers also may have recruited.

49

An Elephant combat

Bundi, Rajasthan, ca. 1610–20
Opaque watercolor and ink on paper;
painting: 10¼ x 12⅜ in. (26 x 31.4 cm)
Philadelphia Museum of Art, Alvin O. Bellak Collection, 2004 (2004-146-61)
Published: Desai et al., *Life at Court* (1985), no. 44; Mason et al., *Intimate Worlds* (2001), no. 65

This dramatic elephant fight epitomizes the Hada Master style, in which the action is so intense that it threatens to burst from the page. The two elephants are locked in frenzied battle; a mahout leaps for his life, and footmen with long shafted lances goad the combatants into action and scurry for safety. The French traveler and gem trader François Bernier witnessed such an event in 1663, describing the mud wall erected to separate the animals, seen here being scaled by the more aggressive elephant, who "attacks his opponent and putting him to flight, pursues and fastens on him with such obstinacy that the animals can be separated only by means of *cherkys* or fireworks, which are made to explode between them."[53] The footman at lower left appears to be doing precisely as Bernier described. The vitality and immediacy of this drawing strongly suggest that it was drawn from life, the artist perhaps sharing the high (and safe) vantage point enjoyed by the Rao for viewing this dangerous sport.

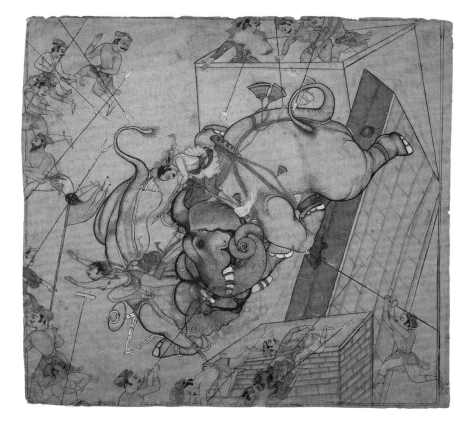

Early Master at the Court of Mandi

Active at the court in Mandi in the reigns of Raja Hari Sen and Raja Suraj Sen,
Himachal Pradesh, ca. 1635–60

A distinctive corpus of Rajput-court works in a seventeenth-century Mughalesque style recently has been linked securely to the court in Mandi in the hill region of Himachal Pradesh in the second quarter of the century.[54] This attribution of works under the nomenclature Early Master at the Court of Mandi provides firmer grounding for understanding the dynamics of the relationship between the seventeenth-century Rajput and Mughal art. It should not be surprising that art production closely mirrored political relationships; the Hindu Rajput courts, both on the plains and in the hill regions, increasingly came under the influence of Mughal court culture as they were progressively absorbed into the Mughal political sphere. That Raja Hari Sen of Mandi (r. 1604?–37) had his portrait painted in the Mughal manner of the Jahangir school is a clear attempt of a provincial ruler to emulate the metropolitan court culture of the day.[55] The Takri script inscription names Mandi as its source. Access to Mughal court painting was made possible by allegiance-affirming visits of such rulers to the imperial capital, often accompanied by their elder son and heir, and also by periodic tours of the emperor. According to Jahangir's own memoirs, the *Jahangirnama*, he conducted state visits to the hill states in 1622, 1623, and 1624, during which local rulers were received at his encampment.[56] Eminent court painters such as Mansur, who was famed for his flower and animal studies (Nos. 36, 37), routinely accompanied the emperor on such state tours.

Beginning under Raja Hari Sen and greatly stimulated under the reign of his son Suraj Sen (r. 1637–64), the Early Master of Mandi cultivated a new hybrid style that served the social and political needs of his patrons. It deftly merged Mughal elements into an essentially Rajput style. From the Mughal tradition, he borrowed linear perspective, attention to fine detailing, and a subdued palette, with subtle pastel coloring replacing the assertive colors of Hindu painting. The Early Master is identified most readily by his use of a lime-green ground, his signature color, directly emulating imperial portraits of the period.

Subject matter reflected the pluralistic needs of the patrons. The portrayal of the raja in the Mughal mode, often complete with falcon, is a status marker of Mughal portraiture; Hindu divinities depicted in Rajput-style palace interiors (No. 52), and contemporary townscapes provided the settings for scenes from the epic literature (No. 51). The Early Master produced sophisticated and skilled paintings that reflect well the political needs and social aspirations of his patrons. With their passing, painting at the court of Mandi largely reverted to the prevailing Hindu style, exemplified by the work of the master painters responsible for the Devi (No. 56) and *Rasamanjari* series (No. 55).

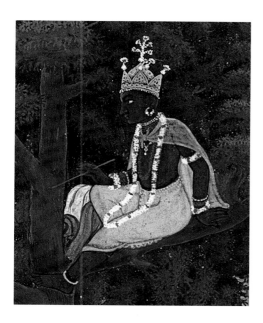

50

The *gopis* pleading with Krishna to return their clothes: folio from a *Bhagavata Purana* series

Mandi, Himachal Pradesh, ca. 1635–50
Opaque watercolor on paper;
painting: 11¾ x 7¾ in. (29.8 x 19.7 cm);
page: 13¾ x 9¼ in. (34.9 x 23.5 cm)
The Kronos Collections
Published: Kramrisch, *Painted Delight* (1986), no. 113

The Early Master at the Court of Mandi's characteristic subtle palette, lime-green ground, and perspectival rendering of a tree platform and intercepting hillock with herdsmen are fully at play in this masterful painting. This subject, so beloved of Hindu painters, is rendered in a unique vision that brings this favored scene from the epic literature into a post-Mughal Rajput style. The aesthetic flavor is new, the creation of a singular artist working at the interface of Rajput hill and imperial Mughal court cultures.

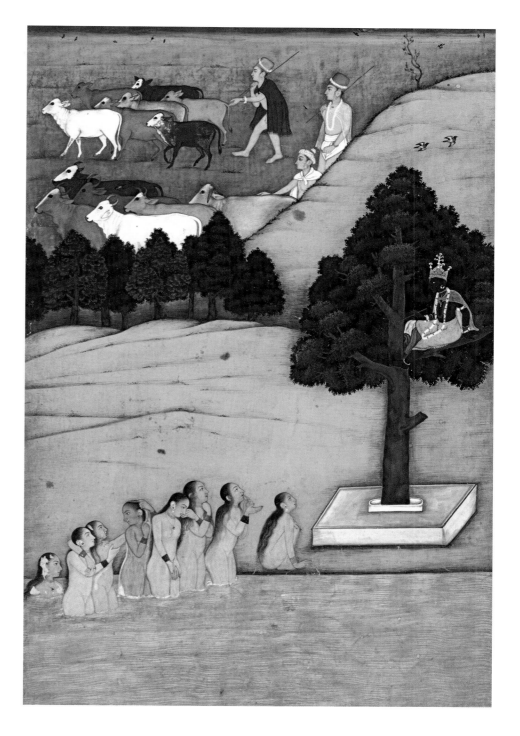

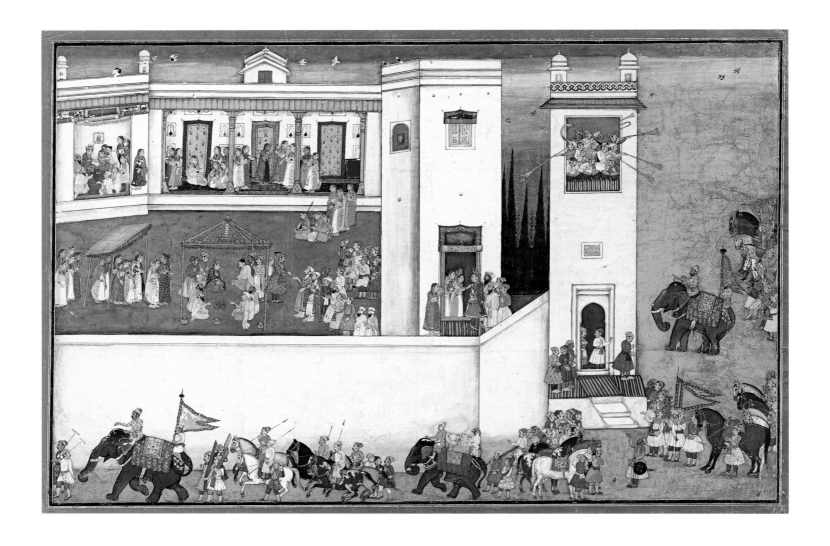

51

**Wedding ceremony of Rama and Sita:
folio from *a Ramayana* series**

Mandi, Himachal Pradesh, ca. 1635–50
Opaque watercolor and ink on paper;
page: 13¼ x 19½ in. (33.7 x 49.5 cm)
Catherine and Ralph Benkaim Collection
Published: Glynn, "Early Painting in Mandi"
(1983), fig. 15

This is the concluding scene of three known
works that narrate the marriage of Rama and
Sita. The groom appears in the sequence of
views that build the narrative, from his arrival
at the palace gates, celebrated by trumpeters
in the watchtower, to being seated beneath a
temporary *mandapa* (pavilion) in the court-
yard, awaiting his bride. Daring perspectival
rendering of the palace architecture creates
internal and external spaces in which the
events are staged. The artist's signature
ground color, lime green, provides a foil for
the wedding party and entourage, rising to a
high skyline of deepening blue, marked by
birds in flight. It is a skillful exercise in con-
tinuous narrative painting.

52

Krishna celebrates the festival of Holi at Ayutthaya: folio from a *Bhagavata Purana* series

Mandi, Himachal Pradesh, ca. 1635–50
Opaque watercolor and gold on paper,
14 x 9⁹⁄₁₆ in. (35.6 x 24.3 cm)
Private Collection
Published: Christie's London, October 3, 1990,
lot 80; Beach and Koch, *King of the World* (1997),
fig. 24

This lavish painting employs the pictorial language of an imperial Mughal *darbar* (royal audience) scene to depict Krishna (*née* Rama) being honored at the court of Ayutthaya. The women of the court and female entertainers are arrayed in a circle, thus evoking the *Krishnalila-rasalila* (Dance of Divine Love), in which Krishna dances with each and all of the *gopis* simultaneously, rewarding them for their devotion (*bhakti*). The setting is the courtyard of Mandi palace, as seen in the *Wedding ceremony of Rama and Sita* (No. 51). White marble fluted pillars shimmer against the gold-drenched interior, further enlivened with rolled multicolored textile blinds and backdrops. The octagonal golden throne evokes imperial imagery, and precious objects—west Asian glass bottles and Chinese porcelain perhaps—fill the display niches in the Mughal manner.

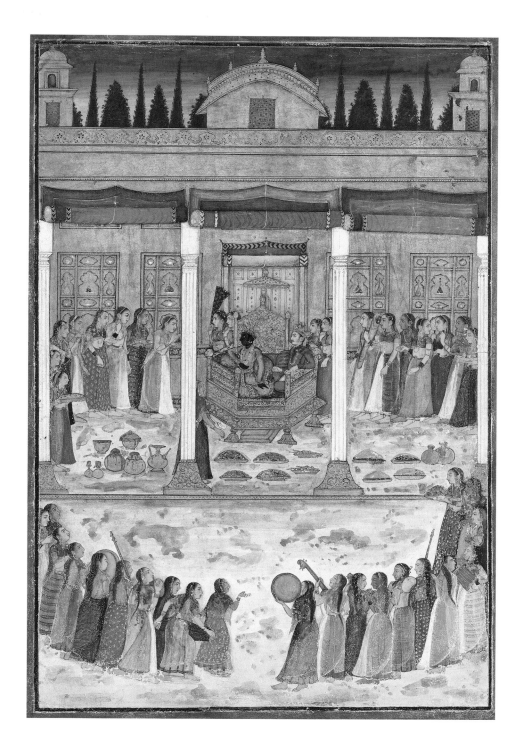

LATE MUGHAL PAINTING AND THE RENAISSANCE OF THE HINDU COURTS
1650–1730

Jorrit Britschgi

Although imperial Mughal painting suffered its most debilitating hiatus following the closing of the painting workshops under Emperor Aurangzeb (r. 1658–1707), at the same time, painting in other parts of India was to experience an unprecedented flowering. The drastic reduction in imperial painting activity directly fueled this subimperial and regional renaissance, with unemployed artists seeking patronage at the Hindu courts of western and northern India, and those of the Deccan Sultanates.

Aurangzeb's orthodox convictions led him to banish music and painting from his court in the last quarter of the seventeenth century, and in 1681, he moved his capital to Aurangabad in the Deccan. This brought an end to consistent patronage of the arts, and it also meant that the aesthetic ideas fostered under the three emperors Akbar, Jahangir, and Shah Jahan no longer were sustained through enlightened patronage. There was now no imperial patron who valued artists for their individual achievements, nurturing and promoting a particular artistic vision. It was only under the emperors Bahadur Shah I (r. 1707–12) and Muhammad Shah (r. 1719–48) that such patronage was restored. Among the artists who worked during that period are Mir Kalan Khan and the most prominent artist at court, Kalyan Das (also known as Chitarman II).

Given the dearth of stylistic innovation and the absence of imperial patronage toward the end of the seventeenth century, many artists at court simply repeated formulaic solutions from the period of Shah Jahan. Pictures tended to feature familiar subjects and follow established conventions. Yet for artists now left without any appreciable encouragement, there were nonetheless new possibilities. Some of them doubtless sought new patrons in Delhi, while others moved with the transfer of the court to the Deccan region, and still others found employment at the numerous courts in Rajasthan.

The artist Bhavanidas (active ca. 1700–48) worked from the last years of Aurangzeb's reign and into the reign of Emperor Farrukhsiyar. He produced what might be described as the last classical examples of Mughal painting—works infused with the spirit of the Shah Jahan era, psychologically charged pictures of imperial life (Fig. 18). In addition, he created numerous genealogical portraits that reflect a search for the lost brilliance of the past; although they are dignified and obey accepted protocol, their compositions seem somewhat stiff and lifeless. Bhavanidas was among those artists who went in search of appointments at other courts. Around 1719, thanks to close relations between the Mughal court and the state of Kishangarh, he began to work at Kishangarh court where, in time, he became the highest paid artist in the workshop there.[1]

Artists who, like Bhavanidas, were taken up by the Rajput courts, encountered a prevailing aesthetic wholly different from the one they had known in the imperial Mughal setting. Rajput pictures featured flat strong colors, simple narrative techniques, and a seemingly archaic rendering of architecture. In Mewar, outside influences were adopted only hesitantly and to a limited degree, as reflected in the subimperial style of such painters as Nasiruddin (Nos. 45, 46) and Sahibdin (No. 47), who continued to assert conservative Rajput values. The Stipple Master exemplifies this tension; although he adopted elements of Mughal and Deccani painting in his characteristic technique of dots occasionally giving way to short strokes and a palette reminiscent of grisaille painting, there is nothing to compare with his work in the painting of either the artists who preceded him or those who came after him. Other painters in Rajasthan, in Bundi for example, came into contact with the Mughal idiom earlier and developed it further, as can be seen in the work of the Hada Master (No. 48).

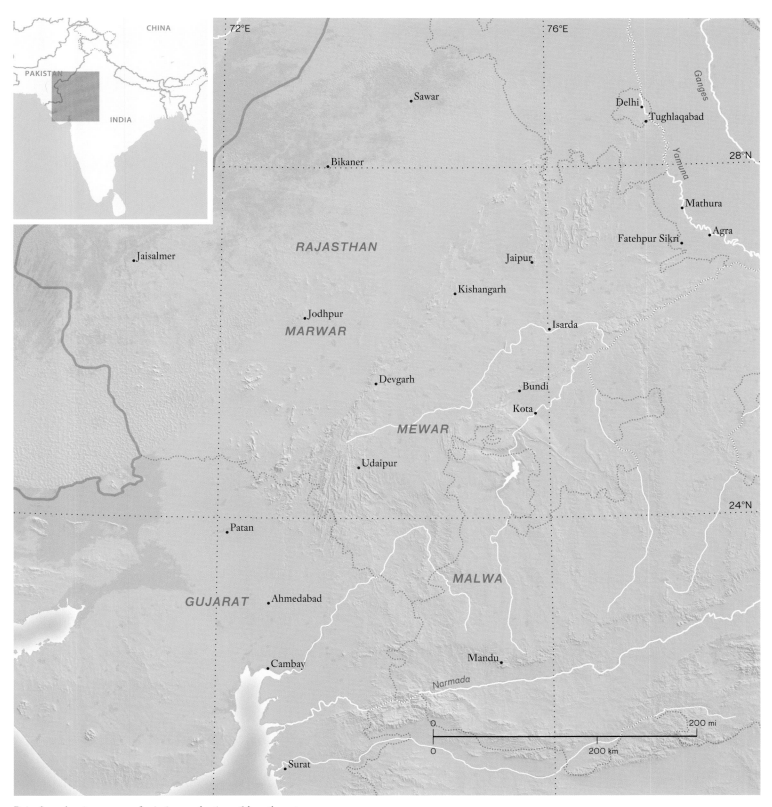

Rajasthan, showing centers of painting production, 16th–19th century

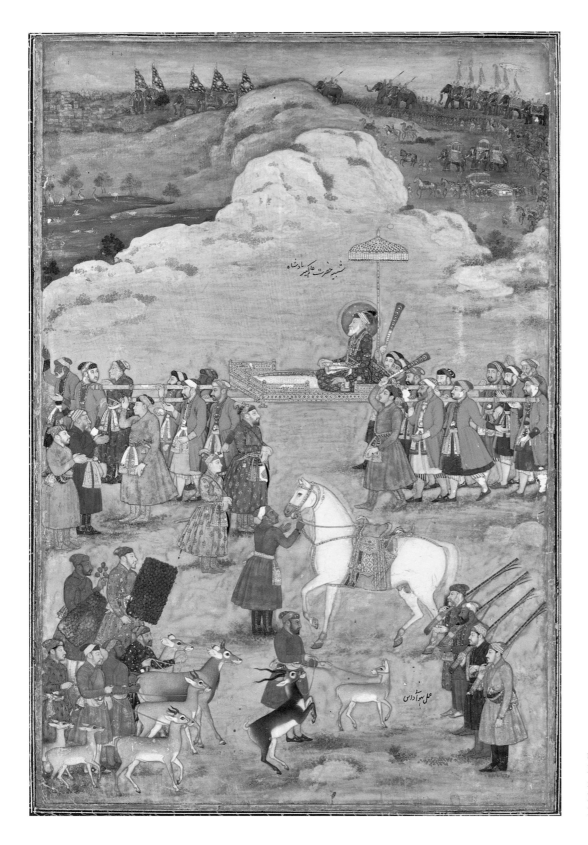

FIGURE 18. *Aurangzeb at a royal hunt*, by
Bhavanidas, Mughal, ca. 1700–1715, 22⅞ x
15⅛ in. (58.1x 38.4 cm). The Metropolitan
Museum of Art, New York, Louis V. Bell
Fund, 2003 (2003.430)

In the workshops in Kota, which split off from Bundi in 1631 as an independent principality, hunting and religious scenes were given fresh interpretations repeatedly.

The exchange of pictorial ideas and stylistic trends is illustrated most clearly in the painting of Bikaner under Maharaja Karan Singh (r. 1631–69) and his successor Anup Singh (r. 1669–98). The painter 'Ali Raza (active ca. 1645–65), originally from Delhi, worked for the former prince, and his illustration of one of Karan Singh's dreams is permeated with Mughal stylistic notions while at the same time observing the Rajput preference for strong colors.[2] One of his followers, Ruknuddin, built on this stylistic idiom. His dreamy scenes of women drinking in a garden and depictions of classical Hindu subjects like the *ragamalas* are equally indebted to Mughal naturalism. It is especially interesting in this context to consider the workshop structure at the Rajasthan courts. Their painters generally came from a single family (in the case of Bikaner, two separate clans), and familial relationships are much more apparent in these than in the artists from the Mughal court, where one painter who was born at court proudly signed himself as such (*khanazad*). Family cohesion and a shared approach to composition and knowledge of pigment preparation were of central importance in these smaller workshops. In Bikaner, an especially rigid system prevailed in which the master controlled the products of his workshop, and many pictures bear his name, even though in terms of style, they can hardly be attributed to the master himself.[3]

The family-based workshops in Rajasthan and the Pahari region represent a distinct contrast to the highly structured ateliers at the imperial courts. Thanks to this system, it is possible to trace a family style across several generations of painters.[4] A superb example is provided by the works of Kripal, Devidasa, and Golu from Nurpur (Nos. 55, 57, 59). Each workshop maintained a fund of drawings that represented the artistic legacy of whole families and that could be adapted to the taste of the time and a given ruler when necessary. Artist families working at smaller courts, where patronage was less consistent than at those of the early Mughal rulers, might also look elsewhere for possible commissions.

The earliest examples of painting from the Pahari region, produced during the Akbar period, are indebted to the *Caurapancasika* style prevalent through all of northern India, and served as one of the sources for the later style of the region.[5] At the same time, however, works by the Early Master at the Court of Mandi indicate that distinctly Mughal stylistic elements had already been adopted around 1635.[6] Compared to these pictures, the works of Meju (Mankot, No. 63) and the artist family from Nurpur (Kripal, Devidasa, and Golu) employ a wholly different idiom; they are icon-like images that represent an aesthetic quite unlike that of realistic Mughal paintings. They rely on richly contrasting colors and a predominance of line and blocks of color over spatial arrangement. The works of the two Bahu masters (possibly father and son or two brothers) employ the same aesthetic.

Thus, whereas painting became increasingly marginalized at the courts of the Mughals, this inadvertently led to a revival of painting at the Hindu courts, both in Rajasthan and in the northern hills, the Pahari region of Himachal Pradesh.

Ruknuddin

Active at the court in Bikaner ca. 1650–97,
especially under the patronage of Anup Singh

Bikaner, a desert town in Rajasthan, is known for a hybrid style that incorporates influences from both the Mughal workshops and the remote Deccan. Relatively little is known about the early phase of this type of painting. Two clans produced the majority of Bikaner's painters. Ruknuddin, who had an impressively long career, was one of the area's most established artists. Under the ruler Anup Singh (r. 1669–98), he rose to the position of workshop director.

Although the documents relating to painting in Bikaner are informative and the most important artist genealogies have been researched,[1] the system of smaller studios is not as well understood. Hundreds of paintings are assigned to Ruknuddin according to their inscribed annotations, but they exhibit such a broad range of styles that it is impossible to attribute them to a single hand. Apparently, numerous painters worked on various series, wholly beholden to the style of the master. Further, works by Ruknuddin's son Ibrahim, for example, may have been inventoried under his father's name.

It is documented that Karan Singh (r. 1631–69), Anup Singh's predecessor, summoned painters from Delhi to his court, among them 'Ali Raza. It is tempting to assume that Ruknuddin was trained under 'Ali Raza, about whom little is heard after 1660. Around 1650, the ruler requested that 'Ali Raza record with his brush one of his dreams, a vision of Lakshmi and Narayana. Ruknuddin painted the same subject some thirty years later (No. 54).

Ruknuddin was a master of color and patterns. In this work, the exquisitely rendered folds of Vishnu's robe, the semitransparent fabrics of the women presenting gifts to the divine couple, and the subtle shading of the faces are obviously reminiscent of Mughal painting. Beautiful women, even in a secular context, were among Ruknuddin's favorite subjects (No. 53). If one compares such pictures from the 1660s and 1670s as a group, one is particularly struck by the porcelain-like treatment of the faces that recurs in works of this period.

Ruknuddin accompanied the rulers of Bikaner on their military campaigns to the Deccan, which were conducted as part of their contractural service to the Mughal court. He is associated with a number of portraits painted there in a distinctly Mughal manner, reflecting his exposure to further currents of influence.

53

Ladies of the *zenana* on a roof terrace

Bikaner, Rajasthan, dated by association 1666
Opaque watercolor, ink and gold on paper,
9 x 6 in. (22.9 x 15.2 cm)
The Kronos Collections, New York

In this scene of harem women amusing them-
selves on a roof terrace, the artist evoked a
comfortable and hedonistic world. The influ-
ence of Mughal painting is indisputable, in
both the subject matter and the style in which
it is rendered. Ruknuddin probably was trained
by the Delhi painter 'Ali Raza; he later replaced
him as chief painter in Bikaner. Ruknuddin
also spent some time in the Deccan, as
inscriptions on two of his works attest.[7]

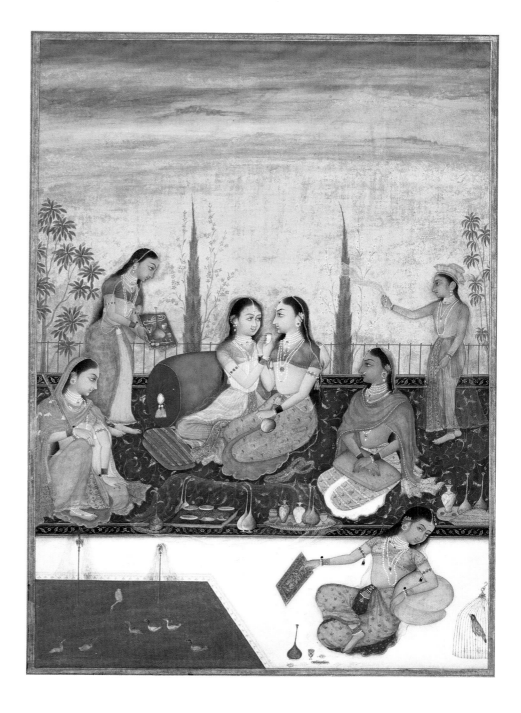

54

**Vishnu with Lakshmi enthroned,
on a roof terrace**

Bikaner, Rajasthan, dated 1678

Inscribed: painter's name and year 1735 inscribed
on reverse in *devanagari* script

Opaque watercolor on paper;

painting: 7⅝ x 10³⁄₁₆ in. (19.4 x 25.8 cm);

page: 10⁷⁄₁₆ x 12¹⁵⁄₁₆ in. (26.5 x 32.8 cm)

Museum Rietberg, Zurich, Bequest of Lucy
Randolph (RVI 1854)

Published: Falk, Smart, and Skelton, *Indian
Painting: Mughal and Rajput and a Sultanate
Manuscript* (1978), no. 60; Beach, *The New
Cambridge History of India: Mughal and Rajput
Painting* (1992), pl. J

Pictures of Vishnu with his consort Lakshmi
were popular in the Bikaner ateliers. It appears
that they were based on a prototype from
around 1650 by the Delhi artist 'Ali Raza, on
which an inscription relates that the piece
illustrates a dream of Maharaja Karan Singh.[8]
Ruknuddin's version of the subject, dated
1678, adopted 'Ali Raza's composition but
placed the scene on a terrace. The work is
mentioned in the inventory lists (*bahis*) as a
"painting of the deities Lakshmi-Narayana,
seated on a throne, rendered frontally, eleven
maids attending them."[9]

Nurpur Masters: Kripal, Devidasa, and Golu

Active ca. 1660–ca. 1690, ca. 1680–ca. 1720, and ca. 1710–ca. 1750, respectively; Kripal was the head of an artist family from Nurpur, including his son Devidasa and grandson Golu

Each of these three generations of painters, beginning with Kripal and continuing with his son Devidasa and the latter's son Golu, left a series of illustrations for the *Rasamanjari*. The text they illustrated takes up the popular theme of the hero and heroine (*nayaka–nayiki*) and catalogues the many aspects of love (longing, rejection, and deception, among others).

Together with other works attributed to these artists, their three versions of this text comprise a corpus of work that is unique in Indian painting for its icon-like quality. These paintings are dominated by the use of thick pigments, polished colors, monochromatic backgrounds devoid of descriptive details, and occasionally, they include applied lustrous green beetle wings and dots of shell-lime body-white that stand in relief to the picture surface.[10]

There is no documentation of the existence of painter families in Basohli, but there are inventory lists (*bahis*) for the painter Devidasa from Nurpur, so one can assume that all three painters originated at Nurpur, in Himachal Pradesh.[11] The three series were produced in rapid succession, Kripal's around 1660–70, Devidasa's in 1695, and Golu's around 1715. Although the hero is not characterized as such in the text itself, the artist Kripal associated the *nayaka* expressly with the god Krishna, who is omnipresent and is thus intended to show the prototypical nature of the scenes. Additional folios with depictions of a goddess (based on an as yet unidentified text) are attributed to the artist Kripal. Meditative verses (*dhyanas*) on the backs of the works invoke the great goddess, and Kripal's depictions of her are to be understood in the same light, as pictures for meditation, providing believers with an iconic bridge to divinity.

Kripal's son Devidasa undoutedly had access to his father's sketches. Even so, his series diverges in two significant respects; he does not employ the beetle wings and does not adopt Krishna as his hero. His works are situated more evidently in the present, with a patron-prince as the main protagonist. Whether or not the latter change reflects the express wish of his patron cannot be determined.

Golu, too, whose *Rasamanjari* series is of inconsistent quality, built on the paintings of his father in composition. He also had a princely figure assume the role of the hero (*nayaka*), whose features in Golu's series closely resemble those of the ruler Raja Daya Dhata (r. 1700–1735).[12] Once again, the artist employed beetle-wing cases as adornments. Both Golu and his father Devidasa produced *Ragamala* series, which are readily distinguished.

Above: Portrait of Golu, ca. 1750, Nurpur, Himachal Pradesh. National Museum, New Delhi (68.29)

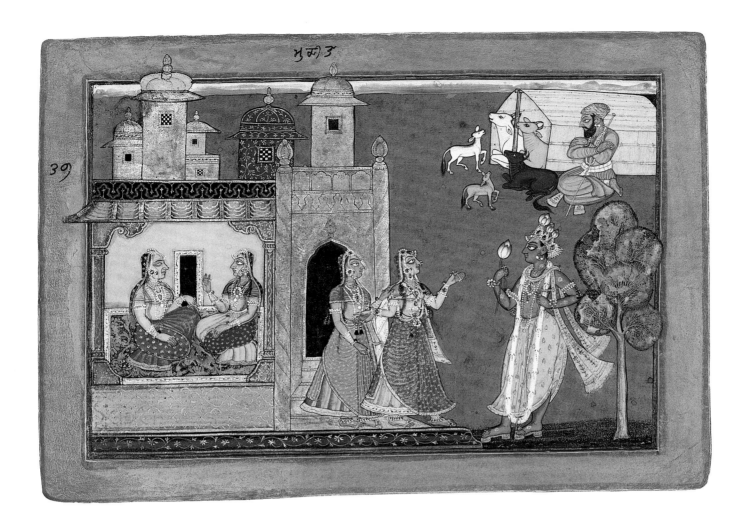

55

The Nayika Mudita: folio from the *Rasamanjari* I series, no. 29

Nurpur, Himachal Pradesh, ca. 1660–70
Inscribed: Upper margin, *mudita*, "the delighted one" and on reverse a quotation from the *Rasamanjari,* beginning "Her husband is out in the pastures . . ."*
Opaque watercolor, gold, silver, and beetle-wing cases on paper, 9⁷⁄₁₆ x 13³⁄₁₆ in. (23.9 x 33.5 cm)
The San Diego Museum of Art, Edwin Binney 3rd Collection (1990.1039)
Published: Goswamy and Smith, *Domains of Wonder* (2005), no. 78*

According to Bhanudatta's Sanskrit love poem *Rasamanjari*, which classifies and celebrates the moods of love, Mudita was one of the heroines (*parajika*). She is married but harbors longings for a secret lover, whose coming she eagerly awaits. The moment shown here is ideal, as she is attended by only two relatives, one blind and the other deaf, and her husband is in the field tending the cows (at upper right). Her hero-lover (*nayaka*) appears in the form of Krishna and approaches her with a lotus blossom in his hand. Figures move seamlessly between interior and exterior spaces, and the jewels of the heroes, set with green luminous beetle wings, shimmer in anticipation.

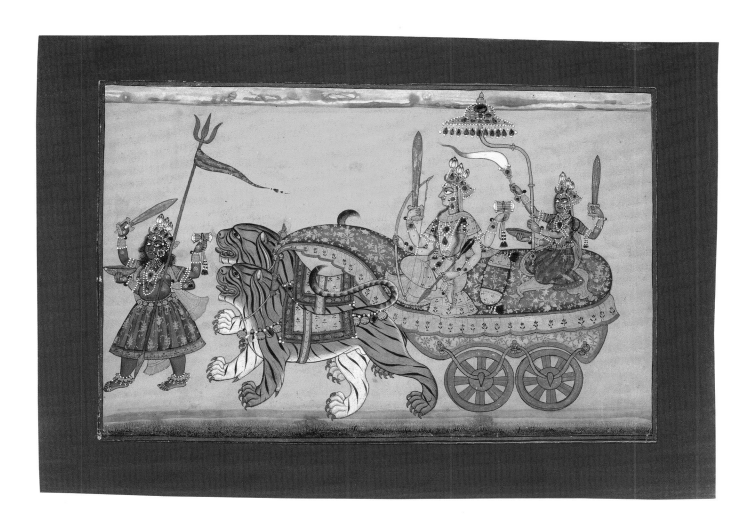

56

Devi parades in triumph

Nurpur, Himachal Pradesh, ca. 1660–70
Opaque watercolor, gold, and beetle-wing cases
on paper, 7⁵/₁₆ x 10¹¹/₁₆ in. (18.5 x 27.2 cm)
Museum Rietberg, Zurich, permanent loan,
Collection of Barbara and Eberhard Fischer,
on loan to the Museum Rietberg, Zurich
Published: Ghose, "The Basohli School of Rajput
Painting" (1929), fig. 7; W. G. Archer, *Indian
Paintings from the Punjab Hills* (1973), vol. 2,
pl. 17; Fischer, Goswamy, and Pathy, *Göttinnen:
Indische Bilder im Museum Rietberg Zürich*
(2005), no. 2

This composition in a horizontal format is among Kripal's most impressive works. The great goddess is shown riding in a carriage drawn by a pair of tigers; unlike her two companions, she is in full profile. Radiating calm and heavily armed with the weapons of the gods, Devi sits in her chariot with crossed legs, honored with yak whisk and parasol. The intense yellow ground and the numerous irridescent green beetle wings invest the picture with an iconic potency. Kripal paid little attention to landscape, employing only a horizontal line and tufts of grass. Instead, he concentrated attention on the goddess herself, thereby capturing the grandeur of the great Devi. Elsewhere, as in his *Rasamanjari* pictures for example, architecture and landscape play a greater role that is appropriate to their more overtly narrative content (No. 55).

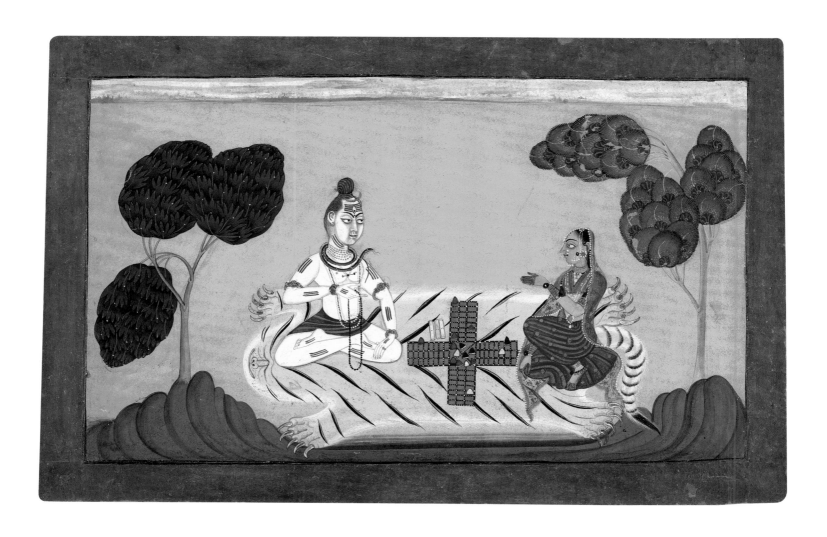

57

Shiva and Parvati playing *chaupar*: folio from a *Rasamanjari* series

Basohli, Jammu, dated 1694–95

Opaque watercolor, ink, silver, and gold on paper; painting: 6½ x 10⅞ in. (16.5 x 27.6 cm); paper: 8 x 12¼ in. (20.3 x 31.1 cm)

The Metropolitan Museum of Art, New York, Gift of Dr J.C. Burnett, 1957 (57.185.2)

Published: Craven, *Miniatures and Small Sculptures from India* (1966), fig. 55; Goswamy and Fischer, *Pahari Masters* (1992), no. 26; Kossak, *Indian Court Painting* (1997), no. 43; Dehejia et al., *Devi, the Great Goddess* (1999), p. 89; Mackenzie and Finkel, *Asian Games* (2004), p. 51

As is witnessed in Devidasa's depiction of Shiva and Parvati, even gods cheat. Shiva has won Parvati's necklace in the dice game *chaupar*. The three elongated ivory dice and the cross-shaped gaming board indicate that the game, played on a tiger skin, has just been interrupted. With an outstretched hand, Parvati demands that the forfeited necklace be returned to her. Although—or precisely because—these are gods who cheat at games and end up at odds with each other,

Devidasa here emphasized human responses. Note Parvati's outstretched demanding hand, the way Shiva turns his head toward the viewer, not to mention the comedy of the situation Devidasa used to visualize Bhanudatta's *Rasamanjari* text.

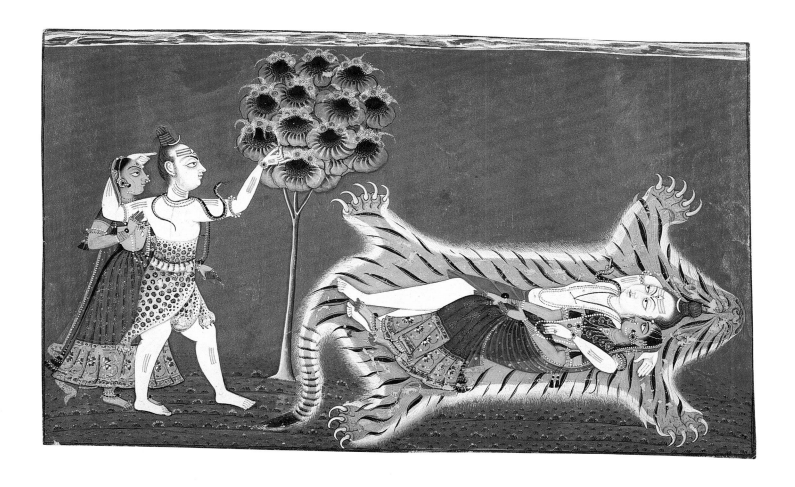

58

Shiva and Parvati: folio from the
Rasamanjari II series
Nurpur/Basohli, Himachal Pradesh/Jammu,
dated 1694–95
Inscribed: in Sanskrit verse, quotation from
Bhanudatta's *Rasamanjari*, "Om. His own foot
he places forward first . . ."*
Opaque watercolor and gold on paper;
6¾ x 11³⁄₁₆ in. (17.1 x 28.4 cm)
The San Diego Museum of Art, Edward Binney
3rd Collection (1990.1043)
Published: Goswamy and Smith, *Domains of*
Wonder (2005), no. 79*

The *Rasamanjari* begins with an invocation
to Shiva. The believer is called upon to sum-
mon the god, to cause him to appear before
his inner eye. In this case, Shiva is invoked
in his androgynous form, in which half his
body is male and the other half female. In both
scenes, the artist placed Shiva's consort
Parvati close to the god as a (second) left
half, suggestive of the Ardhanishvara repre-
sentation when they are conceived as a single
divine entity. In this tender depiction, Shiva
plucks flowers from a tree and unites with her
on a tiger-skin rug.

59

The lover prepares to depart:
folio from the *Rasamanjari III* series

Nurpur, Himachal Pradesh, ca. 1710–20

Opaque watercolor on paper;

painting: 6⅞ x 10⅝ in. (17.5 x 27 cm);

page: 8½ x 12¹¹⁄₁₆ in. (21.6 x 32.2 cm)

Collection of Barbara and Eberhard Fischer,

on loan to the Museum Rietberg, Zurich

Published: W. G. Archer, *Visions of Courtly India*

(1976), no. 71

The compositions of Golu's illustrations for the *Rasamanjari* are greatly indebted to those of his father, Devidasa (Nos. 57, 58). The artist Golu undoubtedly would have been aware of his father's version, and he surely had access to sketches in the family workshop. Nevertheless, Golu — or his workshop, considering the clearly visible differences in quality within his series — took a different approach. Whereas in Kripal's paintings, Krishna slips into the role

of the *nayaka* (ideal lover) and in Devidasa's, a prince assumes that function, in Golu's *nayakas,* the features are modeled after those of his patron Raja Daya Dhata (r. 1700–1735). In this work, Golu's *nayaka* is setting out in the dead of night. The heroine — although anticipating the hero's departure with her head thrown back — remains unshaken, and in the words of the *Rasamanjari,* she "neither heaved a sigh nor dropped a tear from her eyes."

Bahu Masters

Active at the court of Bahu, Jammu region, ca. 1680–ca. 1720;
possibly father and son or two brothers

The *Ramayana*, an extensive series that tells the story of Rama and Sita, serves as the first point of reference for the œuvre of these two masters at the court of Bahu, located near Jammu in the Pahari region. The manuscript, which originally consisted of more than 279 illustrated folios, exhibits stylistic variants suggesting that different painters worked on it at different times (and possibly even in different places). The pioneering scholar of Pahari painting William Archer was the first to distinguish four distinct styles in this vast work.[13] While the folios that illustrate the first part of the epic are rendered in Styles I and II, the last parts of the story were painted in two disparate styles, a feature not uncommon in larger picture series that, we can assume, were produced over an extended period of time.

The world evoked in the pictures in Styles I and II, attributed to the first and second Bahu masters, is self-contained. Stylized fields of color and delicately executed patterns dominate in these works, which are related to the earlier pictures by Kripal and Devidasa in their color aesthetic. Here, stylized colors combine with thickly applied shell-lime white alternating with pricked gold.

To enhance the effect of the monochrome ground, the first Bahu painter frequently omitted a horizon line. His architectural elements have a purely decorative quality, while all his figures are related directly to the action; they recite, listen attentively, place a hand on a neighbor's shoulder, or gesticulate. The second Bahu master shares the same color sense, but his picture elements are arranged more carefully. Certain facial types borrow from the repertoire of the first Bahu master (although with more rounded eyes). The narrative's immediacy is broken by the horizon line inserted high above the picture, as though the painter wished to set the story of the gods in a recognizably earthly realm.

On the basis of stylistic indicators, other works that are not from the *Ramayana* series discussed here can also be attributed to both painters, notably pictures for musical scores *(ragamalas)* as well as princely portraits. One can assume that both the first and second Bahu masters were working in the same atelier and in all probability were related, possibly father and son, or brothers.

Above: Portrait of a Bahu Master, detail from a folio of the Shangri II *Ramayama* series. Bahu, Jammu, ca. 1680–95. National Museum, New Delhi (62.2487)

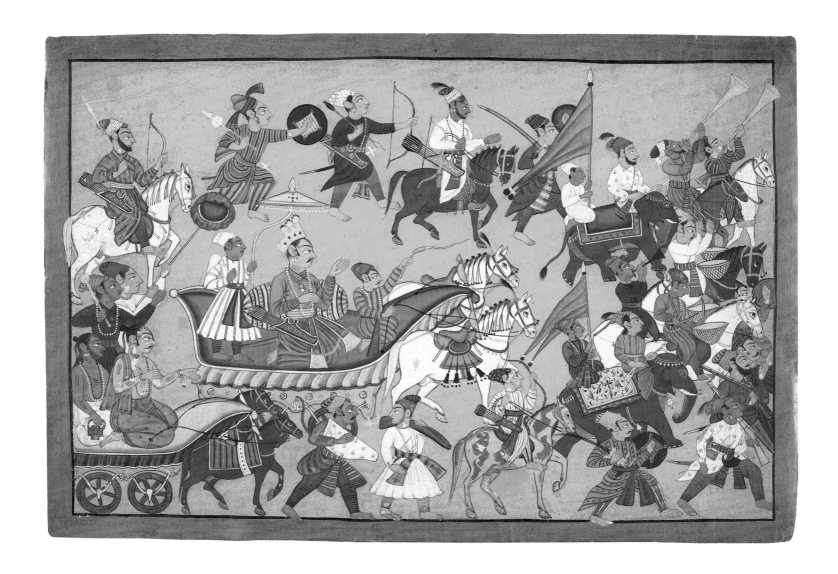

60

King Dasaratha and his retinue proceed to Rama's wedding: folio from the Shangri II *Ramayana* series
Bahu, Jammu, ca. 1690–1710
Opaque watercolor and ink on paper;
painting: 7¾ x 11⅝ in. (19.7 x 29.5 cm);
page: 8¾ x 12½ in. (22.2 x 31.8 cm)
The Metropolitan Museum of Art, New York,
Purchase, The Dillon Fund, Evelyn Kranes
Kossak, and Anonymous Gifts, 1994 (1994.310)

Published: Czuma and Archer, *Indian Art from the Bickford Collection* (1975), no. 110; Kossak, *Indian Court Painting* (1997), no. 42

Rama's marriage is the central event in the *Ramayana.* Here, King Dasaratha is seen on his way to the wedding, accompanied by an ostentatious retinue with standard bearers, trumpeters, and drummers. Similar compositions by the Second Bahu Master document the return of the wedding party after the ceremony.[14] A horizon line is included in those works, but it is missing in this one. The pictures of the Second Bahu Master also differ in other details, including the physiognomies of the figures. And, while here the wheels are spoked, they are solid in the pictures of the first masters.

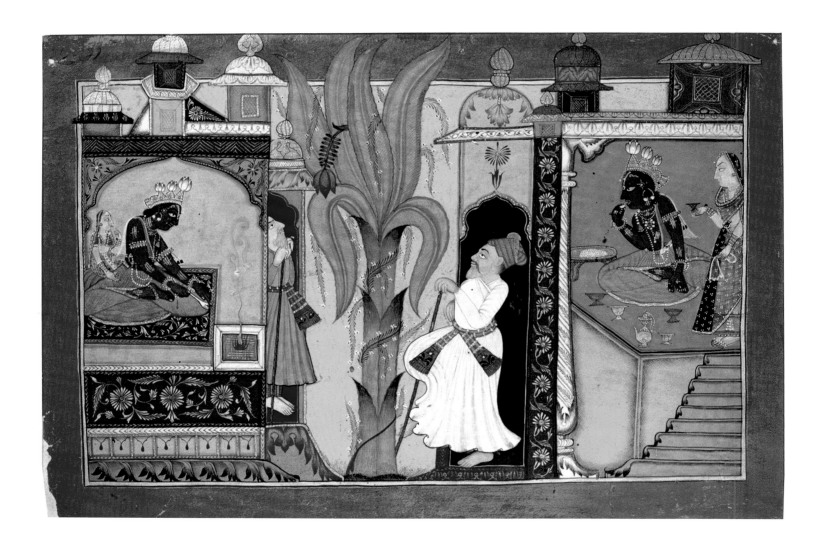

61

**Vasishtha visits Rama: folio from
the Shangri I *Ramayana* series**

Bahu, Jammu, 1680–90

Opaque watercolor, ink, and gold on paper;
page: 8½ x 12½ in. (21.6 x 31.8 cm)

Private Collection

Published: Kossak, *Indian Court Painting*
(1997), no. 41

Exquisitely executed textile patterns and architectural ornaments play a major role in the pictures of the First Bahu Master. These are balanced by monochrome areas of intense color that set off the elegant decor. In this scene, the sage Vasishtha is visiting Rama, instructing him on the correct purification rituals to be performed before his investiture as king. The scene is divided into two areas by the plantain tree that dominates the composition; the leaves reach into the picture's border, as do the turrets of the palace's roof. On the left, Rama is preparing a fire offering, and to the right, he is taking nourishment before fasting. The absence of a skyline further adds to the concentrated energy of this closed world.

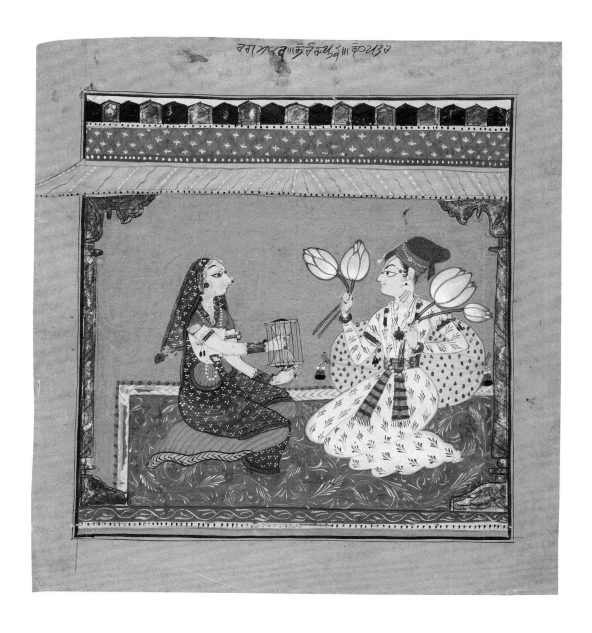

62

Raga Madhava:
folio from a *Ragamala* series

Bahu, Jammu, ca. 1720
Opaque watercolor and ink on paper;
painting: 6⁵/₁₆ x 5²⁹/₃₂ in. (16 x 15 cm);
page: 7²⁹/₃₂ x 7⁵/₁₆ in. (20 x 18.5 cm)
Museum Rietberg, Zurich,
Collection of Alice Boner (RVI 1226)
Published: Boner, Fischer, and Goswamy,
Sammlung Alice Boner (1994), no. 273

This sheet is part of a *Ragamala* series that can be attributed to the Second Bahu Master. The subject evokes the *raga madhava* (the sentiment of sweetness, as in bees drawn to a lotus) and is a *raga* associated with a springtime melody. The iconography adopted here showing a young prince holding lotus blossoms in each hand appears to be unique; it might represent the artist's personal interpretation of this *raga*; more conventional renderings depict a beautifully dressed and bejeweled woman as a bringer of good fortune. Here, the accompanying lady is playing the hourglass *damaru* drum and is enjoying the prince's attention. The gold and silver surfaces, seen in the pavilion's awning and pillars, are tooled with punch-marks to capture and reflect light, so enlivening the picture surface.

Master at the Court of Mankot (Meju)

Active ca. 1680–1730

The name of the painter who worked at the court of Raja Mahipat Dev (r. 1660–90) of Mankot at the end of the seventeeth century is only known from a single source, one portrait of a local ruler that bears the name Meju.[15] It is thanks to another coincidence that one can place this artist in the village of Mankot, in Himachal Pradesh. Although numerous works from the descendants of the Mankot princes survive and point to the ongoing existence of painting workshops there, it is only the letter to Raja Mahipat Dev discovered on the back of a picture that provides definite proof of the location of the school associated with the painter Meju.[16] The link between painter, patron, and court was established by a discarded letter that had been employed to line and strengthen a painting. Sheets of paper used for artist's sketches were routinely used for lining paintings.

Meju made numerous portraits and illustrations for both sacred texts and musical modes (*ragamalas*). Characteristic of his work are the monochromatic backgrounds — mainly olive-green and yellow-orange — the reduction of pictorial detail to only what is absolutely necessary for the narrative, and the use of strong dominant colors throughout. These elements are particularly visible in his two series on the *Bhagavata Purana* (see No. 63). The landscape-format series, probably the earlier of the two, shows the main protagonist, Krishna, repeated in a monochromatic landscape, either playing with the *gopis* or battling evil in the form of demons. The later vertical series essentially takes over this arrangement of the preceding one, but the artist was forced to abandon certain pictorial elements for spatial reasons. In both series, Meju extended architectural elements or figures beyond the picture's border. By breaking out of the composition's frame, the artist suggested the possibility of action beyond the limits of a particular picture.

63

Celebrations of Krishna's birth:
page from a *Bhagavata Purana* series

Mankot, Jammu, ca. 1700–1725
Opaque watercolor and ink on paper;
painting: 9 x 6 in. (22.9 x 15.2 cm);
page: 11¾ x 8⅜ in. (29.8 x 22.2 cm)
The Cleveland Museum of Art, Edward L.
Whittemore Fund (1988.70)
Published: Ehnbom, Skelton, and Chandra,
Indian Miniatures: The Ehrenfeld Collection
(1985), no. 100

Meju, the name ultimately used by the painter
at the court of Mankot, left behind two differ-
ent series on the *Bhagavata Purana* that have
very similar compositions. However, one is in
a vertical format, while the other is horizontal.
Here, the festivities in honor of the birth of
Krishna are accompanied by fanfares and
drumming. In the lower right corner, a priest
is presenting Krishna's foster father, Nanda,
with bunches of grass. Repeatedly in the
works of the Mankot Master, pictorial ele-
ments extend beyond the painting's actual
borders; note the sheath of the man's sword
at lower left and the bell of the trumpet at
upper right, which add an enlivening spatial
dimension to the composition.

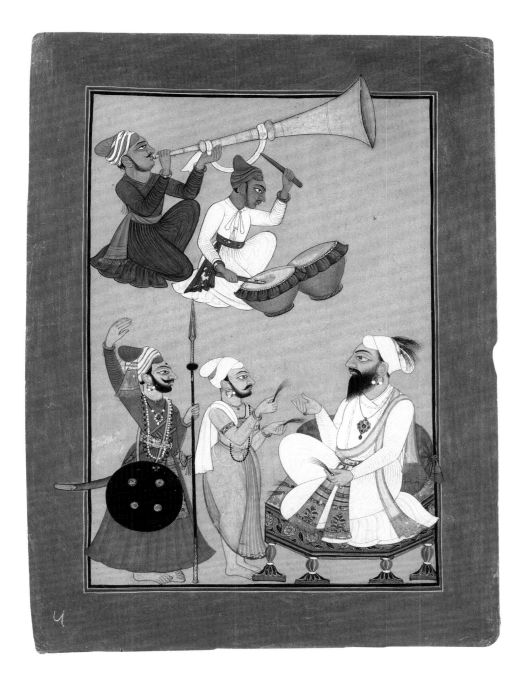

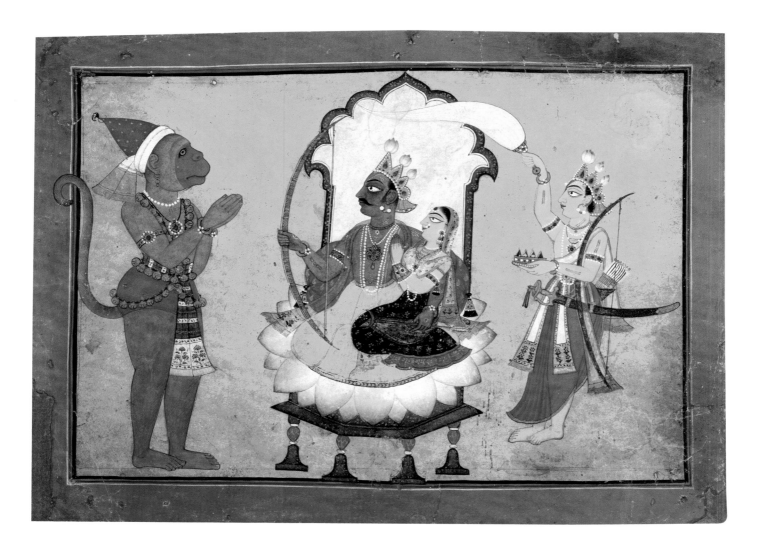

64

Hanuman paying homage to Rama: folio from a *Dasavatara* series

Mankot, Jammu, ca. 1700–1710
Opaque watercolor on paper;
painting: 6⁷/₁₆ x 9³/₈ in. (16.3 x 23.8 cm);
page: 7³/₁₆ x 10⁵/₈ in. (19.8 x 27 cm)
Museum Rietberg, Zurich,
Collection of Alice Boner (RVI 1206)
Published: Skelton, *Indian Miniatures from the XVth to XIXth Centuries* (1961), no. 32;
W. G. Archer, *Indian Paintings from the Punjab Hills* (1973), vol. 2, pl. 52; Goswamy and Fischer, *Pahari Masters* (1992), no. 52; Boner, Fischer, and Goswamy, *Sammlung Alice Boner* (1994), no. 262, pl. 16; Britschgi and Fischer, *Rama und Sita* (2008), no. 87

Sparse pictorial details and intense yellow backgrounds lend an iconic quality to the works of the Master at the Court of Mankot. This scene most probably comes from a series on the descent of the god Vishnu (*dasavatara*), in which Rama appears as a just ruler. Seated with his consort on a lotus-blossom throne, Rama is venerated by the monkey general Hanuman and to the right is attended by Lakshmana, his brother and constant companion throughout their adventures and trials in the epic *Ramayana*. The artist eschewed the sense of movement he so skillfully employed in the *Bhagavata Purana* paintings, the objective being to depict Rama's majesty rather than visually narrate the text. Visible in the gold areas are depressions (*suikari*) that were made with a blunt needle to capture light, so enriching the picture surface.

Stipple Master

Active at the Court of Amar Singh II, Udaipur, ca. 1690–1715

Following the pioneering career of Sahibdin, painters in Udaipur, Rajasthan, mainly reproduced illustrations for religious manuscripts based on his compositions. Toward the end of the seventeenth century, an artist arrived at the court who would establish a style that persisted for nearly thirty years under the prince and later ruler Amar Singh II (r. 1698–1710) and his successor Maharana Sangram Singh II (r. 1710–1734). He is identifed as the Stipple Master. The style of this anonymous artist remained a singular phenomenon at the court. He favored a nearly monochrome approach, a style with precedents in both Mughal and Deccan painting, the *nim qalam* technique. Amar Singh likely became aware of the technique through exposure to Mughal examples. It is also documented that the ruler was interested in paintings from Bundi and Kota,[17] and therefore, works from those places, influenced by the Chunar Ragamala Masters (No. 44) provided another avenue of Mughalesque influence.

The range of subjects that can be attributed to the Stipple Master makes it clear that he had direct access to his patron. Included are intimate scenes that show him in his pleasure gardens in reverie, in his summer pavilions, or in the palace with the women of his harem. The artist's work dates mainly from the reign of Amar Singh II, and its stylistic uniformity suggests that patron and painter — as Catherine Glynn put it — had a "shared vision."[18]

The Stipple Master's palette is very limited. As a rule, only the figures and portions of the architecture or flora and fauna are set off in color, while the background remains for the most part minimally defined or in some passages, unpainted altogether. One work that according to its inscription shows the ruler in front of his picture gallery in Rajnagar (No. 66) combines the artist's stylistic features; the prince's women are lined up against an untreated background, drawing the viewer's gaze to Amar Singh II, who is depicted on a larger scale that reflects his importance.

The style that the Stipple Master practiced seems to have fallen out of favor during the end of the first quarter of the eighteenth century, and by looking at paintings produced at the royal atelier for Sangram Singh II, one quickly understands that more grand and more complex compositions began to dominate the output of painting at Udaipur.

65

Maharana Amar Singh II riding a Jodhpur horse

Udaipur, Rajasthan, ca. 1700–1710
Inscribed: on reverse in *devanagari* script,
"it is from Jodhpur"
Opaque watercolor and ink on paper;
painting: 13³/₁₆ x 10³/₄ in. (33.5 x 27.3 cm);
page: 14¹¹/₁₆ x 12¹/₈ in. (37.3 x 30.8 cm)
The Metropolitan Museum of Art, New York,
Cynthia Hazen Polsky and Leon B. Polsky Fund,
2002 (2002.177)
Published: Sotheby's New York, December 10,
1982, lot 91, and March 22, 2002, lot 20

Numerous pictures exist that depict Amar Singh on horseback with attendants, clearly one of the Stipple Master's favorite subjects. In such works, the focus is on the main subject, the horse, painted a radiant blue. The foreground is marked by only a few tufts of grass, and in the background, beyond the lightly shaded crest of the hill, there are a temple and a palace pleasure garden. The understated technique displayed by this artist has echoes of the Persian–Mughal painting technique of *nim qalam*, half-tone painting, a variant of European grisaille techniques of tonal painting.

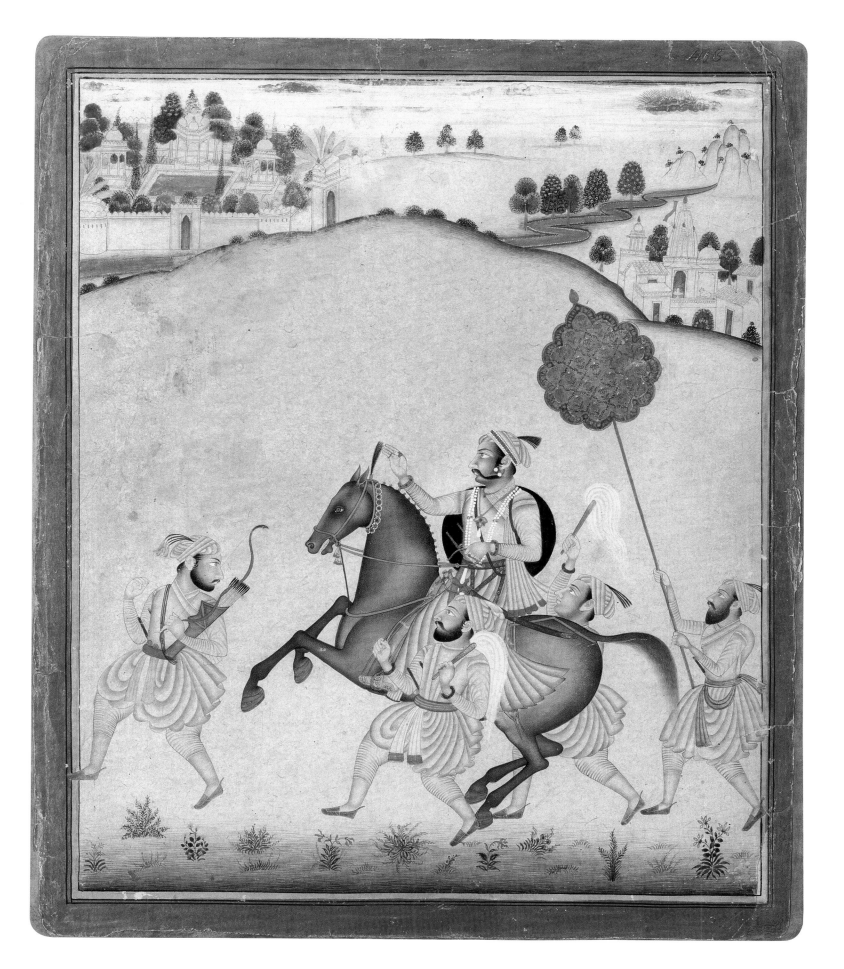

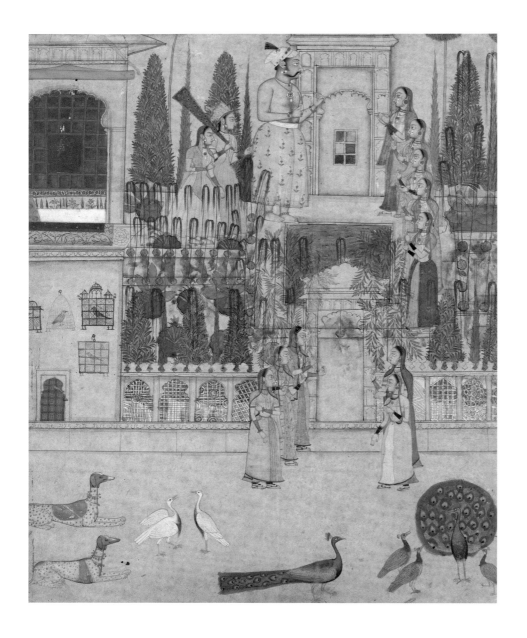

66

Maharana Amar Singh II with ladies of the *zenana* outside the picture hall at Rajnagar

Udaipur, Rajasthan, ca. 1707–8
Inscribed: "Maharana Amar Singh standing in the garden of the Chitrasali [Picture Hall] at Rajnagar"
Opaque watercolor, ink, and gold on paper; painting: 9½ x 7⁵/₁₆ in. (24.1 x 18.5 cm); page: 18⅞ x 14⅞ in. (47.9 x 37.8 cm)
The Metropolitan Museum of Art, New York, Friends of Asian Art, Purchase, Mrs. Vincent Astor Gift, 1998 (1998.161)
Published: Topsfield, *Court Painting at Udaipur* (2002), p. 131; Nardi, "Mewari Paintings in The Metropolitan Museum of Art" (2006), fig. 6

Rajnagar, not far from Udaipur, had a special importance for Amar Singh II and therefore also for his artists. Around the years 1692–98, the Stipple Master served as painter to Prince Amar Singh (the future Maharana Amar Singh II). In this work — as in many others by the Stipple Master — Amar Singh II appears naked to the waist, and the painter's technique of dots and short strokes is clearly visible on his subject's torso. The background is largely unpainted, and color accents are employed with great restraint. Particularly apparent is the artist's use of a hierarchical ordering that depicts the prince larger than the attendant ladies of the *zenana*.

Masters of Early Kota

Active ca. 1660–1740

Painting from Kota between the middle of the seventeenth century and the first half of the eighteenth century is very poorly documented, yet there are a handful of pictures bearing artist names, including Niju or Shaykh Taju.[19] Stuart Cary Welch assigned the pictures from Kota and Bundi, all of them very similar in both style and subject matter — generally hunting or battle scenes — to three artists: the Master of the Elephants, the Kota Master, and Shaykh Taju.[20] Milo Beach's recent research has resulted in a different set of attributions. He recognized the Hada Master (active in Bundi and subsequently in Kota) and three styles from Kota set by individual artists whom he refers to as Artists A, B, and C. The B group shows the influence of the artist Niju.[21]

Artists like the Hada Master had a major influence on the development of painting in Kota, in both style and content. For example, motifs such as the lion climbing a tree in *Ram Singh I of Kota hunting at Makundgarh* (No. 69) were prefigured in the repertoire of Bundi painting. Yet the technique is different. Short brushstrokes predominate, notably in the foliage, and also wet washes, as seen in the bushes in the background. A most unusual technique was used to render the water splashing against the hunting platform; there, the pigments were sprayed onto the paper rather than brushed. The faces, by contrast, are formulaic, and they can be traced back to late works of the Hada Master. Instead of occupying the foreground, the actual hunting scene is embedded in a detailed landscape.

67

Ram Singh I of Kota hunting rhinoceros

Kota, Rajasthan, ca. 1700

Opaque watercolor on paper;

page: 12⅝ x 18¾ in. (32.1 x 47.6 cm)

Private Collection

Published: Lee and Montgomery, *Rajput Painting* (1960), no. 36; Beach, *Rajput Painting at Bundi and Kota* (1974), figs. 71–77; Welch, *India: Art and Culture* (1985), no. 242; Welch, *Rajasthani Miniatures* (1997), fig. 1

Although badly damaged, this hunting scene is one of the most dramatic known examples of the genre. The elephant as combatant was a favored subject in the court painting of Bundi, from which the Kota school evolved following the creation of that state by Shah Jahan in 1631. The subject of this painting, the elephant and two noble riders, are united as a single force, pitiless in pursuit of their prey. The Kota Master created one of the most powerful renderings of the hunt in Indian art, with skilled tonal modeling of the beasts and restrained use of color that is confined to the elephant's harnessings and blankets. Stuart Cary Welch wrote of this work that such is its compelling energy that it makes us "feel the thud of feet and the lashing of ropes, and hear the clang of bells."[22]

68

Rao Madho Singh of Kota hunting wild boar

Kota, Rajasthan, ca. 1720

Opaque watercolor on paper;

page: 19¹¹/₁₆ x 24½ in. (50 x 62.2 cm)

The Ashmolean Museum, Oxford,

lent by Howard Hodgkin (LI.118.79)

Published: Topsfield and Beach, *Indian Paintings and Drawings from the Collection of Howard Hodgkin* (1991), no. 35; Bautze, "Portraitmalerei unter Maharao Ram Singh von Kota" (1988–89), fig. 14

The drama of the forest hunt depicted could hardly be surpassed. Madho Singh lunges forward, clutching the neck of his mount, to deal the deathblow to one of the boars with his punch-dagger (*katara*). The hunting dog and the rider's tassels flying out behind underscore the dramatic movement as they dash through the wooded landscape. Despite the apparent spontaneity of this work, with its confident application of light brushwork, the composition is in fact directly modeled on an earlier mural painting preserved at the neighboring state of Bundi.[23] This relationship between wall paintings and works on paper underscores a wider phenonemon in Indian painting that, however, can be securely documented only rarely.

69

Ram Singh I of Kota hunting at Makundgarh

Kota, Rajasthan, ca. 1690
Opaque watercolor and ink on paper;
page: 13⁵/₃₂ x 10¹⁹/₃₂ in. (33.5 x 26.8 cm)
Private Collection
Published: Falk, Smart, and Skelton, *Indian Painting: Mughal and Rajput and a Sultanate Manuscript* (1978), no. 69; Beach, *Rajput Painting at Bundi and Kota* (1974), figs. 60–61

This is the earliest known hunting scene painted on paper from Kota, and it is also one of the most visually dense depictions. The main protagonist is not the hunter but rather his prey, the lion climbing a tree and biting its trunk. This motif, taken from the repertoire of Bundi painting,[24] together with the recognizable facial types, is evidence of the influence of the Hada Master (No. 48). The complex and dense composition extends vertically up the page, as if the viewer is climbing the rugged terrain to the summit, where the picture's climax, the death of the lion, is depicted. The Kota Masters cultivated a distinctive technique that deftly combines ink drawing and lightly applied color washes to great effect.

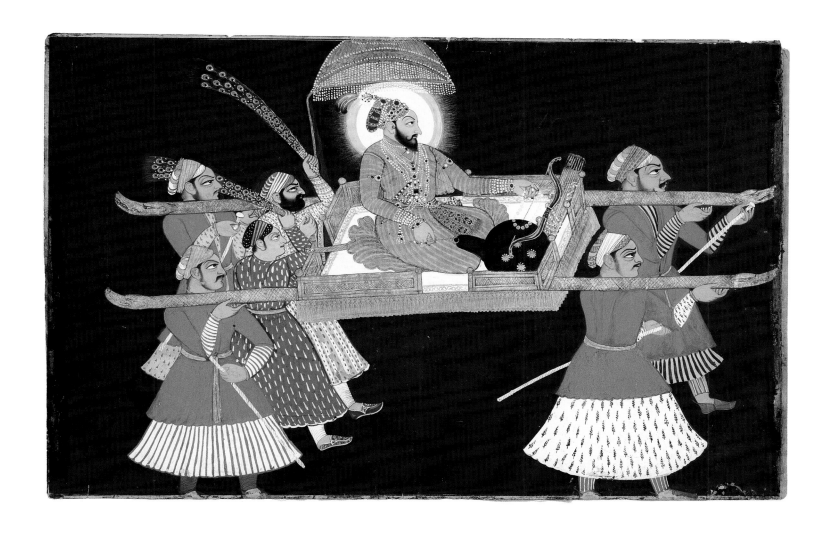

70

Emperor Farrukhsiyar being paraded in a palanquin

Kota, Rajasthan, ca. 1713
Opaque watercolor on paper;
page: 14³/₁₆ x 9³/₁₆ in. (36 x 23.3 cm)
Gursharan S. and Elvira Sidhu

In 1713, the ruler of Kota state in Rajasthan Rao Bhim Singh journeyed to Delhi to offer his congratulations on the accession of Emperor Farrukhsiyar. The events witnessed there presumably inspired this palanquin scene by a Kota master. The work marks a new development in the Kota school, a movement away from the Bundi-inspired landscapes to a reassertion of older conventions, the use of flat washes of dense color on an undifferentiated ground; the effect is as strong as it is compelling. A tilted perspective affords a detailed description of emperor, attendants, and palanquin bearers alike. A preliminary drawing or study for this painting, probably based on events observed during the Kota ruler's diplomatic visit to Delhi, has been identifed.[25]

Bhavanidas

Active at the Mughal court until ca. 1719, then at the court of Raj Singh (r. 1706–48) in Kishangarh to ca. 1748

The later eighteenth-century Mughal painter Bhavanidas is one of the important links between the imperial ateliers and workshops outside the Mughal empire's centers of power. His career falls into two periods; for the first, he was at the Mughal court at Delhi until around 1719, and during the second, he worked in the principality of Kishangarh in Rajasthan.[26]

In the first decades of the eighteenth century, Bhavanidas painted numerous pictures illustrating the genealogies of the great Mughal rulers. One of these, for example, depicts the sons and grandsons of the emperor Shah Jahan (No. 71); another is a group portrait with Timur, the founder of the Mughal dynasty and his descendants.[27] These works are characterized by a formal arrangement of the subjects, whereas others, for example a picture of Emperor Aurangzeb setting out on a hunting party, are structured with greater freedom and number among the last great works of the Mughal workshops.[28] During Aurangzeb's reign (1658–1707), these workshops were gradually dismantled, and the patronage and training of painters were increasingly neglected. Although a few artists, most notably Chitarman II and Mir Kalan Khan, achieved a last flowering of Mughal painting under Aurangzeb's successors, others were obliged to seek their livelihood in other regions of India.

Bhavanidas was one of these who sought a new position far from the political centers of power. From around 1719, he worked at the Rajput court of Raj Singh (r. 1706–48) in Kishangarh. His appointment there was probably arranged through family connections between the Mughals and the princes of Kishangarh. During this period, Bhavanidas began to experiment with new genres such as depictions of famous horses and dreamlike landscape settings for portraits of rulers and paved the way for the expressive characterization of the Krishna and Radha theme, which was brought to perfection by Bhavanidas's student Nihal Chand.

71

Darbar scene with four sons and two grandsons of Shah Jahan

Mughal court at Delhi, ca. 1700–1710

Inscribed: on a vase at lower center, in Persian in *nastal'iq* script, "work of Bhavanidas." A later inscription on the mount identifies the princes of Shah Jahan by name*

Opaque watercolor and gold on paper,

11⁷⁄₈ x 7¹¹⁄₁₆ in. (30.2 x 19.6 cm)

The San Diego Museum of Art,

Edward Binney 3rd Collection (1990.365)

Published: Binney, *Indian Miniature Painting from the Collection of Edwin Binney* (1973), p. 93, no. 68; Pal et al., *Romance of the Taj Mahal* (1989), p. 26, no. 17; Schmitz, "After the Great Mughals" (2002); Goswamy and Smith, *Domains of Wonder* (2005), no. 61*

A number of genealogical pictures survive from Bhavanidas's first period at the Mughal atelier in the service of Bahadur Shah (r. 1707–12).[29] They share the same formal arrangement of picture elements, and various motifs recur in many of them — low tables with porcelain vases of flowers, carpets with floral patterns, and a canopy awning decorated with a pair of birds of paradise circling a solar motif. This work depicts the four sons and two grandsons of Shah Jahan, notably (clockwise, from upper right) Shah Shuja' Bahadur, Aurangzeb, Bahadur Shah, A'zam Shah, Murad Bakhsh, and Dara Shukoh. In this hierarchically ordered group portrait, Bhavanidas did not attempt to present the princes of Shah Jahan's household as personable individuals but rather was content to create an official portrait of two generations of Mughal princes.

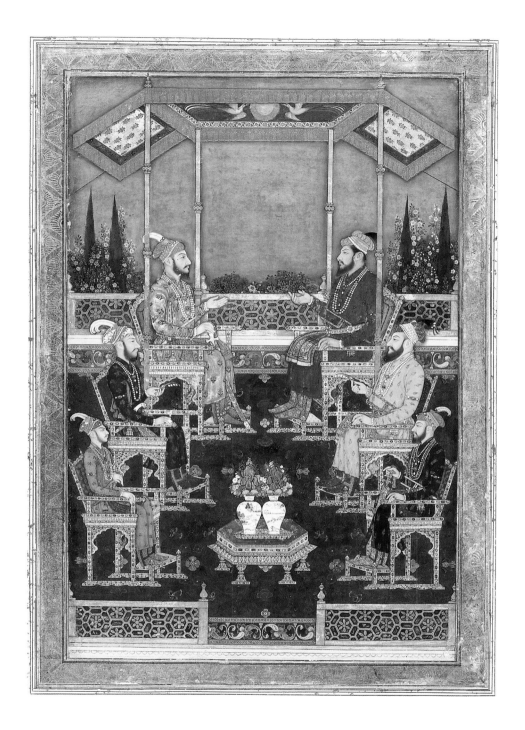

Chitarman II (Kalyan Das)

Active at the court of Emperor Muhammad Shah in Delhi, ca. 1700–ca. 1745

K alyan Das, more popularly known as Chitarman II, was born around 1680, at a time when court atelier structures had largely collapsed, following Emperor Aurangzeb's disavowing of the visual arts.[30] The first two decades of his career can be viewed as a formative period; his apogee came after that time, when he became the most important court painter of his age under a new patron, Emperor Muhammad Shah (r. 1719–48). The intimate subjects he produced, for example the emperor engaged in sex, make it clear that the artist's agenda was dictated by the patron.[31] At the court in Delhi, Chitarman II became a specialist in portraits and figure painting. More formulaic genres such as audience scenes became less prevalent; instead, the patron Muhammad Shah had himself depicted as a hedonistic prince, seen seated on a litter and admiring his garden at sunset (No. 73).

Chitarman II's art documents the emergence of a new era, one that clearly departs from the naturalistic Mughal paintings of the sixteenth and seventeenth centuries, with their vogue for perspectival devices. His works appear somewhat cool at first glance; his colors — predominantly muted whites and grays — tend to have little gradation, rendering his pictures flat and geometric. The figures and architecture are arranged somewhat mechanically, as if with the use of a grid. Chitarman II purveyed a style that, to some extent, was atypical for Mughal-painting; his bold and flat application of color does, however, link to an aesthetic that is similar to contemporary paintings by Meju from the Pahari region.

72

Prince A'zam Shah enters Ahmedabad

Mughal court at Ahmedabad, ca. 1701
Inscribed: in Persian, "When he had become
governor of Ahmedabad in Gujarat, the day he
was [entering] the city — a depiction of that time,
and he had dyed his beard red"*
Opaque watercolor, ink, and gold on paper,
14⅛ x 24⅜ in. (35.9 x 61.9 cm)
The Ashmolean Museum, Oxford,
lent by Howard Hodgkin (LI.118.22)
Published: Welch, *Indian Drawings and Painted
Sketches* (1976), no. 22; Hodgkin and McInerney,

Indian Drawing (1983), no. 39; Topsfield and
Beach, *Indian Paintings and Drawings from the
Collection of Howard Hodgkin* (1991), no. 17*;
Filippi, *Indian Miniatures and Paintings . . . The
Collection of Howard Hodgkin* (1997), no. 22

This majesterial drawing represents Prince
A'zam Shah, the third son of Emperor Aurang-
zeb, on the occasion of his triumphal entry
into Ahmedabad, the capital of Gujarat, where
he served as the Mughal governor from 1701
to 1705. The prince is depicted inspecting the

city from a palanquin, surrounded by royal
guards and ranks of soldiers who hold back
the swelling and disorderly crowds. Undoubt-
edly, such a large scale and detailed study
was intended as a model for a rather grand
painting, although none has survived.

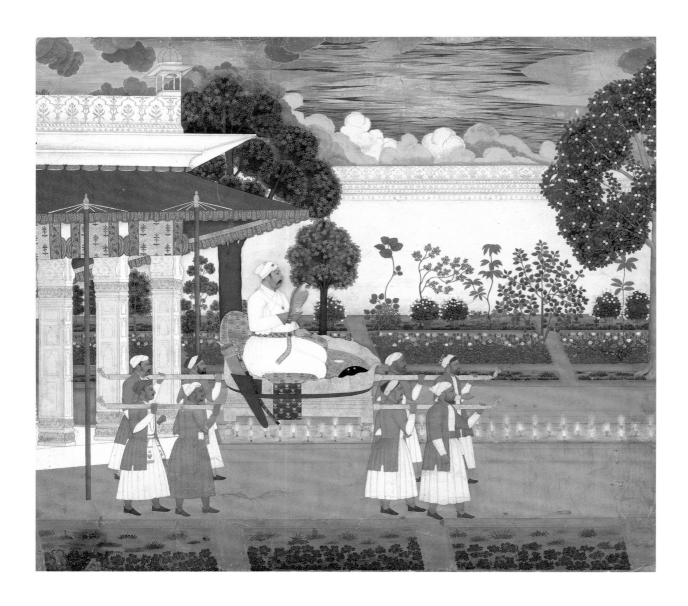

73

Emperor Muhammad Shah with falcon viewing his garden at sunset from a palanquin

Mughal court at Delhi, ca. 1730
Opaque watercolor and gold on paper,
15¹/₁₆ x 16¾ in. (38.3 x 42.5 cm)
Museum of Fine Arts, Boston, Arthur Mason
Knapp Fund (26.283)
Published: Welch, *Imperial Mughal Painting*
(1978), pl. 39; Schmitz, "After the Great Mughals"
(2002); McInerney, "Mughal Painting During the
Reign of Muhammad Shah" (2002), pp. 22–23;
Cummins, *Indian Painting from Cave Temples*
(2006), pl. 37

This attributed work shows Chitarman II at the height of his powers. The composition's formal structure is immediately apparent; each element is carefully placed in this skillfully orchestrated work. The use of white and gradations of gray lends an extra radiance to the pure hues and gold details and serves as a foil to the meticulously rendered garden plants and trees. This walled garden is the interior world of the patron, Muhammad Shah, renowned for his connoisseurship and cultivation of the arts. In a dramatic backdrop above the enclosing wall, a window in the clouds reveals a section of reddish sky streaked with gold. As Cary Welch astutely observed of this late Mughal masterpiece, "Mughal culture long survived its political failure."[32]

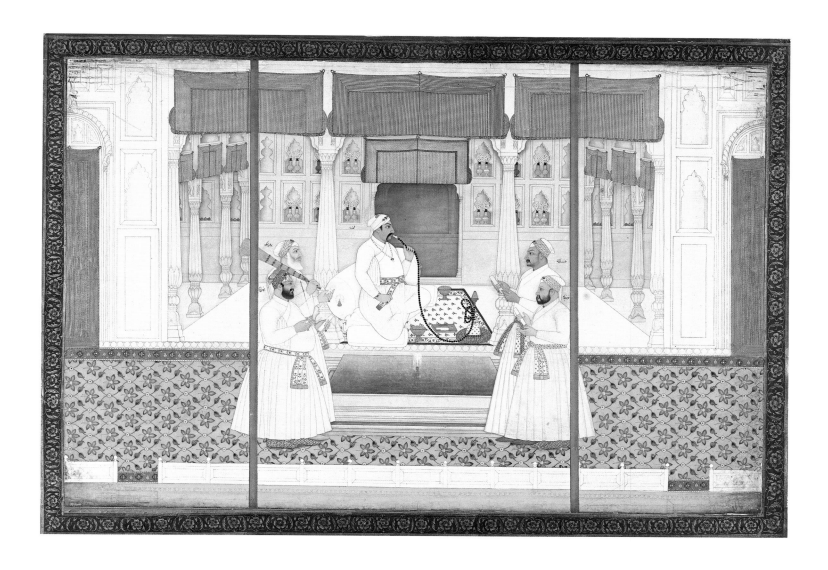

74

Emperor Muhammad Shah with four courtiers, smoking a *huqqah*

Mughal court at Delhi, ca. 1730

Opaque watercolor and gold on paper,

12⁵⁄₁₆ x 18⁷⁄₁₆ in. (31.2 x 46.8 cm)

The Bodleian Library, University of Oxford

(Ms. Douce Or. A. 3, fol. 14r)

Published: Beach, *The New Cambridge History of India: Mughal and Rajput Painting* (1992), pl. O; Topsfield, *Indian Paintings from Oxford Collections* (1994), no. 24; Topsfield, *Paintings from Mughal India* (2008), no. 49

Chitarman's preference for orderly and often symmetrical compositions with architecture limited to white and shades of gray is clearly visible in this scene depicting his patron Muhammad Shah, seen here smoking a (*hookah*) water pipe. Four notable courtiers, identified by inscription as Khan Dauran, Qamaruddin Khan, Raushanuddaula, and Sa'adat Khan Burhanulmulk, the latter the governor of Oudh, flank a fountain in front of the prince.[33] The elegant setting underscores the formal nature of the occasion depicted, the reception of senior nobles by the emperor.

MUGHAL AFTERGLOW AND THE LATER COURT STYLES IN THE PAHARI REGION AND RAJASTHAN
1730–1825

Jorrit Britschgi

The tradition of the great imperial workshops of the Mughal empire would never be wholly restored after the plundering of Delhi by Nadir Shah in 1739 and the subsequent invasion of the Afghans. Never again would the once so splendid Mughal empire attain its former extent and glory, and the cultural power tended to shift away from the politically instable capital toward new centers of patronage.

Some of the later emperors, such as Bahadur Shah (r. 1707–12), Farrukhsiyar (r. 1712–19), and above all, Muhammad Shah (r. 1719–48),[1] had maintained smaller workshops to be sure, or had engaged individual painters, but never again on the scale of the previous two centuries. Yet during this period, painters adopted important stylistic stimuli and developed them further, especially in regions less affected by the empire's decline.

The pictures of the later Mughal painters, such as Mir Kalan Khan, Chitarman II, Nidha Mal, Hunhar, and Faqirulla, depict Islamic and Hindu subjects in equal numbers. Genre scenes of idealized elegant court women or sages and yogis in their hermitages were especially favored. Portraits also remained as popular as ever. But instead of splendidly ornamented scenes, the palettes generally are more restrained. Artists experimented with varied sources of light and also with ways to create shadows, a novelty in Indian painting, for until this time, shadows—in faces or even cast by bodies—had not been in evidence at all. The moon and sun had been included earlier but not as direct sources of light. Mir Kalan Khan was particularly fascinated with rendering pale moonlight, flickering oil lamps, or the rays from lamps used to blind game during the hunt (No. 75). These innovations were not reflected widely in the capital, owing to the absence of both consistent patronage and any appreciable system for training painters. However, events that were occurring outside the principal centers of power came to represent an important development in Indian painting.

With the increasing political chaos in Delhi, numerous painters began to emigrate to Awadh[2] and Bengal. There, under the nawabs, smaller flourishing courts had emerged at which painters might find employment. The most important cities where something of a revival of Mughal painting was happening were Lucknow, Faizabad, Murshidabad, Patna, and Allahabad.[3] In those places, magnificent buildings were erected, and music, poetry, and painting were cultivated, so that the center of Indian culture was shifted effectively to the east. Not surprisingly, all the named artists of stature from this period worked at the courts of rulers including Shuja' al-Dawla (r. 1753–75), Nawab of Awadh. And even in those regions, given the increasing influence of the English East India Company and other Europeans, painting was to undergo a further and fundamental change.

In the foothills of the Himalayas, the Pahari region, important stylistic developments occurred in the period between 1730 and 1810 that indicate painting was not greatly affected by the political troubles of the Mughal capital. The greatest painters came from Pandit Seu's (ca. 1680–1740) workshop in Guler. Over a period of 150 years, artists from Guler would produce works that are among the most beautiful products in all Indian painting. Pandit Seu incorporated elements from the late Mughal style, although he did so much more hesitantly than his son Nainsukh, for example.[4] One can see such naturalistic innovations in a work from his *Ramayana* series (Fig. 19) in the trees and banana groves and in

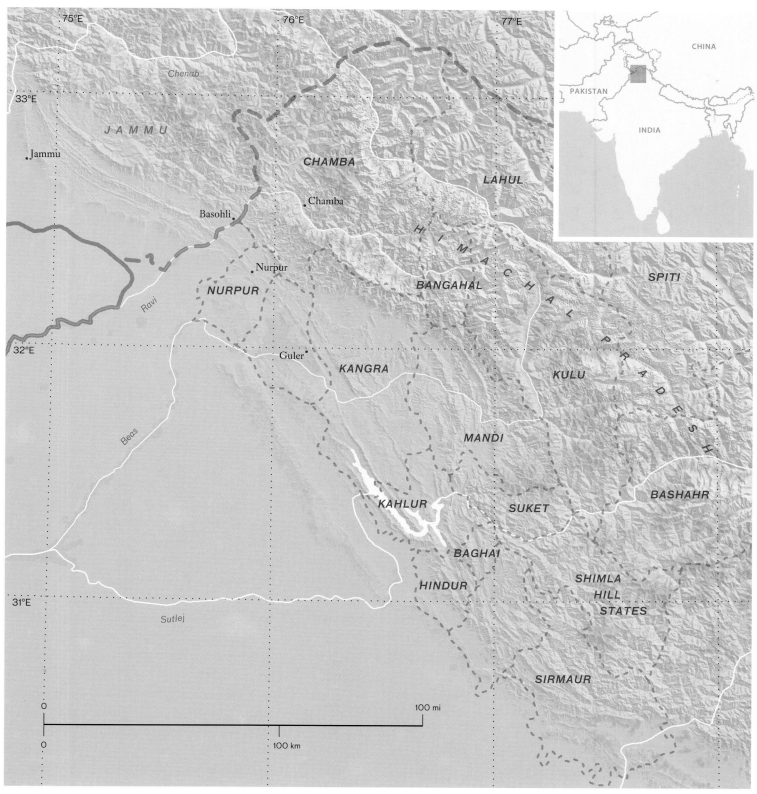

Himachal Pradesh, Jammu, and the Punjab Hills, centers of painting production, 16th–19th century

FIGURE 19. Drunken monkeys and bear fighting in the Madhuvana Grove: folio from a *Ramayana* series, attributed to Pandit Seu, ca. 1720. Guler, Himachal Pradesh; page: 8⁷⁄₁₆ x 12 in. (21.5 x 30.5 cm), painting: 6⁷⁄₈ x 10¼ in. (17.5 x 26 cm). Museum Rietberg, Zurich (RVI 845)

the sequence of movements of drunken monkeys and bears falling over themselves in a forest clearing. Yet earlier pictorial conventions still predominate—distinct outlines and a fondness for strong background colors. Pandit Seu's sons Manaku and Nainsukh were schooled in their father's workshop but followed divergent artistic paths. Manaku can be thought of as a champion of the traditional family workshop style. His paintings, for example the continuation of his father's never completed *Ramayana* series (No. 79), exhibit the same stylistic approach—precisely observed figures combined with a continuing preference for a flat application of color. His brother Nainsukh (Delight of the Eyes), however, began experimenting with new genres and techniques far more than his brother Manaku did. Nainsukh's œuvre is dominated by portraits of his major patrons, most notably Balwant Singh (1724–1763) (Nos. 82, 83). These works, like Chitarman II's pictures of Muhammad Shah, document an extremely close association between artist and patron. In Indian painting, it was exceptional that an artist might have such constant access to his patron; in this case, the relationship is clearly indicated by the fact that Nainsukh was in attendance at Balwant Singh's deathbed, in which the figure probably depicts the deceased ruler.

The sons of Manaku and Nainsukh—Fattu, Khushala, Kama, Gaudhu, Nikka, and Ranjha—referred to collectively as the First Generation (after Nainsukh and Manaku), carried on the rich

family legacy while working for princes in the Kangra Valley.[5] Their works that are indebted more clearly to those of Nainsukh than those of Manaku attest to the artist family's uniform vision. Precisely because of this, one cannot speak of a Kangra style; it is more appropriate to recognize a style of family-based workshops. The moods evoked in the epics and poems illustrated by these First Generation artists are captured brilliantly (Nos. 87–89). Nature serves as more than a mere setting for the events portrayed; it is now used to convey a given atmosphere. Techniques such as depth perspective clearly show that conventions from Mughal painting were assimilated widely.

Other important workshops were also located in the Kangra region, notably that of the painter Purkhu. A contemporary of the First Generation artists, Purkhu created numerous portraits of his courtly patrons, especially Sansar Chand of Kangra (r. 1775–1823) (Fig. 3). In addition, he produced illustrations for the major Indian epics and for the Hindu devotional *bhakti* literature, for example the *Gita Govinda*.

Painting in Udaipur, as first identifiably represented by the work of Nasiruddin and Sahibdin, did not adopt realistic elements from Mughal painting to the same degree. A typical eighteenth-century example is a large atelier that worked to satisfy the seemingly unending demand for illustrations of religious texts and for court scenes of great grandeur (Nos. 101 and Fig. 20). The princes in the extensive palace complex above Lake Pichola had themselves pictured in the landscape of Udaipur, typically as viewed from above and in combination with blindingly white palace facades. Works document important events at court under Jagat Singh II (r. 1734–51), for example, almost as meticulously as any diarist would represent them. The extravagant display of splendor in the paintings from this period also must be seen as a response to a growing political impotence. Mewar was under mounting pressure from Maratha advances from the south; it is as though they might be able to stave off impending danger with painted images of an ordered and opulent world. A relatively uniform style predominated at the highly organized Udaipur ateliers, and the strictures imposed on artists allowed little opportunity for individual expression. This is evident most clearly in the careers of Bagta and Chokha; both were trained in these ateliers but then returned to Devgarh, where they were able to develop their art in a smaller and more intimate environment free of established conventions (No. 97).

The absence of large ateliers at the Mughal capital also favored the development of local workshops at other courts. Bhavanidas began working in Kishangarh, for example, during the first quarter of the eighteenth century, and armed with his courtly Mughal stylistic repertoire, he trained artists like Nihal Chand, who would usher in the ultimate flowering of Kishangarh painting under the ruler Savant Singh. These painters, even more than those of the Pahari region, specialized in pictures pervaded with *bhakti* sentiments. Among their most frequently painted subjects are large images of Krishna and Radha. These are romantic and ecstatic works, with expansive backgrounds in which a recurring feature is the depiction of the figures with highly arched eyebrows, pointed noses, and elongated faces.[6]

While it is possible to discern a decline in the eighteenth century from earlier cultural greatness and outstanding artistic achievement, Indian painting was enriched during that period in various ways by itinerant painters and by new patrons such as the nawabs and the officials of the English East India Company. At many Indian courts, the quality of painting decreased rapidly, indicating that this flowering around the political periphery was relatively brief; the artists from the second generation after Nainsukh and Manaku in Guler bear witness to this process. Art patronage was not equally vigorous in the hills and at smaller courts, and the lack of a centrally embedded atelier to support both the training of artists and the patronage of art was beginning to take its toll.

FIGURE 20. Maharana Jagat Singh is rowed to his island palace, unknown master at the court of Udaipur, ca. 1740. Rajasthan, Udaipur. Museum Rietberg, Zurich, Gift of Balthasar and Nanni Reinhart (RVI 1832)

Mir Kalan Khan

Active at the court of Muhammad Shah in Delhi and for Shuja' al-Dawla, Nawab of Awadh, ca. 1730–ca. 1770

One might characterize the style of Mir Kalan Khan as eccentric or mannerist. Although the painter was a contemporary of Chitarman II, he developed an entirely individual style, devoid of influence from the dominant style of the day, that of the court of Muhammad Shah at Delhi. Mir Kalan Khan was a master of expansive panoramas and of tonality that occasionally verges on the strident, even loud, owing to his daring use of color. He also produced works in a soft palette that closely approximates the appearance of watercolors. Most notable among these are depictions of saints and mystics living in isolation, a particularly popular subject.[7] Another series is extremely fascinating due to the use of unusual light sources; saints are shown at a fire, for example, or in moonlight, and each scene is carefully illuminated from multiple light sources.

Mir Kalan Khan worked at a time when the political situation in northern India was highly unstable. Following the capture and sacking of Delhi by the Persian ruler Nadir Shah in 1739, there was further internal unrest. Yet it was possibly the very uncertainty of the times that led the painter to explore such a broad range of subjects and techniques over the course of his career.

The artist's earliest signed and dated work (No. 75) is typical in two respects. It depicts a night scene, and it attests to his interest in the rendering of varied sources of light. The subject matter is simple, but Mir Kalan Khan created a complex spatial structure that extends far into the distance. Tents and villages are painted only cursorily in white, even at the upper edge of the picture. The light cast by the lamp belonging to the hunter dressed in a skirt of leaves may be rendered scientifically; the effect is wholly credible, with subtle modeling. This painting was made in Delhi, but Mir Kalan Khan also produced another series elsewhere, for Shuja' al-Dawla, Nawab of Awadh.[8] In view of the tense political situation in the mid-eighteenth century, it is not surprising that painters moved away from Delhi to newly emerging centers of power, principally in the eastern provinces, where they maintained their own ateliers and courted the favor of the local aristocracy. Instead of the relatively coherent styles preferred in the extensive illustration projects commissioned by the sixteenth- and seventeenth-century Mughal emperors, this phase of Indian painting presents a period of great diversity that is most apparent if one compares the works of Chitarman II with those of Mir Kalan Khan. While the former operated with a subdued and consistent color palette, the latter experimented with a variety of color schemes and compositional patterns.

75

Hunting antelopes at night: page from the St. Petersburg Album

Mughal, Delhi, dated 1734–35
Inscribed: "work of Mir Kalan 1147 [1734–35]"
Opaque watercolor and ink on paper, 3⅜ x 11⅛ in. (8.6 x 28.3 cm)
Russian Academy of Sciences, Institute of Oriental Studies, St. Petersburg (Ms. 30, f. 56r)
Published: Habsburg et al. *The St. Petersburg Muraqqa* (1996), pl. 214

Mir Kalan Khan, who signed and dated this work, was a contemporary of Chitarman II and shared with him the patronage, although not the highest favor, of emperor Muhammad Shah for much of his career. His work is both archaic and eccentric, exploring with clinical precision the effects of theatrical lighting (a Mughal fascination of a century earlier) and an old-school naturalism that was becoming increasingly unfashionable. His compositions are complex and, as seen here, often enigmatic. Two hunting parties appear, a tribal couple hunting by torchlight seen at left, and to the right, a Mughal hawking party led by an adolescent prince, perhaps the emperor's son Prince Ahmad Shah. The latter appears at the vanguard of a large army wending its way through this deeply recessed and gloomy landscape. This nocturnal hunting scene takes place in a complex layered space, which includes individual elements that Mir Kalan Khan was to use again in later pictures (No. 76).

76

Baz Bahadur and Rupmati hawking

Mughal, Delhi, ca. 1740–50

Opaque watercolor on paper, 8³/₁₆ x 10½ in.
(20.8 x 26.7 cm)

Eva and Konrad Seitz Collection

Published: Seyller and Seitz, *Mughal and Deccani
Paintings* (2010), no. 20

The Muslim ruler Baz Bahadur and his beloved, Rupmati — a favorite subject in Indian painting that transcends caste and religious affiliation — are shown on horseback in this expansive landscape. Although the lighting effects in this attributed work are less dramatic than they are in the signed and somewhat earlier work in the St. Petersburg album (No. 75), it is possible to recognize elements common to both pictures.[9] Both share a landscape that extends far into the distance in a series of overlapping hillocks and a common treatment of the equestrian groups and specific motifs like the felled lion who is transported on a camel.

Manaku

Active at the court in Guler ca. 1725–ca. 1760; son of Pandit Seu,
brother of Nainsukh, father of two sons, Fattu and Khushala

The painter Pandit Seu worked in Guler, Himachal Pradesh, and together with his two sons Manaku and Nainsukh, he dominated one of the most exciting periods of Pahari painting. Manaku remained more indebted to his father's style, while Nainsukh studied Mughal painting extensively and left the court in Guler to work for other patrons.

Manaku, the older of the two brothers, produced a true masterpiece in 1725, his illustrations to the last part of the *Ramayana*, the so-called Siege of Lanka series (No. 79). In that work, he continued the large-format *Ramayana* series that his father had begun, developing new compositional solutions for the depiction of complex narrative scenes. The young Manaku painted with the sure hand of a seasoned practitioner, and his talent, attested by his drawings, was immediately celebrated. Around 1730, he produced a series of 150 folios on one of the central texts of Krishna worship, the *Gita Govinda*.[10] No illustrations for that text had been painted before in the Pahari region. Created for a Lady Malini, the series represents the crucial turning point in Manaku's early work. It presented a considerable challenge to understand all the subtleties and complexities of the text and to develop appropriate compositional solutions. An especially beautiful example is Manaku's visualization of the textual passage describing the south wind cooling itself in the Himalayas (No. 77).

Manaku's work borrowed from that of his father, Pandit Seu, in its formal repertoire, especially visible in conventions for rendering trees and faces and in its compositions with monochrome backgrounds and high horizon lines with white and blue washes. Only in his later works (No. 81) did more realistically painted elements become more evident.

The artistic legacy of the brothers Manaku and Nainsukh was taken up by their sons. A series attributed to Manaku's son Fattu,[11] from around 1760, reveals considerable borrowing from Manaku's work, while the style of other known works by the sons of these brother artists is more reminiscent of that of Nainsukh.

Above: Portrait of Manaku, attributed to Nainsukh, Guler, Himachal Pradesh, ca. 1740.
Government Museum of Art, Chandigarh (D-116)

77

South wind cools in the Himalayas: folio from a *Gita Govinda* series

Guler, Himachal Pradesh, dated 1730
Opaque watercolor on paper, 8⅜ x 12¹⁄₁₆ in.
(21.2 x 30.7 cm)
National Museum New Delhi (51.207/9)
Published: Randhawa, *Basohli Painting* (1959),
pl. 21; Daljeet, *Indian Miniature Painting* (2006),
pp. 178–79

The 150 folios of the *Gita Givinda* that Manaku completed for a Lady Malini in 1730 are a remarkable achievement, for this was the first time this twelfth-century text was illustrated in the Pahari region. At the same time, the series — along with other individual works that bear his name — is crucial to any reconstruction of Manaku's career at the Guler court. The depiction of the hot south wind served as a pattern for the artists of the first generation (No. 78). Both define the hot and unhealthy south with snake-entwined trees and the Himalayas with snow and ice, but, although they share the same pictorial elements of trees and rocks, the compositions are very different. Following his father, Pandit Seu, in his *Ramayana* series, Manaku incorporated a high horizon line edged with clouds, an archaic convention that disappeared with the next generation of painters.

78

South wind cools in the Himalayas: folio from the second Guler *Gita Govinda* series

Guler, Himachal Pradesh, ca. 1775
Opaque watercolor on paper;
painting: 6⅛ x 10 in. (15.6 x 25.4 cm);
page: 7 x 10¹³/₁₆ in. (17.8 x 27.4 cm)
Museum Rietberg, Zurich, Eva and
Konrad Seitz Collection (A 6)
Published: Daljeet, *Indian Miniature Painting*
(2006), pp. 178–79

This work is so close in composition to Manaku's visualization of the same passage

from the *Gita Govinda* from 1730 (No. 77) that this artist of the first generation (see p. 166) must have known that earlier work. In connection with Radha and Krishna, the *Gita Govinda* speaks of hot winds, fragrant with sandalwood and laden with serpent venom, which carry from the south into the Himalayas. In Manaku's original realization, the source of the wind is on the left, and the snow in the Himalayas is on the right; in this later version, the south is set in the background, and the Himalayas appear in the foreground. Both works are highly original visualizations of the *Gita Govinda*'s evocative text.

79

**Rama releases the demon spies
Shuka and Sarana: folio from a
Ramayana Siege of Lanka series**
Guler, Himachal Pradesh, ca. 1725
Inscribed: on reverse with Sanskrit text in
devanagari script
Opaque watercolor, ink, and gold on paper;
painting: 22¼ x 31¼ in. (56.5 x 79.4 cm);
page: 23½ x 32¾ in. (59.7 x 83.2 cm)
The Metropolitan Museum of Art, New York,
Rogers Fund, 1919 (19.24.1)

Published: Craven, *Ramayana: Pahari Paintings*
(1990), p. 28; Goswamy and Fischer, *Pahari
Masters* (1992), pp. 250–51; Kossak, *Indian Court
Painting* (1997), no. 46

The Siege of Lanka series is the first one that
can be attributed to Manaku. It covers only
the last portions of the Valmiki *Ramayana*
and therefore can be thought of as a continu-
ation of the series begun by his father, Pandit
Seu. The large format was unusual for its time

and called for new compositional solutions.
One suspects that the works from this series
were conceived more for recitation of the text
before a large audience than for private view-
ing. Eight completed works are known, as are
a larger number of unfinished paintings and
drawings for the series.

80

Rama and Lakshmana overwhelmed by arrows: folio from a *Ramayana* Siege of Lanka series

Guler, Himachal Pradesh, ca. 1725
Ink on paper; painting: 22⅜ x 31½ in.
(56.8 x 80 cm); page: 23½ x 33 in.
(59.7 x 83.8 cm)
The Metropolitan Museum of Art, New York,
Rogers Fund, 1919 (19.24.4)
Published: B[reck], "Recent Accessions; Rama-yana Illustrations" (1919), pp. 64–65; Coomaras-wamy, *Catalogue of the Indian Collections in the Museum of Fine Arts, Boston* (1926), pp. 46, 78ff.;

Dimand, *A Handbook of Mohammedan Decorative Arts* (1930), p. 65; Beach, "A Bhagavata Purana from the Punjab Hills" (1965); Craven, *Miniatures and Small Sculptures from India* (1966), fig. 60a; Craven, *Ramayana: Pahari Paintings* (1990), no. 58; Kossak, *Indian Court Painting* (1997), no. 47

One has to marvel at Manaku's assured hand in the drawings for the Siege of Lanka series, as he captured such a complex scene with such an economy of strokes. Even repeated elements, such as the monkeys and bears, are individualized, attesting to the artist's gift

for observation and characterization. The two main protagonists in this scene, Rama and Lakshmana, have been captured by magical serpent arrows, and the army is deliberating how they might be saved. Evident in this drawing are typical Manaku compositional elements, such as the curved horizon line and the half submerged fish in water, both devices derived from the repertoire of his father, Pandit Seu.

81

Krishna playing blindman's bluff

Guler, Himachal Pradesh, ca. 1750–55
Inscribed: on reverse, "painted by Manak"*
Opaque watercolor, ink, and gold on paper,
9⅝ x 6¾ in. (24.4 x 17.1 cm)
The Kronos Collections
Published: N. C. Mehta, *Studies in Indian Painting*
(1926), pl. 21; Khandalavala, *Pahari Miniature
Painting* (1958), no. 241; Goswamy and Fischer,
Pahari Masters (1992), no. 111*; Kossak, *Indian
Court Painting* (1997), no. 60

This late work, one of the few that bear
Manaku's name, includes stylistic elements
that suggest greater borrowings than occurred
earlier from the work of his brother Nainsukh.
The trees, for example, are painted realistically,
and they no longer are based on formulaic
stereotypes like those seen in the *Gita Govinda*
series. The landscape appears embedded in
space, with the edges of the hill rendered in
the lighter tones seen in many paintings from
the first generation after Nainsukh. The mono-
chrome background has given way to a land-
scape with lush vegetation, and stars and a
resplendent full moon shine down on the pro-
ceedings. Typical Manaku compositional ele-
ments include the indication of a river in the
foreground. It is not known whether this work
was a single piece or part of a series.

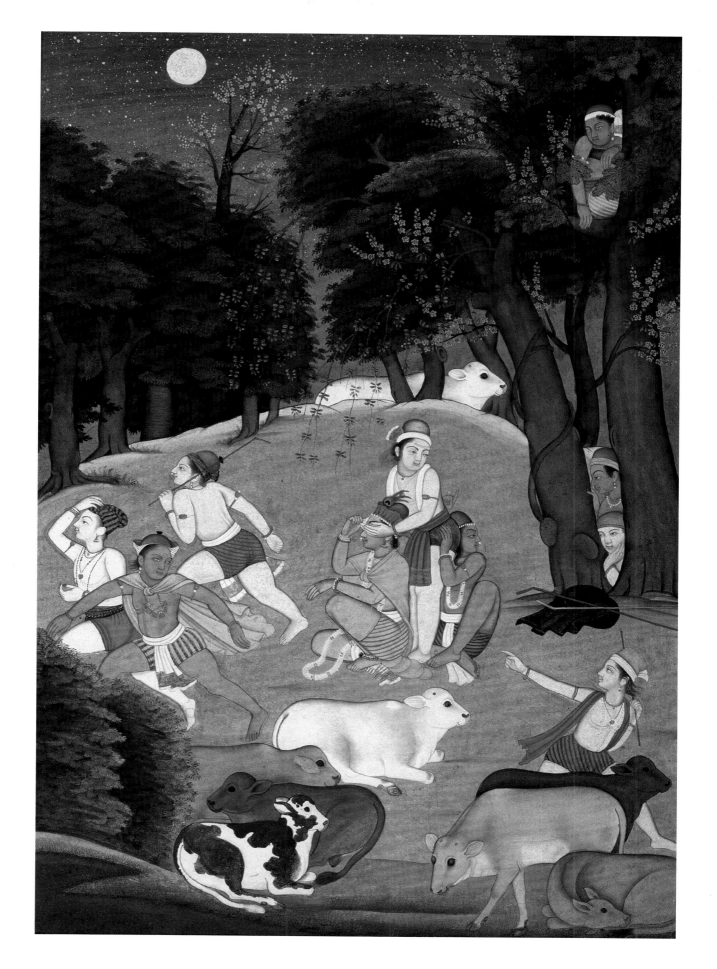

Nainsukh

*Active ca. 1735–78, first at Guler, then at Jasrota for Mian Zorawar Singh
and his son Balwant Singh; son of Pandit Seu, brother of Manaku,
father of Kama, Gaudhu, Nikka, and Ranjha*

Nainsukh, the younger brother of Manaku (see pp. 153–59), is one of the most exceptional figures in Pahari painting. Like his brother, he was schooled in the stylistic idiom developed by his father, Pandit Seu. But while Manaku based his career at the court of Guler on the fundamental principles of his father, Nainsukh took another path, one that is apparent in both his choice of picture subjects and his unmistakable style. Although his early work is insufficiently documented (No. 85), there are indications that Nainsukh was familiar with the pictures of the Mughal painters and borrowed from them in matters of composition and style.

The best documented phase of Nainsukh's career begins with his departure from the family atelier for Jasrota, where around 1740, he began painting for a ruler by the name of Mian Zorawar Singh and his son Balwant Singh.[12] Nansukh depicted Balwant Singh in countless paintings that attest to the painter's incredibly sensitive ability to capture specific situations and moods. His relationship with Balwant Singh must have been a close one, and the range of pictures produced in this period is broad, capturing the minutia of the ruler's daily life — the prince having his beard trimmed, looking out of the window of his palace, relaxing in front of the fireplace, or writing a letter. Even given the closeness of the relationship, it is extraordinary that in at least two pictures depictng scenes of the prince's life, Nainsukh appears in a relatively prominent position; one of those works shows Balwant Singh viewing a painting (No. 83).[13] One can easily imagine the painter shadowing his patron and using his precise gift for observation to register every detail of what he saw, however unimportant. An outstanding example of this is his depiction of a temporary tented memorial shrine on which hangs an amulet that Balwant Singh is frequently pictured wearing, suggesting that the urn contains the ashes of Nainsukh's patron (No. 84).

Nainsukh's gift for precise observation and his interest in realistic pictures indicate that he pursued an artistic vision wholly different from that of his brother Manaku, who worked within more traditional parameters. The works by the sons of Manaku and Nainsukh (see pp. 166–75) appear to be more substantially indebted to Nainsukh's painterly approach than to Manaku's.

Above: Self-portrait of Nainsukh, Guler, Himachal Pradesh, ca. 1730. Indian Museum, Kolkata (659)

82

Raja Balwant Singh of Jasrota worships Krishna and Radha

Jasrota, Himachal Pradesh, ca. 1745–50

Opaque watercolor, ink, silver, and gold on paper,
7¾ x 6⅛ in. (19.7 x 15.6 cm)

The Metropolitan Museum of Art, New York,
Rogers Fund, 1994 (1994.377)

Published: Goswamy, *Nainsukh of Guler* (1997),
no. 44; Kossak, *Indian Court Painting* (1997),
no. 58

In this intensely personal image of a devotee, Balwant Singh stands in veneration of a vision of Krishna and Radha enthroned on a gilded and cushioned throne. The setting is a terrace in his own court, offset with a beautifully decorated arched niche, painted in a manner to suggest *pietre dure* (*parchin kari*). An orange-colored canopy projects diagonally into the composition. The remaining space, occupied by the devotee, is devoid of descriptive or decorative details, and a simple vista of a river and hills beyond completes the composition. Subtly, Nainsukh created two contrasting worlds, one occupied by the deity and the other by his devotee (*bhakta*) standing at the threshold. Balwant Singh gazes on Krishna (*dharana*) and in turn receives his Lord's grace.

83

Raja Balwant Singh of Jasrota viewing a painting presented by the artist Nainsukh

Jasrota, Himachal Pradesh, ca. 1745–50
Opaque watercolor and gold on paper,
8¼ x 11¹³/₁₆ in. (21 x 30 cm)
Museum Rietberg, Zurich, Gift of Balthasar and Nanni Reinhart (RVI 1551)
Published: W. G. Archer, *Indian Paintings in the Punjab Hills* (1952), fig. 36; Khandalavala, *Pahari Miniature Painting* (1958), no. 93; Goswamy, "Pahari Painting: The Family as the Basis of Style"

(1968), fig. 2; W. G. Archer, *Indian Paintings from the Punjab Hills* (1973), vol. 2, pl. 142; Desai et al., *Life at Court* (1985), no. 86; Goswamy and Fischer, *Pahari Masters* (1992), no. 117; Goswamy, *Nainsukh of Guler* (1997), no. 39

In Indian painting, it is rare for artists to depict themselves in their works. When they do, it is generally as a discrete marginal detail, at the edge of an audience scene for example. But here, Nainsukh portrayed himself prominently, bent forward in deference, waiting for his patron Balwant Singh's reaction to the picture of Krishna he is studying intently. This unusual composition reveals the close relationship that existed between the prince and the artist that extended over twenty-five years, including a period of exile with his patron in Guler. No detail escapes Nainsukh, whether it is the *hookah* (tobacco pipe) sheathed in fabric or the rendering of the lush foliage visible beyond the portico.

84

Portable Vishnu shrine, probably the reliquary for Balwant Singh

Guler, Himachal Pradesh, 1763
Inscribed: in Takri script, "The picture of Shri Lakshmi Narayana"*
Opaque watercolor and gold on paper;
painting: 5²⁹/₃₂ x 7½ in. (15 x 19.1 cm);
page: 7½ x 9¼ in. (19.1 x 23.5 cm)
Private Collection

Published: Welch and Zebrowski, *A Flower from Every Meadow* (1973), no. 46; Christie's London, April 23, 1981, lot 186; Goswamy and Fischer, *Pahari Masters* (1992), no. 126*; Goswamy, *Nainsukh of Guler* (1997), no. 87

It is known from written sources that in 1763, Nainsukh accompanied the ashes of his patron Balwant Singh on the journey to Haridwar, and there, the ashes were committed to the river.[14] In this picture, there is one convincing indication that Balwant Singh's mortal remains are beneath the white cloth, notably the amulet that hangs around it. The same amulet appears in several of Nainsukh's portraits of Balwant Singh. The most important phase of Nainsukh's career came to an end with this work. Beginning in 1742, he had painted so many portraits of Balwant Singh that they almost constitute a diary, and here, he paid his patron his last respects.

85

A Troup of trumpeters

Guler, Himachal Pradesh, ca. 1735–40

Opaque watercolor on paper, 6⅜ x 9¼ in.

(16.2 x 23.5 cm)

Private Collection

Published: Ashton, *The Art of India and Pakistan* (1950), no. 621; Goswamy, *Nainsukh of Guler* (1997), no. 13

Nainsukh probably produced this early work while still in Guler, before he left his father's workshop to move to Jasrota. It portrays a group of *turhi* players on a terrace, energetically blowing into their instruments. Already in evidence are Nainsukh's gift for precise observation and his skill in creating a complex composition with directional thrusts like those of the trumpets that energize this work, heightened by accents of color. There is no clue as to what these musicians are celebrating, but likely candidates include a wedding or a birth.

86

An Acolyte's progress

Guler, Himachal Pradesh, ca. 1760–65

Opaque watercolor and ink on paper, 7 x 10½ in.
(17.8 x 26.7 cm)

Cynthia Hazen Polsky

Published: Arthur Tooth and Sons, *Indian Paintings* (1975), no. 42; Goswamy, *Nainsukh of Guler* (1997), no. 86; Topsfield et al., *In the Realm of Gods and Kings* (2004), no. 82

This is one of only two known works in Nainsukh's oeuvre that depict an allegorical subject in a continuous narrative. It is intended to be read from left to right and shows the advancement and temptation of a *Brahmacharya* (Hindu adept). First, the pupil is shorn. Then, he spies another pupil picking ripe fruits from a tree. As though the curse of temptation still clings to him, he is struck by a falling fruit and continues swiftly on his way.

First Generation after Manaku and Nainsukh: Fattu, Khushala, Kama, Gaudhu, Nikka, and Ranjha

Active at a number of Pahari region courts, mainly in the Kangra Valley, ca. 1740–1830; sons of Manaku (Fattu and Khushala) and Nainsukh (Kama, Gaudhu, Nikka, and Ranjha)

The four sons of Nainsukh and two sons of Manaku are known collectively as the first generation after Nainsukh and Manaku. Building on the artistic legacy of their grandfather Pandit Seu and their fathers, the six younger artists left behind an extensive œuvre that attests to the family's consistent artistic vision and uniformly impressive output.

A relatively small court like Guler, the family's home in Himachal Pradesh, could not provide a living for so many talented artists. Nainsukh left the atelier around 1740; he first worked in Jasrota, then in Basohli, and was ultimately joined there by his nephew Fattu and his youngest son, Ranjha. There were numerous small courts in the region, and they offered opportunities for talented painters seeking new opportunities. Surprisingly little is known about the authorship of individual series of paintings, and works cannot be assigned confidently to specific artists.

The influence of a large-format *Bhagavata Purana* series produced by Manaku can be seen in a less accomplished series depicting the same subject attributed to his son Fattu.[15] The faces are more angular, and the scenes are routinely placed in front of a monochrome background. The atmosphere evoked in the texts is not realized nearly as clearly as it is in the works by Manaku. It appears that the family style gradually shifted from the transitional Seu-Manaku phase toward the refined vocabulary of Nainsukh, characterized by a gift for precise observation, an absolutely assured hand, and an exceptional ability to convey human emotions. The *Gita Govinda* series of around 1775 (No. 92), *Bhagavata Purana* series of around 1780 (No. 89), *Ramayana* series of around 1780 and later additions (No. 87),[16] and other works attributed to the artists of the first generation document these changes most impressively. They represent the culmination of Pahari painting, and thanks to their startling combination of dreamlike lyricism and realism, they are among the most alluring of Indian paintings.

87

**Rama, Sita, and Lakshmana
at the hermitage of Bharadvaja:
folio from a *Ramayana* series**

Kangra, Himachal Pradesh, ca. 1780
Opaque watercolor and ink on paper;
painting: 8⅛ x 12⅛ in. (20.6 x 30.8 cm);
page: 9¹⁵⁄₁₆ x 14¹⁄₁₆ in. (25.2 x 35.7 cm)
The Metropolitan Museum of Art, New York,
Seymour and Rogers Funds, 1976 (1976.15)
Published: Kossak, *Indian Court Painting*
(1997), no. 62

As told in the *Ramayana*, the cell of the hermit of Bharadvaja is one of the first places that Rama, his consort Sita, and his half-brother Lakshmana visited after they were exiled from Ayudhaya, their rightful home. The hermitage scene depicted here is immediately preceded in the narrative by the three protagonists crossing the river. That event appears in the upper left of this composition, and it is also the subject of a separate painting in the series. Continuous narratives can be identified in many pictures from this *Ramayana* series. What the artists were able to capture especially well — a legacy of their father's and uncle's precise gifts for observation — are wonderful landscape scenes, visualizations of those described in detail in Valmiki's *Ramayana*.

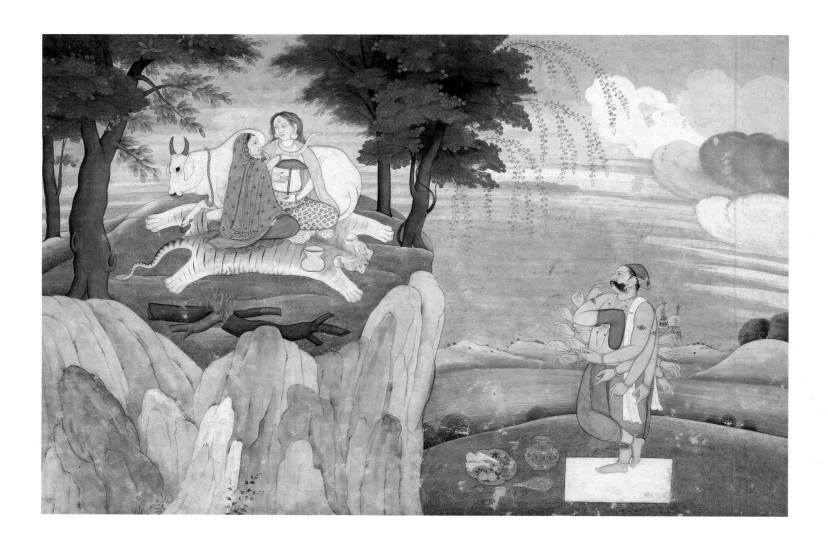

88

**Banasura's penance, his vision
of Shiva and Parvati: folio from
an *Usha-Aniruddha* series**

Probably Chamba, Himachal Pradesh, ca. 1775
Opaque watercolor on paper;
painting: 8¹/₁₆ x 11 ¹⁵/₁₆ in. (20.5 x 30.4 cm);
page: 8¹⁵/₁₆ x 12³/₈ in. (22.7 x 31.4 cm)
Museum Rietberg, Zurich, Collection Eva and
Konrad Seitz (B 41)

The subject of this series, the story of Usha and Aniruddha, is found in the tenth book of the *Bhagavata Purana.* One night, Banasura's daughter Usha dreams of the handsome prince Aniruddha and surrenders her virginity to him. Banasura goes to war against Krishna over this stain on his family honor. But his life is saved thanks to the intervention of Shiva, and in the present painting, Banasura is seen worshipping Shiva and Pavati enthroned on Mount Kailash. This work is attributed to Nikka (ca. 1745–1833), third son of Nainsukh, who enjoyed the patronage of Raja Raj Singh of Chamba and was granted land there, which his descendants still occupy to this day.

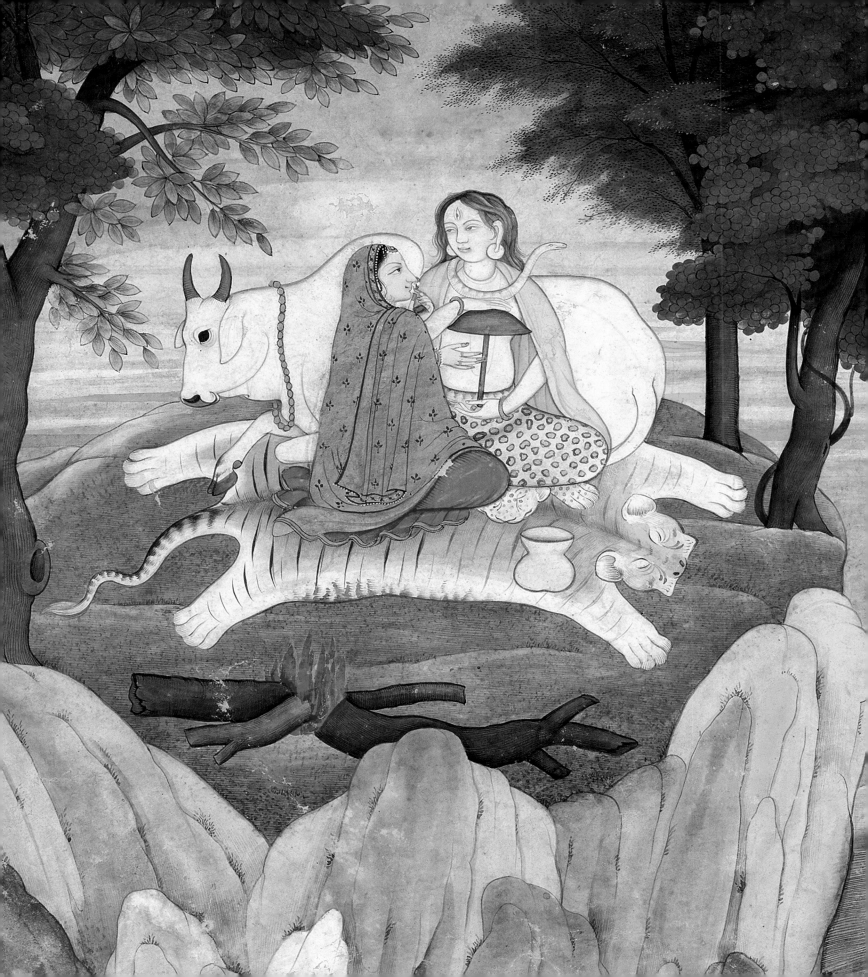

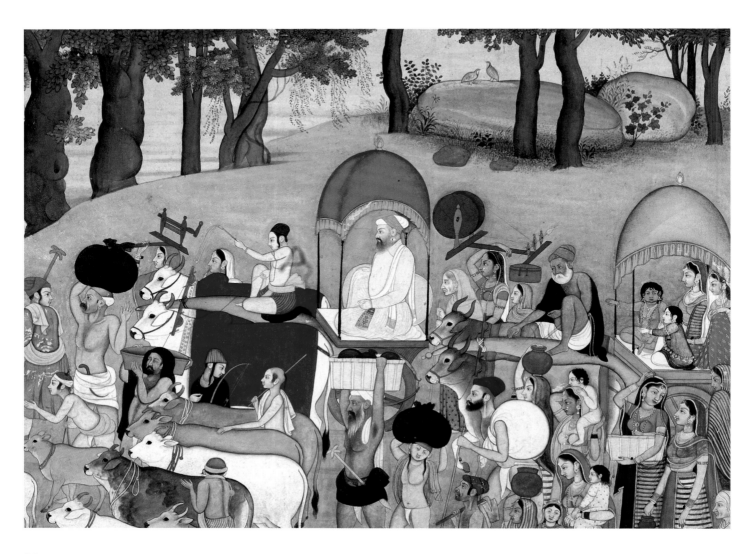

89

**The Infant Krishna journeying from
Gokula to Vrindavan: folio from a
Bhagavata Purana series**

Guler, Himachal Pradesh, ca. 1780
Opaque watercolor on paper, 10⅞ x 14 in.
(27.6 x 35.6 cm)
National Museum, New Delhi (49.19/239)
Published: Randhawa, *Kangra Paintings of
the Bhagavata Purana* (1960), pl. 5

In the classic image of journeying in India, we
are so taken up with the evocative descrip-
tion of the everyday toils of traveling that we
could overlook the subject of the painting,
the infant Krishna, who is seen at right seated
on a simple buffalo-drawn carriage. This is
Krishna's version of the biblical Flight into
Egypt; he was sent from his palace to the
countryside to live with foster parents in
order to escape a prediction of infanticide.
The intensity of the foreground activity con-
trasts with the quiet calm of the landscape
beyond, which is a forecast of Krishna's happy
childhood years to be spent in the village
of Vrindavan with his foster parents, Yasoda
and Nanda.

90
Krishna and Radha enjoy a winter's evening on a roof terrace, in the month of *Margashirsha* (November–December): folio from a *Baramasa* series

Guler, Himachal Pradesh, ca. 1780
Opaque watercolor, gold and silver-colored
paint on paper, 11¹¹⁄₁₆ x 8⅛ in. (28.1 x 20.6 cm)
Philadelphia Museum of Art, Alvin O. Bellak
Collection, 2004 (2004-149-76)
Published: Spink & Son, *Two Thousand Years
of Indian Art* (1982), no. 115; Mason, *Intimate
Worlds* (2001), no. 84

The artists of the first generation after Manaku
and Nainsukh explored new themes, and a
favored subject was paintings illustrating the
pleasures of each season, based on poems
for each of the months (*Baramasa*). In this
interpretation of *Margashirsha* (November–
December), the cold season is evoked by a
pair of lovers, Krishna and his companion, on
a candlelit terrace, huddled together under a
blanket beneath a starry sky. Krishna is offer-
ing her a quid of betel (a stimulant to be
chewed and savored) for her enjoyment.

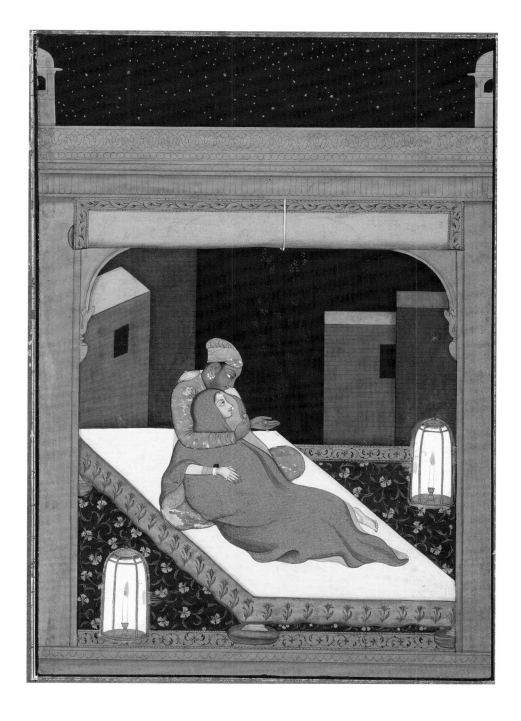

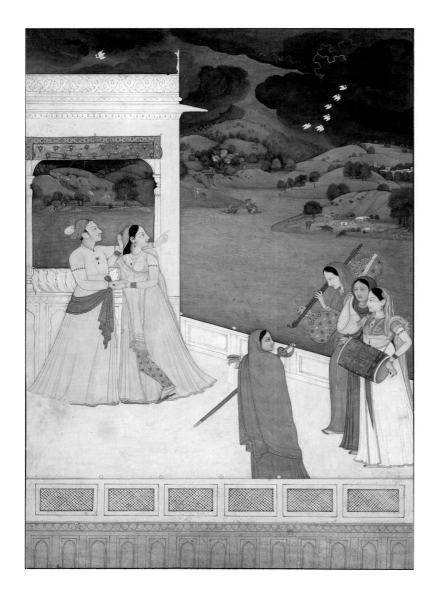

91

Lovers watching an approaching thunderstorm

Guler, Himachal Pradesh, ca. 1780–90
Opaque watercolor and gold on paper;
painting: 9⅝ x 6⅝ in. (24.4 x 16.8 cm);
page: 11 x 7¹³/₁₆ in. (28 x 19.8 cm)
Museum Rietberg, Zurich, Collection Eva and
Konrad Seitz (A 12)
Published: W. G. Archer, *Indian Paintings from
the Punjab Hills* (1973), vol. 2, pl. 204

In addition to the magnificent, sensitively painted series portraying the *Bhagavata Purana* (No. 89), the *Ramayana* (No. 87), and the *Gita Govinda* (No. 92), there are numerous surviving single works by the artists of the first generation after Manaku and Nainsukh. In this example, a princely couple, serenaded by three female musicians, stand on a terrace and gaze in joyous anticipation at the approach of a storm, which is announced by a flash of lightning. The artist also celebrates the pastoral surroundings; the green tones could not be more intense. The palette reflects the intense light that appears in advance of a storm.

92

The Village beauty: folio from the Guler *Bihari Satsai* series

Guler, Himachal Pradesh, ca. 1785
Opaque watercolor, ink, and gold on paper,
7½ x 5⅛ in. (19.1 x 13 cm)
The Kronos Collections
Published: N. C. Mehta, *Studies in Indian Painting* (1926), pl. 22; Randhawa, *Kangra Paintings of the Bihari Sat Sai* (1966), pl. 13; W. G. Archer, *Indian Paintings from the Punjab Hills* (1973),

vol. 1, p. 296, vol. 2, pl. 214; Kossak, *Indian Court Painting* (1997), no. 65

The *Satsai* (700 verses) of Bihari Lal (1595–1663) tell of lovers in various situations. For their portrayal of that series, the artists chose an oval format surrounded with an ornamental frame, here with arabesque gold decor on a blue ground. The village beauty is one of the most impressive paintings of the group,

highly charged with erotic undercurrents. The corresponding lines from the poem tell of the maiden's garlands of water lilies and the glory of her breasts: "Thus standing, that lovely damsel, with fulsome bosom, keeps watch on the field."[17] The framing action takes place in the background, set off by a diagonal landscape feature, where an older woman is describing the maiden's charms to Krishna.

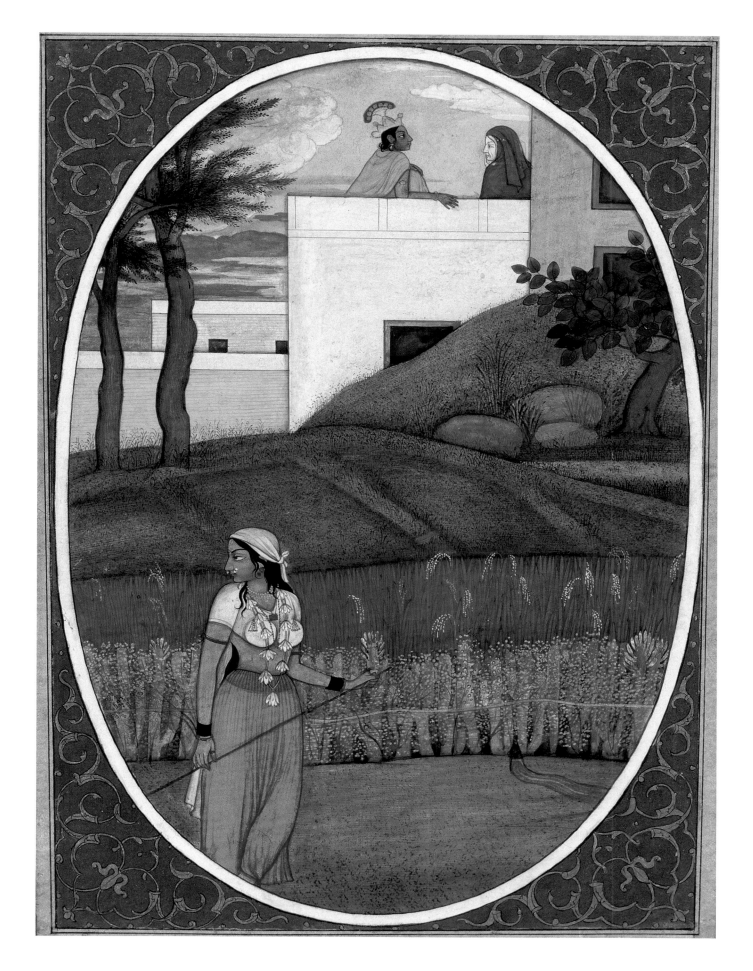

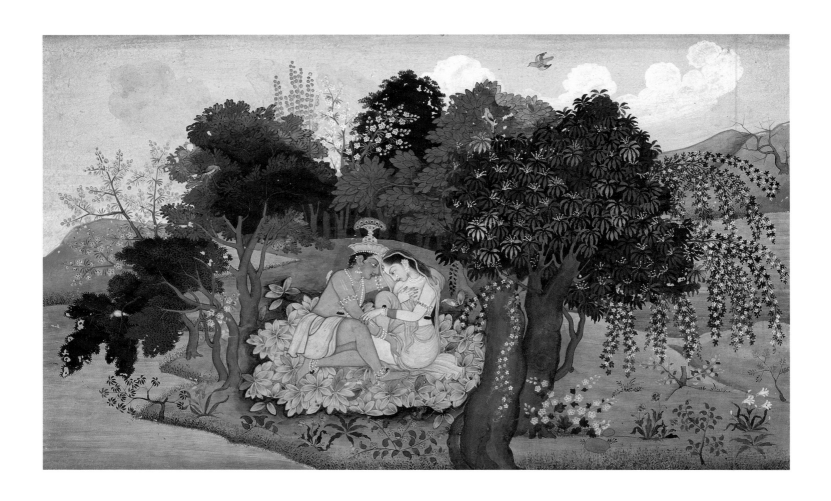

93

Krishna with Radha in a forest glade: folio from the second Guler *Gita Govinda* series

Guler, Himachal Pradesh, ca. 1775
Opaque watercolor on paper;
painting: 6⁹⁄₁₆ x 10¹⁄₁₆ in. (16.6 x 25.6 cm);
page: 6⁷⁄₈ x 10¹³⁄₁₆ in. (17.5 x 27.5 cm)
Collection of Barbara and Eberhard Fischer,
on permanent loan to the Museum Rietberg,
Zurich (REF 35)
Published: W. G. Archer, *Indian Paintings from the Punjab Hills* (1973), vol. 2, pl. 7

In no other illustration for Jayadeva's twelfth-century *Gita Govinda* are human emotions reflected in nature as vividly as they are in this series. The poem, one of the most important of the *bhakti* texts, explores the full range of human emotions through the story of the dalliance of Krishna and Radha. This scene portrays the first sensual engagement between the two lovers, which is set in a forest glade adjacent to the Yamuna River. It attests to the brilliance the painters achieved in capturing the various phases of love in their depictions of figures in natural settings. Nature, with its abundance of flowers, appears to be announcing the imminent consummation of their passion.

94

The Marital bliss of Nala and Damayanti: folio from a *Nala-Damayanti* series

Kangra, Himachal Pradesh, ca. 1800–1810

Commissioned by Raja Samar Chand of Kangra (r. 1774–1823)

Ink and opaque watercolor on paper;
painting: 8¾ x 13⅛ in. (22.2 x 33.3 cm);
page: 11½ x 15½ in. (29.2 x 39.4 cm)

The Metropolitan Museum of Art, New York, Rogers Fund, 1918 (18.85.3)

Published: Khandalavala, *Pahari Miniature Painting* (1958), pp. 227–30; Eastman, *The Nala-Damayanti Drawings* (1959); Craven, *Miniatures and Small Sculptures from India* (1966), fig. 67a; Welch and Zebrowski, *A Flower from Every Meadow* (1973), no. 83; Welch, *Indian Drawings and Painted Sketches* (1976), pp. 110–11, 134–35; Goswamy and Fischer, *Pahari Masters* (1992), pp. 346–47; Kossak, *Indian Court Painting* (1997), no. 66

In this painting based on the poem of Shrisharsh, the *Naishadhacharita*, the marital happiness of Nala and Damayanti is described. It is one of a larger group of pictures that remained unfinished but nonetheless are among the most accomplished works of the first generation after Manaku and Nainsukh. Nala appears three times. On the left, he attempts to draw his bride to his bed; in the middle scene, he amuses himself, watching as Damayanti is tended by seven servant girls; on the far right, he enters a palace interior.

Purkhu of Kangra

Active ca. 1780–1820

During the reign of Sansar Chand (r. 1775–1823), Kangra was a large state in the Pahari region of Himachal Pradesh and was important both politically and culturally. In view of the sheer quantity of surviving eighteenth- and nineteenth-century paintings from Kangra, it must have maintained a very large artist workshop, at its peak probably under the direction of the *chitrera* (painter) Purkhu.

In addition to pictures documenting the public and private life of his patron, Purkhu painted numerous illustrated series depicting religious themes. If one compares the contemporary works by the painters of the first generation after Manaku and Nainsukh of Guler with those from Purkhu's workshop, the differences are obvious. Those of the first group are lyrical and dreamlike while capturing the atmosphere of the texts illustrated, whereas Purkhu tended to work in a style best described as journalistic. At first glance, the facial types in Purkhu's audience scenes and portraits do not seem particularly individualized, but closer examination reveals subtle distinctions. This is observed, for example, in Sansar Chand contemplating paintings, a work that also indicates how much Indian pictures were appreciated by a patron and his inner circle of connoisseurs. Sansar Chand and his courtiers are enjoying images of beautiful women. At the lower left is a figure intended to represent a painter,[18] holding a fabric cover used to protect pictures.[19] Whether or not this is Purkhu is an open question.

In addition to his courtly scenes, fascinating features of Purkhu's work are also evident in the extensive religious series he completed — *Harivamsa*, *Shiva Purana*, *Ramayana*, *Gita Govinda*, *Kedara Kalpa*.[20] His illustrations for the *Gita Govinda*, for example, attest to his gift for innovation, evidenced in representations of the seductive Krishna in all his facets (No. 95). In addition to depictions meant to visualize the omnipresence of the divine seducer, the artist at the same time worked on elaborate landscapes that are more mannered than examples by the artists of the first generation after Manaku and Nainsukh, to be sure, but are nonetheless convincingly idyllic descriptions of nature.

Above: Presumed self-portrait of Purkhu, detail of *Sansar Chand of Kangra admiring pictures with his courtiers*, attributed to Purkhu, ca. 1800–1815 (Fig. 3). Eva and Konrad Seitz Collection

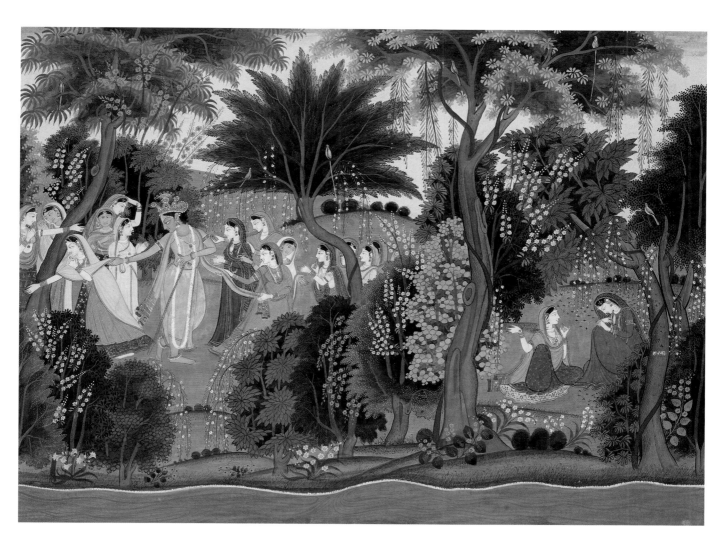

95

Krishna flirting with the *gopis*, to Radha's sorrow: folio from a *Gita Govinda* series

Kangra, Himachal Pradesh, ca. 1810–20
Opaque watercolor and gold on paper;
painting: 9⁷/₁₆ x 12⁵/₈ in. (24 x 32 cm);
page: 11 x 14⁵/₁₆ in. (28 x 36.3 cm)
Museum Rietberg, Zurich, Bequest of
Lucy Rudolph (RVI 1852)
Published: W. G. Archer, *Indian Paintings
from the Punjab Hills* (1973), vol. 2, no. 67(i);
Sotheby's New York, March 20, 1997, lot 4

Purkhu may have known the *Gita Govinda* series by the masters of the first generation after Manaku and Nainsukh (No. 93), for it seems that his rendering of nature was inspired by their work. Here, Purkhu gave free expression to the emotions described in the poem. The figures are highly animated, and the natural setting is orchestrated to reflect the moods evoked in different views of the composition, a feature seen to even greater effect in the pictures of the first generation after Manaku and Nainsukh. A signature feature, reminiscent of the work of Manaku, is the white line that indicates the bank of the Yamuna River.

Bagta

Active ca. 1761–1814, first at the court in Udaipur up to ca. 1769
during the reign of Ari Singh (r. 1761–73) then at Devgarh under
Rawat Jaswant Singh (r. 1737–76), Rawat Ragho Das (r. 1776–86),
and Rawat Gokul Das II (r. 1786–1821), father of Chokha and Kavala

Mewar painting from the late eighteenth and early nineteenth centuries featured large format works with well established formulaic compositions and defined conventions for rendering figure types and architectural settings, and these left relatively little room for individual artistic innovation. Bagta underwent his training in the large ateliers in Udaipur, and he must have recognized early in his career that this environment left him little scope for pictorial inventions of his own. It is apparent that at the court workshop an artist's personal interests were subordinated to a well-defined house style. Based on Bagta's early dated work, it appears that in 1769, he left Udaipur[21] and settled in Devgarh to the north, where his style suddenly underwent a drastic change, as if no longer constricted as it was at Udaipur.

His portraits of Anop Singh, his first major patron and a prince known for his extreme corpulence, are so individualized that they have almost become caricatures. These works exhibit sharply contrasting colors and are characterized by frequent reworking of the principal figures and a minimalist simplication of the surrounding details that focuses attention on the principal subject (No. 96). In one of the artist's larger scale pictures, Rawat Gokul Das at Singh Sagar Lake Palace (No. 97), the landscape dominates in a manner most uncharacteristic of Indian painting. This work provides an oblique and aerial view of lake and surrounding landscape, with the human presence marginalized. The topographical treatment suggests Bagta is in part evoking the European cartographic tradition. In this majestic landscape, Gokul Das is portrayed a number of times, shooting waterbirds or lounging in the lake palace. The composition is both daring and convincingly executed, incorporating expressively painted rocks and trees and such details as horses bathing in the lake.

Bagta also painted hunting and court audience scenes that are more expressive in coloring and attest to his range.[22] This extraordinary artist produced his last dated work in 1814. His son Chokha had become the main artist painting in Devgarh around 1811, after having undergone training, as his father had, in Udaipur.

96

Kunvar Anop Singh hawking

Devgarh, Mewar, Rajasthan, ca. 1777
Opaque watercolor on paper;
painting: 14³/₁₆ x 10 ⁷/₁₆ in. (36 x 26.5 cm);
page: 16⅛ x 11⅝ in. (41 x 29.5 cm)
Museum Rietberg, Zurich, Gift of Carlo
Fleischmann Foundation (RVI 2198)
Published: Beach and Singh, *Rajasthani Painters
Bagta and Chokha* (2005), fig. 41; Crill and
Jariwala, *Indian Portraits* (2010), no. 38

This portrait of Kunvar Anop Singh on horse-back, holding his hunting falcon in a gloved hand and with a kill in the foreground, is a study in opulence; witness the prince's bejeweled turban and other finery. It is also a study in obesity; the horse appears to visibly bow under his master's mighty form. Bagta played with the rider's corpulence, making rider and horse seem exaggerated almost to the point of caricature. Anop Singh's formal attire is a reminder that hawking served as a status indicator in the later Rajput world, as it had done previously in Iranian and Mughal court culture (No. 14). This portrait was painted shortly before the subject's untimely death at age twenty-two.

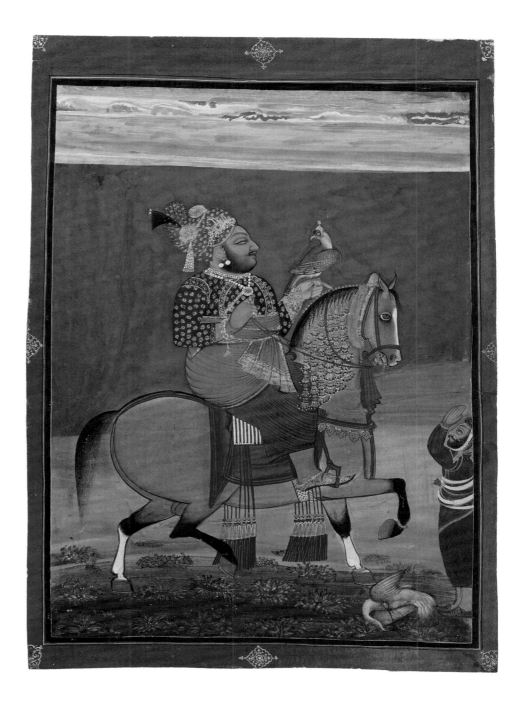

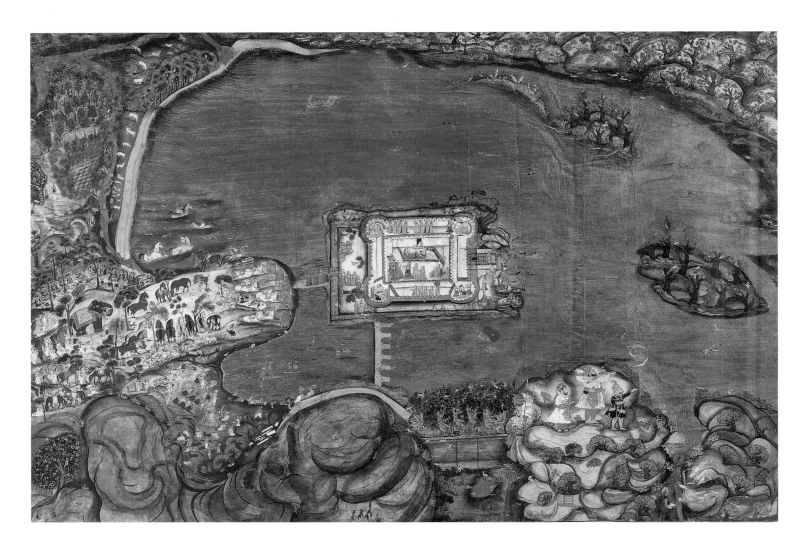

97

Rawat Gokul Das II at Singh Sagar Lake Palace, Devgarh, shooting fowl

Devgarh, Mewar, Rajasthan, dated 1806

Inscribed: on reverse in *devanagari* script, "The likeness of Maharavat Shri Gokul Das at the Singh Sagar, accompanied by his uncle Ravat Gyan (?) Singh and Amarji; presented in the pavilion on Monday 12th of the dark half of Sravan V.S. 1863. By the painter Bagta"*

Opaque watercolor with gold and silver on paper, 21⅝ x 31½ in. (54.9 x 80 cm)

The Ashmolean Museum, Oxford, lent by Howard Hodgkin (LI.118.80)

Published: Topsfield and Beach, *Indian Paintings and Drawings from the Collection of Howard Hodgkin* (1991), no. 40*; Beach, *The New Cambridge History of India: Mughal and Rajput Painting* (1992), pl. P; Topsfield, *Court Painting at Udaipur* (2002), fig. 195; Beach and Singh, *Rajasthani Painters Bagta and Chokha* (2005), fig. 68, pp. 58, 59, 121

This depiction of a shooting excursion undertaken by Rawat Gokul Das (r. 1786–1821) at Singh Sagar is the most innovative and impressive work produced by Bagta at Devgarh.

The landscape, seen from shifting oblique and aerial perspectives, is dominated by expressively painted rock formations and trees that encircle the lake in a quasi-topographical manner. Aerial views are not unusual in Mewar painting and are especially employed for palace scenes (No. 104). This vista does not focus on a single event but rather progresses to a number of scenes in which the prince reappears. A comparable topographical approach is employed in a spectacular view of Jaipur, representing the fortress city of Ranthambhor (No. 98).

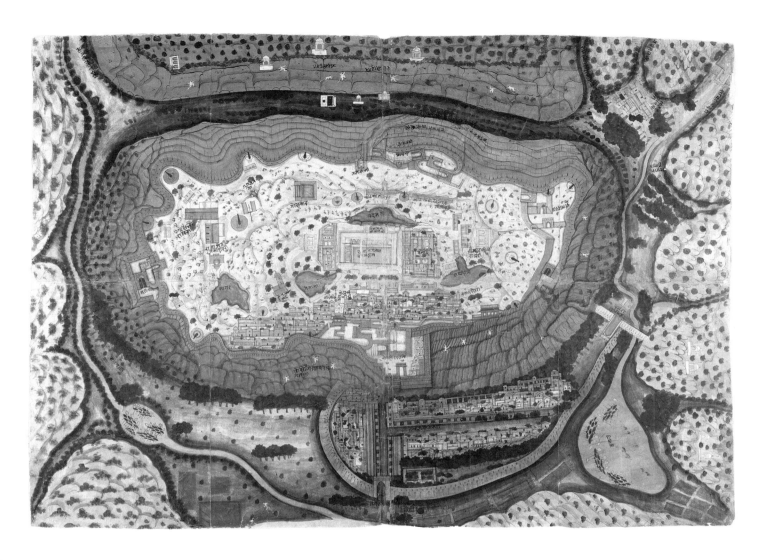

98

Fortified city of Ranthambhor

Jaipur, Rajasthan, ca. 1810–18

Inscribed: dated to the reign of Jagat Singh of
Jaipur (r. 1803–18)

Opaque watercolor and ink on paper,

29 x 40¼ in. (73.7 x 102.2 cm)

The Metropolitan Museum of Art, New York,

Fletcher Fund, 1996 (1996.100.6)

Published: Kossak, *Indian Court Painting*
(1997), no. 79

The lofty palaces of Rajasthan, often sited on fortified hills, invited renderings with daring perspectives. With Bagta's 1806 pioneering depiction of Singh Sagar Lake Palace (No. 97), new possibilities opened up. The circulation of European topographical maps undoubtedly provided the conceptual tools for depicting what the artist of this spectacularly large work could only imagine—an aerial view. The river-moated hill location of Ranthambhor fort and town could only have

been conceived in this manner by an artist familiar with the conceptual language of mapmaking; the landscape appears contoured, but on closer examination, it is in fact tiered. The artist wedded traditional Indian renderings of hillocks, rocky outcrops, and trees to a way of seeing that must have come from cartography. While many of the features are rendered in plan, the townscapes are seen in elevation, creating a multifarious vision that is new in Indian painting.

Chokha

*Active 1799–ca. 1826, first at Udaipur under the patronage of Maharana
Bhim Singh (r. 1778–1828), then at Devgarh ca. 1811–after 1826
under Rawat Gokul Das II (r. 1786–1821); son of Bagta, father of Baijnath*

The career path followed by Chokha — Bagta's second son — paralleled that of his father in many aspects. Chokha was born in Devgarh, where Bagta worked as a painter, but he received his actual training in the large ateliers in Udaipur, where his father had produced his first works roughly forty years earlier.[23] Like those of his father, Chokha's early pictures are indebted to the prevailing atelier style at Udaipur. More original compositions appear only in his Devgarh period. The artist returned there around 1811, and it appears that he replaced his father as that court's leading painter; Bagta's last documented work there dates from 1814.

Chokha's first works were produced for the patron Maharana Bhim Singh (r. 1778–1828) of Udaipur. To judge from the great number of surviving pictures, it seems that the prince was obsessed with portraits of himself. Much favored in Udaipur painting of this period are depictions of the dazzlingly white palace architecture, typically only highlighted with a few color accents.[24] Only a short time later, Chokha was in the employ of the ruler of Devgarh, and his works there display evidence of a change in style. Although Chokha adopted some of his father's characteristic motifs, notably the featuring of hunting dogs and the use of circular lightly washed areas of color, in a number of later pictures of the ruler Gokul Das (described by an English official as "Herculean in bulk"[25]), his facial features are individualized somewhat less strongly.

In Chokha's last known works, it is evident that he was responding to Mughal conventions as well as European subjects, which had not greatly influenced Bagta, the notable exception being his aerial view of Singh Sagar.[26] The careers of Bagta and Chokha are among the most interesting in Rajput painting. One sees both father and son striving toward defining an independent pictorial style. For both, a change of patron was necessary to achieve that goal.

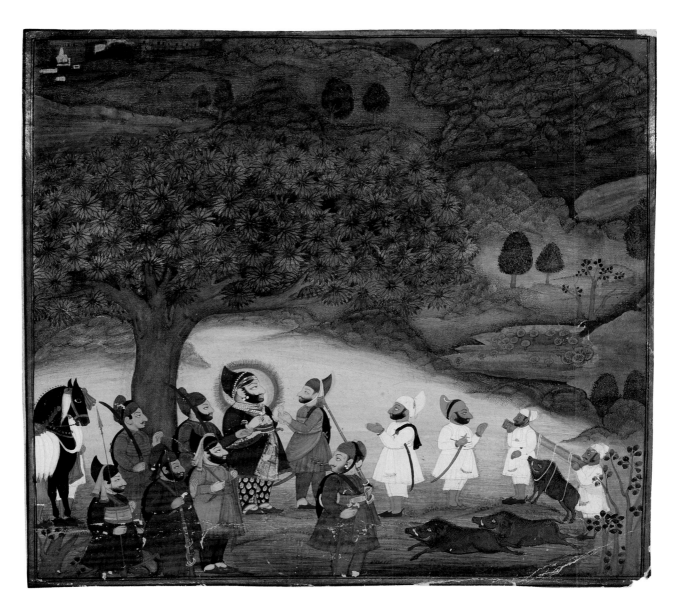

99

**Maharana Bhim Singh reviewing
the kill after a boar hunt**

Devgarh, Mewar, Rajasthan, ca. 1803

Opaque watercolor on paper,

page: 10¼ x 9⁵⁄₁₆ in. (26 x 23.7 cm)

Gursharan S. and Elvira Sidhu

Published: Beach and Singh, *Rajasthani Painters*

Bagta and Chokha (2005), p. 91, fig. 109

The color palette Chokha used in this picture recalls comparable depictions of hunting scenes by his father, Bagta.[27] But the landscape has become more complex, forecasting the expressive depictions in which Chokha excelled. He developed such works during his apprenticeship at the atelier in Udaipur between 1799 and 1811, the period of this work. A wide range of green tones, alternating with varied rock formations, forms the background for the main scene, where Maharana Bhim Singh is presented inspecting his kill of three boars.

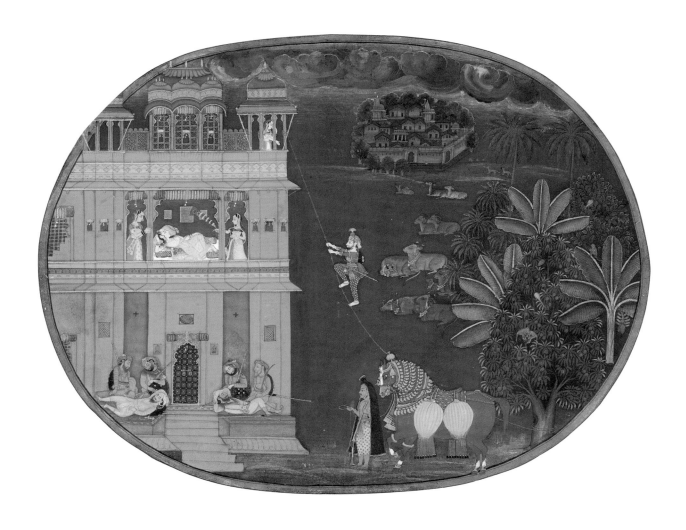

100

**Escapade at night: a nobleman
climbs a rope to visit his lover**

Udaipur, Mewar, Rajasthan, ca. 1800–1810
Opaque watercolor, ink, and gold on paper;
painting: 11½ x 14⅞ in. (29.2 x 37.8 cm);
page: 12¼ x 16⅛ in. (31.1 x 41 cm)
The Metropolitan Museum of Art, New York,
Purchase, Friends of Asian Art Gifts, 2006
(2006.451)
Published: Queens Museum, *Aspects of Indian
Art and Life* (1983), no. 60

Chokha had a special fascination with night
scenes in which he could explore the effects
of light. This composition, depicting a lover
climbing a rope secured to his trusty horse, is
a masterful nocturnal study. The object of
the nobleman's affection awaits him in her
bedchamber, while below, the palace guards
sleep. A maidservant has secured the rope to
the rooftop pavilion, and below, the nobleman's
handsome horse stands steady, anchoring the

rope with the necessary tautness. Many of
Chokha's finest hunting scenes are set at twi-
light, and this night scene represents a natu-
ral development in his work. Few painters
could have captured the atmosphere so evoc-
atively; the portrayal of this daring escapade
serves to heighten the tension in the lovers'
risky meeting.

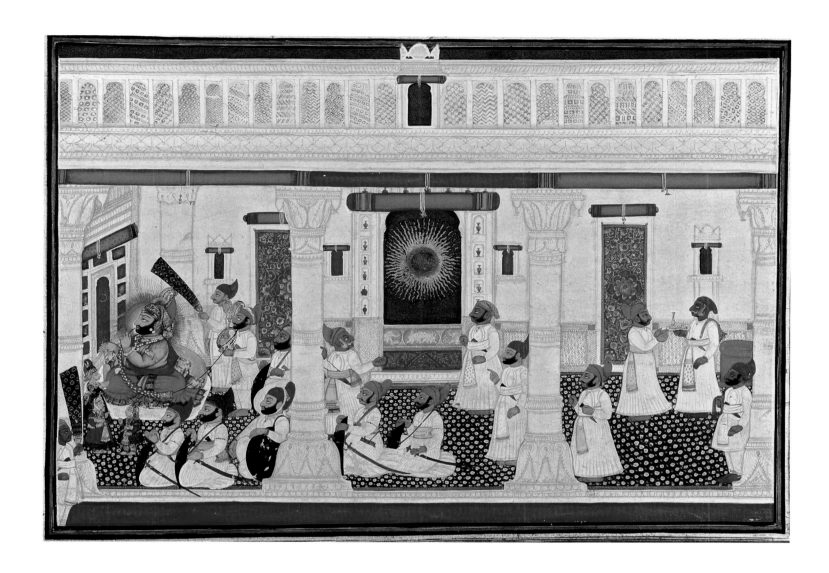

101

**Maharana Bhim Singh and his sons
in the Surya Mahal**

Udaipur, Mewar, Rajasthan, ca. 1810
Opaque watercolor on paper,
page: 11⅜ x 15⅞ in. (28.9 x 40.3 cm)
Gursharan S. and Elvira Sidhu
Published: Topsfield, *Court Painting at Udaipur*
(2002), fig. 202; Beach and Singh, *Rajasthani
Painters Bagta and Chokha* (2005), fig. 91

Chokha worked mainly for Bhim Singh (r. 1778–1828) in Udaipur. To judge from the number of surviving portraits of that prince, one can only assume that he was obsessed with depictions of himself. In its structure and coloring, this view is a classic example of Udaipur painting of the time, with the architecture in white sparingly heightened with color accents. Bhim Singh is shown smoking

a *hookah* (water pipe) and attended by courtiers. The conventional architectural setting can be compared to the early works of Chokha's father, Bagta, a reflection of the inherent conservatism of court painting at Udaipur in the early nineteenth century.

LATE INDIAN COURT PAINTING, COMPANY PAINTING, AND THE COMING OF PHOTOGRAPHY
1825–1900

Jorrit Britschgi

Indian painting of the nineteenth century underwent important adjustments that can be explained in large part by changes in the political situation and the resulting shift in patronage. Additionally, a new era had dawned, with new subjects and mediums that posed an increasing threat to traditional Indian painting. It is therefore not surprising that only infrequently does one encounter an extraordinary painter working in the traditional manner. As the end of premodern court painting approached, important shifts in style, subject matter, and organization took hold.

The gradual dismantling of the atelier structure established over the course of centuries, both at the Mughal courts and at smaller courts in Rajasthan and the Pahari region, where family workshops were the rule, resulted in an artistic vacuum. Interest in painting on the part of princes and rulers had waned, so painters were no longer able to practice their trade as they had earlier. As a result of the new conditions, they were forced to change the way they worked and increasingly found themselves working for multiple patrons. This already had been the case for such eighteenth-century artists as Mir Kalan Khan and Bhavanidas.

European colonial powers had gained a footing in India during the sixteenth century. In Goa, for example, the Portuguese established a center for sea trade in spices, textiles, and luxury goods. Their presence increased in the following decades. Missionaries were dispatched to the Mughal courts, and tribute was paid to the new rulers. Artists such as Keshav Das and Basawan avidly copied the European works of art that were circulated at India's courts, and they studied the new artistic techniques. Although these contacts would directly affect Indian painting, by no means were they as important as the European influence on

India's artists was during the eighteenth and early nineteenth centuries. In order to make India's wealth of resources accessible to the European market, the Dutch, the French, the Danes, and the British gradually established trading companies on the subcontinent. At first, their officials stationed in India, most notably those of the English East India Company, had to negotiate with the Mughal courts, but as the political system deteriorated, they came to deal directly with local powers.

Initially, peaceful trading interests were supported soon enough by military intervention, and increasingly, the economic and political influence of princes and local rulers was weakened. Yet among the foreigners, painters found new patrons interested in the indigenous culture. More and more, it was these European officials who commissioned Indian pictures rather than local princes. Works produced by Indian painters for European patrons associated with the trading companies are known as Company Paintings, a designation that refers to both their patrons and their accommodation to European tastes.[1]

One of the officials who collected Indian paintings, commissioned them, and had them bound in splendid albums is Antoine Polier (1741–1792). The picture shown here (Fig. 21) portrays this son of French Protestants enjoying a *Nautch* performance (of professional dancers), apparently at his residence in Lucknow. He is depicted in a manner reminiscent of representations of Indian rulers, although the style is clearly very different. For example, note the precise perspectival rendering of the architecture and other features derived from European painting such as the depiction of shadows, which had been featured only rarely in earlier Indian painting. Polier's correspondence, published under the

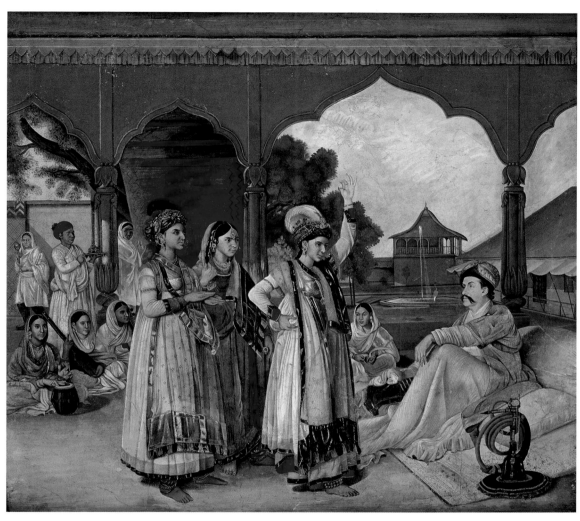

FIGURE 21. Antoine Louis Polier watching a *Nautch* performance. Lucknow, India, ca. 1785.
Museum Rietberg, Zurich, Balthasar Reinhart Bequest (2005.83)

title *Ijaz-i-Arsalani*,[2] is a rich source of information about the new patrons in India. For example, one learns from it that Polier commissioned pictures from the painter Mihr Chand (Mehrchand), then passed them along to junior painters for the completion of border decorations or had them bound in albums.[3] Now and again, there is mention of a painter's assistant by the name of Duli Chand, who also worked for Polier. In addition, Polier's correspondence includes references to his contacts with European artists who sought their fortunes in India. The letters document a meeting with the English painter William Hodges (1744–1799) as well as Polier's close friendship with John Zoffany (1733–1819).[4] Indian artists were greatly inspired by the presence of European

artists in India — Tilly Kettle, William Carpenter, Francesco Renaldi, to name only a few[5] — and there are numerous examples of Indian copies after European paintings (No. 106).[6] European techniques and notions of style forced Indian painters to adapt to new pictorial conventions, but most notably, it was their subject matter that changed.

Suddenly, after what often were long and dangerous sea voyages, the officials stationed in India were exposed to an exotic world with challenging climate. Often highly educated, they attempted to discover India not only by studying and translating Indian texts (as Polier, William Jones, Colin Mackenzie, and others did) but also by researching the natural sciences and ethnology.

Compendiums of fauna, flora, and important architectural monuments were in vogue in eighteenth-century England, and it is not surprising that these men tried to comprehend that foreign country using such methodologies. India's most important architecture was documented with views of both facades and interiors, and paintings of its plant and animal worlds were commissioned. For example, the painter Zayn-al Din of Calcutta produced such works for Sir Elijah and Lady Impey in Calcutta in the late eighteenth century.[7] Other genres were devoted to India's native populace, its characteristics, festivals, and customs.

Perhaps the most impressive collection of such pictures was assembled by the Scottish brothers William and James Fraser.[8] Although very few of their works are signed, the so-called Fraser Masters were artists living in Delhi who were related to Ghulam 'Ali Khan.[9] The two brothers' correspondence reveals quite clearly how deliberate the commissioned portraits of representatives of the various professional groups and castes were. Although those works were intended to be purely documentary, their subjects, generally looking directly at the viewer, were portrayed with obvious empathy, whether bearded warriors, fine-limbed dancers, or simple villagers. These paintings represent a hybrid style between late Mughal-era portraiture and ethnographic studies. European characteristics include the use of shadows, the frequent isolation of the figure in front of a monochrome background, the sensitivity in the rendering of faces, the use of watercolor technique, and the presence of stippling. In a certain sense, the realism anticipates the introduction of photography to India. On many of the Fraser portraits, there are numbers in William Fraser's hand keyed to corresponding identifications (some by E. S. Fraser) on a slip of paper attached to the back, for example, "Yaccob Ooozbe, a rich merchant, native of Bockhara."[10] This is another indication of the brothers' documentary intent.

The pictures of the Fraser brothers are also the last high-quality works by Indian painters produced for officials of the English East India Company. Along with Delhi and Awadh, Calcutta was home to numerous painters, such as the already mentioned Zayn al-Din and his contemporaries Bhawani Das and Ram Das. Local painters in Patna, Varanasi, and Mushidabad produced similar pictures, often for travelers. The establishment of art schools with European instructors — in Bombay, Calcutta, and Madras, among other cities — provided for the training of a new generation of painters. With artists like Raja Ravi Varma (1848–1906), Abindranath Tagore (1881–1951), and Gaganendranath Tagore (1867–1938), Indian painting entered the modern age.

The development of painting in Udaipur in the nineteeth century is clearly illustrated by the works of the artist Tara and his two sons, Mohanlal and Shivalal. One sees from paintings by Nasiruddin (the painter of the Chawand *Ragamala*) and Sahibdin that artists in the principality of Mewar adopted few influences from Mughal painting. Even in the nineteenth century, Mewar's large atelier adhered to a pictorial aesthetic that had been established over the centuries. The artist Tara, under Sarup Singh (r. 1842–61), was one of the last great representatives of Mewar painting (Fig. 22). His pictures, for example (Nos. 104, 105), employed large formats, and only rarely did he experiment with European painting techniques, as in his 1851 copy of William Carpenter's portrait of Sarup Singh (No. 106). One of his sons, Shivalal (together with his pupil Parasuram), continued Tara's legacy. Shivalal's compositions, such as No. 108, present a wealth of detail and a documentary quality reminiscent of photography, and Tara's second son, Mohanlal, began to experiment with the new medium (for a portrait showing him with his camera, see No. 110). Such experimentation had been encouraged even earlier in the larger cities where photographic studios and societies

joined by both Europeans and Indians were established quickly. Moreover, the rulers in Alwar and Jaipur already had set up court *photokhanehs* (a term derived from the name for painting ateliers). Jaipur's Sawai Ram Singh II (r. 1835–80) was fascinated with the new medium and documented his surroundings in photographs.[11] Although Mohanlal's signed photographs in the palace at Udaipur are undistinguished, they demonstrate how the two brothers took divergent paths. Borrowings between painting and photography were common, and judging from the subject matter of early court photography, its chief function, like that of the painting it replaced, was the documentation of events at court. Overpainted or partially colored albumen prints attest to the meshing of the two mediums (No. 109).

In the Pahari region, a high point in painting had been ushered in by the artists of the first generation after Manaku and Nainsukh. To be sure, their successors (the "second generation after Manaku and Nainsukh"[12]) continued to produce works for various patrons in the Kangra region, yet they lack the convincing quality of the local painting from around 1780–1810. At the beginning of the nineteenth century, the atelier of Purkhu, who, followed by his four sons (Ramkrishna, Ramdayal, Chandanu, and Ruldu, some of whom worked in Jammu and Mandi), painted for such patrons as Sansar Chand and Anirudh, represents a departure. Yet with the exception of artists like Sajnu, the continuity of Indian painting broke down abruptly in the nineteenth century, and the Pahari region's golden age came to an end.

FIGURE 22. Portrait of Tara, court painter of Udaipur, with his two sons, Shivalal and Mohanlal, by William Carpenter, 1851. Watercolor. Victoria and Albert Museum, London (IS.139-1881)

Masters of the Company Portraits: Ghulam 'Ali Khan and Others

Active in Delhi 1810–40

It is astonishing how little is known about artists from the circle of Ghulam 'Ali Khan in Delhi, as their works were produced no more than two hundred years ago. European officials, among them Antoine Polier (born in Lausanne, 1741), worked in various parts of India for the English East India Company and provided artists with commissions for new subjects not traditionally of interest to Indian patrons. These pictures — many of them depictions of architecture, flora and fauna, or different occupations and population groups — are executed with a pronounced realism and an interest in social documentation with a distinctly ethnographic edge. In deference to the fact that the majority of the patrons were employees of one of the European trading companies, of which the English East India Company was the most dominant, the style has been termed Company School.

The largest and most impressive group of such paintings was commissioned by the Scottish brothers William and James Fraser. William was first stationed in India in 1802, and together with James, he commissioned an extensive series of pictures of the native peoples. Representatives of various population groups — Afghans, Gurkhas, Sikhs — and foreign ambassadors were portrayed, and they are seen gazing out at the viewer either singly or in groups of various sizes (Nos. 102, 103).[13]

The styles oscillate between the Mughal portrait genre and European-inspired ethnographic studies. They focus on the subjects themselves in a documentary manner, eschewing the usual predilection for ornamentation and embellishment. The subjects typically are depicted standing on a slight elevation, either in front of a white background or occasionally, before a backdrop of their native village. European pictorial devices, such as the introduction of cast shadows, are combined with Indian rendering techniques as seen in the stippling of body areas. Often detailed inscriptions attest that the Fraser brothers indeed were interested in documenting the great variety of Indian peoples and their costumes.

Given the systematic recording of the identity of the subjects depicted, it is all the more surprising that they failed to include the names of the artists in their correspondence. Rather, they are simply referred to only generically as the "painters"; only one, Lallji, is identified by name.[14] Accordingly, little is known about the individual members of the families of artists who worked around Ghulam 'Ali Khan. Yet these portraits are unquestionably among the most impressive examples of the genre. They present sympathetic images of the Indian populace of the nineteenth century, and to some extent, they anticipate the early photographic portraits of a half-century later that were to mark the demise of this genre of painting.

102

Four tribesmen

Delhi region, Haryana, ca. 1815–16
Inscribed: identified in Persian and transcribed
in English in the hand of William Fraser*
Opaque watercolor on paper;
painting: 9³⁄₁₆ x 14³⁄₄ in. (23.3 x 37.4 cm);
page: 12³⁄₈ x 17¹⁄₁₆ in. (31.4 x 43.4 cm)
The David Collection, Copenhagen (60.2007)
Published: Hobhouse, *Indian Painting During the
British Period* (1986), no. 38; Archer and Falk,
India Revealed (1989), no. 62*

Local artists typically in the employ of Euro-
pean residents in India and working in a
Western realist mode were dubbed Company
Painters after the trading companies for whom
their patrons worked. The tribesmen seen
here are painted using a stippling technique,
and the rendering of their physiques is based
on European modes of modeling. The num-
ber visible above the head of each figure is
repeated in a corresponding key in William
Fraser's hand on a protective sheet attached

to the back. Although this and other works
commissioned by the Fraser brothers appear
somewhat ethnographic in intent, the skill of
the Indian artist raised them above mere doc-
umentation; the participants engage the viewer
directly and are portrayed with great empathy.

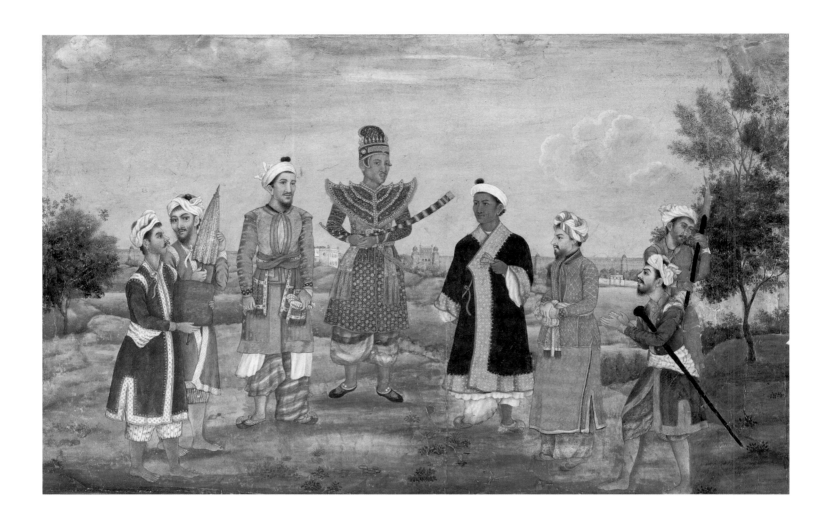

103

Burmese ambassador Nud Myaw Manakala Kyaw, his emissaries and interpreter, accompanied by Indian attendants

Delhi, Haryana, ca. 1820
Opaque watercolor, ink, and gold on paper,
10 x 15½ in. (25.4 x 39.4 cm)
The Metropolitan Museum of Art, New York,
Gift of Dr. Julius Hoffman, 1909 (09.227.1)
Published: Welch et al., *The Islamic World*
(1987), p. 28; Archer and Falk, *India Revealed*
(1989), p. 104

King Bodawpaya (r. 1782–1819) of Burma dispatched Burmese ambassadors to Delhi hoping to seal a pact against the expanding colonial power of Britain. The name of the ambassador shown here is not given, but he can be identified on the basis of another version of this painting from the Fraser Album.[15] In the latter work, the ensemble is shown in reverse orientation, and thus, it is likely that a punch was used to transfer the original image to this later version, to which two figures have been added, one on the far left, the other on the far right. The Red Fort in Delhi is visible in the background.

Tara

Active at Udaipur ca. 1836–70, especially under Sarup Singh

The artist Tara enjoyed his most productive phase under the prince Sarup Singh (r. 1842–61), from whom he received ongoing support. Tara followed the tradition of documenting the daily cycle of Mewar court life, illustrating festivals, official receptions, court entertainments, and hunting parties.[16] Although not an innovative painter, he became celebrated for his large format compositions that stand at the threshold between late painting and early photography.

Tara's works are dominated by an organized compositional style characterized by geometric forms. In the first version of the celebrations on the occasion of the spring Holi festival (No. 104), the prince appears atop an elephant, strewing colored powder. The work employs Tara's typical perspective, in which the view down into the palace courtyard is combined with a rendering of the palace facades. On either side, at the Tripolia Gate on the right, for example, the facades are swung outward — a long-established convention. The depiction of the elephants and courtiers is in a regular static arrangement. This disposition may reflect the courtly hierarchies and protocol that had to be observed in such illustrations.

Long before Tara, the Udaipur landscape, with the palace complex towering above Lake Pichola, had inspired local artists to combine topographical views with court activities. The English artist William Carpenter visited Udaipur in 1851, and while there, he made a watercolor portrait of Sarup Singh. Tara copied the work, employing new modeling techniques and a green pigment imported from Europe (No. 106).

Around 1858, the first works appeared on which it is noted that Tara worked together with his son Shivalal.[17] Tara had trained both his sons Shivalal and Mohanlal to follow in his profession. An impressive watercolor study by William Carpenter shows Tara with them in the year 1851 (Fig. 22). Shivalal continued in his father's conventional style, while the second son, Mohanla, pursued a different path.

Above: Portrait of Tara, ca. 1870s. Photograph. Pictorial Archives of the Maharanas of Mewar, City Palace Museum, Udaipur

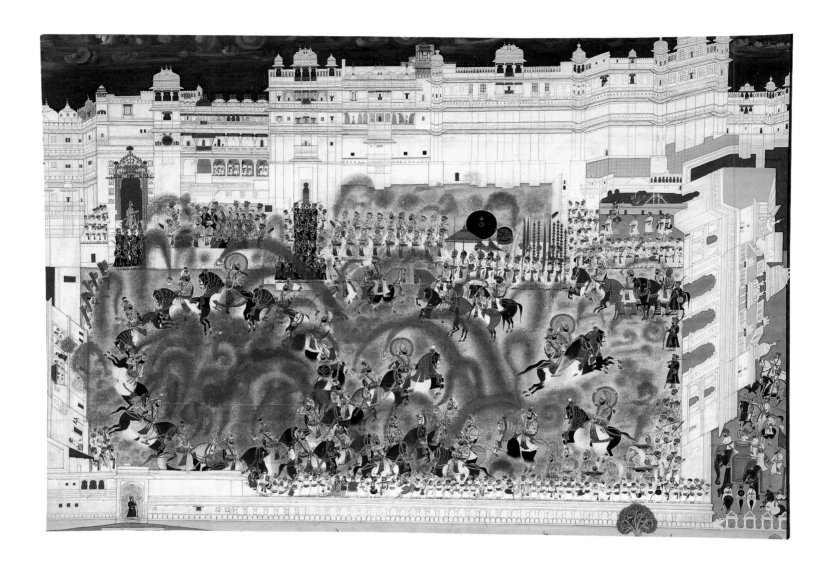

104

**Maharana Sarup Singh and
his courtiers on elephants
celebrating the festival of Holi**

Udaipur, Mewar, Rajasthan, 1850

Opaque watercolor on paper, 35¹³/₁₆ x 50 in.
(91 x 127 cm)

The City Palace Museum, Udaipur (2010.T.0011)

Published: Topsfield, *Court Painting at Udaipur*
(2002), fig. 234

The colored powders (*gulal*) resembling fire-works that are strewn on the occasion of the Holi festival suggest anarchic abandon. But that does not mean that courtly etiquette has been abandoned; rather, the spectators that frame the event are arranged in ordered rows, according to rank. The scene is composed with Tara's typical use of multiple perspectives, combining a view of the courtyard of the

palace from above with a depiction of its facade viewed in elevation. A British artist described the spectacle on the occasion of the Holi festival of 1877: "The powder is tossed using a handkerchief tied around the wrist at one end . . . thus making a kind of sling."[18] Large syringes were also used, to spectacular effect.

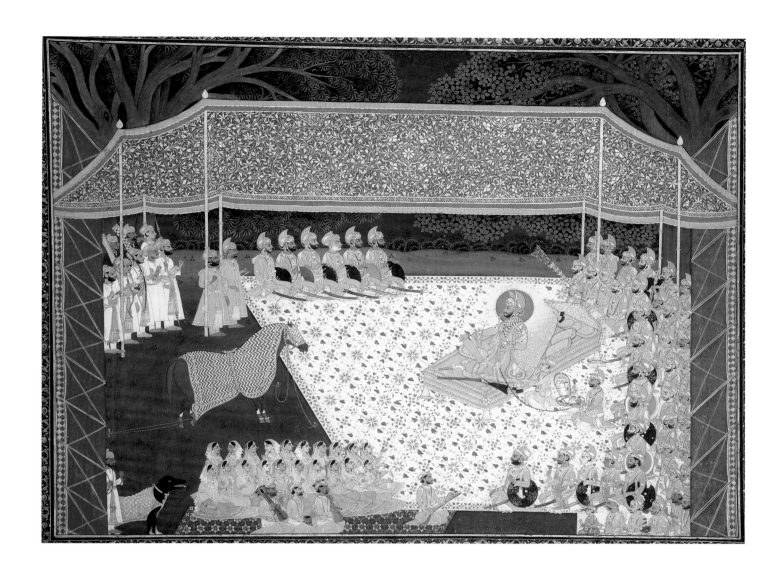

105

**Maharana Sarup Singh inspects
a prize stallion**

Udaipur, Mewar, Rajasthan, dated 1845–46
Inscribed: on the reverse, a partly legible
devanagari inscription identifying the ruler,
horse, and other figures
Opaque watercolor, ink, and gold on paper;
painting: 16¾ x 22¾ in. (42.5 x 57.8 cm);
page: 19 x 24⅞ in. (48.3 x 63.2 cm)
The Metropolitan Museum of Art, New York,
Cynthia Hazen Polsky and Leon B. Polsky Fund,
2001 (2001.344)
Published: Sotheby's New York, March 20, 2001;
Topsfield, "The *Kalavants* on Their Durrie" (2004),
pp. 256–57

The major part of Tara's career occurred during the reign of Maharana Sarup Singh (r. 1842–61), whose patronage he enjoyed. In this charming scene, the inspection of a prized stallion, who is presented with a richly decorated horse blanket, is taking place during a formal assembly of courtiers accompanied by musicians. The order that Tara imposed on the composition is typical of his pictures and emphasizes their documentary nature. Favorite horses and elephants were much prized, and often, as here, they were identified by name (see also No. 22). The highly elaborated ornamentation of the surface detail is typical of Tara's finest work.

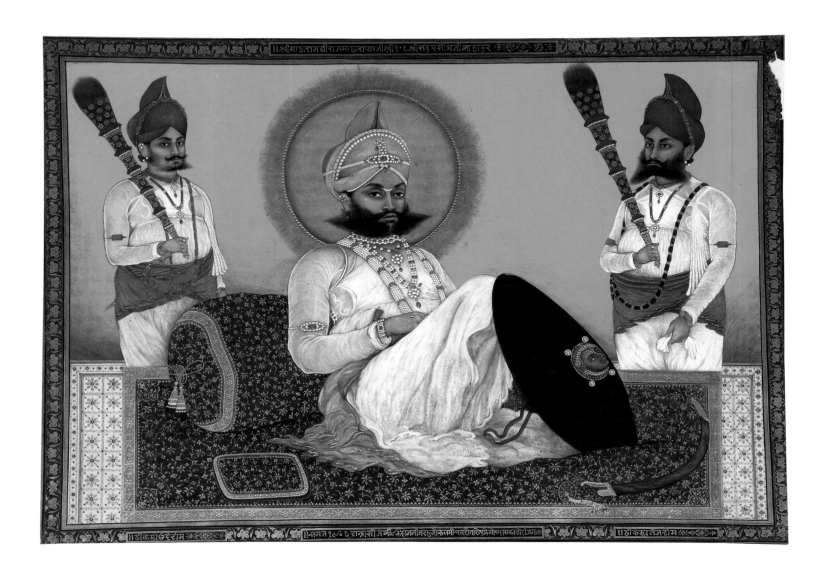

106

Portrait of Sarup Singh with attendants, after William Carpenter

Udaipur, Mewar. Rajasthan, 1851

Opaque watercolor on paper, 13¹⁵/₁₆ x 19⁷/₈ in. (35.5 x 50.5 cm)

The City Palace Museum, Udaipur (2010.T.0014)

Published: Topsfield, *Court Painting at Udaipur* (2002), fig. 239

The English watercolorist William Carpenter visited Udaipur in 1851, and while there painted, among other works, a portrait of Sarup Singh. In this interpretation of Carpenter's study by Tara, we see an artist renowned as a master painter in the Udaipur tradition responding to the techniques of European watercolor as

exemplified in Carpenter's work. While the flat green ground is typical of Mughal-inspired Indian portraiture, Tara consciously attempted to imitate Carpenter's technique in his representation of the drapery and in his suggestion of spatial depth, here rendered somewhat unsuccessfully.

Shivalal and Mohanlal

Active at Udaipur, second half of the 19th century; sons of Tara

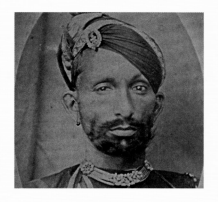

A final phase of painting in Udaipur began under the rulers Sajjan Singh (r. 1874–84) and Fateh Singh (r. 1884–1930) and was influenced by both photography and examples of oil painting. In the ateliers, the brothers Shivalal and Mohanlal, sons of the painter Tara, followed different paths.

A work is known that was produced by Shivalal in collaboration with his father in 1858. Shivalal specialized in hunting scenes, most of them created on location, in which the sequence of events is presented dramatically in an expansive landscape. In some of them, Shivalal himself is depicted, and in others, it is probably his brother Mohanlal (functioning as an assistant) who is shown.[19] One of Shivalal's greatest strengths is the realistic, topographically accurate rendering of hunting reserves and of the landscape around Udaipur.

The increasing realism in such depictions also called another medium into play—photography. The rulers of Jaipur and Alwar had already established photographic studios (*photokhana*) for the purpose of documenting the visits of dignitaries. Shivalal also worked with the new medium, not from behind the camera but rather as a painter, coloring the albumen prints (No. 109), either with traditional Indian pigments or with oils. While some photographs were completely painted over, on others, only portions were colored, the faces, for example, or the regalia.

The medium of photography, with its immediacy and its accuracy, heralded the end of traditional painting. Painters at court were insufficiently prepared for the arrival of photography. Some artists tried to adopt the perspective and compositional schemes of photographs in their pictures, but with limited success. Inevitably, activities at court came to be recorded in the new medium. Even Mohanlal began to capture hunting scenes with a camera, marking the end of traditional picture making in the courts of India.

Above: Portrait of Mohanlal, ca. 1875. Photograph. Pictorial Archives of the Maharanas of Mewar, City Palace Museum, Udaipur

107

Maharana Fateh Singh shooting a leopard at Kamlod ka Magra

Udaipur, Mewar, Rajasthan, dated 1889
Inscribed: signed Shivalal
Opaque watercolor on paper, 50⅜ x 39¾ in.
(128 x 101 cm)
The City Palace Museum, Udaipur (2010.T.0013)
Published: Topsfield, (1990), no. 44

Shivalal created this landscape of remarkable dynamism and tension; the vegetation becomes denser and darker as it plunges into a deep ravine. This compositional pull downward is countered by the simultaneous depiction of successive stages of the leopard hunt. The same animal is pictured being shot, attacked by wild boars, and finally, lying dead on its back above the ridge of the hill. The exceptionally large scale of this work is impressive and indicates that such pictures were intended to be displayed in the Udaipur palace, framed or set into wall recesses. As such, they represent a shift away from mural painting to interior decor in the European manner.

108

Maharana Fateh Singh's hunting party crossing a river in a flood

Udaipur, Mewar, Rajasthan, dated 1893
Inscribed: signed Shivalal
Opaque watercolor on paper, 32½ x 62¼ in.
(82.5 x 158 cm)
The City Palace Museum, Udaipur, Maharana
of Mewar Charitable Foundation (2010.T.0006)
Published: Topsfield, *Court Painting at Udaipur*
(2002), fig. 261

This spectacular panoramic vista, of the royal hunting party forging a flooded river, is a composition unprecedented in the history of Indian painting. Surely, it must be inspired by innovations in panoramic photography in which multiple views are composed into a single vision. Shivalal daringly filled more than half the composition with the gray waters of the swollen river, beyond which distant hills under lush vegetation are illuminated by lightning, which dances across the darkened sky. Into this setting, he placed the riders forging the river in single file. It is a surprisingly modern work, painted in the last decade of the century, which boldly asserts the validity of painting in the age of photography.

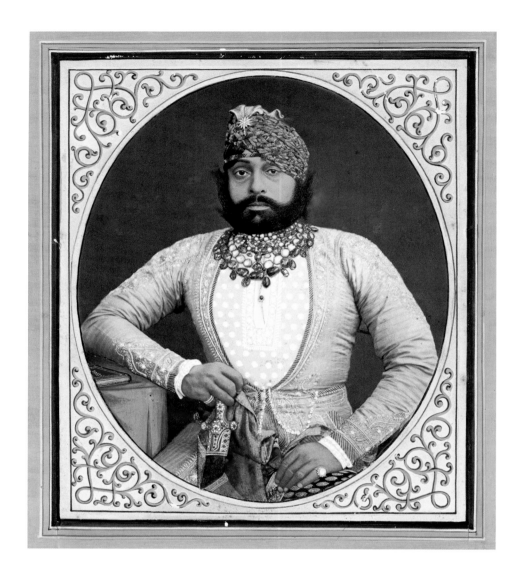

109
Portrait of Jaswant Singh II of Jodhpur (1873–1896)

Jodhpur, Rajasthan, ca. 1875
Inscribed: "Auspicious Shri Rajrajeshwar
Rajadhiraj Rajaji Shri Jaswant Singhji's picture
made by painter Shivalal"
Albumen print, hand-colored, 10¼ x 8¹⁵⁄₁₆ in.
(26 x 22.7 cm)
The City Palace Museum, Udaipur (2008.06.0356)

Early portrait photographs in India were frequently hand-colored, blending the mediums of photography and painting. Either the entire photograph was overpainted, or more commonly, features were heightened in color. The portrait, regalia, costume, and jewelry were favored for this treatment. The photographer responsible for this portrayal of Jaswant Singh II of Jodhpur is unknown. However, an inscription beneath the picture names the artist Shivalal, who colored the albumen print with both oil- and water-based pigments.[20]

110
Portrait of Mohanlal with his camera

Udaipur, Mewar, Rajasthan, ca. 1875
Albumen print, 3⅞ x 2⁵/₁₆ in. (9.8 x 5.8 cm)
The City Palace Museum, Udaipur (2008.01.0104)

One of the favored formats of early photographers in India was the *carte-de-visite*, a type of calling card avidly collected at the time that featured the owner's portrait. Albumen prints almost always were used for these small format prints. The subject here is likely the painter-photographer Mohanlal himself, posing with his camera and holding the lens cover in his hand. A number of Mohanlal's pictures are documented in the Udaipur City Palace photographic archives.[21] Most courts either maintained a photographer in the same manner that court painters were employed in the household, or else, they increasingly turned to the services of commercial photographic studios, which arose rapidly in India.

GLOSSARY OF LITERARY SOURCES

John Guy

This Glossary introduces the key texts and literary works on which the paintings in this publication are based. Some are among the most ancient epics in world history; others were composed in historical times and were first illustrated in painted editions within a few years of their creation. Some of the Mughal history paintings on occasion were based on the artist's direct observation, others on contemporary descriptions of the events depicted.

INDIAN TEXTS

Ashtasahasrika Prajnaparamita (Perfection of Wisdom in 8000 Verses): Buddhist Mahayana text, probably dating from around the first century BCE; the oldest extant copy is a mid-first century CE Gandhari edition on birchbark. In its fullest rendition, it has 8,000 verses, venerating the Perfection of Wisdom Sutra as the goddess of compassion *Prajnaparamita*. The text consists principally of *sadhanas*, invocations and chants intended to summon up protective spells, made tangible in invoking the names of Bodhisattvas or Taras. The earliest painted manuscript depiction of these deities is a palm-leaf edition produced in the fifth year of the reign of Mahipala I (ca. 980–ca. 1026) at Nalanda monastery in Bihar around 985.

Balagopalastuti (Praise of the Youthful Krishna): Hindu devotional work of prose written by the thirteenth-century Vaishnava devotee Bilvamangala, recounting the exploits of the infant and youthful Krishna. It was illustrated most extensively in the fifteenth century in western India, in an indigenous style shared with Jain painting. A complete illustrated manuscript is preserved (Museum of Fine Arts, Boston); many are dispersed.

Baramasa: poetic form in which *nayaka-nayiki* love themes are explored, each month linked to the expression of a particular lover's longing. Most recently, it has been based on Keshavdas's late sixteenth-century poem the *Rasikapriya*, in which these themes are expressed principally through the love of Radha and Krishna and was much favored in later north Indian court painting.

Bhagavata Purana (Ancient Stories of Lord Vishnu): one of the great popularizing commentary texts of Hinduism, datable to the ninth or tenth century in its present form, with primary focus on Vishnu *bhakti* (devotion). The *Dasavataras* of Vishnu are recounted in detail, but special attention is paid to Krishna. Book Ten, which occupies a quarter of the entire *Bhagavata*, is one of the most complete accounts of Krishna's life in Indian literature. Scenes from this canto were most favored for illustration in painting series; there, the exploits and adventures of the youthful Krishna were celebrated, and the love of Krishna and the *gopis* was interpreted as an allegory for spiritual devotion and union with god.

Bhramar Git (Song of the Bee): composed by Nanddas in Hindi in the 1560s, this work explores the theme of Krishna's dance with the *gopis* (*raslila*) in the groves of Braj, his departure, and Krishna's emissary Uddhav's unsuccessful attempt to console them with philosophy after Krishna's disappearance. This underscoring of the opposition between knowledge (*jnana*) and emotional devotion (*bhakti*) in north Indian Krishna worship had broad appeal in a time of expanding popularity of the Vaishnava cult. It was explored in paintings of the Rajput courts, as can be seen in the work of Sahibdin at Udaipur in the 1640s.

Bihari Satsai (Seven Hundred Verses of Bihari): celebrated Hindi poem composed by Bihari between 1662 and 1665. The poet took lessons from the famous Keshav, author of the *Rasikapriya*. While living at Mathura, Bihari was invited by the Mughal emperor Shah Jahan to Agra, where he was in residence when Mirza Raja Jai Singh (r. 1611–67) invited him to court at Amber, near Jaipur, where *Satsai* was composed, in over 700 couplets in *shringar raga* (erotic sentiment), describing the romances of Krishna, principally through the voice of Radha. It became famous in its day and was soon celebrated in a series of paintings produced at the court of Kangra (National Museum, New Delhi) and elsewhere.

Caurapancasika (Fifty Stanzas of a Love-Thief): love poem written in Sanskrit by the Kashmiri poet Bilhana, working at the Kalyana court at in the late eleventh century. It describes a poet recalling his shared passion with the princess of a royal house in which he served, awaiting his imminent execution for loving above his station. These poignant verses inspired a series of paintings in a manuscript edition dated to the early sixteenth century, now preserved in the N. C. Mehta Collection (Ahmedabad). These *Caurapancasika* manuscript paintings gave rise to the use of the term *Caurapancasika group* to denote north Indian Hindu painting of the Sultanate, pre-Mughal period.

Dasavatara (Ten Appearances): the ten incarnations (*avatara*) of Vishnu, literally Vishnu's "Descent" from heaven to earth "whenever there is a decay in righteousness" (*Bhagavad Gita*) in order to restore moral order. They are popular subjects for later Hindu court paintings, especially those devoted to Krishna's actions in support of virtuous kingship.

Gita Govinda (Song of Govinda): love poem composed by the Orissan *bhakta* Jayadeva in the twelfth century, celebrating Krishna's dalliances with the *gopis* of Vrindavan, and especially the romance of Radha and Krishna. It gained great popularity in the emerging Vaishnava *bhakti* movement. The earliest illustrated edition preserved belongs to the early sixteenth century (CSMVS Museum, Mumbai), executed in the *Caurapancasika* style.

Kalpasutra (The Book of Ritual): principal Jain text, containing biographies of the four most significant Jinas and the rules of ritual, monastic behavior, and daily conduct for monks and nuns. The *Kalakacharyakatha* (the story of the teacher Kalaka), an influential moralizing work, frequently appended in the *Kalpasutra*. Scenes from the lives of the Jinas were favored for manuscript illustration. The earliest dated Jain illustrated manuscript, on palm-leaf, is preserved at Mudbidri, in the Deccan, dated 1060. Painted wooden covers with complex pictorial narratives appear soon after this date. Jain painted *Kalpasutras* had their heyday in the fourteenth and fifteenth centuries.

Kedara Kalpa: Shaiva text celebrating Shiva's abode at Mount Kailash and the merits of undertaking the arduous pilgrimage there, narrated through the journeying of the five *siddhas*. It was occasionally chosen as a subject for paintings, particularly in eighteenth-century Pahari painting, as seen in a series from Guler, Himachal Pradesh.

Laur Chanda: series of romantic tales adapted from Indian vernacular languages, employed to present allegorical tales on the fate of the soul. It was composed around 1370 and gained wide popularity in both Hindu and Sultanate Muslim court circles. The earliest illustrated manuscripts appear in the late Sultanate period. Among the finest is an edition from the Delhi area, datable to the second quarter of the sixteenth century (CSMVS Museum, Mumbai; John Rylands Library, Manchester).

Mahabharata (Story of Bharata): ancient Sanskrit epic of India, narrating the heroic deeds of the Kauravas and their rivals the Pandavas. This longest poem in literary history is attributed to the sage-poet Vyasa who, the text tells us, dictated it to Ganesha. It is assigned to around 300 BCE and assumed its present form probably by around 300 CE. It was favored for illustration in the later Hindu courts, especially in the Punjab Hill states of Himachal Pradesh. The *Mahabharata* was translated into Persian on the instruction of Akbar and titled *Razmnama*.

Nala-Damayanti: mythical romance in which princess Damayanti of the Vidarbha kingdom chooses the imperfect mortal King Nala over the succession of gods and demons who propose to her. This story is based on the *Naishadhiyacarita*, an extended *mahakavaya* (great poem) extracted from the *Mahabharata*, and illustrated editions follow the textual narrative closely. A popular romance for later Hindu court painting, the most extensive series is a set of large-scale finished drawings commissioned by the Raja Samsar Chand of Kangra (1774–1823), which may have been intended to serve as cartoons for a mural series (Museum of Fine Arts, Boston, and elsewhere).

Pancatantra (Five Books): collection of Indian animal fables written in Sanskrit, of uncertain date, but perhaps fourth century CE in its present form; the *Hitopadesha* (Book of Good Council) is a later summary. It was intended for teaching ethics, worldly wisdom, and good governorship to prospective rulers. Such collections were written with humor and allegorical intent, primarily for the entertainment and education of those in power. Inspired free renderings of these stories exist in the Arabic, Persian and Muslim Indian worlds, of which the *Kalila wa Dimna* and the *Anvar-i Suhayli* are the most famous.

Ragamala (Garland of Melodies): series of musical modes, "tinged with emotion," each designed to evoke a particular flavor (*rasa*) and emotion (*bhava*), classified first, according to the time of day or night of a particular season, and second, according to the emotion they express. Painters sought to capture these same emotions and moods in series of paintings that mirror the musical modes. In addition to these requirements, *Ragamala* paintings usually indicate a specific deity to be associated with the *raga*. The six principal ragas are Bhairava, Dipaka, Sri, Malkaunsa, Megha, and Hindola; each is associated with one of the six seasons—summer, monsoon, autumn, early winter, winter, and spring.

Ramayana (Adventures of Rama): second great epic poem of Sanskrit literature, believed to have been composed around the third century BCE by the sage-poet Valmiki, describing the exploits of Rama. Devotional aspects linking Rama to Vishnu were introduced around second-third century CE and subsequently became a seminal work of the Hindu worldview, especially admired as role models of kingship and virtuous rule. The *Ramayana* was much illustrated in court painting of the later Hindu courts.

Rasamanjari (Bouquet of Delight): Sanskrit composition, written by Bhanudatta in Bihar in the fifteenth century, devoted to the expression and classification of moods and emotions (*nayika-bheda*) of the Nayaka (hero-lover) and Nayaki (heroine-loved) in Sanskrit poetry. This tradition has its origins in the first treatise on dramatic arts, Bharata's *Natyashastra*. The *Rasamanjari* inspired many other works in the same genre, and also painted versions, especially in the courts of Basholi and Nurpur.

Rasikapriya (Manual for Connoisseurs): Hindi treatise on the classification of ideal lovers (*nayakas* and *nayikai*), composed as an extended love poem by Keshavdas in 1591 for his patron, the Raja of Orchha. It was directly modeled on Bhanudatta's *Rasamanjari* of a century earlier but with a more elaborate classification of lovers and loved. A popular erotic work, it was widely illustrated, most famously by the Mewar master Sahibdin in the 1630s (National Museum, New Delhi).

Shiva Purana (Ancient Stories of Shiva): one of the principal *puranas* dedicated to Shiva, incorporated in the *Mahapurana*. Among the earliest painted versions is a twelfth-century Nepalese manuscript cover (Pritzker Collection, Chicago); it occurs less frequently in later Indian painting, principally in works of the eighteenth-century Pahari schools.

Usha-Aniruddha: Krishna-*bhakti* related story recounting the love of Usha, the beautiful daughter of the demon Banasura, who is imprisoned by her father in his fortress castle Agnigarh. Usha sees her chosen love in a dream, and her friend Chitralekha, a gifted artist, paints a number of portraits so that he might be identified. Usha had dreamed of Aniruddha, Krishna's grandson, who is magically brought to Usha. They secretly wed and live together at Agnigarh.

Vasanta Vilasa (Festival of Spring): Gujarati poem composed in the early fifteenth century celebrating the joys of lovers in spring. A cloth painted version commissioned by an Ahmedabad merchant named Candrapala in 1451 is the earliest and most exhaustive pictorial rendering known (Freer Gallery, Washington D.C.).

PERSIAN TEXTS

Anvar-i Suhayli (Lights of Canopus): collection of ancient Indian animal fables freely adapted in Persian from the Sanskrit *Pancatantra*, closely related to the *Kalila wa Dimna*, both reintroduced into Muslim India from Iran. A richly illustrated edition, with 36 painted pages, was produced for Akbar in 1570–71 (School of Oriental and African Studies, University of London), and another edition, heavily illustrated in the Safavid manner, also belonging to Akbar's reign, is dated 1582 (Victoria and Albert Museum, London). Akbar instructed his court chronicler Abu'l Fazl in 1583 to prepare a version in less florid Persian of the *Anvar-i Suhayli*, which survives as the *Iyar-i Danish*. Prince Salim commissioned a copy in 1604, during his self-exile in Allahabad, which was only completed according to its colophon in 1610–11 (British Library, London).

Baharistan (Garden of Spring): composed by Jami (1414–92), the last great classical Iranian poet and celebrated *sufi* mystic, to celebrate the birth of a son in 1487. He modeled his *Baharistan* on Sa'di's *Gulistan*. Other famous works are the *Haft Awrang* (Seven Thrones) and *Nafahat al-uns* (Breaths of Fellowship). An imperial copy of *Baharistan* was prepared for Akbar at Lahore in 1595 by the calligrapher Muhammad Husayn and illustrated by sixteen leading court painters (Bodleian Library, Oxford) and illustrates the chapters devoted to Wise Men, Generosity, and Love only. A copy of *Nafahat al-uns* was prepared for Akbar in 1603 (British Museum, London).

Darab-nama (Tales of Darab): Sultanate or early Mughal rendering of the *Shahnama* in the form of a series of stories by Abu Tahir. A richly illustrated copy was produced at Lahore around 1580, including the painter Basawan (British Library, London, 149 paintings).

Divan of Hafiz: collected works of Iran's greatest Sufi poet, Hafiz (ca. 1326–90). A copy was prepared in 1527 in Shiraz, probably for Prince Sam Mirza, younger brother of Shah Tahmasp (1514–1576). A fine Mughal copy was produced at Lahore in 1588, illustrated by Miskin (Fogg Art Museum, Cambridge, Mass., 15 paintings).

Bustan (The Orchard, 1257) and *Gulistan* (Rose Garden, 1258): poems that form part of the *Kulliyat* (Collected Works) composed by the Iranian mystic poet Sa'di (ca. 1215–1292) of Shiraz, the most widely celebrated and illustrated of Persian poets. Born in Shiraz, he studied in Baghdad, traveled widely, and witnessed much of the devastation of both Mongol invasions and Christian crusades. He returned to Shiraz in old age and was esteemed at court for his wisdom and his poetry. The most celebrated edition of *Bustan* by Bihzad is that of 1488 (National Library, Cairo) and also, the 1527 Shiraz edition (Walters Art Museum, Baltimore). Fine Mughal editions of the *Gulistan* were produced for Akbar at Fatehpur Sikri, dated 1581 (Royal Asiatic Society, London) and Agra, dated 1604 (Aga Khan Trust).

Hamzanama (Story of Hamza), or *Dastan-i-Amir Hamza*: history of Amir Hamza, uncle of the Prophet Mohammed and champion of Islam, who became a figure of popular legend and romance. The story is probably of Persian origin but was especially popular in Mughal India. Emperor Humayun is assumed to have initiated an enormous illustrated edition of 1400 paintings, although the project may have been Akbar's initiative. It was the largest undertaking of the early Mughal atelier, made under the direction of two famous émigré Iranian artists, Mir Sayyid 'Ali and 'Abd al-Samad, and was in production from around 1557–58 until 1572–73 (Museum of Applied Arts, Vienna, 61 paintings; Victoria and Albert Museum, London, 27 paintings; and elsewhere).

Iskandarnama (Life of Alexander): composed by the great Iranian poet Nizami (1140–1203), as part of his *Khamsa* (Five Poems/Treasures). It describes the conquests of Alexander the Great, in later Islamic literature sometimes identified with the prophet Dhul-Qarnayn. The finest pre-Mughal illustrated edition is the Sultanate style manuscript commissioned by Sultan Nusrat Shah of Bengal in 1531–32, undoubtedly at his capital of Gaur (British Library, London).

Jami-al-Tawarikh (Collection of Chronicles/Histories): written by a Mongol statesman, Rashid al-Din Fazdullah (d. 1318). It provides a history of the Mongols. The finest illustrated copy, dated 1595, was looted from the imperial library at Delhi in 1739, by the Persian emperor Nadir Shah and is now preserved in the Golestan Palace Library, Tehran.

Kalila wa Dimna: collection of animal fables of early Indian origin (see *Panchatantra*), which surfaced in Arabic and then Persian versions of a lost sixth-century Sasanian work, *Fables of Bidpai*. These fables returned to India as *Kalila wa Dimna* and *Anvar-i Suhayli*, the former known first from a Lodi Sultanate manuscript dated 1492 (National Museum, New Delhi). Both became very popular in Mughal India.

Khamsa (Five Poems/Treasures) *of Amir Khusraw Dihlavi*: Indian scholar-poet Amir Khusraw Dihlavi (1253–1325) was also an eminent musician and Sufi, who wrote in both Persian and Hindustan. He was born at Patiala in northern India of an émigré Turk father, and during his successful career, he served as court poet under five successive rulers of the Mu'izzu (1206–90), Khaliji (1290–1320), and Tughluq (1320–1414) Delhi Sultanates. He authored a *Khamsa*, composed poems still reputedly recited in Sufi shrines in India today, innovated the design of the *tabla*, and stimulated the adoption of the Persian *ghazal* vocal style in India. An imperial edition of his *Khamsa* was commissioned by Akbar (The Walters Art Museum, Baltimore, and The Metropolitan Museum of Art, New York).

Khamsa (Five Poems/Treasures) *of Nizami*: written by Iranian poet Nizami (1140–1203), who established a literary style that served as a model for later Persian epic poetry. Each of the five poems is illustrated independently: *Makhzan ul-asrar* (Treasure House of Secrets), *Khusraw u Shirin* (romantic story of a Sassanian King), *Laili u Majnun* (tragic love of an Arab poet for a Bedouin maiden), *Iskandarnama* (Life of Alexander), and *Haft paikar* (Seven Beauties). The finest imperial copy was prepared in 1539–43 in the atelier of Shah Tahmasp, Tabriz, in the Safavid style (British Museum, London, 17 paintings); an imperial Mughal copy is dated 1595 (British Museum, London, 37 paintings, and The Walters Art Museum, Baltimore, 5 paintings).

Ni'mat nama (Book of Delicacies): dedicated to the culinary arts as practiced under Ghayas Shah and his son Nasir al-Din. It was produced in the Shiraz-style of Iran at Malwa around 1500 (British Library, London).

Shahnama (Book of Kings): the poem-legend of Persia, begun by Daqiqi (d. 980) and completed thirty years later by Abu'l-Qazim Firdawsi (934–1020) of Tus, in 1010, composed in 60,000 couplets. This epic poem recounts the history of Persia's pre-Islamic rulers from the first mythical kings to the downfall of the Sasanians in the mid-seventh century. It was instrumental in establishing modern Persian as a literary language. A series of illustrated editions dated to the early fourteenth century and attributed to Tabriz and Shiraz are the likely prototypes that were imported into Sultanate India (Arthur M. Sackler Gallery, Smithsonian Institution, Washington D.C., dated 1341). Famous illustrated copies include the *Gulshan Shahnama* (Golestan Palace Library, Tehran), 1430, Herat, and the imperial *Shahnama* (dispersed) 1522–37, Tabriz.

Tarik i-Husain Shahi: Persian poem celebrating the reign of Husain Nizam Shah I (r. 1553–65) of the Deccan Sultanate Ahmadnagar. Much attention is devoted to praising the beauty of his first queen, Khanzada Humayun. The manuscript appears to have been left unfinished at his death in 1565, and so is datable shortly before that year. Manuscript and twelve of the fourteen original painted folios are preserved in the Bharata Itihasa Samshodhaka Mandala, Poona.

MUGHAL HISTORIES AND BIOGRAPHIES

Akbarnama (History of Akbar): written by Abu'l Fazl (1551–1602) under the emperor's direction and provides an official history of the reign up to the year of the author's death. Volume 1 recounts Akbar's ancestry, from Timur, Babur, and Humayun; volumes II and III give a chronological account of events in Akbar's reign. Volume III is also known as the *Ain-i Akbari* (Akbar's Institutes). The Victoria and Albert Museum's illustrated copy, of about 1589–90, is generally accepted as the first imperial copy (117 paintings). A second imperial copy, from about 1604–5, is shared between the British Museum, London (vol. I, 39 paintings) and the Chester Beatty Library, Dublin (vol. II and part of vol. III, 61 paintings).

Baburnama (History of Babur): Babur's (1483–1530) memoirs, written in his native Chaghata'i Turkish, translated into Persian by Abd al-Rahim Khan i-Khanan at Akbar's request, and presented to him on November 24, 1589 (as described in the *Akbarnama*). The bulk of this illustrated edition is in the Victoria and Albert Museum, London. In the 1590s, a number of copies were prepared for distribution among members of the imperial family and inner court (National Museum, New Delhi; State Museum of Oriental Cultures, Moscow; British Library, London; and The Walters Art Museum, Baltimore).

Jahangirnama (*Tuzuk i-Jahangiri*, Memoirs of Jahangir): the personal memoirs of the emperor Jahangir (r. 1605–27), preserved as a Persian text. It was reputedly also produced as an illustrated volume under the emperor's direction, but this has not survived, and it was dispersed, some paintings surviving in later imperial albums and in the Raza Library, Rampur.

Muraqqa (picture albums): the earliest Mughal evidence of creating picture albums occurs in the *A'in-i Akbari*, where Abu'l Fazl refers to Akbar ordering "to have likenesses taken of all the grandees of the realm. An immense album was thus formed." The most famous *muraqqa* assembled by Emperor Jahangir is the Gulshan Album, now preserved in the Golestan Palace Library, Tehran, with folios in the Staatsbibliothek, Berlin. It seems that the *Tuzuk i-Jahangiri*, written personally by the emperor, was intended to incorporate numerous independent paintings, in the manner of a *muraqqa*. Regrettably, it does not survive intact. The major surviving albums are associated with Shah Jahan, notably the *Minto*, *Wantage* (Victoria and Albert Museum, London), *Kevorkian* (The Metropolitan Museum of Art, New York), and the *Late Shah Jahan Album*, the latter now dispersed (Arthur M. Sackler Gallery, Smithsonian Institution, Washington D.C. and elsewhere).

Padshahnama (History of the King of the World): official state biography of emperor Shah Jahan, written as three volumes, each covering a decade of the emperor's reign. The Windsor Castle manuscript belongs to the volume describing the first decade, authored by Muhammad Amin Qazwini. It has forty-four paintings, many of which are signed, by eminent court artists including Balchand, Lalchand, Ram Das, 'Abid, and Payag, among others.

Tarikh-i-Alfi (History of the Millennium): begun at Akbar's request in 1582 and intended to be completed by 1592, the thousandth year of the Islamic era. It was still being revised in 1594 and was probably never completed. Illustrated copies of finished sections were prepared in the 1580s.

Timurnama (History of the House of Timur): prepared at Akbar's request, tracing Timur's descendants down to the twenty-second year of Akbar's reign. An imperial copy was prepared in Fatehpur Sikri, dated 1584 (Khuda Bakhsh Oriental Public Library, Patna, 132 paintings).

PERSIAN TRANSLATIONS OF INDIAN TEXTS

Bahr al-Hayat: Persian translation of a Sanskrit text, *Amritakunda* (Pool of Nectar), dealing with the theory and practice of yoga, including the eighty-four postures of yogis. One copy contains twenty-one paintings, each depicting a meditation posture (Chester Beatty Library, Dublin).

Harivamsa (Genealogy of Vishnu): Sanskrit text that was often appended to the *Mahabharata*, translated into Persian at Akbar's request before 1586 and richly illustrated (Maharaja Sawai Man Singh II Museum, Jaipur). Another illustrated imperial edition, dating from the 1590s, is in the State Museum, Lucknow, with six paintings in the Victoria and Albert Museum, London, and four in The Metropolitan Museum of Art, New York.

Iyar-i Danish (Touchstone of Knowledge): revised translation of the *Pancatantra*, undertaken by Abu'l Fazl in 1588. An illustrated copy, in production at the time of Akbar's death in 1605, is shared between the Chester Beatty Library, Dublin (96 paintings) and the Cowsaji Jehangir collection, India (52 paintings).

Jog Bashisht: Sanskrit treatise, the *Yoga-Vasishtha*, translated in 1597–98 at Akbar's request. It recounts the goals of Hindu asceticism and how they might be reached without physical separation from worldly affairs. An illustrated imperial edition is dated 1602 (Chester Beatty Library, Dublin, 41 paintings).

Ramayana (The Adventures of Rama): the great epic poem of Sanskrit literature rendered into Persian during Akbar's reign. It describes the exploits of Rama. The finest and most complete copy is in the Maharaja Sawai Man Singh II Museum, Jaipur. Early seventeenth century editions are in the Freer Gallery, Washington D.C. and Qatar National Museum.

Razm-nama (Books of Wars): Sanskrit epic poem the *Mahabharata*, translated into Persian. The translation was commissioned by Akbar in 1582 and was done by Bada'uni under the supervision of Naqid Khan. The imperial copy, illustrated with 169 painting miniatures, was completed for the emperor soon after 1584 (Maharaja Sawai Man Singh II Museum, Jaipur).

Tutinama (Tales of a Parrot): Sanskrit text, the *Shukasaptati* (Seventy Tales of a Parrot), seemingly via a Persian intermediary collection of stories, *Jawahir al-Asmar* (Gems of Stories, by 'Imad bin Muhammad), then abridged and adapted by the Iranian poet and devout *Sufi* Ziya al-din Nakhshabi (d. 1350), who had emigrated to Sultanate India in the reign of Qutb al-din Khalji (r. 1316–20). He settled in Budaun, near Delhi, where he composed the *Tutinama* around 1330, drawing on a variety of Sanskrit and Persian stories, principally the *Shukasaptati*, but also on the *Pancatantra*, the Persian *Sindbadnama* (Tales of Sinbad), and the *Kalila wa Dimna*. The verses concern ethical, philosophical, and mythical matters. Two important illustrated editions survive (Cleveland Museum of Art copy of around 1565–70, 211 paintings, and the copy of 1580–85 in the Chester Beatty Library, Dublin, 113 paintings).

PERSIAN TRANSLATIONS OF CHRISTIAN TEXTS

Dastan-i Ahwal-i Hawariyan (Lives of the Apostles): Prepared by Father Jerome Xavier (1549–1617) at Akbar's direction and translated into Persian with the assistance of Abd al-Sattar ibn Qasim Lahauri. A revised edition was prepared at Jahangir's request. A copy is preserved in the Bodleian Library, Oxford.

Mir'at al-Quds (Mirror of Holiness), also known as *Dastan-i Masih* (Life of Christ, or Story of the Messiah): Father Jerome Xavier, leader of the third Jesuit mission to the court of Akbar, arrived at Lahore in 1595 and was directed to write an account of Christ's life. Father Jerome presented his text to Akbar at Agra on May 5, 1602, and it was translated from the Portuguese into Persian with the assistance of Abd al-Sattar ibn Qasim Lahauri. It is known in at least seventeen extant manuscripts, including an illustrated edition in Lahore, and another, with 24 illustrated pages preserved, in The Cleveland Museum of Art. Further folios from the later copy are in various collections.

PREFACE

1. Abu'l Fazl, *The Ain-i Akbari*, translated by H[enry] Blochmann (Calcutta: Asiatic Society of Bengal, 1873), vol. 1, p. 107.

2. Ibid., pp. 107–8.

3. Jahangir, *The Jahangirnama: Memoirs of Jahangir, Emperor of India*, translated by Wheeler M. Thackston (Washington, D.C.: Freer Gallery of Art, Arthur M. Sackler Gallery, 1999), p. 268.

4. Milo Cleveland Beach, with Stuart Cary Welch and Glenn D. Lowry, *The Grand Mogul: Imperial Painting in India, 1600–1660*, exh. cat. (Williamstown: Sterling and Francine Clark Art Institute, 1978), p. 86.

5. B[rijindra] N[ath] Goswamy and Eberhard Fischer, *Pahari Masters: Court Painters of Northern India*, Artibus Asiae Supplementum 38 (Zurich: Museum Rietberg Zürich, 1992), p. 269.

6. Milo C[leveland] Beach, Eberhard Fischer, and B[rijindra] N[ath] Goswamy, eds., *Masters of Indian Painting*, 2 vols., Artibus Asiae Supplementum 48 ([Zurich]: Artibus Asiae Publishers, 2011).

THE ART OF THE BOOK IN SOUTH ASIA

1. Paul Dundas, *The Jains*, 2nd ed. (1992; London and New York: Routledge, 2002), pp. 70–71.

2. Barbara Stoler Miller, ed., *Theater of Memory: The Plays of Kalidasa* (New York: Columbia University Press, 1984), pp. 5–6.

3. Milo Cleveland Beach, *Rajput Painting at Bundi and Kota* (Ascona: Artibus Asiae Publishers, 1974).

4. Miller, ed., *Theater of Memory*, pp. 85–176.

5. John Guy, *Indian Temple Sculpture* (London: V & A Publications, 2007), p. 51.

6. Moti Chandra, *Studies in Early Indian Painting*, Rabindranath Tagore Memorial Lectures, 1964, University of Pennsylvania (New York: Asia Publishing House, 1970), p. 14.

7. Miller, ed., *Theater of Memory*, p. 41.

8. Stella Kramrisch, "Introduction to the Visnudharmottara [(Pt. III): A Treatise on Indian Painting and Image Making (Calcutta: University of Calcutta, 1928)," in *Exploring India's Sacred Art: Selected Writings of Stella Kramrisch*, edited by Barbara Stoler Miller (Philadelphia: University of Pennsylvania Press, 1983), pp. 263–72, 339–41; Parul Dave Mukherji, *The Citrasutra of the Visnudharmottara Purana* (New Delhi: Indira Gandhi National Centre for the Arts; Motilal Banarsidass Publishers, 2001).

9. Chandra, *Studies in Early Indian Painting*, p. 28.

10. See also British Library Or. 13869; Jeremiah P. Losty, *The Art of the Book in India*, exh. cat. (London: British Library, 1982), pl. 14, pp. 35–36. These are devoted to Shaiva-linga worship scenes, representations of the avatars of Vishnu, and illustrated editions the *Devi Matsyma* (Glorification of the Goddess) text celebrating the goddess, especially Durga. Important examples are preserved in the National Archives, Kathmandu.

11. For a discussion and depiction of this subject in Jain painting, see John Guy and Deborah Swallow, eds., *Arts of India, 1550–1900* (London: Victoria and Albert Museum, 1990), pp. 32–33.

12. Priyatosh Banerjee, "Painted Covers of the Two Gilgit Manuscripts," *Oriental Art* 14, no. 2 (1968), pp. 114–18; Deborah Klimburg-Salter, "The Gilgit Manuscript Covers and the 'Cult of the Book,'" in *South Asian Archaeology 1987, Venice*, edited by M. Taddei (Rome: Instituto Italiano per il Medio ed Estremo Oriente, 1990), part 2, pp. 815–27.

13. Oskar von Hinüber, *Antiquities of Northern Pakistan: Reports and Studies*, vol. 5, *Die Palola sahis: Ihre Steininschriften, Inschriften auf Bronzen, Handschriften kolophone und Schutzzauber* (Mainz: Verlag Philipp von Zabern, 2004).

14. Central Museum Lahore, Pakistan, acc. no. G-155.

15. Rajeshwari Ghose, ed., *Kizil on the Silk Road: Crossroads of Commerce and Meeting of Minds* (Mumbai: Marg Publications, 2008), pp. 78–79.

16. Ajatashatru was the fifth century B.C.E. king of Magadha and founder of Pataliputra (Patna), and patron and protector of the Buddha and his *sangha*. He is referred to in the early Pali commentary, the *Samaññaphala Sutta*.

17. Fa Xian is unclear if these were sculptural or painted cloth images, but more likely the latter; James Legge, *A Record of Buddhistic Kingdoms: Being an Account by the Chinese Monk Fa-Hien of His Travels in India and Ceylon (A.D. 399–414) in Search of the Buddhist Books of Discipline* (1886; New York: Dover, 1965), p. 106.

18. Nicolo Conti, quoted in Makrand Mehta, *Indian Merchants and Entrepreneurs in Historical Perspective with Special Reference to Shroffs of Gujarat, Seventeenth to Nineteenth Centuries* (Delhi: Academic Foundation, 1991), p. 116.

19. S[adashiv] V. Gorakshkar, "A Dated Manuscript of the *Kalakacharya Katha* in the Prince of Wales Museum," *Bulletin of the Prince of Wales Museum* 9 (1964–66), pp. 56–57, figs. 69–71.

20. Glenn D. Lowry and Milo Cleveland Beach, with Roya Marefat and Wheeler M. Thackston, *An Annotated and Illustrated Checklist of the Vever Collection* (Washington, D.C.: Arthur M. Sackler Gallery, Smithsonian Institution, 1988), p. 68.

21. Guy and Swallow, eds., *Arts of India, 1550–1900*, pls. 4, 17.

22. W[illiam] Norman Brown, trans. and ed., *The Vasanta Vilasa: A Poem of the Spring Festival in Old Gujarati Accompanied by Sanskrit and Prakrit Stanzas and Illustrated with Miniature Paintings* (New Haven: American Oriental Society, 1962).

23. For the most comprehensive study of the production and purpose of the *Hamzanama*, see John Seyller et al., *The Adventures of Hamza: Painting and Storytelling in Mughal India*, exh. cat. (Washington, D.C.: Freer Gallery of Art and Arthur M. Sackler Gallery of Art, Smithsonian Institution; London: Azimuth Editions Limited, 2002).

FROM PALM-LEAF TO PAPER: MANUSCRIPT PAINTING, 1100–1500

1. For Alchi, see Roger Goepper et al., *Alchi: Ladakh's Hidden Buddhist Sanctuary, the Sumtsek* (London: Serindia, 1996).

2. *Pancaraksa* is an esoteric collection of five mystic spells or charms (*vidya*) intended to protect the devotee from misfortunes and ensure the fulfillment of all desires. These charms came to be personified as female deities, their descriptions codified in the *Sadhanamala* and *Nispannayogavali* by the twelfth century; Dipak Chandra Bhattacharyya, *Studies in Buddhist Iconography* (New Delhi: Manohar, 1978), p. 69. See also Marie-Thérèse de Mallmann, *Introduction à l'iconographie du tântrisme bouddhique* (Paris: Adrien-Maisonneuve, 1975).

3. Cambridge University Library, Add. 1464; Asiatic Society of Bengal, Kolkuta, G.4713. Assigning secure dates to the reigns of Pala monarchs has proved highly problematic, and the chronology largely remains unsettled. Newly discovered stone and copperplate inscriptions routinely necessitate adjustments, as with the discovery of a "new" Gopala II; see Gauriswar Bhattacharya, "Discovery of a New Pala Ruler," *Journal of the Asiatic Society of Bangladesh (Humanities)* 41, no. 1 (1996), pp. 193–95. I am grateful to Karen Weissenborn for this reference.

4. J[eremiah P]. Losty, "The 'Vredenburg Manuscript' in the Victoria and Albert Museum," in *Makaranda: Essays in Honour of Dr. James C. Harle*, edited by Claudine Bautze-Picron (Delhi: Sri Satguru Publications, 1990), pp. 189–99, figs. 1–12; see Claudine Bautze-Picron, "The 'Vredenburg Manuscript' and Its Book Covers," in *The Diverse World of Indian Painting, Vichitra-Visva: Essays in Honour of Dr. Vishwa Chander Ohri*, edited by Usha Bhatia, Amar Nath Khanna, and Vijay Sharma (New Delhi: Aryan Books International, 2009), pp. 1–15, for the rediscovery of the "lost" book covers.

5. The three confirmed products of Nalanda monastery are: AsP mss. dated sixth year of the reign of Mahipala I, Asiatic Society of Bengal, Kolkata. G.4713; AsP mss. dated fifteenth year of reign of Ramapala, Bodleian Library, Oxford, MS Sansk. A.7 (R); AsP mss. dated fifteenth year of reign of Vigrahapala (III?), Asia Society New York, inv. 1987.1 (and rededicated in eighth reign year of Gopala (IV?).

6. Moti Chandra, *Jain Miniature Paintings from Western India*, Jain Art Publication Series, 1 (Ahmedabad: Sarabhai Manilal Nawab, 1949), p. 57, pls. 190–92. It is preserved in the Jain monastic library at Jaisalmer.

7. Vadi Devasuri was a contemporary and close friend of the famed Jain theologian and polymath Hemachandra.

8. Chandra, *Jain Miniature Paintings from Western India*, pp. 59–62, pls. 193–98.

9. For a substantially complete illustrated edition in the Museum of Fine Arts, Boston, acc. no. 30.106, see W[illiam] Norman Brown, *Miniature Painting in Western India* (New York: College Art Association, 1930). See also Guy and Swallow, eds., *Arts of India, 1550–1900* , pl. 19.

10. See John Guy, *Woven Cargoes: Indian Textiles in the East* (New York: Thames and Hudson, 1998), for carbon-14 dated Gujarati textiles displaying these distinctive features of the Western Indian painting style.

11. S[adashiv] V. Gorakshkar, "A Dated Manuscript of the *Kalakacharya Katha* in the Prince of Wales Museum," *Bulletin of the Prince of Wales Museum* 9 (1964–66), pp. 56–57, figs. 69–71.

12. Simon Digby, "The Literary Evidence for Painting in the Delhi Sultanate," *Bulletin of the American Academy of Benares* 1 (1967), pp. 47–58.

13. Karl J. Khandalavala and Moti Chandra, "A Consideration of an Illustrated Ms from Mandapadurga (Mandu) Dated 1439 A.D. and Its Bearing on Certain Problems of Indian Painting," *Lalit Kala*, no. 6 (1959), pp. 8–29, pls. 1–7.

14. Ibid.

15. The manuscript, now dispersed, is published in B[rijindra] N[ath] Goswamy, "Nainsukh of Guler," in *Painters of the Pahari Schools*, edited by Vishwa Chander Ohri and Roy C. Craven, Jr. (Mumbai: Marg Publications, 1998), pp. 68–97.

16. Another edition, of similar date and also of Indian origin, is more in the contemporary mode of Shiraz Iran, underscoring the uniqueness of the *Jainesque Shahnama;* compare Vever Collection, published in Glenn D. Lowry and Milo Cleveland Beach, with Roya Marefat and Wheeler M. Thackston, *An Annotated and Illustrated Checklist of the Vever Collection* (Washington, D.C.: Arthur M. Sackler Gallery, Smithsonian Institution, 1988), pls. 192–98.

17. For painting of Sultanate Bengal, see Robert Skelton, "The Iskandar Nama of Nusrat Shah: A Royal Sultanate Manuscript Dated 938 A.H. 1531–32 A.D.," in *Indian Painting: Mughal and Rajput and a Sultanate Manuscript*, [edited by Michael Goedhuis], sale cat. (London: P. & D. Colnaghi and Co., 1978), pp. 135–44.

18. John Guy in Beach, Fischer, and Goswamy, eds., *Masters of Indian Painting*, p. 31.

19. Exemplified in the manuscript of that name in the N. C. Mehta Collection, Ahmedabad; see Leela Shiveshwarkar, *The Pictures of the Chaurapanchasika, A Sanscrit Love Lyric* (New Delhi: The National Museum, 1967).

20. Reconstructed and analyzed in B[rijindra] N[ath] Goswamy, *A Jainesque Sultanate Shahnama and the Context of Pre-Mughal Painting in India* (Zurich: Museum Rietberg Zürich, 1988).

21. John Guy, *Palm-leaf and Paper: Illustrated Manuscripts of India and Southeast Asia*, exh. cat. (Melbourne: National Gallery of Victoria, 1982).

22. Saryu Doshi, ed., *Masterpieces of Jain Painting* (Bombay: Marg Publications, 1985).

23. Chandra, *Jain Miniature Paintings from Western India*, ch. VI.

24. Sarabhai Manilal Nawab and Rajendra Sarabhai Nawab, *Jaina Paintings*, vol. 2, *Paintings on Paper, Commencing from V.S. 1403 to V.S. 1656 Only* (Ahmedabad: Messrs Sarabhai Manilal Nawab, 1985), p. 24.

25. Karl J. Khandalavala and Moti Chandra, *New Documents of Indian Painting—A Reappraisal* (Bombay: Board of Trustees of the Prince of Wales Museum of Western India, 1969).

EARLY HINDU-SULTANATE PAINTING, 1500–1575

1. See George Michell and Mark Zebrowski, *The Architecture and Art of the Deccan Sultanates*, The New Cambridge History of India, 1, no. 7 (Cambridge and New York: Cambridge University Press, 1999), for an overview of their pioneering studies of the art and architecture of the Sultanate Deccan.

2. Skelton, "The Iskandar Nama of Nusrat Shah," pp. 135–38. This author's pioneering studies of Sultanate painting have helped redefine our understanding of the syncretic process that resulted in the early Mughal school.

3. Douglas Barrett and Basil Gray, *Painting of India* ([Geneva]: Skira, 1963), p. 116. This unfinished manuscript celebrates the reign of Husain Nizam Shah I (r. 1565–9) of the Deccan Sultanate Ahmadnagar.

4. Daniel J. Ehnbom, "Three Miniatures from a Bhagavata Purana Series," in *Two Thousand Years of Indian Art*, sale cat. (London: Spink & Son Ltd., 1982), pp. 17–18.

5. Published in Leela Shiveshwarkar, *The Pictures of the Chaurapanchasika, A Sanscrit Love Lyric* (New Delhi: The National Museum, 1967).

6. The cupola, crenulations, and projecting *makara* eave bracket are all features of Sultanate palace architecture of the period.

7. Shiveshwarkar, *The Pictures of the Chaurapanchasika*, p. 22.

8. John Seyller et al., *The Adventures of Hamza*.

9. The Cleveland manuscript survives with 341 folios intact, of which 211 are illustrated; Pramod Chandra and Daniel J. Ehnbom, *The Cleveland Tuti-nama Manuscript and the Origins of Mughal Painting*, exh. cat. (Chicago: The University of Chicago, 1976), pp. 16–17.

10. Chandra in ibid., pp. 62–72, proposed the dates 1562–77; John Seyller reassigned the production window five years earlier on the basis of a previously unread date on one folio, dated 1564–65; John Seyller, "A Dated Hamzanama Illustration," *Artibus Asiae* 53, no. 3–4 (1993), pp. 502–5.

11. Others argue for a Malwa-Rajput origin; see Andrew Topsfield, *Court Painting at Udaipur: Art Under the Patronage of the Maharanas of Mewar*, Artibus Asiae Supplementum 44 (Zurich: Museum Rietberg Zürich, [2002]), pp. 21–52.

12. Ehnbom, "Three Miniatures from a Bhagavata Purana Series," pp. 17–18.

13. Robert Skelton, *Rajasthani Temple Hangings of the Krishna Cult from the Collection of Karl Mann, New York*, exh. cat. (New York: American Federation of the Arts, 1973).

14. Karl [J.] Khandalavala and Jagdish Mittal, "The *Bhagavata* MSS from Palam and Isarda—A Consideration in Style," *Lalit Kala*, no. 16 (1974), p. 29.

15. Abu'l Fazl, *The Ain-i Akbari*, p. 108.

16. John Guy, "Mughal Painting under Akbar: The Melbourne 'Hamza-nama' and 'Akbar-nama' Paintings," *Art Bulletin of Victoria*, no. 22 (1982), fig. 9.

17. Muhammed A. Simsar, trans. and ed., *The Cleveland Museum of Art's Tuti-nama: Tales of a Parrot, by Ziya' u'd-Din Nakhshabi* (Cleveland: The Cleveland Museum of Art; Graz: Akademische Druck- u. Verlagsanstalt, 1978), p. 102.

18. Seyller et al., *Adventures of Hamza*.

19. Chandra and Ehnbom, *The Cleveland Tuti-nama Manuscript and the Origins of Mughal Painting*, pp. 17–18; illustrated in Simsar, trans. and ed., *The Cleveland Museum of Art's Tuti-nama*, pls. 8 and 31.

THE GOLDEN AGE OF MUGHAL PAINTING, 1575–1650

1. The function of the *kitabkhana* is examined in Michael Brand and Glenn D. Lowry, *Akbar's India: Art from the Mughal City of Victory*, exh. cat. (New York: The Asia Society, 1985), chap. 3, pp. 57–85.

2. Abu'l Fazl, *The Ain-i Akbari*, pp. 109–10.

3. Antonio Monserrate, *The Commentary of Father Monserrate, S.J., on His Journey to the Court of Akbar*, translated by J[ohn] S. Hoyland; annotated by S. N. Banerjee (London: Humphrey Milford, Oxford University Press, 1922).

4. Abu'l Fazl, *The Ain-i Akbari*, p. 107.

5. See also the Jahangir Album of the State Library, Berlin; Ernst Kühnel and Hermann Goetz, *Indian Book Painting from Jahangir's Album in the State Library of Berlin* (London: Kegan Paul, Trench, Trubner and Co., 1926), fol. 18a.

6. Abu'l Fazl, *The Ain-i Akbari*, p. 107.

7. Monserrate in John Correia-Afonso, *Letters from the Mughal Court: The First Jesuit Mission to Akbar (1580–1583)*, (Bombay: Heras Institute of Indian History and Culture, 1980), p. 82.

8. Netherlandish engraving, especially from Antwerp, of Christian subjects and allegorical themes were circulated widely by the Jesuits; see Milo Cleveland Beach, "The Gulshan Album and Its European Sources," *Museum of Fine Arts, Boston, Bulletin* 63, no. 332 (1965), pp. 63–91; Beach, with Welch and Lowry, *The Grand Mogul*, pp. 27, 62–63, 183 n. 7; and Milo Cleveland Beach, "The Mughal Painter Abu'l Hasan and Some English Sources for his Style," *The Journal of the Walters Art Gallery* 38 (1980), pp. 6–33; see also Ashok Kumar Srivastava, *Mughal Painting: An Interplay of Indigenous and Foreign Traditions* (New Delhi: Munshiram Manoharlal Publishers, 2000).

9. James I's ambassador to the court of Jahangir, Sir Thomas Roe, presented English miniatures to the emperor, reportedly including a work by the contemporary miniaturist Isaac Oliver, which Jahangir immediately had copied; see Jahangir, *The Jahangirnama*. That a portrait of James I, probably a miniature after the youthful portrait of 1605 (Courtauld Institute, London), was presented to Jahangir is witnessed by it being directly copied in a *darbar* scene by the imperial painter Bichitr around 1615–18 (St. Petersburg Album); see Milo Cleveland Beach, *The Imperial Image: Paintings for the Mughal Court*, exh. cat. (Washington, D.C.: Smithsonian Institution, 1981), p. 30.

10. Ellen S. Smart, "Yet Another Illustrated Akbari *Baburnama* Manuscript," in *Facets of Indian Art*, edited by Robert Skelton et al. (London: Victoria and Albert Museum, 1986), pp. 105–15.

11. Victoria and Albert Museum, London, and Indian Museum, Kolkuta; published in Asok Kumar Das, *Mughal Painting During Jahangir's Time* (Calcutta: The Asiatic Society, 1978), pls. 60, 57.

12. Jahangir, *The Jahangirnama*, p. 268.

13. Self-portraits do appear in Akbar's reign but are most probably private works, not intended for presentation to the emperor, such as Keshav Das's Poor Petitioner.

14. Beach, *The Imperial Image*.

15. Abu'l Fazl, *The Ain-i Akbari*, p. 107.

16. Lowry and Beach, *An Annotated and Illustrated Checklist of the Vever Collection*, p. 130. It has been suggested that the former is a self-portrait, but it is more probable that both are the work of Daulat.

17. Jahangir, *The Jahangirnama*, p. 268.

18. Abu'l Fazl, *The Ain-i Akbari*, , p. 108; see also Guy, "Mughal Painting under Akbar," pp. 25–41.

19. Jahangir, *The Jahangirnama*, p. 104. See Beach, Fischer, and Goswamy, eds., *Masters of Indian Painting*.

20. For the dating of the Victoria and Albert Museum *Akbarnama*, see John Seyller, "Codicological Aspects of the Victoria and Albert Museum *Akbarnama* and Their Historical Implications," *Art Journal* 49, no. 4 (1990), pp. 379–87; and Susan Stronge, *Painting for the Mughal Emperor: The Art of the Book, 1560–1660* (London: V & A Publications, 2002), p. 84.

21. Illustrated in Asok Kumar Das, "Farrukh Beg: Studies of Adorable Youths and Venerable Saints," in *Mughal Masters: Further Studies*, edited by Asok Kumar Das (Mumbai: Marg Publications, 1998), fig. 2.

22. Babur, *The Babur-nama in English (Memoirs of Babur)*, translated by Annette Susannah Beveridge, 2 vols. (London: Luzac and Co., 1922), pp. 287–88.

23. Asok Kumar Das, "Calligraphers and Painters in Early Mughal Painting," in *Chhavi-2: Rai Krishnadasa Felicitation Volume*, edited by Anand Krishna (Benares: Bharat Kala Bhavan, 1981), pp. 92–97, figs. 271–88; disputed by Som Prakash Verma, *Mughal Painters and Their Work: A Biographical Survey and Comprehensive Catalogue* (Delhi: Oxford University Press, 1994), p. 151.

24. Asok Kumar Das, "An Introductory Note on the Emperor Akbar's *Ramayana* and Its Miniatures," in *Facets of Indian Art*, edited by Robert Skelton et al. (London: Victoria and Albert Museum, 1986), pp. 94–104; Asok Kumar Das, "Akbar's Imperial *Ramayana*: A Mughal Persian Manuscript," in *The Legend of Rama: Artistic Visions*, edited by Vidya Dehejia (Bombay: Marg Publications, 1994), pp. 73–84.

25. Abu'l Fazl, *The Ain-i Akbari*, p. 108.

26. Thomas Roe, *The Embassy of Sir Thomas Roe to the Court of the Great Mogul, 1615–1619, as Narrated in His Journal and Correspondence*, edited by William Foster, 2 vols. (London: The Hakluyt Society, 1899), vol. 1, pp. 213–14.

27. Adam von Bartsch, Suzanne Boorsch, and John Spike, *Italian Artists of the Sixteenth Century*, The Illustrated Bartsch, 31 [*Le peintre-graveur*, 15 (Part 4)] (New York: Abaris Books, 1986), p. 416, no. 14 (526).

28. Jahangir, *The Jahangirnama*, p. 268.

29. Ibid.

30. *Shah Jahan Enthroned*, ca. 1628, Walters Art Gallery; see Beach, "The Mughal Painter Abu'l Hasan and Some English Sources for his Style," fig. 22.

31. Suggested identifications by Robert Skelton; see ibid., p. 24.

32. Jahangir, *The Jahangirnama*, p. 268.

33. Asok Kumar Das, "Mansur," in *Master Artists of the Imperial Mughal Court*, edited by Pratapaditya Pal, *Marg* 42, no. 4 (Bombay: Marg Publications, 1991), p. 40.

34. Jahangir, *The Jahangirnama*, p. 333.

35. John Seyller, *Pearls of the Parrot of India: The Walters Art Museum* Khamsa *of Amir Khusraw of Delhi* (Baltimore: The Walters Art Museum, 2001).

36. Kühnel and Goetz, *Indian Book Painting from Jahangir's Album*, pl. 20.

37. Beach, Welch and Lowry, *The Grand Mogul*, p. 95.

38. Milo Cleveland Beach and Ebba Koch with Wheeler [M.] Thackston, *King of the World: The Padshahnama, an Imperial Mughal Manuscript from the Royal Library, Windsor Castle*, exh. cat. (London: Azimuth Editions; Washington, D.C.: [Arthur M,] Sackler Gallery, Smithsonian Institution, 1997), no. 18.

39. Translation by Annemarie Schimmel, and Payag signature identified by Robert Elgood.

40. François Bernier and Irving Brock, *Travels in the Mogul Empire, A.D. 1656–1668*, translated by Archibald Constable, 2nd ed. revised by Vincent A. Smith (1891; London: Humphrey Milford, Oxford University Press, 1916), p. 378.

41. Yedda A. Godard, "Les Marges du Murakka' Gulshan," *Athar-é Iran* 1 (1936), pp. 29–30.

42. Robert Skelton, "Shaykh Phul and the Origins of Bundi Painting," in *Chhavi-2: Rai Krishnadasa Felicitation Volume*, edited by Anand Krishna (Benares: Bharat Kala Bhavan, 1981), pp. 123–29, figs. 347–50; Milo Cleveland Beach, *Rajput Painting at Bundi and Kota* (Ascona: Artibus Asiae Publishers, 1974).

43. James Tod, *Annals and Antiquities of Rajasthan, or the Central and Western Rajput States of India*, edited and annotated by William Crooke, 3 vols. (London: Humphrey Milford, Oxford University Press, 1920), vol. 3, p. 1484.

44. As recounted in the mid-nineteenth-century Bundi chronicle, *Vamsabhaskara* by Suryamalla Misrana; I am indebted to Cynthia Talbot for this source.

45. First noted by Stuart C[ary] Welch, *The Art of Mughal India: Paintings and Precious Objects*, exh. cat. (New York: The Asia Society, 1963).

46. Original translation by Simon Digby; see Skelton, "Shaykh Phul and the Origins of Bundi Painting," pp. 123–29, figs. 347–50.

47. Identified and translated by G. K. Kanoria. Twenty-four folios survive, the majority in the Kanoria Collection, Patna; Gopi Krishna Kanoria, "An Early Dated Rajasthani Ragamala," *Journal of the Indian Society of Oriental Art* 19 (1952–53), pp. 1–5.

48. Victoria and Albert Museum, published in Guy and Swallow, eds., *Arts of India, 1550–1900*, p. 78.

49. Andrew Topsfield, "Sahibdin's *Gita Govinda* Illustrations," in *Chhavi-2: Rai Krishnadasa Felicitation Volume*, edited by Anand Krishna (Benares: Bharat Kala Bhavan, 1981), pp. 231–38, figs. 502–23; Andrew Topsfield, "Sahibdin's Illustrations to the *Rasikapriya*," *Orientations* 17, no. 3 (1986), pp. 18–31; and Andrew Topsfield, ed., *Court Painting in Rajasthan* (Mumbai: Marg Publications, 2000), provide the pioneering studies of Sahibdin.

50. As suggested by Shridhar [Krishna] Andhare, "Mewar Painters, Their Status and Genealogies," in Skelton, *Facets of Indian Art*, pp. 176–84; and Andrew Topsfield, *Court Painting at Udaipur*.

51. Klaus Ebeling, *Ragamala Painting* (Basel, Paris, and New Delhi: Ravi Kumar, 1973), p. 120.

52. Beach, *Rajput Painting at Bundi and Kota*. Previously titled Master of the Elephants in Stuart Cary Welch, *Rajasthani Miniatures: The Welch Collection from the Arthur M. Sackler Museum, Harvard University*, exh. cat. (New York: The Drawing Center, 1997), pp. 19–23.

53. Bernier and Brock, *Travels in the Mogul Empire, A.D. 1656–1668*, p. 276.

54. Largely based on the scholarship of Catherine Glynn, "Early Painting in Mandi," *Artibus Asiae* 44, no. 1 (1983), pp. 21–64; and Catherine Glynn, "Further Evidence for Early Painting in Mandi," *Artibus Asiae* 55, no. 1–2 (1995), pp. 183–90.

55. Government Museum and Art Gallery, Chandigarh; Glynn, "Early Painting in Mandi."

56. Jahangir, *The Jahangirnama*.

LATE MUGHAL PAINTING AND THE RENAISSANCE OF THE HINDU COURTS, 1650–1730

1. Navina Haidar in Beach, Fischer, and Goswamy, eds., *Masters of Indian Painting*, p. 532.

2. *Vaikuntha Darshana*, Bharat Kala Bhavan, Varanasi (10671); see Karl Khandalavala, Moti Chandra, and Pramod Chandra, *Miniature Paintings from the Sri Motichand Khajanchi Collection* (Delhi: Lalit Kala Akademi, 1960), p. 48, pl. E.

3. Naval Krishna, "Bikaneri Miniature Painting Workshops of Ruknuddin Ibrahim and Nathu," *Lalit Kala*, no. 21 (1985), p. 23.

4. B[rijindra] N[ath] Goswamy, "Pahari Painting: The Family as the Basis of Style," *Marg* 21, no. 4 (1968), pp. 17–62.

5. The *Devi Mahatmya* manuscript, probably from Jaisinghpur; see B[rijindra] N[ath] Goswamy and Eberhard Fischer, *Pahari Masters: Court Painters of Northern India*, Artibus Asiae Supplementum 38 (Zurich: Museum Rietberg Zürich, 1992), pp. 15–27.

6. Benkaim in Beach, Fischer, and Goswamy, eds., *Masters of Indian Painting*, p. 411.

7. Malini Roy, *50 x India: De 50 mooiste miniaturen van het Rijksmuseum/The 50 Most Beautiful Miniatures from the Rijksmuseum*, exh. cat. (Amsterdam: Nieuw Amsterdam Uitgevers, 2008), p. 88; and Vishakha N. Desai, with B[rijindra] N[ath] Goswamy and Ainslie T. Embree, *Life at Court: Art for India's Rulers, Sixteenth–Nineteenth Centuries*, exh. cat. (Boston: Museum of Fine Arts, 1985), pp. 32–33.

8. Khandalavala, Chandra, and Chandra, *Miniature Paintings from the Sri Motichand Khajanchi Collection*, p. 48.

9. Naval Krishna, "Painting and Painters in Bikaner: Notes on an Inventory Register of the Seventeenth Century," in *Indian Painting: Essays in Honour of Karl J. Khandalavala*, edited by B[rijindra] N[ath] Goswamy, with Usha Bhatia (New Delhi: Lalit Kala Akademi, 1995), p. 277.

10. W[illiam] G[eorge] Archer, *Indian Paintings from the Punjab Hills: A Survey and History of Pahari Miniature Painting*, 2 vols. (London and New York: Sotheby Parke Bernet, 1973), vol. 1, p. 45. For a further discussion of this inscription, see Goswamy and Fischer, *Pahari Masters*, p. 60.

11. Goswamy and Fischer, *Pahari Masters*, p. 63.

12. Archer, *Indian Paintings from the Punjab Hills*, vol. 2, pl. 305.

13. Ibid., vol. 1, pp. 325–29.

14. Jorrit Britschgi and Eberhard Fischer, *Rama und Sita: Das Ramayana in der Malerei Indiens*, exh. cat. (Zurich: Museum Rietberg Zürich, 2008), nos. 6 and 7.

15. Goswamy and Fischer, *Pahari Masters: Court Painters of Northern India*, pp. 96, 97, figs. 31–32.

16. Ibid., fig. 30.

17. See Catherine Glynn in Beach, Fischer, and Goswamy, eds., *Masters of Indian Painting*, p. 519.

18. Ibid.

19. Beach, *Rajput Painting at Bundi and Kota*, pl. 115; and Beach in Beach, Fischer, and Goswamy, eds., *Masters of Indian Painting*, p. 477.

20. Stuart Cary Welch with Mark Zebrowski, *A Flower from Every Meadow: Indian Paintings from American Collections*, exh. cat. (New York: The Asia Society, 1973); Stuart Cary Welch, *Indian Drawings and Painted Sketches, Sixteenth Through Nineteenth Centuries*, exh. cat. (New York: The Asia Society, 1976); Stuart Cary Welch and Kimberly Masteller, eds., *From Mind, Heart, and Hand: Persian, Turkish, and Indian Drawings from the Stuart Cary Welch Collection*, exh. cat. (New Haven: Yale University Press, 2004).

21. See Beach in Beach, Fischer, and Goswamy, eds., *Masters of Indian Painting*, pp. 459–78 (Kota) and 209–306 (Bundi).

22. Stuart Cary Welch, *India: Art and Culture, 1300–1900*, exh. cat. (New York: The Metropolitan Museum of Art, 1985), pp. 359–60, no. 242.

23. Joachim K. Bautze, "Portraits of Rao Ratan and Madho Singh Hara," *Berliner Indologische Studien* 2 (1986), fig. 14.

24. See *Rao Bhoj Singh Killing a Tiger*, in Beach, Fischer, and Goswamy, eds., *Masters of Indian Painting*, p. 301, fig. 10.

25. Unpublished, noted in ibid., p. 460, no. 14.

26. Haidar in ibid., p. 532.

27. See Linda York Leach, *Paintings from India*, The Nasser D. Khalili Collection of Islamic Art, edited by Julian Raby, vol. 8 (London: The Nour Foundation in association with Azimuth Editions and Oxford University Press, 1998), pp. 140–41, no. 39.

28. Haidar in Beach, Fischer, and Goswamy, eds., *Masters of Indian Painting*, list no. 3 (fig. 6), pp. 530 and 535–36.

29. See ibid., pp. 534–35, figs. 3–5.

30. McInerney in ibid., p. 549.

31. Desai, Goswamy, and Embree, *Life at Court: Art for India's Rulers*, pp. 88–89, no. 71.

32. Stuart Cary Welch, *Imperial Mughal Painting* (New York: George Braziller, 1978), p. 117.

33. Terence McInerney, "Mughal Painting During the Reign of Muhammad Shah," in *After the Great Mughals: Painting in Delhi and the Regional Courts in the Eighteenth and Nineteenth Centuries*, edited by Barbara Schmitz, *Marg* 53, no. 4 (Mumbai: Marg Publications, 2002), p. 24.

MUGHAL AFTERGLOW AND THE LATER COURT STYLES IN THE PAHARI REGION AND RAJASTHAN, 1730–1825

1. McInerney, pp. 12–33.
2. Malini Roy, "Origins of the Late Mughal Painting Tradition in Awad," in *India's Fabled City: The Art of Courtly Lucknow*, edited by Stephen [A.] Markel (Munich: Prestel Verlag, 2010), pp. 165–86.
3. J[eremiah] P. Losty, "Towards a New Naturalism: Portraiture in Murshidabad and Avadh, 1750–80," in *After the Great Mughals*, pp. 34–55.
4. Goswamy and Fischer, *Pahari Masters*, pp. 211–19.
5. Ibid., pp. 307–19.
6. Eric Dickinson and Karl J. Khandalavala, *Kishangarh Painting* (New Delhi: Lalit Kala Akademi, 1959), p. 26, pl. 4.
7. Andrew Topsfield, *Paintings from Mughal India* (Oxford: Bodleian Library, University of Oxford, 2008), no. 70; and Leach, *Paintings from India*, pp. 176–77, no. 49.
8. McInerney in Beach, Fischer, and Goswamy, eds., *Masters of Indian Painting*, list nos. 15–21, p. 603.
9. See Seyller in John Seyller and Konrad Seitz, *Mughal and Deccani Paintings*, The Eva and Konrad Seitz Collection of Indian Miniatures, vol. 1 (Zurich: Museum Rietberg Zürich, 2010), pp. 74–76, where the painting is attributed to Mir Kalan Khan.
10. Goswamy and Fischer in Beach, Fischer, and Goswamy, eds., *Masters of Indian Painting*, p. 636.
11. See Archer, *Indian Paintings from the Punjab Hills*, vol. 2, pls. 36–39.
12. Two signed and dated paintings from 1746 (National Museum) and 1748 (Lahore Museum) are crucial, among many other attributed paintings showing Balwant Singh, to reconstruct Nainsukh's career from 1740 on. A painting dated 1742 (Museum Rietberg) and attributed to Nainsukh is the first known work painted in Jasrota. See Goswamy and Fischer in Beach, Fischer, and Goswamy, eds., *Masters of Indian Painting*, list nos. 2, 3, and 6.
13. The facial features accord with those in a self-portrait, cf. B[rijindra] N[ath] Goswamy, *Nainsukh of Guler: A Great Indian Painter from a Small Hill-State*, Artibus Asiae Supplementum 41 (Zurich: Museum Rietberg Zürich, 1997), p. 49. A second painting in which Nainsukh includes his self-portrait recently appeared on the art market; Christie's New York, March 21, 2008, lot 507.
14. Goswamy, *Nainsukh of Guler*, p. 87.

15. Fischer and Goswamy in Beach, Fischer, and Goswamy, eds., *Masters of Indian Painting*, list no. 1, p. 683.
16. For a drawing from this later section, see Britschgi and Fischer, *Rama und Sita*, pp. 142–43.
17. M[ohinder] S[ingh] Randhawa, *Kangra Paintings of the Bihari Sat Sai* (New Delhi: National Museum, 1966), p. 70.
18. A painting in the National Museum New Delhi identifies a painter with a later inscription as Purkhu.
19. This same type of portfolio can be seen in a picture by Anirudh Chand (Seitz Collection); Archer, *Indian Paintings from the Punjab Hills*, vol. 2, pl. 198.
20. For a listing, see Goswamy in Beach, Fischer, and Goswamy, eds., *Masters of Indian Painting*, pp. 714–15.
21. Milo Cleveland Beach and Rawat Nahar Singh II, *Rajasthani Painters Bagta and Chokha: Master Artists at Devgarh*, Artibus Asiae Supplementum 46 (Zurich: Museum Rietberg Zürich, 2005), p. 23, fig. 21, dated 1769, is Bagta's first documented work painted in Devgarh.
22. Ibid., pp. 61, 63, fig. 74.
23. Ibid., pp. 72–73, 75, figs. 84, 85, 88.
24. Ibid., pp. 78–79, figs. 91, 92.
25. James Tod, *Annals and Antiquities of Rajasthan, or the Central and Western Rajput States of India*. Edited and annotated by William Crooke, 3 vols. (London: Humphrey Milford, Oxford University Press, 1920), p. 154 n. 2.
26. Beach and Singh, *Rajasthani Painters Bagta and Chokha*, pp. 84–86, figs. 101, 102.
27. Beach, Fischer, and Goswamy, eds., *Masters of Indian Painting*, p. 736, fig. 2.

LATE INDIAN COURT PAINTING, COMPANY PAINTING, AND THE COMING OF PHOTOGRAPHY, 1825–1900

1. Mildred Archer, *Company Paintings: Indian Paintings of the British Period* (London: Victoria and Albert Museum, 1992), p. 11.
2. Antoine-Louis Henri Polier, *A European Experience of the Mughal Orient: The I'jaz-i Arsalani (Persian Letters, 1773–1779) of Antoine-Louis Henri Polier*, translated and edited by Seema Alam, Muzaffar Alam, and Seema Alavi (New Delhi and New York: Oxford University Press, 2001).
3. *Ijaz-i-Arsalani*, fol. 113a; fol. 236a; fol. 256b.
4. Penelope Treadwell, *Johan Zoffany: Artist and*

Adventurer (London: Paul Holberton, 2009), p. 366, assumed that Polier's *Nautch* scene (an almost identical version is in the collection of Catherine Aga Khan) is based on a lost oil painting by John Zoffany.
5. For a survey of Western artists who worked in India, see Pauline Rohatgi et al., *Indian Life and Landscape by Western Artists: Paintings and Drawings from the Victoria and Albert Museum, Seventeenth to Early Twentieth Century*, exh. cat. (London and Mumbai: Victoria and Albert Museum, 2008).
6. See, for example, the version by the Udaipur painter Tara after a portrait by William Carpenter. See Topsfield, *Court Painting at Udaipur*, p. 64.
7. Archer, *Company Paintings*, p. 97.
8. For both, see Mildred Archer and Toby Falk, *India Revealed: The Art and Adventures of James and William Fraser, 1801–35* (London: Cassell, 1989).
9. The painter Lallji, whom James Fraser mentioned, painted only a few portraits. Ibid., p. 45.
10. Ibid., no. 137.
11. For examples of his documentation of harem women, see Laura Weinstein, "Exposing the Zenana: Maharaja Sawai Ram Singh II's Photographs of Women in Purdah," *History of Photography* 34, no. 1 (2010), pp. 2–16.
12. Goswamy and Fischer, *Pahari Masters*, p. 307.
13. Archer and Falk, *India Revealed*, pp. 90–105.
14. See ibid., pp. 37–38.
15. Ibid., p. 104.
16. Andrew Topsfield, *Court Painting at Udaipur*, figs. 228–36.
17. Ibid., fig. 234.
18. Andrew Topsfield, *The City Palace Museum, Udaipur: Paintings of Mewar Court Life* (Ahmedabad: Mapin Publishing, 1990), p. 85.
19. Ibid., nos. 40–44.
20. Translated by Sonika Soni.
21. We are grateful to Mrinalini Venkateswaran and Pramod Kumar for this information.

BIBLIOGRAPHY

Abu'l Fazl. *The Ain-i Akbari*. Vol. 1. Translated by H[enry] Blochmann. Calcutta: Asiatic Society of Bengal, 1873.

———. *The Akbarnama of Abu'l Fazl*. Translated by H[enry] Beveridge. Calcutta: Royal Asiatic Society, 1902–39.

Ahluwalia, Roda. *Rajput Painting: Romantic, Divine and Courtly Art from India*. London: British Museum Press, 2008.

Ahmad, Nazir. "Farrukh Husain, the Royal Artist at the Court of Ibrahim 'Adil Shah II." *Islamic Culture* 30, no. 1 (1956), pp. 31–35.

———. "The Mughal Artist Farrukh Beg." *Islamic Culture* 35, no. 2 (1961), pp. 115–29.

Aijazuddin, F. S. "The Basohli Gita Govinda of 1730 A.D.—A Reconstruction." *Roopa-Lekha* 41, no. 2 (1973), pp. 7–34.

Aitken, Molly Emma. "Pardah and Portrayal: Rajput Women as Subjects, Patrons, and Collectors." *Artibus Asiae* 62, no. 2 (2002), pp. 247–80.

———. *The Intelligence of Tradition in Rajput Painting*. New Haven and London: Yale University Press, 2010.

Akbarnia, Ladan, Benoît Junod, and Alnoor Merchant, eds. *The Path of Princes: Masterpieces from the Aga Khan Museum Collection*. Exh. cat. Lisbon: Calouste Gulbenkian Museum, 2008.

Allinger, Eva. "Das Bush im monastischen Tibet." In *Tibet: Kloster öffnen ihre Schatzkammern*, pp. 217–25. Munich: Hirmir Verlag, 2006.

Andhare, S[hridhar] K[rishna]. "Painting from the Thikana of Deogarh." *Bulletin of the Prince of Wales Museum of Western India*, no. 10 (1967), pp. 43–53, figs. 44–56.

———. "A Dated Amber Ragamala and the Problem of Provenance of the Eighteenth Century Jaipuri Paintings." *Lalit Kala*, no. 15 (1971), pp. 47–51.

———. "Mewar Painters, Their Status and Genealogies." In *Facets of Indian Art*, edited by Robert Skelton et al., pp. 176–84. London: Victoria and Albert Museum, 1986.

———. "Painting at the Thikana of Badnore." In *Indian Art and Connoisseurship: Essays in Honour of Douglas Barrett*, edited by John Guy, pp. 212–29. New Delhi: Indira Gandhi National Centre for the Arts; Ahmedabad: Mapin Publishing, 1995.

———. "Imperial Mughal Tolerance of Jainism and Jain Painting Activity in Gujarat." In *Arts of Mughal India: Studies in Honour of Robert Skelton*, edited by Rosemary Crill et al., pp. 223–33. London: Victoria and Albert Museum; Ahmedabad: Mapin Publishing, 2004.

Archer, Mildred. *Company Paintings: Indian Paintings of the British Period*. London: Victoria and Albert Museum, 1992.

Archer, Mildred, and Toby Falk. *India Revealed: The Art and Adventures of James and William Fraser, 1801–35*. London: Cassell, 1989.

Archer, W[illiam] G[eorge]. *Indian Paintings in the Punjab Hills*. [Victoria and Albert Museum] Museum Monograph, 3. London: His Majesty's Stationery Office, 1952.

———. *Indian Painting in Bundi and Kotah*. [Victoria and Albert Museum] Museum Monograph, 13. London: Her Majesty's Stationery Office, 1959.

———. *Indian Paintings from the Punjab Hills: A Survey and History of Pahari Miniature Painting*. 2 vols. London and New York: Sotheby Parke Bernet, 1973.

———. *Visions of Courtly India: The Archer Collection of Pahari Miniatures*. Exh. cat. Washington, D.C.: International Exhibitions Foundation, 1976.

Arnold, Thomas W., and J[ames] V[ere] S[tewart] Wilkinson. *The Library of A. Chester Beatty: A Catalogue of the Indian Miniatures*. 3 vols. London: Oxford University Press, 1936.

Arthur Tooth and Sons. *Indian Paintings from the Seventeenth to Nineteenth Centuries*. London: Arthur Tooth and Sons, 1975.

Ashton, Sir Leigh, ed. *The Art of India and Pakistan: A Commemorative Catalogue of the Exhibition held at The Royal Academy of Arts, London, 1947–8*. Exh. cat. London: Faber and Faber, 1950.

Babur. *The Babur-nama in English (Memoirs of Babur)*. Translated by Annette Susannah Beveridge. 2 vols. London: Luzac and Co., 1922.

———. *The Baburnama: Memoirs of Babur, Prince and Emperor*. Translated, edited, and annotated by Wheeler M. Thackston. New York and Oxford: Oxford University Press, 1996.

Bahadur, K. P., trans. *The Rasikapriya of Keshavadasa*. Delhi: Motilal Banarsidass, 1972.

Bailey, Gauvin Alexander. *The Jesuits and the Grand Mogul: Renaissance Art at the Imperial Court of India, 1580–1630*. Occasional Papers, 1998, Vol. 2. Washington, D.C.: Freer Gallery of Art and Arthur M. Sackler Gallery, Smithsonian Institution, 1998.

Banerjee, Priyatosh. "Painted Covers of the Two Gilgit Manuscripts." *Oriental Art* 14, no. 2 (1968), pp. 114–18.

Barrett, Douglas. "Painting at Bijapur." In *Paintings from Islamic Lands*, edited by R[alph H]. Pinder-Wilson, pp. 142–59. Oxford: Bruno Cassirer, 1969.

Barrett, Douglas, and Basil Gray. *Painting of India*. [Geneva]: Skira, 1963.

Bartsch, Adam von, Suzanne Boorsch, and John Spike. *Italian Artists of the Sixteenth Century*. The Illustrated Bartsch, 31 [*Le peintre-graveur*, 15 (Part 4)]. New York: Abaris Books, 1986.

Bautze, Joachim K. "Portraits of Rao Ratan and Madho Singh Hara." *Berliner Indologische Studien* 2 (1986), pp. 87–106.

———. *Drei "Bundi"-Ragamalas: Ein Beitrag zur Geschichte der rajputischen Wandmalerei*. Monographien zur indischen Archäologie, Kunst und Philologie, 6. Stuttgart: Franz Steiner Verlag, 1987.

———. "Portraitmalerei unter Maharao Ram Singh von Kota." *Artibus Asiae* 49, no. 3–4 (1988–89), pp. 316–50.

———. *Interaction of Cultures: Indian and Western Painting, 1780–1910*. Exh. cat. Alexandria, Va.: Art Services International, 1998.

———. "Early Painting at Bundi." In *Court Painting in Rajasthan*, edited by Andrew Topsfield, pp. 12–25. Mumbai: Marg Publications, 2000.

———. "Sirohi-Malerei in der Mitte des 17. Jahrhunderts." *Indo-Asiatische Zeitschrift: Mitteilungen der Gesellschaft für Indo-Asiatische Kunst, Berlin* 4, no. 5 (2000–2001), pp. 56–71.

Bautze-Picron, Claudine. "The 'Vredenburg Manuscript' and Its Book Covers." In *The Diverse World of Indian Painting, Vichitra-Visva: Essays in Honour of Dr. Vishwa Chander Ohri*, edited by Usha Bhatia, Amar Nath Khanna, and Vijay Sharma, pp. 1–15. New Delhi: Aryan Books International, 2009.

Bayly, C[hristopher] A[lan], ed. *The Raj: India and the British, 1600–1947*. Exh. cat. London: National Portrait Gallery Publications, 1990.

Beach, Milo Cleveland. "A Bhagavata Purana from the Punjab Hills and Related Paintings." *Museum of Fine Arts, Boston, Bulletin* 63, no. 333 (1965), pp. 168–77.

———. "The Gulshan Album and Its European Sources." *Museum of Fine Arts, Boston, Bulletin* 63, no. 332 (1965), pp. 63–91.

———. "Painting at Devgarh." *Archives of Asian Art* 24 (1970–71), pp. 23–35.

———. *Rajput Painting at Bundi and Kota.* Ascona: Artibus Asiae Publishers, 1974.

———. "The Mughal Painter Kesu Das." *Archives of Asian Art* 30 (1976–77), pp. 34–52.

———. "The Mughal Painter Abu'l Hasan and Some English Sources for his Style." *The Journal of the Walters Art Gallery* 38 (1980), pp. 6–33.

———. *The Imperial Image: Paintings for the Mughal Court.* Exh. cat. Washington, D.C.: Smithsonian Institution, 1981.

———. *Early Mughal Painting.* Cambridge, Mass.: Harvard University Press, 1987.

———. *The New Cambridge History of India.* Pt. 1, vol. 3, *Mughal and Rajput Painting.* Cambridge: Cambridge University Press, 1992.

———. "Characteristics of the St Petersburg Album." *Orientations* 26, no. 1 (1995), pp. 66–79.

———. "Govardhan: 'Servant of Jahangir.'" In *Mughal Masters: Further Studies*, edited by Asok Kumar Das, pp. 134–45. Mumbai: Marg Publications, 1998.

———. "Jahangir's Album: Some Clarifications." In *Arts of Mughal India: Studies in Honour of Robert Skelton*, edited by Rosemary Crill et al, pp. 111–18. London: Victoria and Albert Museum; Ahmedabad: Mapin Publishing, 2004.

———. "Wall-Paintings at Bundi: Comments and a New Discovery." *Artibus Asiae* 68, no. 1 (2008), pp. 101–43.

Beach, Milo Cleveland, and Ebba Koch with Wheeler [M.] Thackston. *King of the World: The Padshahnama, an Imperial Mughal Manuscript from the Royal Library, Windsor Castle.* Exh. cat. London: Azimuth Editions; Washington, D.C.: [Arthur M.] Sackler Gallery, Smithsonian Institution, 1997.

Beach, Milo Cleveland, and Rawat Nahar Singh II. *Rajasthani Painters Bagta and Chokha: Master Artists at Devgarh.* Artibus Asiae Supplementum 46. Zurich: Museum Rietberg Zürich, 2005.

Beach, Milo C[leveland], Eberhard Fischer, and B[rijindra] N[ath] Goswamy, eds. *Masters of Indian Painting.* 2 vols. Artibus Asiae Supplementum 48. [Zurich]: Artibus Asiae Publishers, 2011.

Beach, Milo Cleveland, with Stuart Cary Welch and Glenn D. Lowry. *The Grand Mogul: Imperial Painting in India, 1600–1660.* Exh. cat. Williamstown: Sterling and Francine Clark Art Institute, 1978.

Bernier, François, and Irving Brock. *Travels in the Mogul Empire, A.D. 1656–1668.* Translated by Archibald Constable, 2nd ed. revised by Vincent A. Smith. 1891. London: Humphrey Milford, Oxford University Press, 1916.

Bhatia, Usha. *Deogarh Thikana: Miniatures by Bakta and Chokha.* Mumbai: Harmony Art Foundation, [2009].

Bhattacharya, Gauriswar. "Discovery of a New Pala Ruler." *Journal of the Asiatic Society of Bangladesh (Humanities)* 41, no. 1 (1996), pp. 193–95.

Bhattacharyya, Dipak Chandra. *Studies in Buddhist Iconography.* New Delhi: Manohar, 1978.

Binney, Edwin, 3rd. *Indian Miniature Painting from the Collection of Edwin Binney, 3rd.* Vol. 1, *The Mughal and Deccani Schools with Some Related Sultanate Material.* Exh. cat. Portland: Portland Art Museum, 1973.

Binyon, Laurence, and T[homas] W[alker] Arnold. *The Court Painters of the Grand Moguls.* London: H. Milford, Oxford University Press, 1921.

Boner, Georgette, Eberhard Fischer, and B[rijindra] N[ath] Goswamy. *Sammlung Alice Boner Geschenk an das Museum Rietberg Zürich.* Zurich: Museum Rietberg Zürich, 1994.

Bothmer, Hans-Caspar Graf von. *Die islamischen Miniaturen der Sammlung Preetorius.* Exh. cat. Munich: Staatliches Museum für Völkerkunde, 1982.

Brand, Michael, and Glenn D. Lowry. *Akbar's India: Art from the Mughal City of Victory.* Exh. cat. New York: The Asia Society Galleries, 1985.

B[reck], J[oseph]. "Recent Accessions; Ramayana Illustrations." *The Metropolitan Museum of Art Bulletin* 14, no. 3 (1919), pp. 64–65.

Brend, Barbara. *The Emperor Akbar's Khamsa of Nizami.* London: The British Library, 1995.

Britschgi, Jorrit, and Eberhard Fischer. *Rama und Sita: Das Ramayana in der Malerei Indiens.* Exh. cat. Zurich: Museum Rietberg Zürich, 2008.

Brown, Percy. *Indian Painting Under the Mughals, A.D. 1550 to A.D. 1750.* Oxford: Clarendon Press, 1924.

Brown, W[illiam] Norman. *Miniature Painting in Western India.* New York: College Art Association, 1930.

———. *A Descriptive and Illustrated Catalogue of Miniature Paintings of the Jaina Kalpasutra.* Freer Gallery of Art, Oriental Studies, 2. Washington, D.C.: Smithsonian Institution, 1934.

———. "Some Early Rajasthani Raga Paintings." *Journal of the Indian Society of Oriental Art* 16 (1948), pp. 1–10.

Brown, W[illiam] Norman, trans. and ed. *The Vasanta Vilasa: A Poem of the Spring Festival in Old Gujarati Accompanied by Sanskrit and Prakrit Stanzas and Illustrated with Miniature Paintings.* New Haven: American Oriental Society, 1962.

Canby, Sheila R. *Princes, Poets and Paladins: Islamic and Indian Paintings from the Collection of Prince and Princess Sadruddin Aga Khan.* Exh. cat. London: British Museum Press, 1998.

———. "The Horses of 'Abd us-Samad." In *Mughal Masters: Further Studies*, edited by Asok Kumar Das, pp. 14–29. Mumbai: Marg Publications, 1998.

Canby, Sheila [R.], ed. *Humayun's Garden Party: Princes of the House of Timur and Early Mughal Painting.* Bombay: Marg Publications, 1994.

Carvalho, Pedro de Moura. *Mirror of Holiness/Mir at al-quds: Jerome Xavier's Life of Christ Commissioned by Emperor Akbar (ca. 1602) or A Commentary on Father Jerome Xavier's Text and the Miniatures of Cleveland Museum of Art*, with a translation of the text by Wheeler M. Thackston. Leiden: Brill; forthcoming.

Chandra, Moti. *Jain Miniature Paintings from Western India.* Jain Art Publication Series, 1. Ahmedabad: Sarabhai Manilal Nawab, 1949.

———. "Portraits of Ibrahim Adil Shah II." *Marg* 5, no. 1 (1952), pp. 22–28.

———. "An Illustrated Manuscript of the Kalpasutra and Kalakacharyakatha." *Bulletin of the Prince of Wales Museum*, no. 4 (1953–54), pp. 40–48, pls. 7–14.

———. *Studies in Early Indian Painting.* Rabindranath Tagore Memorial Lectures, 1964, University of Pennsylvania. New York: Asia Publishing House, 1970.

Chandra, Moti, and Parmeshwari Lal Gupta. "An Illustrated Manuscript of the *Rasikapriya.*" *Bulletin of the Prince of Wales Museum*, no. 8 (1962–64), pp. 18–21, figs. 18a–20b.

Chandra, Pramod. "Ustad Salivahana and the Development of Popular Mughal Art." *Lalit Kala*, no. 8 (1960), pp. 25–46.

———. "A Unique Kalakacaryakatha MS. in the Style of the Mandu Kalpasutra of A.D. 1439." *Bulletin of the American Academy of Benares* 1 (1967), pp. 1–10, figs. 1–20.

———. *Tuti-nama. Tales of a Parrot: Complete Colour Facsimile Edition in Original Size of the Manuscript in Possession of the Cleveland Museum of Art.* 2 vols. Graz: Akademische Druck- u. Verlagsanstalt, 1976.

Chandra, Pramod, and Daniel J. Ehnbom. *The Cleveland Tuti-nama Manuscript and the Origins of Mughal Painting.* Exh. cat. Chicago: The University of Chicago, 1976.

Cimino, Rosa Maria. *Vita di corte nel Rajasthan: Miniature indiane dal XVII al XIX secolo*. Exh. cat. Florence: Mario Luca Giusti, 1985.

Coomaraswamy, Ananda K. *Indian Drawings*. 2 vols. London: Indian Society, 1910–12.

———. *Catalogue of the Indian Collections in the Museum of Fine Arts, Boston*. Pt. 5, *Rajput Painting*. Cambridge: Harvard University Press, 1926.

———. "An Illustrated Svetambara Jaina Manuscript of A.D. 1260." *Eastern Art* 2 (1930), pp. 237–42.

———. *Catalogue of the Indian Collections in the Museum of Fine Arts, Boston*. Pt. 6, *Mughal Painting*. Cambridge: Harvard University Press, 1930.

Correia-Afonso, John. *Letters from the Mughal Court: The First Jesuit Mission to Akbar (1580–1583)*. Studies in Indian History and Culture of the Heras Institute of Bombay, 24. Bombay: Heras Institute of Indian History and Culture; 1980.

Craven, Roy C., Jr. *Miniatures and Small Sculptures from India: A Special Loan Exhibition of the Historical Art of India from Museums and Collections in the United States*. Exh. cat. Gainesville: University Gallery, 1966.

———. "Manaku: A Guler Painter." In *Painters of the Pahari Schools*, edited by Vishwa Chander Ohri and Roy C. Craven, Jr., pp. 46–67. Mumbai: Marg Publications, 1998.

Craven, Roy C., Jr., ed. *Ramayana: Pahari Paintings*. Bombay: Marg Publications, 1990.

Crill, Rosemary. *Marwar Painting: A History of the Jodhpur Style*. Mumbai: India Book House, [2000].

———. "The Thakurs of Ghanerao as Patrons of Painting." In *Court Painting in Rajasthan*, edited by Andrew Topsfield, pp. 92–108. Mumbai: Marg Publications, 2000.

Crill, Rosemary, and Kapil Jariwala, eds. *The Indian Portrait, 1560–1860*. Exh. cat. London: National Portrait Gallery, 2010.

Cummins, Joan. *Indian Painting from Cave Temples to the Colonial Period*. Boston: Museum of Fine Arts, 2006.

Czuma, Stanislaw, with W[illiam] G[eorge] Archer. *Indian Art from the George P. Bickford Collection*. Exh. cat. Cleveland: The Cleveland Museum of Art, 1975.

Dahmen-Dallapiccola, A[nna] L[ibera]. *Indische Miniaturen: Malerei d. Rajput-Staaten*. Baden-Baden: Holle, 1976.

Daljeet. *Mughal and Deccani Paintings from the Collection of the National Museum*. New Delhi: Prakash Book Depot, 1999.

———. *Indian Miniature Painting: Manifestation of a Creative Mind*. New Delhi: Brijbasi Art Press, 2006.

Dar, Saifur Rahman. *Catalogue of Paintings in the Lahore Museum*. Vol. 1, *Mughal and Rajasthani Schools*. 2nd ed. 1976. Lahore: Lahore Museum, 1990.

Das, Asok Kumar. "Bishndas." In *Chhavi, Golden Jubilee Volume*, edited by Anand Krishna, pp. 183–91, figs. 351–63. [Banaras]: Bharat Kala Bhavan, Banaras Hindu University, 1971.

———. "Ustad Mansur." *Lalit Kala*, no. 17 (1974), pp. 32–39.

———. *Mughal Painting During Jahangir's Time*. Calcutta: The Asiatic Society, 1978.

———. "Calligraphers and Painters in Early Mughal Painting." In *Chhavi-2: Rai Krishnadasa Felicitation Volume*, edited by Anand Krishna, pp. 92–97, figs. 271–88. Benares: Bharat Kala Bhavan, 1981.

———. "An Introductory Note on the Emperor Akbar's *Ramayana* and Its Miniatures." In *Facets of Indian Art*, edited by Robert Skelton et al., pp. 94–104. London: Victoria and Albert Museum, 1986.

———. "Mansur." In *Master Artists of the Imperial Mughal Court*, edited by Pratapaditya Pal, pp. 39–52. *Marg* 42, no. 4. Bombay: Marg Publications, 1991.

———. "Akbar's Imperial *Ramayana*: A Mughal Persian Manuscript." In *The Legend of Rama: Artistic Visions*, edited by Vidya Dehejia, pp. 73–84. Bombay: Marg Publications, 1994.

———. "Persian Masterworks and their Transformation in Jahangir's *Taswirkhana*." In *Humayun's Garden Party: Princes of the House of Timur and Early Mughal Painting*, edited by Sheila [R.] Canby, pp. 135–52. Bombay: Marg Publications, 1994.

———. "Activities of the Jaipur Suratkhana, 1750–1768." In *Indian Art and Connoisseurship: Essays in Honour of Douglas Barrett*, edited by John Guy, pp. 200–211. New Delhi: Indira Gandhi National Centre for the Arts; Ahmedabad: Mapin Publishing, 1995.

———. "Bishndas: 'Unequalled in his Age in Taking Likenesses.'" In *Mughal Masters: Further Studies*, edited by Asok Kumar Das, pp. 112–33. Mumbai: Marg Publications, 1998.

———. "Farrukh Beg: Studies of Adorable Youths and Venerable Saints." In *Mughal Masters: Further Studies*, edited by Asok Kumar Das, pp. 96–111. Mumbai: Marg Publications, 1998.

———. "Salim's *Taswirkhana*." In *Allahabad: Where the Rivers Meet*, edited by Neelum Saran Gour, pp. 56–71. Mumbai: Marg Publications, 2009.

Das, Asok Kumar, ed. *Mughal Masters: Further Studies*. Mumbai: Marg Publications, 1998.

Davis, Shanane. *The Bikaner School: Usta Artisans and Their Heritage*. Jodhpur: RMG Exports, 2008.

Dehejia, Vidya. "The Treatment of Narrative in Jagat Singh's *Ramayana*: A Preliminary Study." *Artibus Asiae* 56, no. 3–4 (1996), pp. 303–24.

Dehejia, Vidya, et al. *Devi, the Great Goddess: Female Divinity in South Asian Art*. Exh. cat. Ahmedabad: Mapin Publishing; Munich: Prestel-Verlag, 1999.

Desai, Kalpana. *Raja Balwant Singh and Artist Nainsukh of the Guler Descent: Paintings in the Collection of the Prince of Wales Museum of Western India*. Mumbai: Prince of Wales Museum, 2000.

Desai, Kalpana, and Pratapaditya Pal, eds. *A Centennial Bouquet: The Khandalavala Collection of Indian Art in the Chhatrapati Shivaji Maharaj Vastu Sangrahalaya*. Mumbai: Marg Publications, 2004.

Desai, Kalpana, with B. V. Shetti, and Manisha Nene. *Jewels on the Crescent: Masterpieces of the Chhatrapati Shivaji Maharaj Vastu Sangrahalaya, formerly Prince of Wales Museum of Western India*. Mumbai: Chhatrapati Shivaji Maharaj Vastu Sangrahalaya; Ahmedabad: Mapin Publishing, 2002.

Desai, Vishakha N. "From Illustrations to Icons: The Changing Context of the *Rasikapriya* Paintings in Mewar." In *Indian Painting: Essays in Honour of Karl J. Khandalavala*, edited by B[rijindra] N[ath] Goswamy, with Usha Bhatia, pp. 97–127. New Delhi: Lalit Kala Akademi, 1995.

Desai, Vishakha N., with B[rijindra] N[ath] Goswamy and Ainslie T. Embree. *Life at Court: Art for India's Rulers, Sixteenth–Nineteenth Centuries*. Exh. cat. Boston: Museum of Fine Arts, 1985.

Diamond, Debra, et al. *Garden and Cosmos: The Royal Paintings of Jodhpur*. Exh. cat. Washington, D.C.: Smithsonian Institution, 2008.

Dickinson, Eric, and Karl J. Khandalavala. *Kishangarh Painting*. New Delhi: Lalit Kala Akademi, 1959.

Dickson, Martin Bernard, and Stuart Cary Welch. *The Houghton Shahnameh*. 2 vols. Cambridge, Mass.: Harvard University Press, 1981.

Digby, Simon. "The Literary Evidence for Painting in the Delhi Sultanate." *Bulletin of the American Academy of Benares* 1 (1967), pp. 47–58.

Dimand, M[aurice] S. *A Handbook of Mohammedan Decorative Arts*. New York: The Metropolitan Museum of Art, 1930.

———. "Several Illustrations from the Dastan-I Amir Hamza in American Collections." *Artibus Asiae* 2, no. 1–2 (1948), pp. 4–13.

Doshi, Saryu. "Twelfth Century Illustrated Manuscripts from Mudbidri." *Bulletin of the Prince of Wales Museum*, no. 8 (1962–64), pp. 29–36, figs. 24a–29c.

———. "Islamic Elements in Jaina Manuscript Illustrations." In *An Age of Splendour: Islamic Art in India*, edited by Karl Khandalavala, pp. 114–21. Bombay: Marg Publications 1983.

Doshi, Saryu, ed. *Masterpieces of Jain Painting*. Bombay: Marg Publications, 1985.

———. *The Royal Bequest: Art Treasures of the Baroda Museum and Picture Gallery*. Bombay: India Book House, 1995.

Ducrot, Vicky, et al. *Four Centuries of Rajput Painting: Mewar, Marwar and Dhundhar Indian Miniatures from the Collection of Isabella and Vicky Ducrot.* Milan: Skira, 2009.

Du Jarric, Pierre. *Akbar and the Jesuits: An Account of the Jesuit Missions to the Court of Akbar.* Translated and annotated by C[harles] H[erbert] Payne. New York and London: Harper and Brothers, Publishers, 1926.

Dundas, Paul. *The Jains.* 2nd ed. 1992. London and New York: Routledge, 2002.

Dye, Joseph M., III. "Payag." In *Master Artists of the Imperial Mughal Court,* edited by Pratapaditya Pal, pp. 119–34. Bombay: Marg Publications, 1991.

Eastman, Alvan Clark. *The Nala-Damayanti Drawings: A Study of a Portfolio of Drawings Made for Raja Samsar Cand of Kangra (1774–1823), Illustrating an Early Indian Romance.* Boston: Museum of Fine Arts, 1959.

Ebeling, Klaus. *Ragamala Painting.* Basel, Paris, and New Delhi: Ravi Kumar, 1973.

Ehnbom, Daniel J. "Three Miniatures from a Bhagavata Purana Series." In *Two Thousand Years of Indian Art,* pp. 17–18. Sale cat. London: Spink & Son Ltd., 1982.

Ehnbom, Daniel J., with Robert Skelton and Pramod Chandra. *Indian Miniatures: The Ehrenfeld Collection.* Exh. cat. New York: Hudson Hills Press, 1985.

Ettinghausen, Richard. *Paintings of the Sultans and Emperors of India in American Collections.* New Delhi: Lalit Kala Akademi, 1961.

Falk, Toby. *Persian and Mughal Art.* Exh. cat. London: P. & D. Colnaghi, 1976.

———. "The Kishangarh Artist Bhavani Das." *Artibus Asiae* 51, no. 1–2 (1992), Notice 1.

Falk, Toby, and Mildred Archer. *Indian Miniatures in the India Office Library.* London: Sotheby Parke Bernet, 1981.

Falk, Toby, Ellen S. Smart, and Robert Skelton. *Indian Painting: Mughal and Rajput and a Sultanate Manuscript.* Sale cat. London: P. & D. Colnaghi and Co., 1978.

Filippi, Gian Giuseppe, ed. *Indian Miniatures and Paintings from the Sixteenth to the Nineteenth Century: The Collection of Howard Hodgkin.* Exh. cat. Milan: Electa, 1997.

Fischer, Eberhard. "The Painter Manaku of Guler: Works of a Great Indian Master in the Museum Rietberg Zürich." *Orientations* 38, no. 2 (2007), pp. 128–36.

Fischer, Eberhard, Albert Lutz, and Brigit Bernegger. *Asiatische Malerei.* Zurich: Museum Rietberg Zürich, 1994.

Fischer, Eberhard, B[rijindra] N[ath] Goswamy, and Dinanath Pathy. *Göttinnen: Indische Bilder im Museum Rietberg Zürich.* Zurich: Museum Rietberg, 2005.

Flores, Jorge, and Nuno Vassallo e Silva, eds. *Goa and the Great Mughal.* Exh. cat. London: Scala Publishers, 2004.

Folsach, Kjeld von. *Art from the World of Islam in the David Collection.* Rev. ed. 1990. Copenhagen: The David Collection, 2001.

———. *For the Privileged Few: Islamic Miniature Painting from the David Collection.* Exh. cat. Copenhagen: Davids Samling, 2007.

Foster, William, ed. *Early Travels in India, 1583–1619.* London: Humphrey Milford, Oxford University Press, 1921.

Fraad, Irma L., and Richard Ettinghausen. "Sultanate Painting in Persian Style, Primarily from the First Half of the Fifteenth Century: A Preliminary Study." In *Chhavi, Golden Jubilee Volume,* edited by Anand Krishna, pp. 48–66, figs. 133–67. [Varanasi]: Bharat Kala Bhavan, Benares Hindu University, 1971.

Gahlin, Sven. *The Courts of India: Indian Miniatures from the Collection of the Fondation Custodia, Paris.* Exh. cat. Paris: Fondation Custodia; Zwolle: Waanders Publishers, 1991.

———. *Couleurs de l'Inde: Nouvelles acquisitions de la Collection Frits Lugt.* Exh. cat. Paris: Foundation Custodia, 2002.

Ghose, Ajit. "The Basohli School of Rajput Painting." *Rupam* 37 (1929), pp. 6–17.

Ghose, Rajeshwari, ed. *Kizil on the Silk Road: Crossroads of Commerce and Meeting of Minds.* Mumbai: Marg Publications, 2008.

Glück, Heinrich, and Ernst Diez. *Die Kunst des Islam.* Propyläen-Kunstgeschichte, 5. Berlin: Propyläen-Verlag, 1925.

Glynn, Catherine. "Early Painting in Mandi." *Artibus Asiae* 44, no. 1 (1983), pp. 21–64.

———. "Further Evidence for Early Painting in Mandi." *Artibus Asiae* 55, no. 1–2 (1995), pp. 183–90.

———. "Evidence of Royal Painting for the Amber Court." *Artibus Asiae* 56, no. 1–2 (1996), pp. 67–93.

———. "A Rajasthani Princely Album: Rajput Patronage of Mughal-Style Painting." *Artibus Asiae* 60, no. 2 (2000), pp. 222–64.

———. "Bijapur Themes in Bikaner Painting." In *Court Painting in Rajasthan,* edited by Andrew Topsfield, pp. 65–77. Mumbai: Marg Publications, 2000.

———. "Mughalized Portraits of Bilaspur Royalty in the Second Half of the Seventeenth Century." In *Arts of Mughal India: Studies in Honour of Robert Skelton,* edited by Rosemary Crill et al., pp. 234–47. London: Victoria and Albert Museum; Ahmedabad: Mapin Publishing, 2004.

———. "Rathore and Mughal Interactions: Artistic Development at the Nagaur Court, 1600–1751." In *Garden and Cosmos: The Royal Paintings of Jodhpur,* by Debra Diamond et al., pp. 10–19, 301–4. Exh. cat. Washington, D.C.: Smithsonian Institution, 2008.

Godard, Yedda A. "Les Marges du Murakka' Gulshan." *Athar-é Iran* 1 (1936), pp. 13–33.

———. "Un Album des Portraits des Princes Timurides de l'Inde." *Athar-é Iran* 2 (1937), pp. 179–277.

Goepper, Roger, et al. *Alchi: Ladakh's Hidden Buddhist Sanctuary, the Sumtsek.* London: Serindia, 1996.

Goetz, Hermann. "The Early Muraqqas of the Mughal Emperor Jahangir." *East–West* 8 (1957), pp. 157–85.

Gorakshkar, S[adashiv] V. "A Dated Manuscript of the *Kalakacharya Katha* in the Prince of Wales Museum." *Bulletin of the Prince of Wales Museum* 9 (1964–66), pp. 56–57, figs. 69–71.

Goswamy, B[rijindra] N[ath]. "Pahari Painting: The Family as the Basis of Style." *Marg* 21, no. 4 (1968), pp. 17–62.

———. *Essence of Indian Art.* Exh. cat. San Francisco: Asian Art Museum of San Francisco, 1986.

———. *A Jainesque Sultanate Shahnama and the Context of Pre-Mughal Painting in India.* Rietberg Series on Indian Art, 2. Zurich: Museum Rietberg Zürich, 1988.

———. "The Painter Nainsukh and his Patron, Balwant Singh." In *The Power of Art: Patronage in Indian Culture,* edited by Barbara Stoler Miller, pp. 235–44. Delhi: Oxford University Press, 1992.

———. *Nainsukh of Guler: A Great Indian Painter from a Small Hill-State.* Artibus Asiae Supplementum 41. Zurich: Museum Rietberg Zürich, 1997.

———. "Nainsukh of Guler." In *Painters of the Pahari Schools,* edited by Vishwa Chander Ohri and Roy C. Craven, Jr., pp. 68–97. Mumbai: Marg Publications, 1998.

———. *Indian Paintings in the Sarabhai Foundation.* Ahmedabad: Sarabhai Foundation, 2010.

Goswamy, B[rijindra] N[ath], and A[nna] L[ibera] Dahmen-Dallapiccola, trans. *An Early Document of Indian Art: The 'Citralaksana of Nagnajit.'* New Delhi: Manohar Book Service, 1976.

Goswamy, B[rijindra] N[ath], and Caron Smith. *Domains of Wonder: Selected Masterworks of Indian Painting.* Exh. cat. San Diego: San Diego Museum of Art, 2005.

Goswamy, B[rijindra] N[ath], and Eberhard Fischer. *Wonders of a Golden Age, Painting at the Court of the Great Mughals: Indian Art of the Sixteenth and Seventeenth Centuries from Collections in Switzerland.* Exh. cat. Zurich: Museum Rietberg Zürich, 1987.

———. *Pahari Masters: Court Painters of Northern India.* Artibus Asiae Supplementum 38. Zurich: Museum Rietberg Zürich, 1992.

Goswamy, B[rijindra] N[ath], V[ishra] C[hander] Ohri, and Ajit Singh. "A 'Chaurapanchasika Style' Manuscript from the Pahari Area: Notes on a Newly-Discovered *Devi Mahatmya* in the Himachal Pradesh State Museum, Simla." *Lalit Kala*, no. 21 (1985), pp. 8–21.

Goswamy, B[rijindra] N[ath], with Usha Bhatia. *Painted Visions: The Goenka Collection of Indian Paintings.* New Dehli: Lalit Kala Akademi, 1999.

Goswamy, Karuna. "An Early Seventeenth Century Painting from Nurpur." In *Arts of Himachal*, edited by Vishwa Chander Ohri, pp. 51–56. Simla: State Museum Simla, 1975.

Grube, Ernst J. *The Classical Style in Islamic Painting: The Early School of Herat and Its Impact on Islamic Painting of the Later Fifteenth, the Sixteenth and Seventeenth Centuries; Some Examples in American Collections.* [Lugano]: Edizioni Oriens, 1968.

Gupta, S[warajya] P[rakash], ed. *Masterpieces from the National Museum Collection.* New Delhi: National Museum, 1985.

Gutman, Judith Mara. *Through Indian Eyes.* Exh. cat. New York: Oxford University Press, 1982.

Guy, John. "Mughal Painting under Akbar: The Melbourne Hamza-nama and Akbar-nama Paintings." *Art Bulletin of Victoria*, no. 22 (1982), pp. 25–41.

———. *Palm-leaf and Paper: Illustrated Manuscripts of India and Southeast Asia.* Exh. cat. Melbourne: National Gallery of Victoria, 1982.

———. *Woven Cargoes: Indian Textiles in the East.* New York: Thames and Hudson, 1998.

———. *Indian Temple Sculpture.* London: V & A Publications, 2007.

Guy, John, and Deborah Swallow, eds. *Arts of India, 1550–1900.* London: Victoria and Albert Museum, 1990.

Guy, John, ed. *Indian Art and Connoisseurship: Essays in Honour of Douglas Barrett.* New Delhi: Indira Gandhi National Centre for the Arts; Ahmedabad: Mapin Publishing, 1995.

Habsburg, Francesca von, et al. *The St. Petersburg Muraqqa': Album of Indian and Persian Miniatures from the Sixteenth Through the Eighteenth Century and Specimens of Persian Calligraphy by 'Imad al-Hasani.* Lugano: ARCH Foundation; Milan: Leonardo Arte, 1996.

Haidar, Navina. "Satire and Humour in Kishangarh Painting." In *Court Painting in Rajasthan*, edited by Andrew Topsfield, pp. 78–91. Mumbai: Marg Publications, 2000.

Heeramaneck, Alice N. *Masterpieces of Indian Painting from the Former Collections of Nasli M. Heeramaneck.* New York: Alice N. Heeramaneck, 1984.

Hendley, Thomas H[olbein]. *Memorials of the Jeypore Exhibition 1883.* Vol. 4, *The Razmnamah.* Jaipur, 1884.

Hinüber, Oskar von. *Antiquities of Northern Pakistan: Reports and Studies.* Vol. 5, *Die Palola sahis: Ihre Steininschriften, Inschriften auf Bronzen, Handschriften kolophone und Schutzzauber.* Mainz: Verlag Philipp von Zabern, 2004.

Hobhouse, Niall. *Indian Painting During the British Period.* Sale cat. London: Hobhouse Ltd., 1986.

Hodgkin, Howard, and Terence McInerney. *Indian Drawing.* Exh. cat. London: Arts Council of Great Britain, 1983.

Hurel, Roselyne. *Miniatures et peintures indiennes: Collection du Département des Estampes et de la Photographie de la Bibliothèque nationale de France.* Paris: Editions BnF, 2010.

Hutton, Deborah [S]. *Art of the Court of Bijapur.* Bloomington and Indianapolis: Indiana University Press, 2006.

'Inayat Khan. *The Shah Jahan nama of 'Inayat Khan: An Abridged History of the Mughal Emperor Shah Jahan, Compiled by His Royal Librarian; The Nineteenth-Century Manuscript Translation of A. R. Fuller (British Library, add. 30,777).* Edited by W[ayne] E. Begley and Z[iyaud-din] A. Desai. Delhi and New York: Oxford University Press, 1990.

Ivanova, A. A., Oleg Fedorovich Akimushkina, Tatiana Vladimirovna Grek, and Leon Tigranovich Giuzal'ian. *Al'bom indiskikh i persidskikh miniatiur XVI–XVIII vv.* Moscow: Izd-vo vostochno literatury, 1962.

Jahangir. *The Tuzuk-i-Jahangiri.* Translated by Alexander Rogers and edited by Henry Beveridge. 2 vols. London: Royal Asiatic Society, 1909–14.

———. *The Jahangirnama: Memoirs of Jahangir, Emperor of India.* Translated by Wheeler M. Thackston. Washington, D.C.: Freer Gallery of Art, Arthur M. Sackler Gallery, 1999.

Johnson, B. B. "A Preliminary Study of the Technique of Indian Miniature Painting." In *Aspects of Indian Art*, edited by Pratapaditya Pal, pp. 139–46, pls. 78–84. Leiden: E. J. Brill, 1972.

Johnson, Robert Flynn, Karen Breuer, and Joseph R. Goldyne. *Treasures of the Achenbach Foundation for Graphic Arts.* Exh. cat. San Francisco: Fine Arts Museums of San Francisco, 1995.

Kanoria, Gopi Krishna. "An Early Dated Rajasthani Ragamala." *Journal of the Indian Society of Oriental Art* 19 (1952–53), pp. 1–5.

Khan, Faiyaz Ali. "Kishangarh Painting and Bani Thani." *Roopa-Lekha* 40, no. 1–2 (1972), pp. 83–88.

———. "The Painters of Kishangarh." *Roopa-Lekha* 51, no. 1–2 (1980), pp. 61–69.

Khandalavala, Karl J. "Balvant Singh of Jammu: A Patron of Pahari Painting." *Bulletin of the Prince of Wales Museum of Western India*, no. 2 (1951–52), pp. 71–81, pls. 8–13.

———. "A 'Gita Govinda' Series in the Prince of Wales Museum (In the Style of the 'Laur-Chanda' and 'Chaurapanchasika' Group)." *Bulletin of the Prince of Wales Museum of Western India*, no. 4 (1953–54), pp. 1–18, pls. A–B.

———. *Pahari Miniature Painting.* Bombay: New Book Co., 1958.

———. *Pahari Miniature Paintings in the N. C. Mehta Collection.* Ahmedabad: Gujarat Museum Society, [1982].

Khandalavala, Karl [J.], and Jagdish Mittal. "The *Bhagavata* MSS from Palam and Isarda—A Consideration in Style." *Lalit Kala*, no. 16 (1974), pp. 28–32, pls. 9–10.

Khandalavala, Karl [J.], and Moti Chandra. "A Consideration of an Illustrated Ms from Mandapadurga (Mandu) Dated 1439 A.D. and Its Bearing on Certain Problems of Indian Painting." *Lalit Kala*, no. 6 (1959), pp. 8–29, pls. 1–7.

———. *New Documents of Indian Painting—A Reappraisal.* Bombay: Board of Trustees of the Prince of Wales Museum of Western India, 1969.

———. *An Illustrated Aranyaka Parvan in the Asiatic Society of Bombay.* Bombay: Asiatic Society of Bombay, 1974.

Khandalavala, Karl [J.], and Saryu Doshi. *A Collector's Dream: Indian Art in the Collections of Basant Kumar and Saraladevi Birla and the Birla Academy of Art and Culture.* Bombay: Marg Publications, 1987.

Khandalavala, Karl J., Moti Chandra, and Pramod Chandra. *Miniature Paintings from the Sri Motichand Khajanchi Collection.* Delhi: Lalit Kala Akademi, 1960.

Kim, Jinah. "Iconography and Text: The Visual Narrative of the Buddhist Book-Cult in the Manuscript of the Ashtasaharika Prajnaparamita Sutra." In *Kaladarpana, The Mirror of Indian Art: Essays in Memory of Shri Krishna Deva*, edited by Devangana Desai and Arundhati Banerji, pp. 255–72. New Delhi: Aryan Books, 2009.

Klimburg-Salter, Deborah. "The Gilgit Manuscript Covers and the 'Cult of the Book.'" In *South Asian Archaeology 1987, Venice*, edited by M. Taddei, part 2, pp. 815–27. Rome: Instituto Italiano per il Medio ed Estremo Oriente, 1990.

Kníñková, Hana. "Notes on the Portrait of Ibrahim 'Adil Shah II of Bijapur in the Náprstek Museum, Prague." In *Facets of Indian Art*, edited by Robert Skelton et al., pp. 116–23. London: Victoria and Albert Museum, 1986.

Koch, Ebba. *Dara-Shikoh Shooting Nilgais: Hunt and Landscape in Mughal Painting*. Occasional Papers, 1998, Vol. 1. Washington, D.C.: Freer Gallery of Art and Arthur M. Sackler Gallery, Smithsonian Institution, 1998.

Kossak, Steven [M]. *Indian Court Painting: Sixteenth–Nineteenth Century*. Exh. cat. New York: The Metropolitan Museum of Art, 1997.

———. "Recent Acquisitions: A Selection, 2001–2002; Asia; Tara, the Buddhist Savioress." *The Metropolitan Museum of Art Bulletin*, n.s., 60, no. 2 (2002), p. 60.

———. *Painted Images of Enlightenment: Early Tibetan Thankas, 1050–1450*. Mumbai: Marg Publications, 2010.

Kossak, Steven [M.], and Martin Lerner. "The Arts of South and Southeast Asia." *The Metropolitan Museum of Art Bulletin*, n.s., 51, no. 4 (1994), pp. 1–88.

Kramrisch, St[ella]. *A Survey of Painting in the Deccan*. Hyderabad: Archaeological Department of H. E. H. The Nizam's Government, 1937.

———. "Introduction to the Visnudharmottara [(Pt. III): A Treatise on Indian Painting and Image Making (Calcutta: University of Calcutta, 1928)]." In *Exploring India's Sacred Art: Selected Writings of Stella Kramrisch*, edited by Barbara Stoler Miller, pp. 263–72, 339–41. Philadelphia: University of Pennsylvania Press, 1983.

———. *Painted Delight: Indian Paintings from Philadelphia Collections*. Exh. cat. Philadelphia: Philadelphia Museum of Art, 1986.

Krishna, Anand. "An Early Ragamala Series." *Ars Orientalis* 4 (1961), pp. 368–72, pls. 1–11.

———. *Malwa Painting*. Varanasi: Bharat Kala Bhavan, Banaras Hindu University, 1963.

Krishna, Anand, ed. *Chhavi-2: Rai Krishnadasa Felicitation Volume*. Benares: Bharat Kala Bhavan, 1981.

Krishna, Naval. "Bikaneri Miniature Painting Workshops of Ruknuddin Ibrahim and Nathu." *Lalit Kala*, no. 21 (1985), pp. 23–27, pls. 11–12.

———. "Painting and Painters in Bikaner: Notes on an Inventory Register of the Seventeenth Century." In *Indian Painting: Essays in Honour of Karl J. Khandalavala*, edited by B[rijindra] N[ath] Goswamy, with Usha Bhatia, pp. 254–80. New Delhi: Lalit Kala Akademi, 1995.

———. "The Umarani Usta Master-Painters of Bikaner and Their Genealogy." In *Court Painting in Rajasthan*, edited by Andrew Topsfield, pp. 57–64. Mumbai: Marg Publications, 2000.

Kühnel, Ernst, and Hermann Goetz. *Indian Book Painting from Jahangir's Album in the State Library of Berlin*. London: Kegan Paul, Trench, Trubner and Co., 1926.

Kurz, Otto. "A Volume of Mughal Drawings and Miniatures." *Journal of the Warburg and Courtauld Institutes* 30 (1967), pp. 251–71.

Leach, Linda York. *Indian Miniature Paintings and Drawings*. The Cleveland Museum of Art Catalogue of Oriental Art, Pt. 1. Cleveland: The Cleveland Museum of Art, 1986.

———. *Mughal and Other Indian Paintings from the Chester Beatty Library*. Vol. 1. London: Scorpion Cavendish, 1995.

———. *Paintings from India*. The Nasser D. Khalili Collection of Islamic Art, edited by Julian Raby, vol. 8. London: The Nour Foundation in association with Azimuth Editions and Oxford University Press, 1998.

Lee, Sherman. *Rajput Painting*. Exh. cat. New York: Asia House, 1960.

Leeuwen-Waller, P. A. van, and H. C. Gallois. *Catalogus: Tentoonstelling van islamische Kunst*. Exh. cat. The Hague: Gemeentemuseum, 1927.

Legge, James. *A Record of Buddhistic Kingdoms: Being an Account by the Chinese Monk Fa-Hien of His Travels in India and Ceylon (A.D. 399–414) in Search of the Buddhist Books of Discipline*. 1886. New York: Dover, 1965.

Lerner, Michael. *The Flame and the Lotus: Indian and Southeast Asian Art from the Kronos Collection*. Exh. cat. New York: The Metropolitan Museum of Art, 1984.

Losty, Jeremiah P. *The Art of the Book in India*. Exh. cat. London: British Library, 1982.

———. *Indian Paintings in the British Library*. New Delhi: Lalit Kala Akademi, 1986.

———. "The 'Vredenburg Manuscript' in the Victoria and Albert Museum." In *Makaranda: Essays in Honour of Dr. James C. Harle*, edited by Claudine Bautze-Picron, pp. 189–99, figs. 1–12. Delhi: Sri Satguru Publications, 1990.

———. "Abul Hasan." In *Master Artists of the Imperial Mughal Court*, edited by Pratapaditya Pal, pp. 69–86. Bombay: Marg Publications, 1991.

———. "Sahib Din's Book of Battles: Rana Jagat Singh's *Yuddhakanda*." In *The Legend of Rama: Artistic Visions*, edited by Vidya Dehejia, pp. 101–16. Bombay: Marg Publications, 1994.

———. "The Development of the Golconda Style." In *Indian Art and Connoisseurship: Essays in Honour of Douglas Barrett*, edited by John Guy, pp. 297–319. New Delhi: Indira Gandhi National Centre for the Arts; Ahmedabad: Mapin Publishing, 1995.

———. "Towards a New Naturalism: Portraiture in Murshidabad and Avadh, 1750–80." In *After the Great Mughals: Painting in Delhi and the Regional Courts in the Eighteenth and Nineteenth Centuries*, edited by Barbara Schmitz, pp. 34–55. *Marg* 53, no. 4. Mumbai: Marg Publications, 2002.

———. "Painting at Lucknow 1775–1850." In *Lucknow Then and Now*, edited by Rosie Llewellyn-Jones, pp. 118–33. Mumbai: Marg Publications, 2003.

———. *Paintings from the Royal Courts of India*. Sale cat. London: Francesca Galloway, 2008.

———. *The Ramayana: Love and Valour in India's Great Epic: The Mewar Ramayana Manuscripts*. Exh. cat. London: The British Library, 2008.

Lowry, Glenn D., and Milo Cleveland Beach, with Roya Marefat and Wheeler M. Thackston. *An Annotated and Illustrated Checklist of the Vever Collection*. Washington, D.C.: Arthur M. Sackler Gallery, Smithsonian Institution, 1988.

Lowry, Glenn D., with Susan Nemazee. *A Jeweler's Eye*. Washington, D.C.: Arthur M. Sackler Gallery, Smithsonian Institution, Washington, D.C., 1988.

Lukens, Marie G. *Islamic Art. The Metropolitan Museum of Art Guide to the Collections*. New York: The Metropolitan Museum of Art, 1965.

Lyons, Tryna. "Mewari Perspectives: Udaipur, Nathadwara, Basi." In *Kingdom of the Sun: Indian Court and Village Art from the Princely State of Mewar*, by Joanna Williams et al., pp. 35–51. Exh. cat. San Francisco: The Asian Art Museum, 2007.

Mackenzie, Colin, and Irving Finkel, eds. *Asian Games: The Art of Contest*. Exh. cat. New York: Asia Society Museum, 2004.

Maclagan, Edward D. *The Jesuits and the Great Mogul*. London: Burns, Oates and Washbourne, 1932.

Mallmann, Marie-Thérèse de. *Introduction à l'iconographie du tântrisme bouddhique*. Paris: Adrien-Maisonneuve, 1975.

Manucci, Niccolao. *Storia do Mogor*. Translated and annotated by William Irvine. 4 vols. London: John Murray, 1906–8.

Marek, Jikri, and Hana Knízková. *The Jenghiz Khan Miniatures from the Court of Akbar the Great*. London: Spring Books, 1963.

Markel, Stephen A. "A New Masterpiece by Mir Kalan Khan." In *The Ananda-vana of Indian Art: Dr. Anand Krishna Felicitation Volume*, edited by Naval Krishna and Manu Krishna, pp. 399–410. Varanasi: Indica Books, 2004.

Markel, Stephen [A]., ed. *India's Fabled City: The Art of Courtly Lucknow*. Munich: Prestel Verlag, 2010.

Martin, F[redrik] R[obert]. *The Miniature Painting and Painters of Persia, India and Turkey from the Eighth to the Eighteenth Century*. 2 vols. London: B[ernard] Quaritch, 1912.

Mason, Darielle, et al. *Intimate Worlds: Indian Paintings from the Alvin O. Bellak Collection*. Exh. cat. Philadelphia: Philadelphia Museum of Art, 2001.

Mathur, Vijay Kumar. *Marvels of Kishangarh Paintings from the Collection of the National Museum, New Delhi*. Delhi: Bharatiya Kala Prakashan, 2000.

McInerney, Terence. *Indian Painting, 1525–1825*. Sale cat. London: David Carritt Limited, 1982.

———. "Manohar." In *Master Artists of the Imperial Mughal Court*, edited by Pratapaditya Pal, pp. 53–68. *Marg* 42, no. 4. Bombay: Marg Publications, 1991.

———. "Mughal Painting During the Reign of Muhammad Shah." In *After the Great Mughals: Painting in Delhi and the Regional Courts in the Eighteenth and Nineteenth Centuries*, edited by Barbara Schmitz, pp. 12–33. *Marg* 53, no. 4. Mumbai: Marg Publications, 2002.

———. "Three Paintings by Abu'l Hasan in a Manuscript of the Bustan of Sa'di." In *Arts of Mughal India: Studies in Honour of Robert Skelton*, edited by Rosemary Crill et al., pp. 80–94. London: Victoria and Albert Museum; Ahmedabad: Mapin Publishing, 2004.

Mehta, Makrand. *Indian Merchants and Entrepreneurs in Historical Perspective with Special Reference to Shroffs of Gujarat, Seventeenth to Nineteenth Centuries*. Delhi: Academic Foundation, 1991.

Mehta, Nanalal Chamanlal. *Studies in Indian Painting: A Survey of Some New Material Ranging from the Commencement of the VIIth Century to Circa 1870 A.D.* Bombay: D. B. Taraporevala Sons, 1926.

———. *Gujarati Painting in the Fifteenth Century: A Further Essay on Vasanta Vilasa*. London: The India Society, 1931.

Michell, George, and Mark Zebrowski. *The Architecture and Art of the Deccan Sultanates*. The New Cambridge History of India, 1, no. 7. Cambridge and New York: Cambridge University Press, 1999.

Michell, George, et al., eds. *In the Image of Man: The Indian Perception of the Universe Through 2000 years of Painting and Sculpture*. Exh. cat. London: Arts Council of Great Britain, 1982.

Miller, Barbara Stoler. *Phantasies of a Love Thief: The Caurapancasika Attributed to Bilhana, A Critical Edition and Translation of Two Recensions*. New York: Columbia University Press, 1971.

Miller, Barbara Stoler, ed. *Theater of Memory: The Plays of Kalidasa*. New York: Columbia University Press, 1984.

Miller, Barbara Stoler, trans. and ed. *Love Song of the Dark Lord: Jayadeva's Gitagovinda*. New York: Columbia University Press, 1977.

Monserrate, Antonio. *The Commentary of Father Monserrate, S.J., on His Journey to the Court of Akbar*. Translated by J[ohn] S. Hoyland; annotated by S. N. Banerjee. London: Humphrey Milford, Oxford University Press, 1922.

Mukherji, Parul Dave, trans. and ed. *The Citrasutra of the Visnud-harmottara Purana*. New Delhi: Indira Gandhi National Centre for the Arts; Motilal Banarsidass Publishers, 2001.

Nardi, Isabella. "Mewari Paintings in the Collection of The Metropolitan Museum of Art: Mughal Influences and Rajput Experimentation at the Court of Maharana Amar Singh II (r. 1698–1710)." *Quarterly Journal of African and Asian Studies* 74 (2006), pp. 425–50.

Nawab, Sarabhai M[anilal]. *Masterpieces of the Kalpasutra Paintings*. Jain Art Publication Series, 7. Ahmedabad: Sarabhai Manilal Nawab, 1956.

———. *Jain Paintings*. Vol. 1, *(Paintings on Palm-Leaves and Wooden Book-covers Only)*. Jain Art Publication Series, 2. Ahmedabad: Messrs Sarabhai Manilal Nawab, 1980.

Nawab, Sarabhai Manilal, and Rajendra Sarabhai Nawab. *Jaina Paintings*. Vol. 2, *Paintings on Paper, Commencing from v.s. 1403 to v.s. 1656 Only*. Ahmedabad: Messrs Sarabhai Manilal Nawab, 1985.

Noey, Christopher, and Janet Temos. *Art of India from the Williams College Museum of Art*. Exh. cat. Williamstown: Williams College Museum of Art, 1994.

Ohri, Vishwa Chander. "The Painter Manaku of Basohli." *Oriental Art* 16, no. 2 (1970), pp. 160–61.

———. "Paintings of the Mid-Eighteenth Century from Guler." *Lalit Kala*, no. 15 (1972), pp. 54–55, pl. 28.

———. "The Beginnings of a Passion: Some Unpublished Early Mandi Paintings." In *Indian Painting: Essays in Honour of Karl J. Khandalavala*, edited by B[rijindra] N[ath] Goswamy, with Usha Bhatia, pp. 316–26. New Delhi: Lalit Kala Akademi, 1995.

———. "Pandit Seu and his Sons Manaku and Nainsukh." In *Painters of the Pahari Schools*, edited by Vishwa Chander Ohri and Roy C. Craven, Jr., pp. 149–66. Mumbai: Marg Publications, 1998.

Okada, Amina. "Cinq dessins de Basâwan au musée Guimet." *Arts asiatiques* 41 (1986), pp. 82–88.

———. "Les peintres moghols et le thème de Tobie et l'Ange." *Arts asiatiques* 43 (1988), pp. 5–12.

———. *Miniatures de l'Inde impériale: Les peintres de la cour d'Akbar (1556–1605)*. Exh. cat. Paris: Editions de la Réunion des Musées Nationaux, 1989.

———. "Basawan." In *Master Artists of the Imperial Mughal Court*, edited by Pratapaditya Pal, pp. 1–16. *Marg* 42, no. 4. Bombay: Marg Publications, 1991.

———. *Indian Miniatures of the Mughal Court*. New York: Harry N. Abrams, 1992.

———. "The Musée Guimet's Prince with a Falcon: An Unknown Portrait by Ustad Mansur." In *Indian Painting: Essays in Honour of Karl J. Khandalavala*, edited by B[rijindra] N[ath] Goswamy, with Usha Bhatia, pp. 327–32. New Delhi: Lalit Kala Akademi, 1995.

———. "Kesu Das: The Impact of Western Art on Mughal Painting." In *Mughal Masters: Further Studies*, edited by Asok Kumar Das, pp. 84–95. Mumbai: Marg Publications, 1998.

Overton, Keelan. "*Vida de Jacques de Coutre*: A Flemish Account of Bijapuri Visual Culture in the Shadow of Mughal Felicity." In *The Visual World of Muslim India: The Art, Culture and Society of the Deccan in the Early Modern Era*, edited by Laura E. Parodi. London: I. B. Tauris, forthcoming.

Pal, Pratapaditya. *The Classical Tradition in Rajput Painting from the Paul F. Walter Collection*. Exh. cat. Hamilton: The Gallery Association of New York State, 1978.

———. *Indian Painting*. Vol. 1, *1000–1700*. Los Angeles: Los Angeles County Museum of Art, 1993.

Pal, Pratapaditya, and Catherine Glynn. *The Sensuous Line: Indian Drawings from the Paul F. Walter Collection*. Exh. cat. Los Angeles: Los Angeles County Museum of Art, 1976.

Pal, Pratapaditya, ed. *Master Artists of the Imperial Mughal Court*. Bombay: Marg Publications, 1991.

Pal, Pratapaditya, et al. *Romance of the Taj Mahal*. Exh. cat. London: Thames and Hudson, 1989.

Parimoo, Ratan. *Gujarati School and Jaina Manuscript Paintings*. N. C. Mehta Collection, vol. 1. Ahmedabad: Gujarat Museum Society, 2010.

Pinder-Wilson, R[alph] H. "Three Illustrated Manuscripts of the Mughal Period." *Ars Orientalis* 2 (1957), pp. 413–22.

Pinder-Wilson, R[alph] H., with Ellen [S.] Smart and Douglas Barrett. *Paintings from the Muslim Courts of India*. Exh. cat. London: World of Islam Festival Publishing Company, 1976.

Polier, Antoine-Louis Henri. *A European Experience of the Mughal Orient: The I'jaz-i Arsalani (Persian Letters, 1773–1779) of Antoine-Louis Henri Polier*. Translated and edited by Seema Alam, Muzaffar Alam, and Seema Alavi. New Delhi and New York: Oxford University Press, 2001.

Poster, Amy G., et al. *Realms of Heroism: Indian Paintings at the Brooklyn Museum*. New York: The Brooklyn Museum, 1994.

Queens Museum. *Aspects of Indian Art and Life*. Exh. cat. Flushing: Queens County Art and Cultural Center, 1983.

Randhawa, M[ohinder] S[ingh]. *Basohli Painting*. Delhi: The Publications Division, Ministry of Information and Broadcasting, Government of India, 1959.

———. "Paintings from Mankot." *Lalit Kala*, no. 6 (1959), pp. 72–75.

———. *Kangra Paintings of the Bhagavata Purana*. New Delhi: National Museum of India, 1960.

———. *Kangra Paintings of the Bihari Sat Sai*. New Delhi: National Museum, 1966.

———. *Kangra Valley Painting*. Rev. ed. 1954. New Delhi: Publications Division, Ministry of Information and Broadcasting, Government of India, 1972.

———. *Miniatures of the Babur Nama*. New Delhi: National Museum, 1983.

Randhawa, M[ohinder] S[ingh], and S. D. Bhambri. *Basohli Paintings of the Rasamanjari*. New Delhi: Abhinav Publications, 1981.

Robinson, B[asil] W[illiam], et al. *Islamic Painting and the Arts of the Book*. London: Faber and Faber, 1976.

Roe, Thomas. *The Embassy of Sir Thomas Roe to the Court of the Great Mogul, 1615–1619, as Narrated in His Journal and Correspondence*. Edited by William Foster. 2 vols. London: The Hakluyt Society, 1899.

Rogers, J. M. *Mughal Miniatures*. London: British Museum Press, 1993.

Rohatgi, Pauline, et al. *Indian Life and Landscape by Western Artists: Paintings and Drawings from the Victoria and Albert Museum, Seventeenth to Early Twentieth Century*. Exh. cat. London: Victoria and Albert Museum; Mumbai: Chhatrapati Shivaji Maharaj Vastu Sangrahlaya, 2008.

Rosenfield, John. *The Arts of India and Nepal: The Nasli and Alice Heeramaneck Collection*. Exh. cat. Boston: Museum of Fine Arts, 1966.

Roy, Malini. *50 x India: De 50 mooiste miniaturen van het Rijksmuseum/The 50 Most Beautiful Miniatures from the Rijksmuseum*. Exh. cat. Amsterdam: Nieuw Amsterdam Uitgevers, 2008.

———. "Origins of the Late Mughal Painting Tradition in Awad." In *India's Fabled City: The Art of Courtly Lucknow*, edited by Stephen [A.] Markel, pp. 165–86. Munich: Prestel Verlag, 2010.

Saraswati, S[arasi] K[umar]. "East Indian Manuscript Painting." In *Chhavi, Golden Jubilee Volume*, edited by Anand Krishna, pp. 243–62. [Varanasi]: Bharat Kala Bhavan, Benares Hindu University, 1971.

———. *Tantrayana Art: An Album*. Calcutta: Asiatic Society, 1977.

Schimmel, Annemarie, and Stuart Cary Welch. *Anvari's Divan: A Pocket Book for Akbar—A Divan of Auhaduddin Anvari*. New York: The Metropolitan Museum of Art, 1983.

Schmitz, Barbara. "After the Great Mughals." In *After the Great Mughals: Painting in Delhi and the Regional Courts in the Eighteenth and Nineteenth Centuries*, edited by Barbara Schmitz, pp. 1–11, figs. 1–7. Mumbai: Marg Publications, 2002.

Schmitz, Barbara, and Ziyaud-Din A. Desai. *Mughal and Persian Paintings and Illustrated Manuscripts in The Raza Library, Rampur*. New Delhi: Indira Gandhi National Centre for the Arts; Rampur: Rampur Raza Library, 2006.

Sen, Geeti. *Paintings from the Akbar Nama: A Visual Chronicle of Mughal India*. Varanasi: Lustre Press, 1984.

Seyller, John. "The School of Oriental and African Studies *Anvar-i Suhayli*: The Illustration of a *De Luxe* Mughal Manuscript." *Ars Orientalis* 16 (1986), pp. 119–51.

———. "Scribal Notes on Mughal Manuscript Illustrations." *Artibus Asiae* 48, no. 3–4 (1987), pp. 247–77.

———. "Codicological Aspects of the Victoria and Albert Museum *Akbarnama* and Their Historical Implications." *Art Journal* 49, no. 4 (1990), pp. 379–87.

———. "Overpainting in the Cleveland *Tutinama*." *Artibus Asiae* 52, no. 3–4 (1992), pp. 283–318.

———. "A Dated Hamzanama Illustration." *Artibus Asiae* 53, no. 3–4 (1993), pp. 502–5.

———. "Recycled Images: Overpainting in Early Mughal Art." In *Humayun's Garden Party: Princes of the House of Timur and Early Mughal Painting*, edited by Sheila [R.] Canby, pp. 49–80. Bombay: Marg Publications, 1994.

———. *Workshop and Patron in Mughal India: The Freer Ramayana and Other Illustrated Manuscripts of 'Abd al-Rahim*. Artibus Asiae Supplementum 42. Zurich: Museum Rietberg Zürich, 1999.

———. "A Mughal Code of Connoisseurship." *Muqarnas* 17 (2000), pp. 177–202.

———. "For Love or Money: The Shaping of Historical Paintings Collections in India." In *Intimate Worlds: Indian Paintings from the Alvin O. Bellak Collection*, by Darielle Mason et al., pp. 12–21. Exh. cat. Philadelphia: Philadelphia Museum of Art, 2001.

———. *Pearls of the Parrot of India: The Walters Art Museum Khamsa of Amir Khusraw of Delhi*. Baltimore: The Walters Art Museum, 2001.

———. "The Walters Art Museum *Diwan* of Amir Hasan Dihlawi and Salim's Atelier at Allahabad." In *Arts of Mughal India: Studies in Honour of Robert Skelton*, edited by Rosemary Crill et al., pp. 95–110. London: Victoria and Albert Museum; Ahmedabad: Mapin Publishing, 2004.

———. "The Colophon Portrait of the Royal Asiatic Society *Gulistan* of Sa'di." *Artibus Asiae* 68, no. 2 (2008), pp. 333–42.

———. "Two Mughal Mirror Cases." *Journal of the David Collection* 3 (2010), pp. 130–59.

———. "A Mughal Manuscript of the *Diwan* of Nawa'i." *Artibus Asiae* 71, no. 2 (2011), forthcoming.

Seyller, John, and Konrad Seitz. *Mughal and Deccani Paintings*. The Eva and Konrad Seitz Collection of Indian Miniatures, vol. 1. Zurich: Museum Rietberg Zürich, 2010.

Seyller, John, et al. *The Adventures of Hamza: Painting and Storytelling in Mughal India*. Exh. cat. Washington, D.C.: Freer Gallery of Art and Arthur M. Sackler Gallery of Art, Smithsonian Institution; London: Azimuth Editions Limited, 2002.

Sharma, O. P. *Indian Miniature Painting: Exhibition Compiled from the Collection of the National Museum, New Delhi*. Exh. cat. Brussels: Bibliotheque Royale Albert Ier, 1974.

Shiveshwarkar, Leela. *The Pictures of the Chaurapanchasika, A Sanscrit Love Lyric*. New Delhi: The National Museum, 1967.

Simsar, Muhammed A., trans. and ed. *The Cleveland Museum of Art's Tuti-nama: Tales of a Parrot, by Ziya' u'd-Din Nakhshabi*. Cleveland: The Cleveland Museum of Art; Graz: Akademische Druck- u. Verlagsanstalt, 1978.

Simsar, Muhammed A. *Golestan Palace Library: A Portfolio of Miniature Paintings and Calligraphy*. Tehran: Zarrin and Simin Books, 2000.

Singh, Chandramani. "European Themes in Early Mughal Miniatures." In *Chhavi, Golden Jubilee Volume*, edited by Anand Krishna, pp. 401–10, figs. 588–94. [Varanasi]: Bharat Kala Bhavan, Benares Hindu University, 1971.

Skelton, Robert. "Murshidabad Painting." *Marg* 10, no. 1 (1956), pp. 10–22.

———. "The Mughal Artist Farrokh Beg." *Ars Orientalis* 2 (1957), pp. 393–411.

———. "Documents for the Study of Painting at Bijapur in the Late Sixteenth and Early Seventeenth Centuries." *Arts asiatiques* 5, no. 2 (1958), pp. 97–125.

———. "The Ni'mat nama: A Landmark in Malwa Painting." *Marg* 12, no. 3 (1959), pp. 44–50.

———. *Indian Miniatures from the XVth to XIXth Centuries*. Exh. cat. Venice: Neri Pozza Editore, 1961.

————. *Rajasthani Temple Hangings of the Krishna Cult from the Collection of Karl Mann, New York.* Exh. cat. New York: American Federation of the Arts, 1973.

————. "The Iskandar Nama of Nusrat Shah: A Royal Sultanate Manuscript Dated 938 A.H. 1531–32 A.D." In *Indian Painting: Mughal and Rajput and a Sultanate Manuscript,* [edited by Michael Goedhuis], pp. 133–52. Sale cat. London: P. & D. Colnaghi and Co., 1978.

————. "Shaykh Phul and the Origins of Bundi Painting." In *Chhavi-2: Rai Krishnadasa Felicitation Volume,* edited by Anand Krishna, pp. 123–29, figs. 347–50. Benares: Bharat Kala Bhavan, 1981.

————. *The Indian Heritage: Court Life and Arts under Mughal Rule.* Exh. cat. London: Victoria and Albert Museum, 1982.

————. *L'Inde des légendes et des réalités: Miniatures indiennes et persanes de la Fondation Custodia, Collection Frits Lugt.* Exh. cat. Paris: Fondation Custodia, 1986.

Skelton, Robert, et al., eds. *Facets of Indian Art.* London: Victoria and Albert Museum, 1986.

Smart, Ellen S. "A Recently Discovered Mughal Hunting Picture by Payag." *Art History* 2, no. 4 (1979), pp. 396–99.

————. "Yet Another Illustrated Akbari *Baburnama* Manuscript." In *Facets of Indian Art,* edited by Robert Skelton et al., pp. 105–15. London: Victoria and Albert Museum, 1986.

————. "Balchand." In *Master Artists of the Imperial Mughal Court,* edited by Pratapaditya Pal, pp. 135–48. Bombay: Marg Publications, 1991.

————. "The Death of Inayat Khan by the Mughal Artist Balchand." *Artibus Asiae* 58, no. 3–4 (1999), pp. 273–79.

Smart, Ellen S., et al. *Pride of the Princes: Indian Art of the Mughal Era in the Cincinnati Art Museum.* Exh. cat. Cincinnati: Cincinnati Art Museum, 1985.

Sodhi, Jiwan. *A Study of Bundi School of Painting.* New Delhi: Abhinav Publications, 1999.

Soudavar, Abolala. "Between the Safavids and the Mughals: Art and Artists in Transition." *Iran* 37 (1999), pp. 49–66.

————. "The Early Safavids and Their Cultural Interactions with Surrounding States." In *Iran and the Surrounding World: Interactions in Culture and Cultural Politics,* edited by Nikki R. Keddie and Rudi Matthee, pp. 89–120. Seattle and London: University of Washington Press, 2002.

Soudavar, Abolala, and Milo Cleveland Beach. *Art of the Persian Court: Selections from the Art and History Trust Collection.* New York: Rizzoli International, 1992.

Spink & Son. *Painting for the Royal Courts of India.* Sale cat. London: Spink & Son, [1976].

————. *Two Thousand Years of Indian Art.* Sale cat. London: Spink & Son, [1982].

Srivastava, Ashok Kumar. *Mughal Painting: An Interplay of Indigenous and Foreign Traditions.* New Delhi: Munshiram Manoharlal Publishers, 2000.

Stchoukine, Ivan, et al. *Illuminierte Islamische Handschriften.* Verzeichnis der orientalischen Handschriften in Deutschland, 16. Wiesbaden: F. Steiner, 1971.

Stooke, Herbert J., and Karl [J.] Khandalavala. *The Laud Ragamala Miniatures: A Study in Indian Painting and Music.* Oxford: B[runo] Cassirer, 1953.

Stronge, Susan. *Painting for the Mughal Emperor: The Art of the Book, 1560–1660.* London: V & A Publications, 2002.

Suleiman, Hamid. *Miniatures of Babur-nama.* Tashkent: Academy of Science of the Uzbek SSR, 1970.

Tibet Museum. *Xizang bo wu guan/Tibet Museum.* Beijing: Encyclopedia of China Publishing House, 2001.

Titley, Norah M., trans. *The Nimatnama Manuscript of the Sultans of Mandu: The Sultan's Book of Delights.* London and New York: Routledge Curzon, 2005.

Tod, James. *Annals and Antiquities of Rajasthan, or the Central and Western Rajput States of India.* Edited and annotated by William Crooke. 3 vols. London: Humphrey Milford, Oxford University Press, 1920.

Topsfield, Andrew. *Paintings from Rajasthan in the National Gallery of Victoria.* Melbourne: National Gallery of Victoria, 1980.

————. "Sahibdin's *Gita Govinda* Illustrations." In *Chhavi-2: Rai Krishnadasa Felicitation Volume,* edited by Anand Krishna, pp. 231–38, figs. 502–23. Benares: Bharat Kala Bhavan, 1981.

————. "Sahibdin's Illustrations to the *Rasikapriya.*" *Orientations* 17, no. 3 (1986), pp. 18–31.

————. "Udaipur Paintings of the *Raslila.*" *Art Bulletin of Victoria,* no. 28 (1987), pp. 54–70.

————. *The City Palace Museum, Udaipur: Paintings of Mewar Court Life.* Ahmedabad: Mapin Publishing, 1990.

————. *Indian Paintings from Oxford Collections.* Ashmolean Handbooks. Oxford: Ashmolean Museum; Bodleian Library, 1994.

————. "The Royal Paintings Inventory at Udaipur." In *Indian Art and Connoisseurship: Essays in Honour of Douglas Barrett,* edited by John Guy, pp. 188–99. New Delhi: Indira Gandhi National Centre for the Arts; Ahmedabad: Mapin Publishing, 1995.

————. *Court Painting at Udaipur: Art Under the Patronage of the Maharanas of Mewar.* Artibus Asiae Supplementum 44. Zurich: Museum Rietberg Zürich, [2002].

————. "The *Kalavants* on Their Durrie: Portraits of Udaipur Court Musicians, 1680–1730." In *Arts of Mughal India: Studies in Honour of Robert Skelton,* edited by Rosemary Crill et al., pp. 248–63. London: Victoria and Albert Museum; Ahmedabad: Mapin Publishing, 2004.

————. *Paintings from Mughal India.* Oxford: Bodleian Library, University of Oxford, 2008.

Topsfield, Andrew, and Milo Cleveland Beach. *Indian Paintings and Drawings from the Collection of Howard Hodgkin.* Exh. cat. New York and London: Thames and Hudson, 1991.

Topsfield, Andrew, ed. *Court Painting in Rajasthan.* Mumbai: Marg Publications, 2000.

————. *The Art of Play: Board and Card Games of India. Marg* 58, no. 2. Mumbai: Marg Publications, 2006.

Topsfield, Andrew, et al. *In the Realm of Gods and Kings: Arts of India.* Exh. cat. London: Philip Wilson Publishers, 2004.

Treadwell, Penelope. *Johan Zoffany: Artist and Adventurer.* London: Paul Holberton, 2009.

Varma, D. N. "Some Unusual Deccani and Late Mughal Miniatures in the Collection of the Salar Jung Museum." *Salar Jung Museum Bi-Annual Research Journal* 15–16 (1981–82), pp. 23–32.

Vaughan, Philippa. "Miskin." In *Master Artists of the Imperial Mughal Court,* edited by Pratapaditya Pal, pp. 17–38. *Marg* 42, no. 4. Bombay: Marg Publications, 1991.

Verma, Som Prakash. *Mughal Painters and Their Work: A Biographical Survey and Comprehensive Catalogue.* Delhi: Oxford University Press, 1994.

————. *Mughal Painter of Flora and Fauna Ustad Mansur.* Delhi: Abhinav Publications, 1999.

Vyas, Lakshmi Dutt. "Dating of the Bundi-style Chunar Ragamala: A New Approach." *Marg* 54, no. 1 (2002), pp. 48–53.

Weinstein, Laura. "Exposing the Zenana: Maharaja Sawai Ram Singh II's Photographs of Women in Purdah." *History of Photography* 34, no. 1 (2010), pp. 2–16.

Welch, Anthony, and Stuart Cary Welch. *Arts of the Islamic Book: The Collection of Prince Sadruddin Aga Khan.* Exh. cat. Ithaca: Cornell University Press, 1982.

Welch, Stuart Cary. "The Paintings of Basawan." *Lalit Kala,* no. 10 (1961), pp. 7–17.

————. *The Art of Mughal India: Paintings and Precious Objects.* Exh. cat. New York: The Asia Society, 1963.

————. *Indian Drawings and Painted Sketches, Sixteenth Through Nineteenth Centuries.* Exh. cat. New York: The Asia Society, 1976.

———. *Imperial Mughal Painting*. New York: George Braziller, 1978.

———. *Room for Wonder: Indian Painting During the British Period 1760–1880*. Exh. cat. New York: The American Federation of Arts, 1978.

———. "Return to Kotak". In *Essays on Near Eastern Art and Archaeology in Honor of Charles Kyle Wilkinson*, edited by Prudence O. Harper and Holly Pittman, pp. 78–93. New York: The Metropolitan Museum of Art, 1983.

———. *India: Art and Culture, 1300–1900*. Exh. cat. New York: The Metropolitan Museum of Art, 1985.

———. "Reflections on Muhammad 'Ali." In *Gott ist schön und Er liebt die Schönheit/God is Beautiful and He Loves Beauty*, edited by Alma Giese and J. Christoph Bürgel, pp. 407–28. Bern: Peter Lang, 1994.

———. "The Two Worlds of Payag—Further Evidence on a Mughal Artist." In *Indian Art and Connoisseurship: Essays in Honour of Douglas Barrett*, edited by John Guy, pp. 320–41. New Delhi: Indira Gandhi National Centre for the Arts; Ahmedabad: Mapin Publishing, 1995.

———. *Rajasthani Miniatures: The Welch Collection from the Arthur M. Sackler Museum, Harvard University*. Exh. cat. New York: The Drawing Center, 1997.

Welch, Stuart Cary, and Kimberly Masteller, eds. *From Mind, Heart, and Hand: Persian, Turkish, and Indian Drawings from the Stuart Cary Welch Collection*. Exh. cat. New Haven: Yale University Press, 2004.

Welch, Stuart Cary, and Milo Cleveland Beach. *Gods, Thrones, and Peacocks: Northern Indian Painting from Two Traditions, Fifteenth to Nineteenth Centuries*. Exh. cat. New York: The Asia Society, 1965.

Welch, Stuart Cary, Annemarie Schimmel, Marie L. Swietochowski, and Wheeler M. Thackston. *The Emperors' Album: Images of Mughal India*. Exh. cat. New York: The Metropolitan Museum of Art, 1987.

Welch, Stuart Cary, et al. *The Islamic World*. New York: The Metropolitan Museum of Art, 1987.

———. *Gods, Kings, and Tigers: The Art of Kotah*. Exh. cat. Munich and New York: Prestel-Verlag, 1997.

Welch, Stuart Cary, with Mark Zebrowski. *A Flower from Every Meadow: Indian Paintings from American Collections*. Exh. cat. New York: The Asia Society, 1973.

Wellesz, Emmy. *Akbar's Religious Thought Reflected in Mogul Painting*. London: George Allen and Unwin, 1952.

Wilkinson, J. V. S. *The Lights of Canopus: Anvar I Suhaili*. London: The Studio, 1929.

Wilkinson, J. V. S., and Basil Gray. "Indian Paintings in a Persian Museum." *The Burlington Magazine for Connoisseurs* 66, no. 385 (April 1935), pp. 168–69, 172–75, 177.

Williams, Joanna, et al. *Kingdom of the Sun: Indian Court and Village Art from the Princely State of Mewar*. Exh. cat. San Francisco: The Asian Art Museum, Chong-Moon Lee Center for Asian Art and Culture, 2007.

Wright, Elaine, Susan Stronge, and Wheeler [M.] Thackston. *Muraqqa': Imperial Mughal Albums from the Chester Beatty Library, Dublin*. Exh. cat. Alexandria: Art Services International, 2008.

Zebrowski, Mark. *Deccani Painting*. London: Sotheby Publications; Berkeley and Los Angeles: University of California Press, 1983.

INDEX

Mohanlal, 10, 188–89, 193, 197; photographic portrait of, *197*; portrait with camera, 188, *201*
Monserrate, Antonio, 50, *50*, 51
Muhammad Shah, 110, 142, *144*, *145*, 146, 148, 150, 151
Muraqqa-e Gulshan, 49

N

Nadir Shah, 146, 150
Nainsukh, 8, 10, 11, 146, 148, 149, 153, 160–65, 166; *An Acolyte's progress* (attributed), *165*; *Portable Vishnu Shrine, perhaps a reliquary for Balwant Singh* (attributed), 160, *163*; portrait of Manaku, *153*; *Raja Balwant Singh of Jasrota viewing a painting presented by the artist* (attributed), 8, 10, 148, 160, *162*; *Raja Balwant Singh of Jasrota worships Krishna and Radha* (attributed), 148, *161*; self-portrait, *160*; *A Troup of Trumpeters* (attributed), *164*
Nala-Damayanti series, *175*
Nanda, *39*, *129*, 170
Nasiri Khan, *92*
Nasiruddin, 52, 98–100, 101, 110, 148, 188; *Malashri Ragini*, 52, 98, *99*, 110; *Varati Ragini*, 52, 98, *100*, 110
Nikka, 148, 160, 166; *Banasura's penance* (attributed), *168*; detail, *169*
Nispannayogavali, 22
Nurpur Masters, 117

P

Padmapani, 20
Padshahnama, Windsor Castle, 53, 76, *78*, *79*, 86, *87*, *92*
Pala manuscripts, 22–23
Pala-Sena dynasties, 34
Pandit Seu, 10, 146, 148, 153, 154, 157, 160; *Drunken monkeys and bears fighting in the Madhuvana Grove* (attributed), 146, 148, *148*
Parvati, *120*, *121*, *168*
Payag, 10, 53, 86, 89–94; *Humayun seated in a landscape, admiring a turban ornament*, *94*; *Nasiri Khan directing the siege of Qandahar*, 89, *92*; *Prince Dara Shikoh hunting*

nilgais (attributed), 89, *93*; self-portrait, 8, 89, *89*; *Shah Jahan riding a stallion*, 52, *91*; detail, *FM*, *90*
Plantin, Christopher, *Royal Polyglot Bible*, 51, 53, *53*
Polier, Antoine-Louis, 186–87, *187*, 190
Prajnaparamita, 22, *22*
Purkhu of Kangra, 148, 176, 189; *Anirudh Chand of Kangra admiring pictures with his courtiers* (attributed), 10, *10*, *176*; *Gita Govinda*, 176; *Harivamsa*, 176; *Kedara Kalpa*, 176; *Krishna flirting with the gopis* (attributed), detail, *BM*; 176, *177*; *Ramayana*, 176; self-portrait, *176*; *Shiva Purana*, 176

R

Radha, 140, 149, 155, *161*, *171*, *174*, *177*
Ragamala, 33, 36, *102*; Chawand, 98, *99*, *100*, 188; Chunar, 35, 52, 95–97, *96*, *97*, 101, 103; *Raga Madhava* (Second Bahu Master), *127*
Raja Hari Sen, 106
Rajaraja Chola, King, 18, *19*
Rajasthan map, *III*
Rama, 124, 125, *126*, 130, *156*, *157*, *167*
Ramayana, 19, 51, 68, *108*, 130; First Generation, 166, *167*, 172; Shangri II series, 124, *125*; Shangri I series, *126*; Siege of Lanka series (Manaku), *156*, *157*; Siege of Lanka series (Seu), 146, 148, 153, 154, 156; Valmiki, 156, *167*
Ramdayal, 189
Ramkrishna, 189
Ranjha, 148, 160, 166; *The marital bliss of Nala and Damayanti* (attributed), *175*
Ranthambhor, 180, *181*
Rasamanjari series, 106, 117–22
Rawat Ragho Das, 178
Roe, Sir Thomas, 68, *75*
Ruknuddin, 11, 113, 114–16; *Ladies of the zenana on a roof terrace*, 114, *115*; *Vishnu with Lakshmi enthroned, on a roof terrace*, 114, *116*

S

Sadeler, Raphael, *Dolor*, 66, *66*
Sadhanamala, 22

Sa'di: *Bustan*, 77, *77*; *Gulistan*, 88, *88*
Sahibdin, 52, 101, 102, 110, 131, 148, 188; *Gita Govinda*, 101; *Malavi Ragini*, 101, *102*, 110; *Ragamala*, 101; *Rasikapriya*, 101; *Sukaraksetra Magatmya*, 101
St. Petersburg Album, 62, 64, 67, 75, 82, 150, *151*, 152
Sajnu (Sahu), 189; *Aklaq-i Nasri* manuscript, *The Painters' atelier*, *9*, 10, 50
Sakuntala, 18, *18*
Salim, Prince (future Jahangir), 52, 58, 74, 82, *83*, 84, *85*, 86
Shah Jahan, Emperor, 50, 51, 52–53, 73, 76, 79, 84, 86, 89, *90*, *91*, *93*, 94, 110, 136, 140, 141; Kevorkian Album, *72*, 84, *90*; Late Shah Jahan Album, 89, 94; *muraqqa* of, *67*
Shahnama: Firdawsi, 21, 25, 29, 30; Islamic, 24, 25; Jainesque, 29–31
Sharif, Muhammad, 56
Shaykh Husayn, 95, *97*
Shikoh, Prince Dara, *93*
Shiva, 20, *120*, *121*, *168*
Shivalal, 10, 188, 193, 197; *Maharana Fateh Singh crossing a river in flood*, 188, 197, *199*; *Maharana Fateh Singh shooting a leopard*, *198*; *Portrait of Jaswant Singh II of Jodhpur* (hand-colored photograph), 197, *200*
Shrisharsh, *Naishadhacharita*, 175
Singh, Rana Amar, 98
Singh, Amar II, 131, 132, *133*, *134*
Singh, Kunvar Anop, 178, *179*
Singh, Anup, 113, 114
Singh, Ari, 178
Singh, Raja Balwant, 8, 148, 160, *161*, *162*, 163
Singh, Rao Bhim, 139, 182, *183*, *185*
Singh, Fateh, 197, *198*, *199*
Singh, Rao Jagat, 52, 102, 103, *104*, 105
Singh, Maharana Jagat I, 101, 148, *149*
Singh, Jaswant II, 197, *200*
Singh, Maharaja Karan, 101, 113, 114, 116
Singh, Rao Madho, 103, *137*
Singh, Mian Zorawar, 160
Singh, Rana Pratap, 98
Singh, Raja Raj, 140, 168
Singh, Ram I, *136*, *138*

Singh, Ram II, 189
Singh, Ratan, 95, *97*
Singh, Rawat Jaswant, 178
Singh, Maharana Sangram II, 131
Singh, Sarup, 188, 193, *194*, *195*, *196*, 197
Singh, Savant, 149
Singh, Rao Surjan, 95
Singh Sagar, 182
Sita, 124, *167*
Siyavash, *30*, *31*
Somesvara III, King, *Manasollasa* (attrib.), 18–19
Stipple Master, 110, 131–34; *Maharana Amar Singh II with ladies of the zenana* (attributed), 131, *134*; *Maharana Amar Singh II riding a Jodhpur horse* (attributed), *133*; detail, *132*
Suraj Sen, 106
Suri, Sri Jinadatta, 23

T

Tagore, Abindranath, 188
Tagore, Gaganendranath, 188
Tahmasp, Shah, 36, 54
Tara, 10, 37, 188, *189*, 193–96, 197; *Maharana Sarup Singh and his courtiers on elephants*, 188, 193, *194*; *Maharana Sarup Singh inspects a prize stallion*, 193, *195*; portrait of, *193*; *Portrait of Sarup Singh with attendants, after William Carpenter*, 187, 188, 193, *196*
Tutinama, 40, 42; Beatty, 95; Cleveland manuscript, 37, *43*

U

Udaipur, 11, 52, 131, 148, 149, 178, 182, 183, 188, 193
Usha-Aniruddha series, *168*

V

Vasanta Vilasa, 21, 98
Vasishtha, *126*
Vatsayana, *Kamasutra*, 17
Vishnu, 17, *17*, 35, *116*; Genealogy of (*Harivamsa*), 51
Vos, Maarten de: *Africa*, 48; *Dolor*, 66

PHOTOGRAPH CREDITS

Unless otherwise specified, all photographs were supplied by the owners of the works of art, who hold the copyright thereto, and are reproduced with permission. We have made every effort to obtain permissions for all copyright-protected images. If you have copyright-protected work in this publication and you have not given us permission, please contact the Metropolitan Museum's Editorial Department. Photographs of works in the Metropolitan Museum's collection are by the Photograph Studio, The Metropolitan Museum of Art. Additional credits and sources appear below; images with catalogue numbers are listed first (grouped with other images that have the same credit), followed by images with figure numbers only:

Nos. 3, 4, 7, 46, 54, 56, 59, 62, 64, 78, 83, 88, 91, 93, 95, 96; figures 19, 20, 21: ©Museum Rietberg, Zurich, photos: Rainer Wolfsberger; **Nos. 5, 19, 55, 58, 71:** © The San Diego Museum of Art; **Nos. 6, 45:** © 2011 Digital Image Museum Associates / LACMA / Art Resource, NY / Scala, Florence; **Nos. 9, 63:** © The Cleveland Museum of Art; **Nos. 11, 74:** © The Bodleian Library, University of Oxford; **Nos. 13, 23:** © Museum of Islamic Art, Doha; **No. 16, figure 2:** © Aga Khan Trust for Culture, Geneva; **Nos. 18, 31, 32, 37, 38, 41, page 89:** © 2011 Her Majesty Queen Elizabeth II / The Bridgeman Art Library; **Nos. 20, 30, 42, 43:** © Arthur M. Sackler Gallery, Smithsonian Institution, Washington, D.C.; **Nos. 21, 29, 35, 75:** The Institute of Oriental Manuscripts of the Russian Academy of Sciences, St. Petersburg; **No. 25:** © Staatsbibliothek zu Berlin, Preussischer Kulturbesitz; **No. 26:** Réunion des Musées Nationaux / Art Resource, NY; **Nos. 28, 68, 72, 97:** © The Ashmolean Museum, University of Oxford; **Nos. 39, 102:** © The David Collection, Copenhagen; **Nos. 49, 90:** © Philadelphia Museum of Art; **No. 73, figure 11:** © 2011 Museum of Fine Arts, Boston; **Nos. 77, 89, pages 117, 124:** © National Museum, New Delhi; **Nos. 104, 106–110, pages 193, 197:** © City Palace Museum, Udaipur (MMCF); **Figures 1, pages 58, 73:** © Golestan Palace Library, Tehran, Photo: Davood Sadeghasa; **Figure 4:** Joseph C. French, *Himalayan Art*, London 1931, plate 5; **Figure 6:** Photograph by V.K. Rajamani, courtesy of John Guy; **Figure 7:** Herbet Härtel, *Indische und Zentralasiatische Wandmalerei*, Berlin 1959; **Figure 9:** National Archives Kathmandu, courtesy of John Guy; **Figure 10:** © Birmingham Museums & Art Gallery; **Figure 12:** Photograph courtesy Center for Art & Archaeology, American Institute of Indian Studies, Gurgaon, India; **Figure 13:** © British Library Board; **Figure 14:** Shiveshwarkar, Leela, and Bilhana. *The Pictures of the Chaurapañchāśikā: A Sanskrit Love Lyric*. New Delhi 1967, no. 19; **Figure 15:** © The Trustees of the Chester Beatty Library, Dublin; **Figure 16:** © Freer Gallery of Art, Smithsonian Institution, Washington, D.C.; **Figure 17:** © President and Fellows of Harvard College, Photo: Allan Macintyre; **Figure 22:** V&A Images/Victoria and Albert Museum, London